Cézanne's Watercolors

Cézanne's Watercolors

Between Drawing and Painting

Matthew Simms

Yale University Press

New Haven ~ London

Designed by Sarah Faulks

Printed in Singapore

Library of Congress Cataloging-in-Publication Data

Simms, Matthew Thomas.
 Cézanne's watercolors: Between drawing and painting / Matthew Simms.
 p. cm.
 Includes bibliographical references and index.
 ISBN 978-0-300-14066-8 (cloth : alk. paper)
 1. Cézanne, Paul, 1839–1906–Criticism and interpretation. 1. Cézanne, Paul, 1839–1906. 11. Title.
 ND1950.C4S56 2008
 759.4–DC22

 2008006085

A catalogue record for this book is available from The British Library

Front endpapers: *Bathers*, detail, 1894–1906, graphite and watercolor on paper, 6¾ × 10⅝ in. (17 × 27 cm). Private collection

Back endpapers: *Male Bathers*, detail, 1899, graphite and watercolor on paper, 7⅞ × 10¾ in. (20 × 27.3 cm). The Pierpont Morgan Library, New York, The Thaw Collection. Photo © David Loggie

Frontispiece: *The Garden Terrace at Les Lauves*, detail, 1902–06, graphite and watercolor on paper, 17 × 21¹/₁₆ in. (43.2 × 53.4 cm). The Pierpont Morgan Library, New York, The Thaw Collection. Photo © The Pierpont Morgan Library, New York, 2008

Contents

Acknowledgments

While researching and writing this book I was fortunate to enjoy a great deal of support, both at the dissertation stage and during the process of transforming it into the present study. It is my pleasure to thank my advisor at Harvard, Yve-Alain Bois, whose ability to think his way into artistic practices has been a model for my own work on Cézanne; as well as Norman Bryson and Henri Zerner, both of whom were important sounding boards for my ideas on Cézanne. During my tenure as the 2000–01 Florence S. Gould post-doctoral fellow at Princeton University, I was invited to write the lead essay for the catalogue of an exhibition of the group of outstanding Cézanne watercolors in the Henry and Rose Pearlman Collection. The opportunity to examine these watercolors in detail on multiple occasions reinforced my conviction that a scholarly study of Cézanne's watercolors was long overdue. Thanks are due to Professor Peter Bunnell and to the Florence S. Gould Foundation for supporting the year of research and writing at Princeton. I also thank Laura Giles, curator of prints and drawings at the Princeton University Art Museum, and Carol Armstrong, both of whom gave me timely feedback on my essay on Cézanne's watercolors.

I began to discuss the possibility of publishing a book on Cézanne with Gillian Malpass of Yale University Press in 2000. Her interest in the project as I worked toward the present manuscript was a vital source of support and encouragement, as was her patience as I brought it to its final form. I am also indebted to Emily Angus and Sarah Faulks of Yale University Press, and to the copy editor who weeded out my grammatical bad habits. The external reader of the manuscript, John House, invited me to discuss his comments with him and to examine the spectacular Cézanne watercolors in the Courtauld Institute of Art. His penetrating criticisms and suggestions for improving the manuscript alerted me to more than one pitfall and challenged me to streamline my argument. Any lingering faults in the text, however, are exclusively my responsibility. At the Courtauld, I was also fortunate to meet Stephanie Buck, curator of drawings, as well as conservators Aviva Burn-

Facing page: detail of pl. 5

stock and Liz Reissner, who were then working on a full technical examination of the Cézannes in the collection of the Courtauld. Their explorations of the physical properties of the watercolors provided the context for a stimulating discussion of Cézanne's watercolor technique and, especially, the role of drawing and painting in his technical process.

In writing the book I have benefited from the valuable feedback of several friends and colleagues. Roger Rothman read an early draft of the manuscript and offered crucial suggestions for improvement. Kendall Brown read the manuscript near its completion and gave useful feedback for polishing the text. C. Jean Campbell, Karen Kleinfelder, and Robert Maxwell also read and commented on parts of the text at various stages. Conversations with friends and colleagues have also informed my thinking in important ways. My thanks are due to Benjamin Buchloh, Hollis Clayson, Peter Gombos, Marc Gotlieb, Peter Holliday, Jean-Claude Lebensztejn, Pavel Machotka, Christine Mehring, Stephen Nelson, Eric Rosenberg, Mark Ruwedel, Jeffrey Ryan, Richard Shiff, David Templeton, Martha Ward, and Andreas Zervigon.

During the period of my research, many museums opened their doors and allowed me to examine and even photograph works that were either in storage or in special collections. I wish to thank the staff of the Graphische Kabinett of the Kunsthaus, Zürich; Duncan Robinson, the director of the Fitzwilliam Museum, Cambridge; the staffs of the Petit Palais and the Musée d'Orsay, Paris; the education department of the Philadelphia Museum of Art, Philadelphia; and the staff of the Mongan Center in the Fogg Art Museum, Cambridge, Massachusetts. I also wish to thank the staffs of the Fondation Jacques Doucet, the Bibilothèque nationale, and the archives of the Musée d'Orsay, Paris; and the staff of the library and gallery of the Courtauld Institute of Art, London. I would also like to thank the staff of the Getty Research Institute and, especially, the staff of the Special Collections. My gratitude is also due to the staff of the Inter-Library Loan Office at CSULB. In gathering images, I have enjoyed the generosity of many private collectors and museums. For help in locating images, I am indebted to Wayne Andersen, Yve-Alain Bois, Richard Brettell, Walter Feilchenfeldt, John House, Christopher Lloyd, Joachim Pissarro, Stephen Platzman, Martine Ragot, Karin von Maur, Simon Wills, and Stephan Wolohojian. To help cover the expense of the images, CSULB generously helped offset the costs of obtaining rights and reproductions. I would also like to thank David Hadlock, chair of the CSULB art department, for his support.

Finally, I want to thank my family. I am deeply indebted to my wife, Florence, and to Bonapo, both of whom provided me with encouragement during the process of writing the book. My sons, Andrew and Gabriel, helped me keep my work and family balance in view. The generosity and kindness of Florence's family in Paris guaranteed that my research would take form under the best circumstances. My brothers and their families offered a much needed reference point outside the precinct of the academy and, in England, my grandmother, my aunt, and my cousins all extended warm welcomes to me. Finally, I owe a great debt of gratitude to my mother, Carol Simms, and her companion, Fredric Wilkins, who have been enthusiastic from the beginning. I dedicate this book to my mother, who first introduced me to Cézanne's art.

Facing page: detail of pl. 116

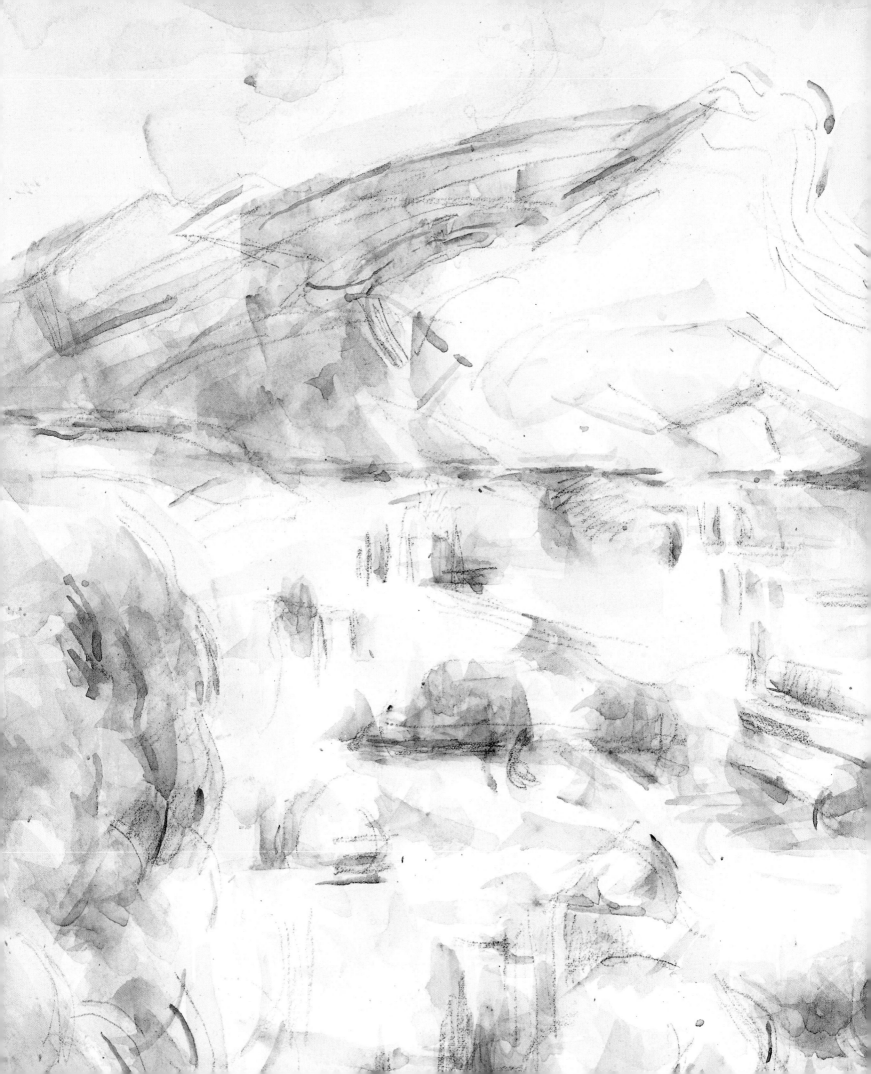

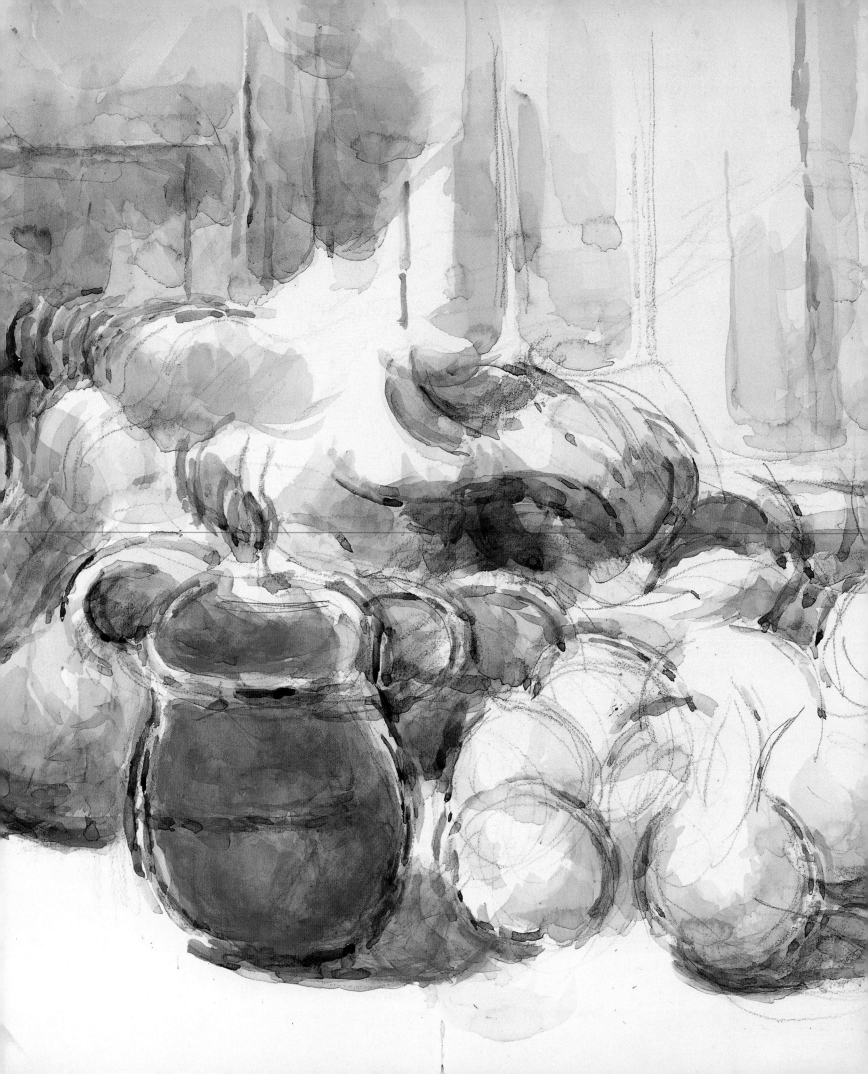

Note on Illustrations

All works are by Paul Cézanne unless otherwise indicated.

A note on dates: I have followed the dates given for Cézanne's watercolors in John Rewald's catalogue raisonné (Rewald, *Paul Cézanne: Watercolors* [Boston, MA: Little, Brown, 1983]), except for the following instances, where revisions have been offered:

In Chapter One, I have given the earliest date for Cézanne's *couillard* watercolors as 1866, based on the date of his announcement of his plan to buy a watercolor box in a letter to Zola of that year.

In Chapter Two, I have allowed for earlier dates for Cézanne's Impressionist watercolors to reflect his engagement with Impressionism beginning already in the early 1870s. Also, watercolors made in L'Estaque, which are dated to 1878–82 in the catalogue raisonné, have been dated 1876–82, to allow for Cézanne's visit to that town in 1876 as a possible moment of execution.

In Chapter Five, I have given 1894–1906 as a time span for all Cézanne's bather sketches, which allows for a possible date of execution at any moment during his work on his three large canvases on the theme of women bathers. Finally, although *Bathers by a Bridge* is assigned a date of 1900 in the catalogue *raisonné*, I have dated it to 1906. It was during the summer of 1906 – his last summer – that Cézanne is known to have worked frequently along the banks of the Arc.

Facing page: detail of pl. 101

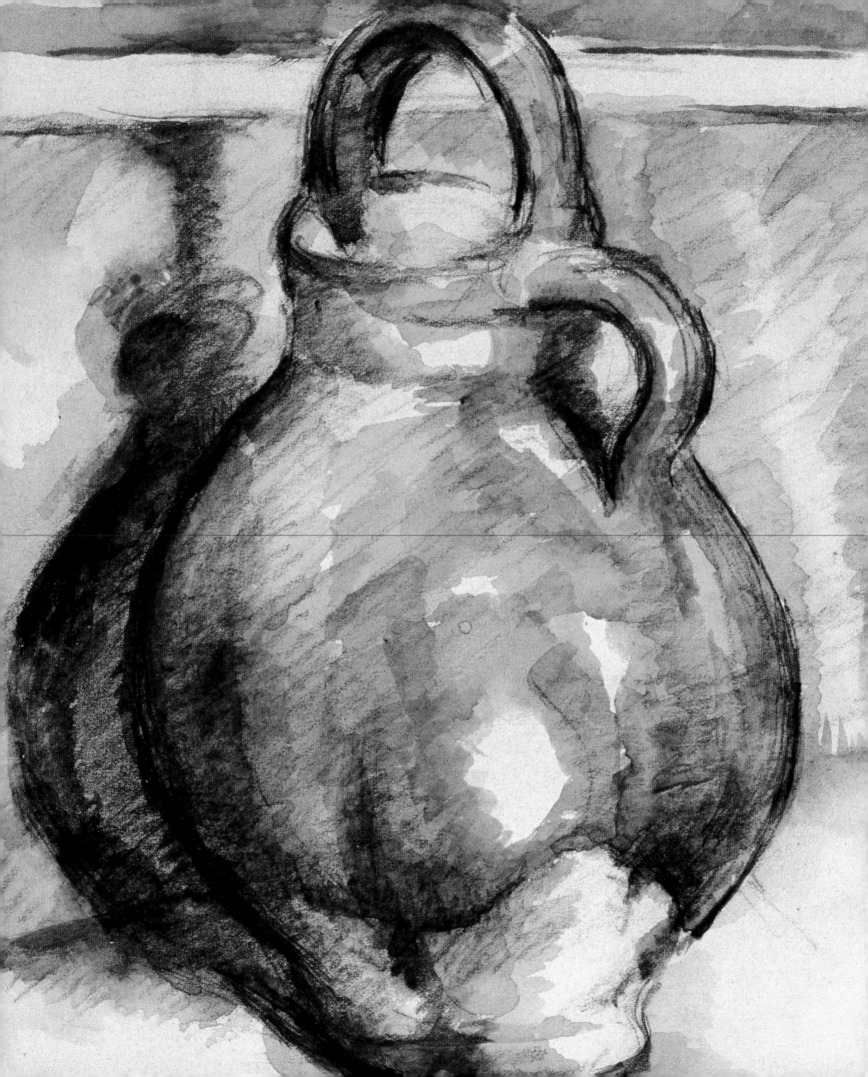

Introduction

Paul Cézanne's watercolors offer the viewer kaleidoscopic arrays of translucent color touches – blue, green, yellow, pink, violet – that appear to shimmer on the luminous paper like so many reflections on the surface of a pond. As one continues to look, graphite pencil lines, like reeds swaying in the watery depths, beckon from what appears to be a subtending, deeper level of the image. These drawn lines, ranging from graphic hatching to sinuous contours, applied with the sharpened point of a pencil, contrast strikingly with the soft, watery touches of color put down by the soggy bristles of a watercolor brush.

This combination of drawing and color was singled out by some of the first viewers to record their impressions of Cézanne's watercolors. In a review of the first exhibition of Cézanne watercolors in 1905, the critic André Fontainas noted that some of them were "admirable drawings" heightened with "only a few touches of color."[1] Writing to a friend in 1907, the poet Rainer Maria Rilke, who had just seen a show of Cézanne's watercolors in Paris, observed similarly that they were made up of "very light pencil outlines and here and there, as if just for emphasis and confirmation, there is an accidental scattering of color, a row of spots, wonderfully arranged and with a security of touch: as if mirroring a melody."[2] Finally, in a review of an exhibition of Cézanne's watercolors in 1913, the critic Gustave Kahn wrote that "the color is pale, discreet, highly dispersed, and hemmed in by many blank spots; it leaves visible all of the drawing, which accentuates the note-like quality of these pages."[3] However these critics characterized the combination of line and color – as "admirable" drawings heightened with a few touches of color, the "mirroring" of a melody, or the note-like and summary renderings of an artist working in haste – they all identified the dialogue between drawing and color, between the pencil and the paintbrush, as crucial to Cézanne's watercolor technique.

Despite this early consensus, subsequent scholarship has been surprisingly inattentive to this pivotal nexus. In his study of Cézanne's watercolors, for instance, Lionello

Venturi suggested that the element of drawing in watercolor was an encumbrance to Cézanne. The advantage of oil painting, he wrote, was that it "easily covered the drawing," whereas watercolor did not or did "not so simply" allow for the drawing's effacement.[4] In Venturi's account, drawing is a distracting "girder" or preliminary "indication" of Cézanne's compositions. The essence of Cézanne's watercolors, he claimed, was "pictorially realized by watercolor," that is, by the application of touches of translucent pigment.[5] Kurt Badt repeated this prejudice against drawing and in favor of color in *The Art of Cézanne*, arguing that drawing was merely a preliminary marking of the page unworthy of close attention. The import of Cézanne's watercolors, Badt claimed, lay in his use of color: "On top of these [pencil lines], he applied unconnected dabs of color, and it was they which first revealed the significance of what the artist had to say."[6] Lawrence Gowing's essay "The Logic of Organized Sensations" contains observations about Cézanne's use of drawing in his watercolors that suggest a greater awareness of its importance, although here too the author privileges color. According to Gowing, "color contrasts" and not pencil drawing became for Cézanne "the internal life of art."[7] Götz Adriani and John Rewald more recently reinforced the impression that drawing, if present in Cézanne's watercolors, is subordinate in interest and importance to color.[8]

The downplaying of drawing in favor of color in scholarship on Cézanne's watercolors can be partially ascribed to remarks made by the artist himself. Gowing, for instance, supports his argument by citing Cézanne's reported dictum that "there is no such thing as line or modeling; there are only contrasts of color."[9] Or, as Cézanne also reportedly explained: "Drawing and color are not different; as one paints one draws; as color becomes more harmonious, drawing becomes more precise."[10] These statements, however, were made in the context of discussions of oil painting and were not meant to deny the existence of the distinct practice of drawing. What Cézanne makes clear with such remarks is that in his oil paintings he sought to render form through color relationships rather than through tonal contrasts and the demarcation of objects by means of sharp, drawn contours. In his drawings, conversely, tonal contrasts and contours were indispensable, as is evident in the vast number of pencil drawings that fill his numerous sketchbooks, in which tonal hatching and drawn contours make up the basis of his representational means. Cézanne could certainly not have meant that there is literally no such thing as line or modeling, therefore, since these were the two essential elements of his pencil drawings. Nor could he have meant that there is no difference between drawing and painting, since this difference was in fact built into his artistic practice, in which each medium was treated as a distinct means of rendering his sensations – one in color and the other in line and tonal modeling.

What made watercolor unique in this context was that it was in this other, third medium that these two otherwise distinct modes of rendering could be brought together in one and the same work of art. Moreover, Cézanne clearly wanted both to remain visible at every stage of the development of his watercolors. The ratio of drawing to color in his watercolors shifted throughout his career, sometimes favoring one, sometimes the other. In rare instances, he even suppressed drawing altogether in favor of the direct application of pure, immediate color. These experiments were few and far between, however, and Cézanne always quickly returned to the use of both pencil and paintbrush in the execution of his watercolors.[11] By overlooking or downplaying drawing in Cézanne's watercolors and, consequently, by missing the dialogue

between drawing and painting in his work in the medium, scholars have lost sight of a key to understanding the unique role that watercolor played in Cézanne's career.[12]

The thesis of this study is that the sequential quality of watercolor, in which line and color are brought into contact with the page in multiple, successive phases of execution, was its main appeal for Cézanne. Watercolor allowed him to render what he termed his "sensations" in the two distinct modes of drawing and painting that accumulated into a complex record of his shifting responses to his motif. Cézanne identified the expression of sensations as the basis of his art in all mediums, starting already at the outset of his career and continuing throughout the rest of his life. Roughly a week before he died, he wrote in a letter to his son that "sensations are at the basis of what I am doing."[13] Scholars have recently underscored the inherent tensions in Cézanne's ambition to exteriorize his sensations.[14] Cézanne, however, never lost faith in his overriding goal of expressing sensations in his art, no matter how difficult, an ambition that was firmly grounded in a broadly shared desire in nineteenth-century French art, from Romanticism to Symbolism, to create authentic records of individual, subjective experience. The critic Gustave Geffroy captured this impulse in remarks on Cézanne published during the artist's lifetime. Cézanne, he wrote, "is a man who looks everywhere around him, who experiences an intoxication in the spectacle unfurled before him, and who wishes to transfer the feeling of this intoxication to the restricted space of the canvas. So, he sets to work and he searches for the means to accomplish this transposition as truthfully as possible."[15] Cézanne took a rare liking to this piece of criticism, even writing to the critic, whom he had not yet met, to express his appreciation: "Yesterday, I read the long article you devoted to shedding light on the experiments I have been making in painting. I want to express to you my gratitude for the sympathy I have found in you."[16]

Geffroy had oil painting in mind, but his conception of Cézanne's ambition as an effort to transpose sensations into art also fits his watercolors. But in contrast to the public art of oil painting, in which Cézanne sought to capture his sensations in a complete and comprehensive manner, watercolor enabled him to engage in a provisional accounting for sensation, in which the task of transposition is shared between the pencil and the paintbrush. The art historian Wayne Andersen has written:

> We look to [Cézanne's] drawings and watercolors because they are near to the spring of conception. We sense in them the more immediate presence of the artist, his spontaneous response to sensations, the impetus and resolution of every judgment, the logic of his technical procedure. They reveal the rich variety of his art, the infinite nuances of expression which formalistic explications, invariably based on major canvases and those late aphorisms by which he disclosed his theories, have obscured by a density of compositional analysis.[17]

In sum, he adds, the watercolors and drawings "relate less to these 'conclusions' than to the process which directed Cézanne toward his sensed but indefinable goal."[18] In addition to giving a glimpse into the process by which Cézanne worked toward his goal of expressing his sensations, his watercolors, I argue here, offered an alternative means of accomplishing this goal, one that, indeed, does not belong to the "conclusions" of the large canvases but instead occupies a space in the margin of Cézanne's art between drawing and painting. Cézanne noted on more than one occasion that his watercolors were for him mere means to fill idle moments while he was not working on oil paintings. This marginal status, however, was also a strength of sorts. Because it was free of

the weighty expectations of oil painting, watercolor allowed Cézanne a greater sense of freedom, spontaneity, and ease in the rendering of his unfolding sensations.

Cézanne's Watercolors brings the unique role played by Cézanne's watercolors in his œuvre into focus. The five chapters of this study trace the development and transformations of Cézanne's use of the medium over the course of his career, paying special attention to the constantly evolving counterpoint of drawing and color in his watercolor technique. In each chapter, Cézanne's watercolors are explored in terms of his stated aim to express his sensations according to his personal, unique temperament.

Chapter One, entitled "Strong Sensations: Cézanne's *Couillard* Watercolors," examines Cézanne's earliest watercolors, dating from the 1860s, and their relationship to general assumptions about the technique and functions of watercolor in nineteenth-century France. From watercolor manuals to Salon criticism, watercolor was usually understood to offer a more immediate mode of expression than oil painting. Moreover, the status of watercolor as a work on paper underscored its proximity to drawing, while its resources of color called to mind associations with oil painting. Cézanne was by no means the first artist to enlist both the pencil and the paintbrush in the execution of watercolors. Even a casual look at the history of nineteenth-century French watercolor practice suggests that the division of the technique into stages of drawing and painting was generally accepted as a necessary condition of the medium. Indeed, questions of medium specificity were raised frequently in conjunction with watercolor. The *differentia specifica* of watercolor, critics broadly agreed, was its status as "colored drawing" – *dessin en couleur, dessin coloré*. The uniqueness of the medium lay in its position between drawing and painting, allowing it to combine the graphic and spontaneous aspects of drawing with the colorful and expressive effects of painting. Watercolor, in sum, was understood to be an inherently mixed medium.

Chapter Two, entitled "Shorthand for Sensation: Cézanne, Watercolor, and Impressionism," explores Cézanne's watercolors from the 1870s, when, through a dialogue with Camille Pissarro, he turned to Impressionism. He embraced Pissarro's conception of watercolor as a rapid means to capture fleeting effects of nature that were outside the range of more time-consuming oil painting. As line becomes more incisive and controlled and as color takes on greater transparency and lightness, a rudimentary division of labor emerges in Cézanne's Impressionist watercolors: the pencil and the paintbrush divide the tasks of processing sensations into those of form and those of light and color. This chapter also includes discussion of the general role played by watercolor in the Impressionist exhibitions in the 1870s and, more specifically, the critical response to the three watercolors that Cézanne exhibited in the exhibition of 1877.

Chapter Three, "Layered Sensations: Watercolor, Completeness, and Duration," focuses on Cézanne's watercolors from the late 1880s to the early 1890s – his so-called mature career – and the intermittent alignment of drawing and color that characterizes them. Through a discussion of general questions of finish and completeness, this chapter suggests that what comes to the fore in Cézanne's mature watercolors are the patterns and rhythms of his attention. This can be seen in the wide variation in the ratio between drawing and color in watercolors of the same motif, as well as in the unevenness of drawing and color in one and the same work, in which the pencil and the paintbrush have pursued divergent itineraries across the paper surface. This chapter allows me to draw a parallel between the layering of drawing and painting in Cézanne's watercolors and mnemonic layering as developed in the writings of the French philosopher Henri Bergson.

The fourth and fifth chapters examine Cézanne's late watercolors, dating from roughly 1895–1906. Chapter Four, "Sensations of Light and Air: Watercolor and the 'Envelope,'" situates Cézanne's late watercolors in the context of his ambition to render the optical flux of light and air that he termed the "envelope." This ambition is evident in views executed outdoors and in still lifes rendered in his studio, in which the pencil and paintbrush collaborate to render shimmering light and circulating atmosphere. In Cézanne's late watercolors, drawing loses its tactile hold on the world and joins color in its calibration to optical sensations. Through comparison of watercolors and oil paintings of the same motifs, this chapter argues that Cézanne's watercolors present a very different image of the envelope than his oil paintings. This is due not only to the combination of drawing and transparent color in his watercolors, but also to the important role played by the blank paper surface, or "reserve."

The divergent effects of watercolor vis-à-vis oil painting is also the subject of the fifth and final chapter, "Harmony and Vitality," which explores the watercolor sketches Cézanne made in his late career in connection with his three large canvases of female bathers. Chapter Five argues that these watercolors recover the emphasis on gestural expression and spontaneity that was seen in his early work in the medium, discussed in the first chapter. Like his early watercolors, these late sketches of bathers are related to large-scale oil paintings that were intended to make a powerful public statement in line with the artist's personal sensations and temperament. Once again, however, watercolor, as a more intimate medium, allowed Cézanne to remain closer to the *première pensée* of his bathers imagery, which I argue was an idealized conception of harmony and vitality. Especially in the summer of 1906, Cézanne took advantage of watercolor's portability and brought it with him to the cool banks of the Arc river on the outskirts of Aix-en-Provence. The watercolors he made there, including at least one image of frolicking bathers, allowed Cézanne to envision a world of physical pleasure and vital harmony that presented a foil to his own life in his final years.

Each chapter, therefore, considers Cézanne's watercolors in terms of their status as an alternative to oil painting. The grounding assumption of this study is that it is only once the position of watercolor between drawing and painting is brought to the fore that the specific function and appeal of watercolor in Cézanne's art can be grasped. Indispensable to making this point, therefore, will be the practice of frequent close looking, which represents an adaptation to the specificity of the objects themselves. Indeed, the layering of Cézanne's watercolors invites the spectator to engage in an experience of viewing that is itself predicated on a movement between drawing and painting, between pencil lines and touches of watercolor. Moving between the drawn and painted marks, I hope to capture something of Cézanne's original process of execution, which was itself divided into stages of drawing and painting. On a more general level, this study participates in a growing interest in the historical conditions and connotations of technique, which has recently emerged as a central concern of the research and discussion of Impressionism.[19] So far, however, few of these studies have considered work in mediums other than oil painting, which reflects an unfortunate bias in scholarship on Impressionism and Post-Impressionism in favor of the medium of oil painting and against the so-called minor mediums of drawing, watercolor, and printmaking.[20] This study seeks to expand the renewed discussion of technique to Cézanne's watercolors by recovering their important dialogue of drawing and painting, of the pencil and the paintbrush.

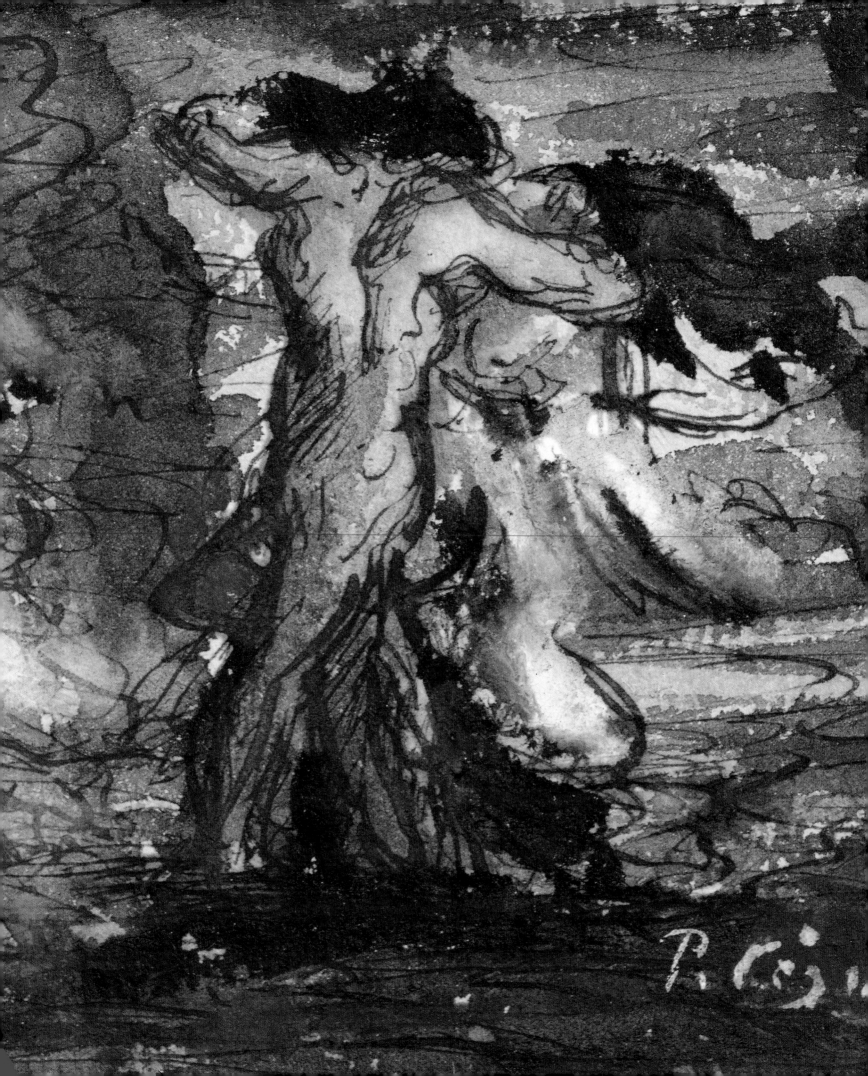

One

Strong Sensations:
Cézanne's *Couillard* Watercolors

One of Cézanne's earliest references to watercolor appears in a letter dated June 30, 1866, written to his friend, the novelist and critic Emile Zola. Cézanne had been living for the previous few weeks in the small town of Bennecourt, located on the banks of the Seine just west of Paris. He was taking advantage of the tranquility of the place to execute several oil paintings, the most ambitious of which was a now-lost, large-scale depiction of laborers at a forge. "The picture isn't going too badly," he explained, "but the time passes so slowly during the day."[1] The problem, he continued, resided in the fact that, because they had jobs, his models were available at the maximum for only a couple of hours a day. In order to occupy his attention for the rest of the time, he planned to buy a set of watercolors. "I must buy myself a box of watercolors (*une boîte d'aquarelle*)," Cézanne announced to Zola, "to work with when I'm not at my oil painting."[2]

Cézanne no doubt wanted to buy a watercolor box like those that were most popular in nineteenth-century France. These convenient, folding containers held cakes of dried color, paintbrushes, and graphite pencils, and included a built-in palette.[3] Frequently, a watercolorist would add to his box a few tubes of body color as well as additional tools, such as sponges, stumps, and scrapers for generating sophisticated effects of transparency and detail. The watercolor boxes could be carried into the countryside or used in the studio. One could either work directly on the pages of a sketchbook or employ individual sheets of specially made, stretched watercolor paper tacked to a board. The title page of Armand Cassagne's *Traité d'aquarelle* illustrates the paraphernalia of the watercolorist, including a metal watercolor box, brushes, water, a pencil leaning against a tube of white gouache, a palette knife, and a scraper (pl. 1).

If, in its portability and water-soluble pigments, watercolor offered Cézanne a practical alternative to oil painting, it also offered him a compelling means of expression whose reduced proportions and fluid pigments allowed for greater spon-

Facing page: detail of pl. 26

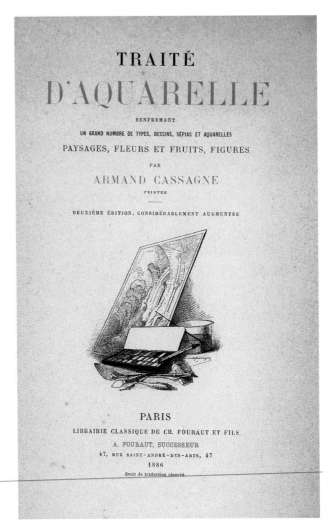

1 Title page of Armand Cassagne, *Traité d'aquarelle.* Deuxième édition, 1886 (1875). The Getty Research Institute. Photo © The Getty Research Institute

taneity and immediacy of execution. In its small, intimate scale and rough-edged, summary execution, watercolor was generally understood in the nineteenth century to offer oil painters an ideal mode of sketching, in which they could render their thoughts and sensations in a raw and provisional form. Watercolor's appeal, that is, lay in the fact that it provided an unedited glimpse into a painter's process of working toward a final composition for his oil painting. These peripheral studies and sketches, in their unselfconscious directness, took on a special value for the connoisseur and critic seeking to find clues to a painter's process of artistic conception. For the oil painter, watercolor provided an arena in which to exercise his eye, hand, and mind in a medium that, while participating in his generative process, nevertheless offered relief from the heavily freighted work of oil painting.

The thesis of this chapter is that Cézanne's turn to watercolor in the 1860s was inspired as much by the medium's association with expressive sketching as it was by its ability to fill idle moments not spent making oil paintings. If this is not directly stated in the few passing references to watercolor in his letters, it is certainly clear in the watercolors themselves, which are infused with immense expressive energy. This is largely the result of the fact that Cézanne was able to combine in his watercolors both drawing and color; he was able to combine, that is, both the range of expressive effects made possible by the pencil or pen and those made

possible by the paintbrush. As I will argue in this chapter, it was specifically in the combination of the gestural effects of drawing and color that Cézanne found watercolor's greatest resource for realizing the esthetic ambition that traverses his early career and which he described as the expression of his "strong sensations."

Watercolor and Temperament

Before 1866, when Cézanne expressed his intention to buy a watercolor box, his exposure to the medium was limited, resulting in just a few doodles on small scraps of paper. His earliest recorded watercolor, dating from 1858, is a clumsy pen and ink drawing heightened here and there with only a few touches of color (pl. 2). It depicts a scene from the Roman Republic, showing, as Cézanne put it, "Cicero striking down Catiline after having uncovered the conspiracy of that dishonorable citizen."[4] A burst of wind emanating from the mouth of the celebrated orator represents the force of his words, which throw the conspirator to the ground before the eyes of the gathered members of the Senate and attendant centurions. Cézanne sent this drawing to Zola, who had recently moved to Paris with his mother, following the death of his father. He sent along a tongue-in-cheek poem designed to lead his friend through what he ironically termed the "incomparable beauties contained in this admirable watercolor."[5] The tone of Cézanne's poem is a clue to how he intended the drawing to be received: the crude draftsmanship and the overblown drama of the subject matter, once set in the context of the mocking poem, suggest irreverence with regard to the high seriousness of the theme. "Oh sublime sight," Cézanne declared in feigned awe, "to amaze the eyes and arouse profound astonishment."[6]

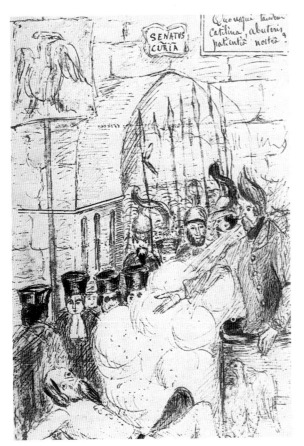

2 *Cicero Striking Down Catiline*, 1858, ink and watercolor on paper, 8½ × 5 in. (21.5 × 12.7 cm). Private collection

Cézanne's early letters to Zola are full of such swipes at the authority of the classical past, as well as at the pretentiousness of its contemporary purveyors. Some of his earliest paintings reflect a similar sense of mocking irreverence. For instance, in a group of allegorical paintings of the *Four Seasons*, which Cézanne affixed to the wall of the Jas de Bouffan – the family home in Aix-en-Provence – he made fun of the stalwart Neo-classical painter Ingres by signing the stiff and awkward paintings with Ingres' name. He even inscribed one of the canvases with the year 1814, the date of an early work by Ingres, entitled *Jupiter and Thetis*, which was the pride of the local Aix museum. Part of this can be understood as a reflection of the anxiety of a young artist in the face of tradition. Indeed, in 1858, when Cézanne executed the watercolor of Cicero and Catiline, he would have been especially oppressed by the weight of tradition, since he was currently cramming for his baccalaureate examination. As he wrote in a contemporary letter: "I tremble when I look upon all the geography, history, Latin, Greek, and geometry that conspire against me."[7] Consequently, his first watercolor should be partly understood as an expression of anxiety; but it also suggests a certain early resistance to the authority of academic tradition that would continue to color his attitudes throughout his career. As late as 1904, Cézanne stated of Ingres that he was, despite suggestions to the contrary, a rather minor painter.[8]

In his own letters to Cézanne, Zola urged his friend to join him in the capital, where they could pursue tandem artistic careers in the literary and visual arts. By early 1860, after passing his exams, Cézanne had become convinced that Zola was

correct in his suggestion that it was only in Paris that an artist could develop freely and in step with the latest aesthetic developments. In a letter dating from the spring of 1860, Zola wrote to Cézanne with an outline of how he might organize his time in Paris:

> Here is how you can schedule your time: from 6 to 11, you'll go to a studio for life painting; you'll have lunch and then, from noon to 4 you will copy, either at the Louvre or at the Luxembourg, whatever masterpiece you choose. That will make 9 hours of work; I think that's enough and that with such a regimen you can't help but accomplish something.[9]

Despite apparent designs to come to Paris in 1860, Cézanne's first trip did not take place until the spring of 1861.[10] This first sojourn, which lasted only until the fall, was by all accounts an abortive failure. In a letter home to a friend, while he was still in Paris, Cézanne complained that he was bored – "I walk around aimlessly all day"[11] – and revealed in the process that his youthful, provincial irreverence had come between him and the artistic resources offered by Paris. "I have seen, needless to say, the Louvre and the Luxembourg and Versailles," his former irony passing over into biting sarcasm: "You know the massive pictures those *admirable monuments* contain – it's all *stunning, astonishing, overwhelming.*"[12]

After this first unsuccessful visit, Cézanne returned to Aix despondent and frustrated; but he was back in Paris the following year, this time fortified with the determination to take seriously Zola's suggestions and to embark on a process of self-education that was, for all intents and purposes, essentially the same as the one Zola had set out for him in his earlier letter. Cézanne made both drawn and painted copies of paintings in the Louvre and the Luxembourg museums; he also enrolled at the Atelier Suisse, a private studio where, for a modest fee, artists could work from the live model (Zola had recommended this studio to his friend in his letter in 1860). It was here that Cézanne met some of the artists who would become his closest friends and supporters, including Camille Pissarro, Claude Monet, Antoine Guillemet, Armand Guillaumin, and Francisco Oller. The Atelier Suisse was an ideal place for Cézanne, who felt great contempt for the students at the Ecole des Beaux-Arts and who made a proud public display of his originality and independence. Unlike the Ecole, the Atelier Suisse required no entry exam; nor was there a course of instruction. Anyone who wanted to paint, draw, or sculpt the nude outside the framework of the official art establishment could attend simply by paying tuition fees.[13] Eugène Delacroix and Gustave Courbet had both worked there on occasion in the past, lending the place the reputation of being a haven for budding artists seeking to work outside the mainstream.

In Paris, Cézanne aligned his art with the general emphasis on assertive and truculent expression of temperament that was espoused by his closest friends and that was widely associated with advanced painting. Already in 1856, for instance, Edmond Duranty, the founder of the short-lived journal *Le Réalisme*, had defined the Realist aesthetic as "the frank and complete expression of individuality; it attacks convention, imitation, all forms of school. A Realist is entirely independent of his neighbor, he renders the sensation he feels in front of things according to his nature, his temperament."[14] Zola also identified the expression of temperament as the pivotal element in art in his art criticism in the 1860s. A work of art, he explained in a review of the Salon of 1866, "is a corner of creation seen through a tempera-

ment."[15] Zola offered a personal definition of the work of art that entailed two crucial elements, one objective and the other subjective:

> There are, according to me, two elements in a work of art: the real element, which is nature, and the individual element, which is man. The real element, nature, is fixed and always the same: it is the same for everyone; I would say that it could serve as a common measure for all works of art produced, if I believed there could be such a common measure. The individual element, man, to the contrary, is infinitely variable, there being as many works of art possible as there are different minds; if temperament did not exist then all paintings would simply be photographs.[16]

The problem, Zola complained, was the leveling criteria of the Salon jury, which rewarded art that was adapted to academic conventions of style and subject matter, and which rejected art that articulated an individual point of view. Worse still was the fact that the Salon-going public – "the crowd," as Zola named it – expected art that was pleasing or awe-inspiring in subject matter. "The crowd," Zola explained, "sees in a painting a subject that seizes it by the neck or the heart, and it asks nothing more from the artist than a tear or a smile."[17] "What I ask for from an artist," Zola declared, in opposition to the expectations of the public and the Salon jury, "is not to give me tender visions or terrifying nightmares; it is to deliver himself, flesh and blood, and to affirm loudly a powerful and particular intelligence, a personality that takes nature broadly in hand and sets it down in front of us, just as he sees it."[18]

Of course, Zola overstated the case, which is especially true of his suggestion that the Salon jury was entirely hostile to originality. In fact, reforms of both teaching and curriculum at the Ecole des Beaux-Arts in 1863 had been inspired by a desire to encourage greater originality and independence of expression in the work of its students.[19] What Zola was responding to, in fact, was something more specific, namely, the general hostility that the Salon jury and the Salon-going public had shown to the work of young Realist artists, including, most importantly, Edouard Manet. The attacks on Manet's art that had taken place at the time of the Salon des Refusés of 1863, where he exhibited *Luncheon on the Grass*, and at the Salon of 1865, where he showed *Olympia*, galvanized Zola's stance against the jury and the "crowd," and bolstered his support of the young Realists. As Zola put it in his review of the Salon of 1866: "there is an inverse relationship between the admiration of the crowd and individual genius. The more you are admired and understood, the more ordinary you are."[20]

Zola's review of the 1866 Salon, published in installments in *L'Evénement*, was cut short by its editor due to objections from subscribers to what they perceived to be Zola's outlandish and insolent views. When Zola republished his review as a booklet later the same year, he prefaced the document with a dedicatory letter to Cézanne, a document that, in retrospect, reveals just how close their thinking was in the 1860s. Zola's tone suggests an intimate conversation:

> It gives me great pleasure, my friend, to address myself directly to you. You cannot imagine how I have suffered during this quarrel that I have just had with the faceless crowd. . . . I write these few pages for you alone; I know that you will read them with your heart and that tomorrow you will feel even greater affec-

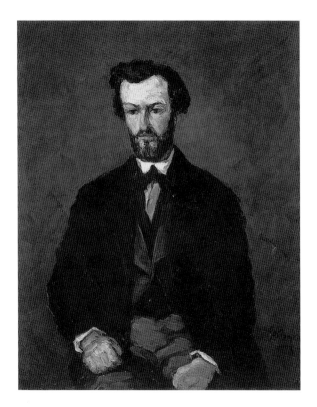

3 *Portrait of Antony Valabrègue*, 1866, oil on canvas, 45¾ × 38¾ in. (116.3 × 98.4 cm). Collection of Mr. and Mrs. Paul Mellon, National Gallery of Art, Washington, DC. Photo © 2000 Board of Trustees, National Gallery of Art, Washington, DC

tion for me. . . . For ten years, we have been talking together about art and literature. . . . We have turned over great heaps of appalling ideas, we have examined and rejected every system, and after such arduous labor, we came to the conclusion that beyond strong and individual life there was nothing but falsehood and folly.[21]

Since Zola's criticism articulated views held in common with Cézanne, it provides useful insights into Cézanne's attitudes about painting during this period.[22] Before this point, in fact, very little is known of what Cézanne thought about the art of his time. In a letter to a friend, written after a visit to the Salon of 1861, he sounds noncommittal with respect to the wide array of art on display. "I've been back to the Salon," he explained: "For someone young at heart, for a child awakening to art, one who says what he thinks, it's my opinion that the best things are to be found there because there you have every taste, every genre, coming together and confronting one another."[23] The views expressed in Zola's review of the Salon of 1866 are far more decisive, suggesting that by this point both he and Cézanne had become more precise about what for them was and was not worthwhile in art. Art, they agreed, must express "strong and individual life."

Cézanne voiced similar sentiments when the two canvases he submitted to the Salon of 1866 were rejected – *Still Life with Bread and Eggs* and *Portrait of Antony Valabrègue* (pl. 3).[24] In a letter of protest to the arts administration, he challenged the authority of the jury, which he argued had no right to judge his art because he had not given it this right himself: "I cannot accept the illegitimate judgment of men to whom I have not myself given the right to assess me."[25] In fact, by submitting his paintings to the jury Cézanne had implicitly given it this right, but his point was that he refused to accept their rejection of his work as a truthful assessment of its value. When the jury saw the *Portrait of Antony Valabrègue*, which is executed almost entirely with a palette knife, one member reportedly exclaimed that it appeared to have been painted "not only with a knife, but with a pistol as well."[26] In defense of such bold effects, both Cézanne and Zola pointed out that they were the expression of a unique "temperament." In Duranty's highly embellished account of a visit to Cézanne's studio in the mid-1860s, he recalled the artist, supplied for the occasion with the pseudonym Maillobert, exclaiming in "a drawling, nasal, hyper-Marseillaise accent": "'one cannot paint without temperament' (he pronounced it 'temperrammennte')."[27]

It was just after he had experienced the rejection of his canvases from the Salon of 1866 that Cézanne mentioned to Zola in his letter, cited at the outset of this chapter, that he wanted to buy a watercolor box. He had lost no time in planning new canvases for submission to the next Salon. Many of Cézanne's watercolors from the late 1860s are sketches and *premières pensées* for ambitious, large-scale paintings planned for submission to the annual Parisian Salon. Small and ephemeral in nature, these sketches were generally rendered in the margins of sheets of sketchbook paper or on small scraps of cardboard. The closest to the theme of laborers working at a forge, which Cézanne was working on during the summer of 1866, is a diminutive rendering (approximately 4 inches [10 cm] square) of a pair of gravediggers burying a coffin under the watchful eyes of a priest in full vestments and a white-robed altar boy holding aloft a ceremonial crucifix (pl. 4). The composition recalls Courbet's *A Burial at Ornans* (Paris, Musée d'Orsay) in its focus on

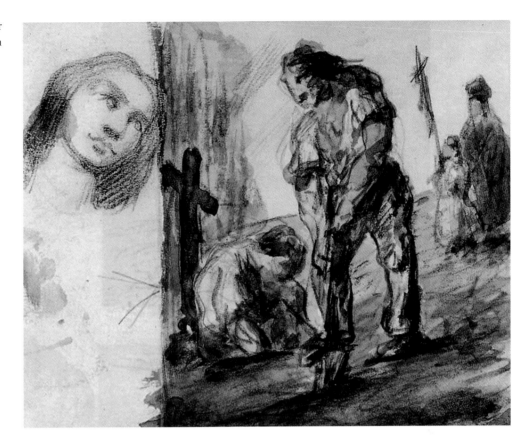

4 *The Gravediggers*, 1866–69, graphite and watercolor on paper, 4¾ × 4½ in. (12 × 11.5 cm). Present location unknown

an interment in the countryside, but with none of the mourners. With a powerful gesture, the figure in the foreground thrusts his shovel into the ground to begin the process of filling the hole.

In contrast, *The Diver*, a more lighthearted sketch, depicts a view of a secret bathing spot where a lone swimmer in mid-dive is just about to splash through the surface of a river or pond (pl. 5). This watercolor was given the title "Woman Diving into Water" (*Femme piquant sa tête dans l'eau*) in the early twentieth century by the critic Félix Fénéon, who was also the manager of the Bernheim-Jeune gallery in Paris. As John Rewald pointed out in his catalogue raisonné of Cézanne's watercolors, however, the image does not show a woman but a young man.[28] The sketch, in fact, seems to draw directly on Cézanne's memories of his youthful summer jaunts in the Aix countryside with his schoolmates Zola and Jean-Baptiste Baille. In a letter to Cézanne in 1860, Zola waxed nostalgic about these summer swimming excursions: "Remember our swimming parties, that happy time when one fine evening, without a care for the future, we made up the drama of the famous Pitot; and that great day spent there on the bank of the river, the sun radiantly sinking, the countryside that perhaps we did not admire much then but which, in memory, now appears to us so calm, so lovely."[29] Already in a letter written two years earlier, Cézanne had proclaimed his excitement for swimming: "The one sure thing is that I can't wait, like an intrepid diver, to plow the waters of the Arc and, in its clear water, to catch the fish that chance offers up to me."[30] *The Diver* seems to depict this intrepid diver – either Cézanne himself or one of his friends. The watercolor also hews closely to Zola's account: the large disk of the orange-tinted sun stands out against the deep blue-violet sky and seems to be "radiantly sinking"

into an awaiting notch in the distant hillside as the peaceful swimmer hovers expectantly just above the water surface.

Cézanne must have considered *The Gravediggers* and *The Diver* less than fully successful, however, because neither seems to have resulted in an oil painting. It was a different matter for *The Wine Grog*, a watercolor sketch for one of two now-lost paintings that Cézanne submitted to, and saw rejected from, the Salon of 1867 (pl. 6). Executed most likely at some point early in the year when Cézanne was working toward a final composition for the painting, it depicts the interior of what appears to be a brothel, complete with an unclad client smoking a pipe and a naked woman sprawled on a mattress in the foreground. Cézanne shows the moment when the intimacy of the carnal chamber is disturbed by the sudden arrival of a servant carrying a platter with teacups and a pot, which may be filled with tea or the wine after which the work is named. In the background stands a table littered with the remainders of a sumptuous lunch, complementing the implied sexual encounter with the additional physical pleasures of eating and drinking – the arriving tea or wine, and the client's tobacco, are the concluding moments in Cézanne's hedonistic fantasy. As scholars have noted, there is in *The Wine Grog* an obvious allusion to Manet's *Olympia* of 1863 (pl. 7).[31] The many parallels, ranging from the subject matter of a sexual transaction to the detail of the black cat on the left side of the composition (Manet's is on the right side), underscore the fact that Manet's painting was on Cézanne's mind in 1867. The pose of the naked woman in the foreground, indeed, makes clear this reference and especially her confrontational, self-confident look out at the spectator (a similarly confrontational look had been one of the most disturbing aspects of Manet's painting when it was exhibited at the Salon in 1865). What makes Cézanne's painting different, of course, is the presence of the client, who also looks out and acknowledges the presence of the spectator.[32]

With *The Wine Grog*, then, Cézanne attempted to achieve a powerful and challenging public expression of his independence that picked up on but also went beyond Manet's *Olympia*. No doubt it was painted on a large canvas, as was his habit with Salon submissions in the 1860s, which would have augmented its impact and drawn attention to this important visual statement. Moreover, Cézanne blatantly mocked the process of submission and judgment by reportedly delivering *The Wine Grog* and a second work to the jury in a wheelbarrow and, upon arrival, being carried into the exhibition hall on the shoulders of his boisterous friends. An item in *Le Figaro* of April 8, 1867 noted a recently published article by Arnold Mortier, who mocked Cézanne's two paintings rejected from that year's Salon:

> I have heard of two rejected paintings done by M. Sésame (nothing to do with *The Arabian Nights*), the same man who, in 1863, caused general hilarity at the Salon des Refusés – and still does! – with a canvas depicting two pig's feet in the form of a cross. This time, M. Sésame has sent to the exhibition two compositions that, though less strange, are nevertheless just as worthy of exclusion from the Salon. These compositions are entitled: *The Wine Grog*. One of them depicts a nude man to whom a very dressed-up woman has just brought a wine grog; the other portrays a nude woman and a man dressed as a *lazzarone*: in this one the grog is spilt.[33]

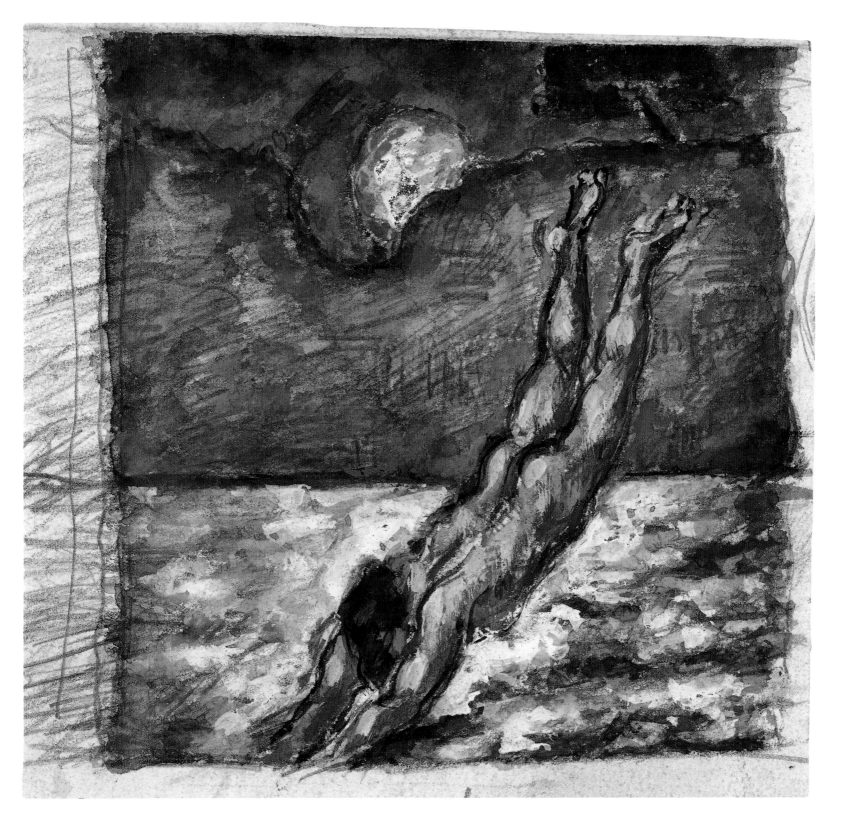

5 *The Diver*, 1866–69, graphite, watercolor, and gouache on paper, 5 × 4¾ in. (12.7 × 12.1 cm). National Museum and Gallery of Wales, Cardiff. Photo © National Museum of Wales

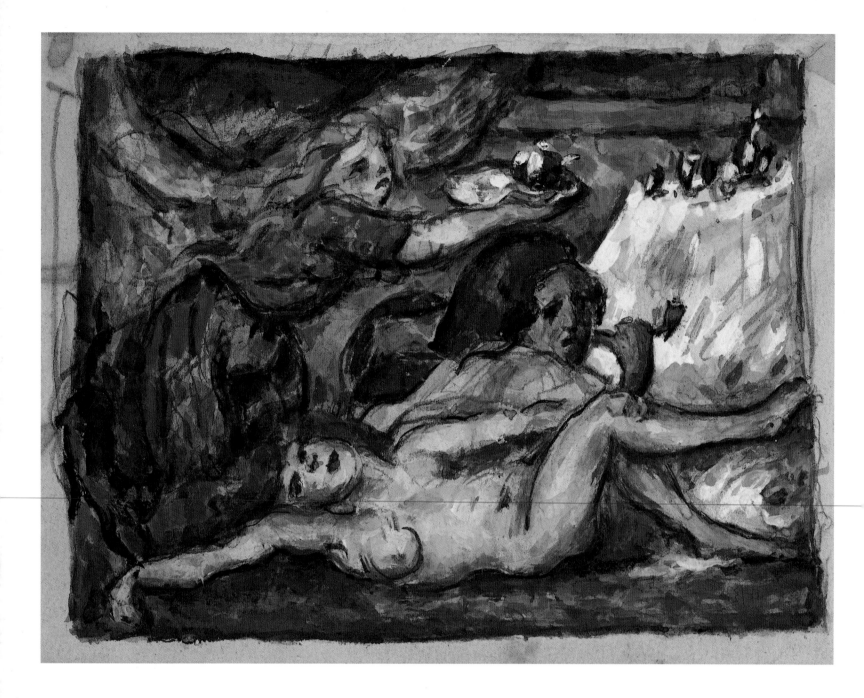

6 *The Wine Grog*, 1866–67, graphite, watercolor, and gouache on paper, 4⅜ × 5¹³⁄₁₆ in. (11 × 14.8 cm). Private collection

Facing page: detail of pl. 6

Zola shot off a quick retort to Mortier, published in *Le Figaro* a week later, in which he defended his friend, noting that he had never painted pig feet: "I must say that I had a hard time recognizing under the mask stuck on his face one of my former schoolmates, M. Paul Césanne [*sic*], who has not the slightest pig's foot in his artistic repertoire, at least not so far." He added: "M. Paul Césanne, in excellent and numerous company, has indeed had two canvases rejected this year: *The Wine Grog* and *Intoxication*."[34] Steven Platzman has recently emphasized the importance that all of this posturing and publicity had for the formation of Cézanne's early reputation as a shocking artist.[35] Later, Cézanne reportedly referred to his paintings of the 1860s as *couillard*, meaning gutsy, or ballsy.[36] His paintings were daring on all levels – content, form, and handling. When in 1866 a member of the Salon jury caricatured his *Portrait of Antony Valabrègue* by claim-

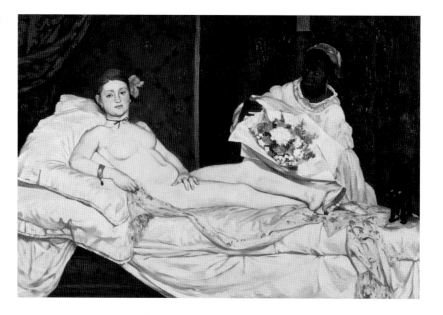

7 Edouard Manet, *Olympia*, 1863, oil on canvas, 130.5 × 190 cm (51 3/8 × 74 3/4 in.). Musée d'Orsay, Paris. Photo © Réunion des Musées Nationaux / Art Resource, NY

ing it had been painted with a pistol, Cézanne must have felt a certain satisfaction that he had hit a nerve. The clenched fists and determined look on the face of the sitter seem to anticipate the inevitable fight with the jury. Already in a letter from the spring of 1865, Cézanne had proudly explained to Pissarro that his submissions to the Salon of that year "will make the Institute blush with fury and despair."[37]

Watercolor, Freedom, and Immediacy

In contrast to all the public posturing, daring, and fighting that Cézanne associated with his oil paintings, watercolors represented a more private and personal form of expression. Like oil sketches and pencil studies, they were part of the repertoire of preliminary explorations and brainstorming that took place before and in the margins of his major, publicly directed canvases. Cézanne was not alone in using watercolor in this manner. One of the main uses of watercolor in France in the nineteenth century was precisely this kind of sketching and exploration of compositions for development in larger, more ambitious oil paintings. Such associations had been made by some of the most admired members of the Romantic generation. In his study of the caricaturist Constantin Guys, "The Painter of Modern Life," published in two installments in 1863 in *Le Figaro*, the critic and poet Charles Baudelaire suggested that watercolor was the perfect medium for an artist who sought to capture the shifting aspects of the Parisian metropolis. The element of speed, in Baudelaire's account, was crucial to the appeal of watercolor. "In the daily metamorphosis of external things," he explained, "there is a rapidity of movement that calls for an equal speed of execution from the artist."[38] Consequently, there are two crucial elements in Guys' watercolor technique: an intense effort of memory that brings a perception or idea back to life – "a memory that says to everything, 'Arise Lazarus'"[39] – and a freedom and rapidity of execution that Baudelaire described as "an intoxication of the pencil and paintbrush, amounting almost to a frenzy."[40] *Woman with a Parasol*, dating from the 1860s, is a magnificent example

of Guys' use of drawing and painting instruments (pl. 8). Baudelaire described his method as follows:

> Monsieur G. starts with a few slight indications in pencil, which hardly do more than mark the position that objects are to occupy in space. The principal places are then sketched in tinted wash, vaguely and lightly colored masses to start with, but taken up again later and successively charged with a greater intensity of color. At the last minute the contour of the objects is once and for all outlined in ink. Without having seen them, it would be impossible to imagine the astonishing effects he can obtain by this method which is so simple that it is almost elementary.[41]

"It is the fear of not going fast enough," he added, "of letting the phantom escape before the synthesis has been extracted and pinned down,"[42] that can be read in Guys' rapid handling.

Of course, watercolor was not alone in answering the call for speedy execution. As Baudelaire explained, many of the so-called minor mediums, such as pencil drawing, pastel, engraving, and lithography were perfectly suited to the task. At the posthumous auction of Eugène Delacroix's watercolors and drawings, which took place the following year, in 1864, these two mediums were generally elided as serving a singular purpose for the artist, namely, the rapid and spontaneous transcription of his raw, barely formed impressions and ideas (pl. 9). As the critic Théophile Silvestre observed, it was the sheer volume and variety of the work that was most striking to those who attended the auction:

> What truly astonished everyone at this public auction of Delacroix's watercolors, drawings, and jottings was the master's untiring abundance, the variety of his motifs, and the dedication with which he rendered the subjects that struck him in all of their forms. One recognized here a man who created without pause in order to appease his heart and mind, and who had condemned his hand to eternal scribbling.[43]

"This collection of watercolors and drawings," he continued, "is a veritable illustrated encyclopedia of impressions: charm or physical terror, naïveté of heart, aspirations or torments of the spirit: it is life seized on the wing by the observer, and made more intense by the poet."[44] Watercolor and drawing, he added, summarizing his overall perception of these marginal works, allowed Delacroix "to express the feelings that animated him more quickly and with greater ease [than oil painting]."[45]

This last point is worth emphasizing, for there was an at times implicit, at times explicit, opposition in these accounts between the private and confessional mediums of drawing and watercolor and the slower, public art of oil painting. Moreover, there was in the minds of many French critics an additional opposition between British watercolors, with their painterly ambitions, and French watercolors, which adhered more closely to the status of drawing. As Henri Lemaître has shown, the efflorescence of watercolor in Britain at the end of the eighteenth century and the beginning of the nineteenth was a reaction against the tradition of tinted and topographical drawings.[46] In reaction against this tradition and its insistence on attenuating and hemming in the expansive force of color, the main exponents of a renewal and transformation of watercolor, most notably Thomas Girtin

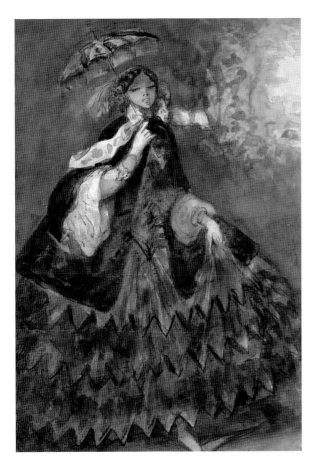

8 Constantin Guys, *Woman with a Parasol*, 1860s, graphite, watercolor, and gouache on paper, 10⅝ × 7¼ in. (27 × 18.4 cm). The J. Paul Getty Museum, Los Angeles. Photo © The J. Paul Getty Museum, Los Angeles

9 Eugène Delacroix, *Sketch for the Massacre at Chios*, 1824, graphite and watercolor on paper, 34 × 30 cm. Musée du Louvre, Paris. Photo © Réunion des Musées Nationaux / Art Resource, NY

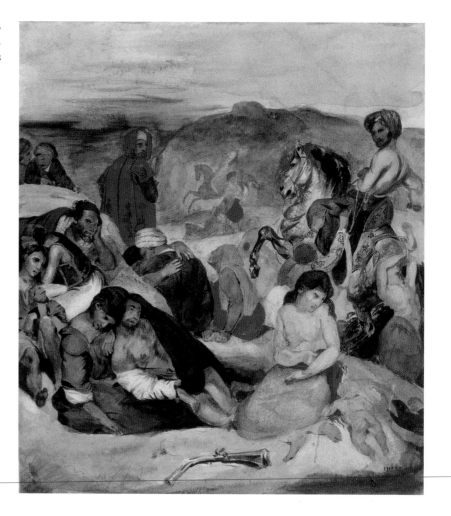

and J. W. M. Turner, shifted their attention to the coloristic and atmospheric possibilities of the medium (pls. 10 and 11). The devotion to the genre of landscape and the commitment to evoking the character of a specific place associated with the topographical tradition were by no means abandoned; rather, they were rethought through the model of Claude Lorrain's dramatic landscape compositions, an impulse that already had its start in the work of Alexander Cozens, William Gilpin, and John Robert Cozens. On a technical level, the resistance to the tradition of the tinted drawing was exerted by reversing the hierarchy of color and line, watercolorists now concentrating their efforts exclusively on generating effects of color, since, for them, such effects constituted the very essence of the medium. With the demand for architectural precision in retreat, places were now depicted through the employment of striking effects of light and atmosphere, which were made possible by the range of effects provided by varying the fluidity and density of the pigment. The absorptive character of the paper surface itself – the specific consistency, density, and weave of its fiber – was exploited for certain correspondences between the wateriness of the medium and the wateriness of depicted landscapes.[47] The great ambition of Girtin and Turner, therefore, was to turn watercolor away from drawing in two important ways: first, by de-emphasizing the role of underdrawing to the point of rendering it invisible, and, second, by attempting to remove watercolor from its traditional association with drawing and its status as a minor art form consigned either to the portfolios of connoisseurs and collectors or to the

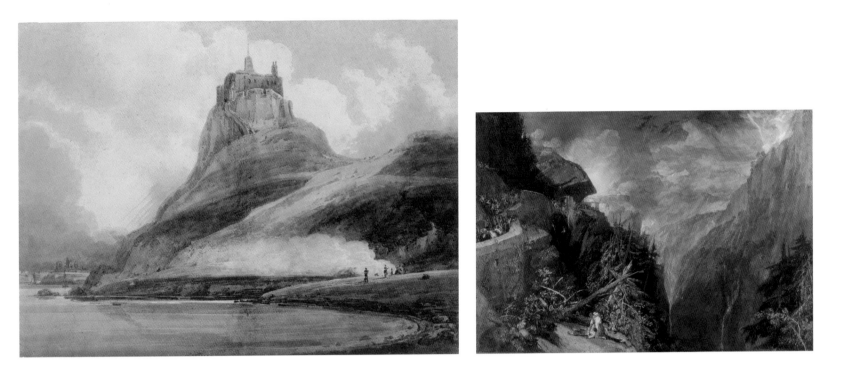

10 (above left) Thomas Girtin, *Lindisfarne Castle, Holy Island, Northumberland*, 1796–97, graphite, gouache, and watercolor on paper, 15 × 20½ in. (38.1 × 52 cm). The Metropolitan Museum of Art, New York, Rogers Fund, 1906 (06.1051.1). Photo © The Metropolitan Museum of Art

11 (above right) Joseph William Mallard Turner, *Battle of Fort Rock, Val d' Aouste, Piedmont*, 1796, gouache and watercolor on paper, 1796. The Tate Gallery, London. Photo © Clore Collection, Tate Gallery, London / Art Resource, NY

private repertoire of preparatory tools available to the oil painter in the course of composing pictures.[48] In his popular text on watercolor, published in 1839, Thales Fielding noted that, with the work of Girtin and Turner, watercolor had become "capable of rivaling the hitherto unrivaled art of painting."[49]

In France, however, the ambition of making watercolor rival oil painting was generally met with suspicion. When Jean-Baptiste Isabey exhibited his monumental watercolor *Museum Staircase* at the Salon of 1817, its painterly ambitions caused confusion (pl. 12). One critic asked: "is this a drawing or a painting that I have before my eyes?"[50] For the British, on the other hand, there had been a clear step from tinted or topographical drawing to watercolor painting in the work of the most prominent practitioners of the art. By the time of the Exposition Universelle in Paris of 1855, where the British exhibited no fewer than 114 watercolors, French critics could freely acknowledge the painterly ambitions of British watercolors; but this was clearly understood to be a peculiarly national concern, one not shared by French artists.[51] In a review of the art on display at the exhibition, Maxime du Camp observed: "The majority of the English watercolors are real pictures (*véritables tableaux*), as much in their dimensions as in the frequently broad and vigorous way they are treated."[52] In another review, the critic Edmond About explained: "I can pass without transition from oil to watercolor paintings: these two genres are less distinct in England than with us. More than one English painting presents the paleness and the faded grace of the watercolor; more than one watercolor has the vigor of an oil painting."[53] But, About continued, there is something amiss in these transgressions of medium specificity: "Artists who expend so much energy trying to do in watercolors that which is easier done with oils remind me of those romantic lovers who enter through the chimney when the door could be opened with a couple of kicks." "When I see watercolor aim for color and grand effects, I have the impression of meeting a young and pretty student who is trying to escape her boarding school in the disguise of a musketeer."[54]

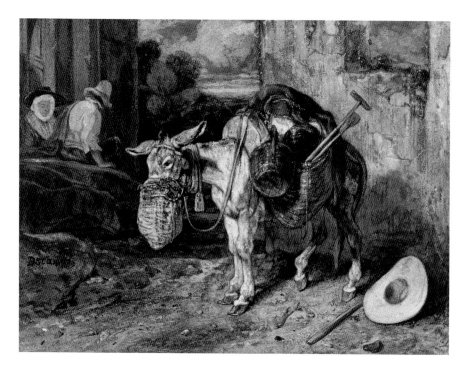

13 Gabriel-Alexandre Decamps, *Donkey*, 1833, watercolor and touches of gouache, heightened with gum varnish, over traces of graphite, on tan wove paper, 220 × 293 mm. The Art Institute of Chicago, Gift of Julius Stewart, 1935.158. Photo © The Art Institute of Chicago

12 Jean-Baptiste Isabey, *Museum Staircase*, 1817, graphite, watercolor, and gouache on paper. Musée du Louvre, Paris. Photo © Réunion des Musées Nationaux / Art Resource, NY

Similar observations were repeated more than a decade later by Charles Blanc, the founding editor of the *Gazette des Beaux-Arts* and an influential art theorist and historian. In his *Grammaire des arts du dessin*, published in 1867, Blanc dedicated a short section to watercolor, in which he reiterated the general perception in France that the British had lost contact with the essence of the medium of watercolor by trying to make it rival the effects and scale of ambition of oil painting. "These days," he wrote, "the English school has sought ways to give to their wash drawings a frankness and solidity that has made of it almost a new genre of painting."[55] Certain French watercolorists, he added, had also been tempted down the same path. Among those guilty, he singled out Gabriel-Alexandre Decamps, who sought to imitate the effects of oil painting in his watercolors through a range of what Blanc termed "mysterious practices and tricks of the medium, the result of which is sometimes astonishing" (pl. 13).[56] Blanc explained:

> Sometimes, for example, he rubs a greasy substance in places against the coarse textured paper that he uses for his watercolors. The greasy substance, caught by the tooth of the paper, does not penetrate to the furrows. Consequently, when the wash is applied it stains the crevices of the paper without being able to color the superficies, from which results a striking effect in which the limpidity of wash is combined with the consistency and apparent density of oil painting. In this way, Decamps managed to express the roughness of old walls, the ruggedness of coarse stones, charred and rough terrain, and the bark of trees.[57]

However astonishing the results might be, what Decamps and the British watercolorists forgot, Blanc complained, was a fundamental truth that no artist could afford to neglect: "one should never try to accomplish in one medium what is better done in another."[58] Rather than use tricks to emulate the effects of oil painting, concluded Blanc, the watercolorist should affirm the identity of watercolor as essentially a form of colored drawing: "In truth, watercolor is but a form of colored

drawing (*Mais à dire vrai, l'aquarelle n'est qu'un dessin en couleur*)."[59] Or, as another critic explained later in the century, "watercolor in France was always referred to as 'colored drawing' (*le dessin coloré*). . . . Like red chalk, ink, and bistre, it made preparations for the works of masters, and animated their initial ideas (*leurs première pensées*)."[60]

Part of what was at stake in the attempt to draw boundaries between oil painting and watercolor was a desire to keep watercolor in its place as a minor medium and to deny it the prestige of oil painting. This impulse, which was shared by other critics, was frequently articulated in gendered terms. Watercolor was understood as a "merely" feminine preoccupation, in contrast to the serious, "masculine" art of oil painting. Such associations are already evident in About's association of watercolor with a young girl trying to escape her boarding school in the disguise of a man – a musketeer, no less. The art theorist Paillot de Montalbert went further and simply dismissed watercolor as a ladies' medium, best suited to "the pretty hands that practice it in Paris and especially in London."[61] In *L'Oeuvre* (*The Masterpiece*), a novel about a struggling artist working in Paris in the 1860s named Claude Lantier (based on a mixture of aspects of Cézanne and Manet), Zola somewhat surprisingly voiced similar assumptions about watercolor as a feminine medium. The protagonist's lover, Christine, cannot understand Lantier's bold and expressive oil paintings because "she had been brought up to admire another, and gentler, art: her mother's watercolors, the dreamlike delicacy of her fan designs, where lilacs sauntered in pairs through gardens of misty blue."[62] As opposed to watercolor, Zola characterized oil painting as a masculine art: "Oh, it's not painting for ladies, and certainly not young ladies," exclaims Lantier.[63] The second-class status afforded to watercolor was reinforced by the fact that it was exhibited in the annual Salons in separate rooms devoted to works on paper. Consequently, as some critics noted, works on paper received proportionally much less attention than either painting or sculpture. In a review of the Salon of 1868, for instance, Jules Castagnary reported that the rooms devoted to works on paper were deserted. "You can walk freely in these empty rooms, look at leisure at these poor pictures that hang indolently against the wall," he explained. "[Y]ou won't be bothered in your peaceful examination by any impassioned enthusiast."[64]

But if the minor status of watercolor vis-à-vis oil painting was justification for belittling and dismissing it, or, at least containing and delimiting it, this minor status was, from the angle of the Romantics, precisely what made it exciting and spontaneous. Watercolor, in other words, in its freedom of handling and unencumbered associations, had an advantage over oil painting. It enabled the painter, to recall Baudelaire's terms regarding Guys, to seize his memories and pin them down before they escaped; or, to recall Silvestre on Delacroix, it allowed him to "seize life on the wing" and to express himself more quickly and fluently than in slower, more pondered oil painting. In a review of the Salon of 1869, the critic Georges Lafenestre made this opposition even clearer with his observation that watercolors and drawings possess "a spontaneity, a vivacity, a virtuosity, that is too often lost in the passage from the quick sketch to the laboriously worked canvas."[65] His remarks were occasioned by the watercolors of Gustave Moreau, which were, for him, a highlight of the exhibition. He too complained that the rooms devoted to watercolor and other works on paper were, "alas, almost always deserted."[66] He suggested, however, that a solution to the general lack of interest in watercolor at

the Salon would be to hang the watercolors and, indeed, the drawings and other sketches as well, beside the oil paintings to which they related. "In such an art exhibition," he explained, ". . . one should no doubt always place beside a painter's large works his works of less ambition, watercolors, drawings and rapid notes, in which his hand is almost always more free and his personality more in evidence."[67] Castagnary also noted in a review of the same Salon that watercolor seemed to offer certain painters an opportunity to work in a freer and more spontaneous manner. Rather than Moreau, Castagnary singled out Vibert: "Such is the case with M. Vibert, whose paintings are too polished (*trop léchée*) but who shows here [in his watercolors] a boldness of touch and an astonishing vivacity of handling."[68]

Albert Boime has described the rise of interest in sketches and summary effects in oil painting in France in the mid-nineteenth century as participating in a general aesthetic of the sketch.[69] The appreciation of effects of sketchiness, of course, dated back at least to the Italian Renaissance. Discussing the merits of the development of oil painting in sixteenth-century Venice, Giorgio Vasari expressed a taste for the liveliness of oil sketches as opposed to the frequently subdued quality of finished paintings. "Many painters," he wrote, "achieve in the first sketch of their work, as though guided by a sort of fire of inspiration . . . a certain measure of boldness: but afterwards, in finishing it, the boldness vanishes."[70] It was, however, more likely Diderot, rather than Vasari, whose taste for the esthetic qualities of the sketch set the tone for appreciation of these qualities in French painting. "Sketches," explained Diderot in his *Salon* of 1767, "generally possess a warmth that pictures do not." Vasari's "inspiration" and "boldness" are here displaced by a vague inner "warmth," gently radiating out toward the beholder. "In a picture," Diderot continued, "I may perceive clearly a single theme; but in a sketch, how many things I may imagine that are only faintly indicated!"[71] If Diderot admired the freshness of the sketch, he did not disagree with reigning academic practice that firmly situated the preparatory work of sketching and studying in the private realm of the artist's studio. The emergence of an aesthetic of the sketch was the result of the increasing interest in the private sketches of oil painters as a more honest and unselfconscious introduction to the artist's personality. As Lafenestre put it, it was in these minor works that stand in the margins of the oil painter's practice that the artist's personality is "more in evidence." The series of preliminary studies – *croquis*, *ébauche*, *pochade*, *étude*, *esquisse* – were the most indicative of the freedom and inspiration of the artist.

Gestural Drawing and Painting

Cézanne was in Paris in February 1864 and may in fact have attended the Delacroix auction. Silvestre noted that the room was crowded with both well-known and as yet unknown artists seeking to gain a glimpse of this private and confessional side of the Romantic master's art. Cézanne may indeed have been among the "infinity of artists from Paris, the provinces, and abroad" that Silvestre mentioned in his account.[72] In a letter dating from the very same month as the auction, Cézanne explained to a friend that he was currently working on a copy of a work by Delacroix.[73] It would have been unlikely for Cézanne, who idolized Delacroix, to let pass this rare opportunity to see his watercolors and drawings.[74] Moreover, the general association of watercolor in France with expressive, rapid sketching is clearly

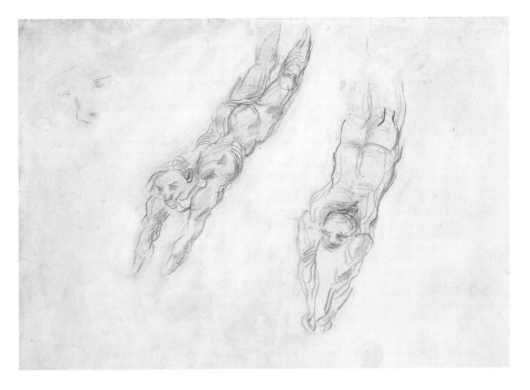

evident in his early use of the medium. His study of *The Wine Grog* reveals a hand that has worked rapidly and has given form to the fantastic scenario in a provisional and spontaneous manner. Something similar can be said of *The Gravediggers* and *The Diver*, watercolor sketches that also capture a sense of immediacy and imaginative exploration. Like Baudelaire's Guys, here too there is a sense that the artist has had to move swiftly to nail down the memory or fantasy before it escaped. And like Delacroix, these works are something of an "illustrated encyclopedia of impressions," to recall again Silvestre's terms.

In each of Cézanne's watercolors discussed so far, there is evidence of a gestural use of both the pencil and the paintbrush. This expressive use of drawing and color is evident in *The Gravediggers*, *The Diver*, and *The Wine Grog*, in which lively pencil sketches subtend subsequent layers of thin and thick color. This manner of drawing is the same as that of his drawings from the Atelier Suisse, visible, for instance, in a page of sketches that relate to *The Diver*, on which Cézanne jotted the form of a male figure in a plunging pose glimpsed from two slightly different angles (pl. 14). We can compare the coursing line and staccato contours in this drawing with the more controlled graphic technique in a drawing that Cézanne made at the Ecole Gratuit du Dessin in Aix before his move to Paris in the early 1860s (pl. 15). The earlier drawing reveals a mastery of academic conventions of contour drawing and modeling in the depiction of a male nude in a classical posture. At the Atelier Suisse, conversely, Cézanne rapidly purged himself of these habits and developed in their place an alternative mode of drawing that was more summary and halting, as well as more closely associated with expressive verve, than his earlier work. At the Atelier Suisse, he also rejected classical poses and studied the male nude instead in a range of nontraditional postures, including reclining on the floor, slumping against the wall, or, as in the case with these drawings, diving. The rapidly applied, broken contours that pick out the lean musculature of the model convey a sense of life and

animation that is as much that of the depicted model as it is that of the artist that jotted them down.

Watercolor manuals generally advised a more judicious and controlled use of drawing as a ground and preliminary armature for the subsequent application of washes of color, a ground that should nevertheless disappear in the final work. That drawing must be present but not too assertive was the counsel of Jules Adeline's *Peinture à l'eau*, in which we read the following practical advice:

> To make the sketch, one must make use of rather hard lead pencils; pencils that are too soft deposit too much black powder on the page, which, in some cases, may darken a light-colored wash. Conversely, a rather fine pencil line can sometimes play a role in defining the different spatial planes. This line, remaining visible beneath the watery colors, can also contribute to a certain firmness of modeling, which, nonetheless, should not be exaggerated. In general, the pencil sketch must always be very light yet very precise and as much as possible one must avoid any misplaced lines.[75]

15 *Academic Nude*, 1859–62, graphite on paper, 24³⁄₁₆ × 18¹³⁄₁₆ in. (61.5 × 47.8 cm). Musée Granet, Aix-en-Provence. Photo © Bernard Terlay, CPA

As a heuristic guide, Cassagne's *Traité d'aquarelle* includes a series of lithographic images of an elm tree against a low wall to illustrate the pacing of a watercolor from its first pencil sketch to the final touches of color, steps it terms the sketch, the first preparation, and the final modeling (pls. 16–18). After fixing the paper to the sketching board, it advises, the watercolorist should "make the sketch, which is the *mise-en-place* of drawing," adding: "let's remember that a good drawing is for the watercolorist an indispensable guide, and that this part of the work must never be neglected, no matter how impatient the young painter may feel to see the effect of color."[76] In the next phase, Cassagne demonstrated how to build up the light and dark areas with washes. "Begin by modeling the trunk of the tree," he suggested, "and render its shadow on the wall; paint the branches, model the undersides of the foliage . . . only now should you add some green hues over the leaves, leaving here and there some empty areas, which will allow you to obtain later on brighter notes."[77] For the last stage, the watercolorist is advised to add the final local hues: "Now that the first preparation is done, there is nothing left but to apply the local color and to vary it as much as possible by diluting it."[78]

These instructions take into account the difficulty of watercolor. Once a wash has been set down on paper it can be lightened or removed only through recourse to a sponge or a scraper – two expedients that were ill advised because they tended to damage the paper surface.[79] Consequently, the artist seeking a fine degree of detail and exact description needed to be perfectly sure where to place the paintbrush. This use of drawing as a preliminary guide for the brush was especially important in topographical and architectural watercolor. A work by Alphonse-Nicolas Crépinet submitted to the competition for the new Paris Opéra in 1861 is an example of this kind of careful pencil drawing used to establish the lineaments of the architecture, while soft washes of color and fine, dexterous strokes of the brush bring out local color and shadows (pl. 19). The landscape painter François-Louis Français likewise always insisted that an initial drawing was crucial in watercolor for planning where washes were to be placed. Français' rule of thumb, indeed his "absolute principle," was that "color should never be applied until the drawing is clearly indicated, be it with pen and ink or with a sharpened pencil, capable of clarifying form."[80] The watercolorist Henri-Joseph Harpignies similarly explained that in his courses he insisted that if a

16 (above left) *Elm, Stage One*, from Armand Cassagne, *Traité d'aquarelle*. Deuxième édition, 1886 (1875), The Getty Research Institute. Photo © The Getty Research Institute

17 (above center) *Elm, Stage Two*, from Armand Cassagne, *Traité d'aquarelle*. Deuxième édition, 1886 (1875), The Getty Research Institute. Photo © The Getty Research Institute

18 (above right) *Elm, Stage Three*, from Armand Cassagne, *Traité d'aquarelle*. Deuxième édition, 1886 (1875), The Getty Research Institute. Photo © The Getty Research Institute

student was planning to spend two hours on a watercolor, an hour and three-quarters should be spent on the drawing phase, "in order to arrive at solid proportions," and only a quarter of an hour spent on the addition of color (pl. 20).[81] "The great illness of our time," complained Cassagne in his *Traité d'aquarelle*, "is the desire to work quickly, from which comes the tendency of many young painters to neglect drawing . . . which they consider to be a hindrance, whereas it should be recognized for what it really is – their most solid support."[82]

These remarks assume a role for drawing that agrees with the traditional identity of drawing as *dessein*, that is, as the foundation and rational structure of the work of art. This association of drawing with intellectual control and order had been inherited by the nineteenth century from the Neo-classical generation, which was continued in theory, if not always in practice, by Ingres. His apodictic "drawing is the probity of art" captures the sense of drawing as not only the ground of art but also its moral compass. Color, in this understanding, was understood to be a simple surface effect, something that represented shifting appearances rather than solid and unchanging essences. In watercolor, this translated into a strict role for drawing as the organizational authority of the page. However light, these pencil lines were meant to determine and circumscribe the places where washes would be applied. No touches of color should be allowed to bleed beyond their demarcated limits, for this would not only represent a breach of the original compositional plan, but it would also represent a breakdown in the hierarchy of drawing and color within the work of art itself. Drawing must always be, to recall Adeline's instructions, "very light yet very precise."[83]

Cézanne's drawing, conversely, is bold and approximate. The pencil marks that we see in *The Diver* cannot be said to ground color in the traditional manner of an underdrawing. The field of hatching that is visible in the hillside is not worked out either as a guide for color or as a means of lending firmness to modeling and form. Rather than grounding color, drawing emerges here as a gestural counterpoint. The pencil has been applied in a nervous, scrubbing manner, which generates a muffled, mysterious energy behind the touches of variously thick and thin color spread over it. In the interstices between the touches of white gouache in the reflections on the water, the dark tone of the soft graphite reminds the viewer that there are two levels of expressive activity in this image: the rough hatching of the pencil that first took hold of the page and the fast ticking of the paintbrush, that has revisited these areas with dabs of dense gouache and washes of translucent pigment. Cézanne's use of the pencil calls to mind Baudelaire's comments, in his *Salon de 1846*, written in defense of what he termed "the drawing of the colorists," which is characterized by "floating and fused lines."[84] In colorist drawing, explained Baudelaire, touch reigns supreme, whereas in pure draughtsmanship, it is exactitude of rendering that presides, "and this exactitude excludes touch (*et cette finesse exclut la touche*)."[85] The gestural marks of Cézanne's pencil, which evince repeated, back and forth sweeps of the artist's hand as it moved across the paper, openly embrace and foreground this quality of "touch." Indeed, such pencil marks are only loosely related to the objects they demarcate and refer as much to the physical process of drawing itself as they do to the things rendered. Colorist drawing, the "noblest and strangest" form of draughtsmanship, explained Baudelaire, "can neglect nature – it represents another nature, analogous to the mind and the temperament of the artist."[86] Or, as he put it a bit further along in his review, pure draughtsmen, such as Ingres, "are naturalists endowed with excellent perception; but they draw by means of reason, whereas colorists, that is, great colorists, draw by means of temperament, almost without knowing it."[87] Likewise, and against the classical model of watercolor propounded in most watercolor manuals, in which drawing was a controlling agent of color that nevertheless should remain subtle and hidden from view, in Cézanne's watercolors, drawing and color operate as mutu-

ally reinforcing tools, neither of which is hierarchically more important than the other, for rendering his intense and unique temperament. These marks are set down not "by means of reason," but "by means of temperament," a quasi-unconscious activity of gestural marking that carries with it a range of associations of spontaneity and authenticity of expression.

Once the mixture of gestural drawing and color has been identified as a key to understanding what was at stake in Cézanne's early watercolor practice it becomes everywhere evident. It even generates a sense of tension in works that depict inanimate and fixed subject matter. This is the case with *Still Life: Flowers and Fruit*, thought to date from 1865–67, which exudes a quality of brooding moodiness that is as much the result of the strange complicity of the objects distributed on the tabletop as it is of the artist's lively handling (pl. 21). The intense, Martian redness of the orange and the white and yellow hues of the flowers stand out sharply in the context of the darkened room. The flowers cannot be individually identified except as notes of bright color: orange, red-orange, red, and white. Green, almond-shaped leaves emerge here and there in the interstices as a counterfoil to the intense reds and oranges. The intensity of color in this watercolor derives in part from the mixture of gouache and watercolor pigments. Gouache, an opaque mixture of color and filler (usually a chalky white, such as lead white or zinc oxide), bound together by a medium of gum and on occasion honey, differed from watercolor proper, which consisted of essentially no more than pigment dissolved in water. Both kinds of pigment can be seen in *Still Life: Flowers and Fruit*, in which diluted washes of blue and black watercolor pigment have been applied to the page with broad, sweeping strokes of the brush. The thick, opaque effects of body color are visible in the bright orange hues of the orb-like fruit at the center of the composition, as well as in the white highlights throughout the picture. In some places, the pigment has been applied in such thick touches that it has cracked while drying, as in the white touches in the bouquet. One can also see zigzag strokes of the pencil in the bouquet. In fact, this watercolor underscores the fact that Cézanne rejected the traditional understanding of drawing as a purely grounding element in watercolor. As one of two modes of expression, he applied drawing at multiple stages in his process of execution, first making sketchy indications on the bare sheet and then bringing the pencil back on top of the color after it had dried. Color was also applied in several stages, shifting between the thin, diluted washes of watercolor pigment and the thick dabs of gouache. The result is not a two-step process of drawing and painting but a series of moments of drawing and painting that accumulate on the paper surface.

Still Life: Flowers and Fruit occupies a very different place in Cézanne's early watercolor practice than do his sketches for oil paintings. Rather than a preparation or dry run for a possible future painting, this work stands on its own as a complete study of an observed group of objects, most likely arranged in the privacy of the Jas de Bouffan. This different status also applies to Cézanne's contemporary landscape watercolors, all of which seem to have been executed in the territory around his hometown in the late 1860s during his breaks from working in Paris. *Landscape with Rock* depicts a view of a rock formation that juts forcefully into a forest clearing (pl. 22); *The Climbing Road* shows an unpaved country road that arcs powerfully across the foreground of a harsh, dry landscape and then climbs steeply up and over a facing hillside (pl. 23). In his study on the artist, Georges

21 (following pages) *Still Life: Flowers and Fruit*, 1865–67, graphite, watercolor, and gouache on paper, 7⅛ × 5½ in. (18 × 14 cm). Private collection and detail of pl. 21

22 *Landscape with Rock*, 1866–69, graphite, watercolor, and gouache on paper, 9⅟16 × 13⁹⁄16 in. (23 × 34.5 cm). Staedelsches Kunstinstitut, Frankfurt am Main. Photo © Ursula Edelmann

Rivière suggested that Cézanne's early landscape watercolors were based as much on his imagination as they were on observation.[88] There is much to support this suggestion in these two watercolors, in which the depicted landscapes seem to come to life through anthropomorphic associations. The rock looks strangely like a head, with a strong chin and prominent jaw, supported by a sturdy neck; the houses in *The Climbing Road*, likewise, seem to peer ominously at the pedestrians moving toward them on the road. In this work in particular the entire landscape appears to writhe with animation, the road that snakes through the terrain becoming something like a vital axis that invests inanimate objects with a strange, otherworldly life. These watercolors call to mind the uncanny tales of Edgar Allen Poe, in which houses and other objects adopt a disturbing psychological presence.[89]

Cézanne's interest in landscape as a motif for his early watercolors was probably kindled by his exposure to the watercolors of his fellow Aixois, François-Marius Granet. After a career working in Italy, Granet retired with his wife to Versailles, where he captured in a series of impressive, lyrical watercolor views the changing aspects of the palace grounds in different seasons. A watercolor dated March 3, 1841 shows a view from the palace toward the Swiss Pond in the distance. The diluted washes of watercolor pigment capture well the misty atmosphere and diffused light of a northern climate (pl. 24). Granet bequeathed nearly 250 watercolors to the

23 *The Climbing Road*, 1867, graphite, watercolor, and gouache on paper, 8⅜ × 13⅝ in. (21 × 34.5 cm). The Eisei-Bunko Museum, Tokyo. Photo © The Eisei-Bunko Museum, Tokyo

24 François-Marius Granet, *The West Pylon of the Gates to the Orangerie, with the Pièce d'Eau des Suisses in the Distance*, March 3, 1841, graphite, watercolor, and black ink on paper, 14.2 × 19.3 cm (5 9/16 × 7 9/16 in.). Musée Granet, Aix-en-Provence. Photo © Bernard Terlay, CPA

Musée d'Aix when he died in 1849 (another 40 watercolors were included in his bequest to the Louvre).[90] The artist and critic Emile Bernard reported at a later date that Cézanne had a special taste for Granet: "He loved Granet's paintings, and he had an excessive indulgence for this rather mediocre painter, perhaps because of his earlier years."[91] Bernard's underestimation of Granet is surprising, but his suggestion that Cézanne would have been most aware of Granet in his early years seems right. Cézanne could easily have seen Granet's watercolors in the museum during his student years in Aix, especially since he was an acquaintance of the director of the museum.[92]

The closest watercolors from Cézanne's early career to Granet's views of Versailles are his views of the grounds of the Jas de Bouffan. He made several such views, depicting the house itself, the *allée* of chestnut trees, and the railway running alongside the property. The most dramatic of these watercolor views shows a corner of a large, rectangular stone basin to the side of the *allée* of chestnut trees, one of the principal points of interest for Cézanne on the property (pl. 25). The perspective of the watercolor is from within the basin itself, which was perhaps drained at the time. To the left there appears a low picket fence, at the base of which can be seen a group of five potted pelargoniums, only two of which are in bloom. Just beyond the fence can be glimpsed the hindquarters of one of the two decorative stone lions that punctuate the corners of the basin. The pale trunk of a chestnut tree, visible beyond the lion, bends away from the viewer toward a second, barely visible tree on the right. As in *Still Life: Flowers and Fruit*, the diluted washes of color in the background of the watercolor contrast sharply with the denser dabs of red, green, yellow, and white gouache in the foreground. It must have been a work such as this one that Cézanne's friend Fortuné Marion had in mind when he wrote in a letter to a mutual friend in 1867 that Cézanne's watercolors were "remarkable": "Incredible colors and a strange effect that I thought watercolor incapable of producing."[93] The strange effect in this watercolor, however, is as much a result of the graphic energy of the pencil as it is of the deep staining of the watercolor pigments and the

33

25 *Basin at the Jas de Bouffan*, 1867–69, graphite, water-color, and gouache on paper, 4⅝ × 7½ in. (11.5 × 19 cm). Private collection. Photo © Galerie Schmit, Paris

Facing page: detail of pl. 25

dry, intense quality of gouache. Cézanne has once again brought the pencil back on top of the color, reversing the usual order of watercolor practice and breaking free of the associations of line as a guiding element for color. In this watercolor, it is color that establishes a context for drawing, which, scribbled against and across it, animates the scene and infuses a sense of vitality into an image of ostensibly immobile objects. To recall Baudelaire's terms, Cézanne has been less concerned here to render nature with exactitude than he has to represent "another nature," that of his intense and personal temperament.

Strong Sensations

Gestural drawing and painting, therefore, emerge as complements in Cézanne's early watercolors. Closer to drawing than painting, these watercolors participate in the general consensus of the 1860s that watercolor was in its essence an ideal mode of sketching and spontaneous rendering that retained better than oil painting the original fire of the artist's immediate sensations and imagination. At the same time, however, watercolor was also in its essence a *mixed* medium, in so far as it called for the successive employment of the pencil or pen and the paint brush.

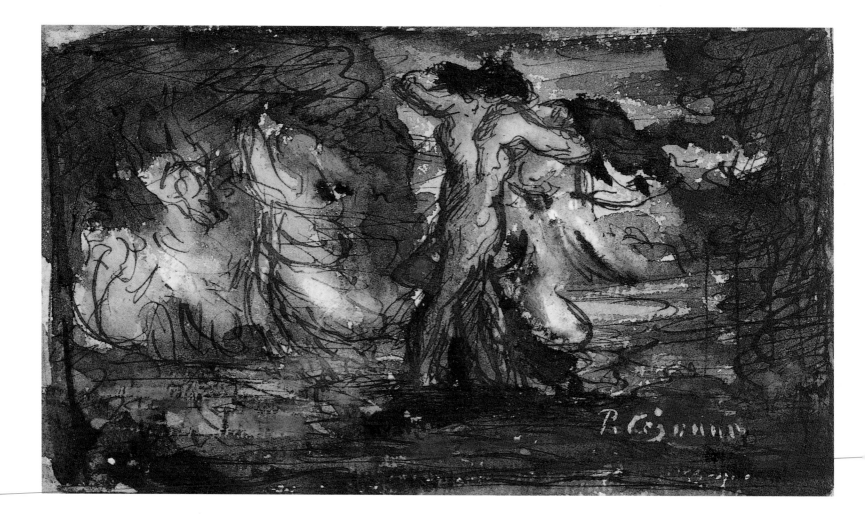

26 *The Abduction*, 1867–69, ink, gouache, and water-color on paper, 2¾ × 5 in. (7 × 12.7 cm). The Pierpont Morgan Library, New York. Photo © Joseph Zehavi (2008). Gift of Donald Oresman in honor of the 75th anniversary of the Morgan Library and the 50th anniversary of the Association of Fellows

Cézanne's watercolors, when compared with his oil paintings, confirm this point. Although final paintings for *The Gravediggers*, *The Diver*, and *The Wine Grog* are either lost or were never executed, the resultant painting is known for another watercolor sketch – *The Abduction* (pl. 26). Thought to date from 1867–69, the watercolor depicts a vaguely rendered forest glade occupied by what appears to be a struggling couple. Additional figures to the left appear to be fleeing in fright. A clearer sense of the composition is provided by a group of drawn sketches clustered along the right-hand margin of a large sheet of paper, the center of which is occupied by an earlier study of a male nude seen from behind (pl. 27). In these drawn sketches, the figures can be made out more clearly than in the watercolor. We can see that at the center of the composition is a male figure who has violently seized a woman by the neck. The violence of the impact is communicated by the attacker's lunging gesture and by the victim's flailing arms and flying hair. The reverberations of this central episode are felt throughout the rest of the composition: the figures at the left can be made out as nymphs who flee in terror, arms raised in panic; a figure at the right, who is barely visible in the watercolor, bends hideously backward as she recoils in the face of the violent spectacle taking place. That Cézanne was intent on getting the poses of the attacker and victim right is evident in a second drawing of the two central figures just to the right of the first drawing. Here, the attacker leans in more than in the first drawing, bringing his head closer to that of his victim.[94]

27 *Male Nude*, 1867–69, graphite on paper. Present location unknown

The watercolor repeats the *mise-en-scène* of the drawings. The recoiling figure on the right, however, has now been reduced to a few looping contours that have been absorbed into the implied frame of the surrounding forest. The most important difference, however, is technical: in the watercolor, Cézanne has used both drawing and color in the rendering of this violent fantasy. The addition of color represents a step toward oil painting, but without losing the graphic effects of drawing. In fact, the graphic intensity of the watercolor exceeds that of the pencil drawings due to the fact that Cézanne has drawn the composition with ink pen rather than pencil. One of the results of this choice is a general elevation of the shrillness of the subject matter. The graphic force of Cézanne's hand has here been translated into sharp, black lines that seem to tear and slice at the page, repeating at the level of handling the violent impulse of the subject matter. Cézanne's use of the pen has also increased the contrasts within the work: black ink stands in greater contrast to the light page than does graphite pencil, hence increasing its dramatic impact. It does this also because the ink inscribes the paper surface in a way that is different from pencil drawing. Where a pencil drags against the texture of the paper surface and leaves behind a granulated path of graphite, the ink pen

deposits a neat line of pigment that retains the incisiveness of the metal point that has scratched the surface rather than dragging softly against its fibers. Taking up the paintbrush, Cézanne applied color in diluted, bleeding washes, rendering the forms of the nymphs at the left all but illegible. Colors have been applied wet into wet, transforming some of the pen lines into spreading auroras of black ink rather than the incisive lines they first were. Gouache has been added in places to pick out colors more assertively – the white drapery, yellow hair, and most importantly, the lurid stains of red blood on the ground and down the right leg of the attacker's victim. Given the small scale of this watercolor, measuring just 3 inches by 5 (7.62 × 12.7 cm), the viewer has to peer into it to make out what it represents; but what the viewer encounters is a powerful expressive energy that is unexpected and extraordinary.

It comes as a surprise to discover just how much the intensity of the watercolor and pencil sketches was sublimated and diffused in Cézanne's final, much larger canvas. In the painting, the scenario of brutal attack has been toned down into a peaceful scene of a swarthy Hercules-like figure lugging away an apparently unconscious or drowsy woman (pl. 28). The nymphs in the distance look on impassively, suggesting business as usual and suppressing entirely the former sense of panic and flight. The handling of the paint is still lively, although now dense and viscous. Ultimately, oil paint cannot retain the liveliness of the watercolor sketch and, especially, the striking combination of the graphic intensity of the ink drawing and the bleeding, expanding stains of color. This does not mean that Cézanne believed his watercolors to be more successful expressions of his feelings than his oils (there is no evidence to suggest this in his letters or reported conversations). What it does suggest, however, is that watercolor allowed for a greater sense of spontaneity and immediacy in the combination of the scribbling pencil or pen and the variously opaque and transparent touches of the paintbrush.

There is no record of the paintings that Cézanne submitted to the Salon of 1868 (could *The Abduction* have been one of them?). In a letter to a friend, Marion explained that despite the fact that Cézanne had again been rejected he remained undaunted.

> Cézanne won't be able to show his work in official, sanctioned exhibitions for a long time. His name is already too well known, and too many revolutionary ideas are connected with it, for the painters on the jury to weaken for a single instant. And I admire the tenacity and sangfroid with which Paul writes to me: "Very well! We'll keep sticking it to them with even more persistence."[95]

"I truly believe," added Marion, "that of all of us it is he who will turn out to have the most violent and powerful temperament."[96] In 1870 Cézanne again submitted two canvases to the Salon – *Portrait of Achille Emperaire* and *Woman with a Flea* – both of which, as in years past, were rejected. Cézanne was interviewed by the critic Stock at the time of the rejection of his paintings and was also the subject of a caricature, which depicted Cézanne as a hirsute provincial wearing one of his rejected paintings as an absurdly oversized earring and brandishing the other in his left hand. The remarks that Stock attributed to Cézanne were some of his most defiant:

> The artists and critics who happened to be at the Palais de l'industrie on March 20th, the last day of the submission of paintings, will remember the ovation given

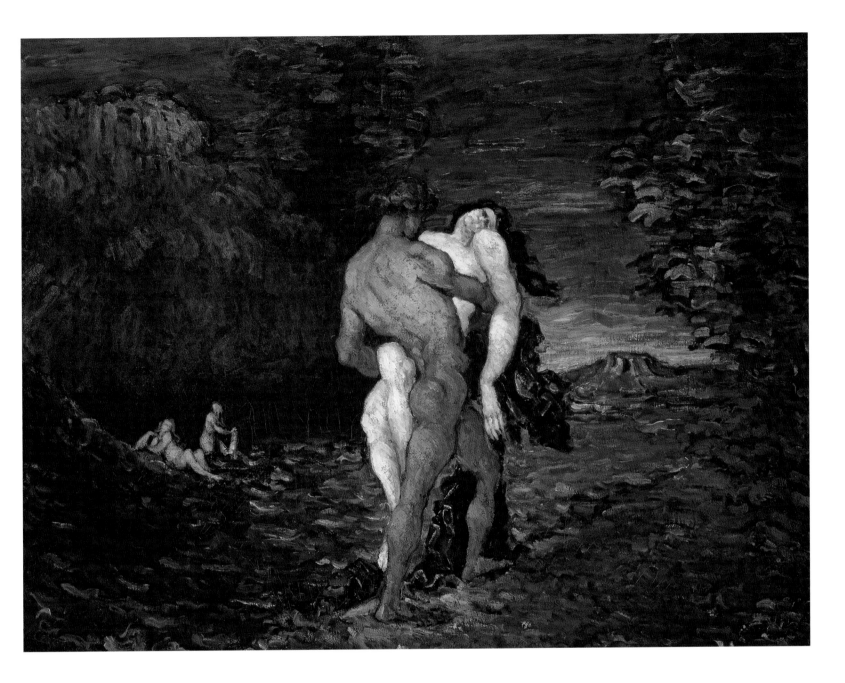

28 *The Abduction*, 1867–69, oil on canvas, 35¼ × 45¾ in. (89.5 × 116.2 cm). The Provost and Fellows of King's College, Cambridge, Keynes Collection. On loan to the Fitzwilliam Museum, Cambridge

to two works of a new kind . . . Courbet, Manet, Monet, and all of you who paint with a knife, a brush, a broom, or any other instrument, you are out-distanced! I have the honor to introduce you to your master: M. Cézannes [*sic*] . . . Cézannes hails from Aix-en-Provence. He is a realist painter and, what is more, a convinced one. Listen to him, rather, telling me with a pronounced Provençal accent: "Yes, my dear Sir, I paint as I see, as I feel – and I have very strong sensations. The others, too, see and feel as I do, but they don't dare . . . they produce Salon pictures . . . I do dare, Sir, I do dare . . . I have the courage of my opinions – and he laughs best who laughs last![97]

In a letter to a friend, Cézanne noted that he had seen the caricature: "I have been rejected in the past, but I'm bearing up not worse than before. Needless to say, I'm still painting and that for the moment, I am well."[98]

29 *Factories near L'Estaque*, 1869, graphite, watercolor, and gouache on paper, 6¼ × 12⅝ (16 × 32 cm). Musée Granet, Aix-en-Provence. Photo © Bernard Terlay, CPA

He also continued to make watercolors, which remained for Cézanne important, private moments of expression. Just the year before, he had made a watercolor study of a group of factories near L'Estaque, which he offered as a gift to Zola's fiancée to attach to her work table (pl. 29). On the verso of the sheet can be read the following dedication: "Watercolor made specially for a work table belonging to Madame Alexandrine-Emile Zola, by Paul Cézanne in April 1869."[99] That *Factories near L'Estaque* should have functioned as a decoration for Zola's fiancée's work table suggests that its industrial subject matter was meant as a humorous contrast to, or commentary on, the kind of home manufacture in which she would have engaged at her work table. It also suggests an implicit contrast with her "feminine" work, such as sewing or perhaps even making delicate watercolors. Both in execution and subject matter, this watercolor suggests that Cézanne agreed at least in principle with Zola's sense that powerful art was opposed to effects of "feminine" delicacy. Everything about it implies that it was made not by what Paillot de Montabert called the "pretty hands" that usually practiced the art, but by a hand that was coarse and "masculine," one that was unflinching and even calculatedly clumsy.[100] This emphasis on virility is consistent with the characterization of Cézanne's early art as *couillard*, with its implicit association of the male anatomy with bold expression. The vertigo of the steep perspective gives a forceful emotional dimension to the view, in which smokestacks belch black smoke into the crisp air of Provence and sully the landscape. The coarse scrubbing of soft graphite and the dramatic staining of the page with white, red, and brown pigments remind us of the status of watercolor as "colored drawing," in which graphic lines and colored washes

mingle to generate effects that exceed the range of either drawing or of oil painting on their own.

When Cézanne expressed his aim to buy a watercolor box in 1866, therefore, he was voicing a desire for a medium that would allow him to further his exploration of subject matter that gave expression to his personal temperament, while bringing within his reach a kind of facility and spontaneity that was generally thought to be impossible in slower oil painting. Between drawing and painting, his watercolors confirm the general association of watercolor with spontaneous rendering, which retains better than oil painting the original fire of the artist's immediate sensations and imagination. Ultimately, the gestural use of the pencil and paintbrush was a means for Cézanne both to register his "strong sensations" and to contribute to the intensification of these sensations through the exploration of striking subject matter and the engagement in aggressive handling. The artist's hand, scribbling across the sheet of paper with a pencil or pen, then dabbing and flicking touches of paint over the subtending lines, and then returning with the pencil and paintbrush to add new lines, marks, color touches, sweeps of the hand, all indicate a powerfully material engagement with the means of rendering that concretizes rather than simply reflects passively the artist's temperament. Such gestures, to use Henri Focillon's term, are "creative." In *The Life of Forms in Art*, Focillon eloquently described the interface of hand and mind in the creative gesture:

The mind rules over the hand; hand rules over mind. The gesture that makes nothing, the gesture with no tomorrow, provokes and defines only the state of consciousness. The creative gesture exercises a continuous influence over the inner life. The hand wrenches the sense of touch away from its merely receptive passivity and organizes it for experiment and action.[101]

"Because it fashions a new world," adds Focillon, the creative gesture "leaves its imprint everywhere upon it."[102] Likewise, the imprint of Cézanne's temperament can be felt everywhere in the gestural drawing and color that characterizes his *couillard* watercolors.

Two

Shorthand for Sensation:
Cézanne, Watercolor, and Impressionism

Cézanne's watercolor practice in the 1870s reflects his general turn toward Impressionism, which began early in the decade and culminated in his adaptation of the Impressionist aesthetic to a personal, constructive manner of painting. During this period, he moved away from the confrontational, *couillard* stance of his early work and reoriented his art toward a slower, more reflective manner of rendering. In his paintings this shift is indicated by a reduction of the scale of his canvases, a lightening of palette, and an atomization of facture. A difference can also be detected in his choice of subject matter. Although Cézanne continued to make imaginary scenes throughout his career, he became increasingly focused at this point on what he referred to as "motifs" selected from nature and, especially, from the outdoor landscape. Similar changes took place in his watercolors, including a general lightening of palette and a new emphasis on outdoor landscape as preferred subject matter. Another change was the emergence of a new and more carefully calibrated relationship between the drawn and painted parts of his watercolors.

The ambition of this chapter is to explore the emergence of an Impressionist model of watercolor in Cézanne's art during the 1870s and extending into the early 1880s. Like his oil paintings, the watercolors that he made during this period evince a desire to make of Impressionism something solid and structured. "I wanted to make of Impressionism," he reportedly stated, "something solid and lasting like the art of the museums."[1] The so-called constructive stroke that Cézanne developed in his oil paintings in the late 1870s is generally understood to have offered a solution to this goal. Watercolor, conversely, remained for Cézanne a shorthand and summary mode of indicating sensations, never an attempt to account for their full scope. Free from the burden of accounting for everything, watercolor allowed him to work in a more subtle and partial mode than in his oil paintings. If in his oil paintings Cézanne sought increasingly to fuse his sensations of form and color in a single,

Facing page: detail of pl. 51

consistent facture, in his watercolors, conversely, the process of rendering sensation continued to be divided into the categories of form and color, line and hue, a division that was determined by the elementary sequencing of the medium into drawn and painted phases. Consequently, Cézanne's Impressionist watercolors present a foil to his oil paintings, insofar as they insist on a division between two orders of sensation – form and color – that the paintings seek to fuse.

Cézanne and Pissarro

A photograph dating from the 1870s shows Cézanne wearing a backpack filled with painting supplies, a canvas, and a collapsible easel (pl. 30). He leans heavily on a walking stick and gazes intently into the distance, anticipating a day of outdoor painting. This image coincides with Cézanne's turn to Impressionism, a process that took place through an artistic dialogue with Pissarro, who lived in Pontoise, a rural town located on the Oise river roughly 20 miles northwest of Paris. Cézanne painted with Pissarro on numerous occasions in the 1870s and early 1880s (the photograph was taken during one of these moments of artistic exchange).[2] Cézanne, accompanied by his mistress, Hortense Fiquet, and their infant, Paul *fils*, first came to the region in the winter of 1872. They at first stayed with Pissarro and his family in Pontoise at 16, rue Malabranche. In a letter to a mutual friend dated September 3, 1872, Pissarro noted that Cézanne was already with him in Pontoise. In the same letter, however, he indicates Cézanne's intention to install his family in the nearby village of Auvers-sur-Oise, where they would reside until spring 1874.[3]

30 Anonymous, *Cézanne*, 1872–77, photograph. Musée d'Orsay, Paris. Photo © Réunion des Musées Nationaux / Art Resource, NY

The relationship between the two men had begun in the 1860s. Pissarro mentioned first meeting Cézanne in 1861, when he encountered "this peculiar Provençal at the Atelier Suisse."[4] The art historian Joachim Pissarro has pointed out that Cézanne's first known letter to Pissarro, dated March 15, 1865, opens with the formal expression "Monsieur Pissarro"; but a year later Cézanne had replaced the formal address with the much more cordial and familiar one of "Mon cher ami."[5] Cézanne had most likely seen Pissarro's large-scale, Realist landscape views of village scenes in the Pontoise region at the Salons of 1866 and 1868. In his reviews of both Salons, Zola had singled out Pissarro's canvases as rare exceptions to the general monotony of official canvases on display: "In the midst of all these dolled-up pictures, the canvases of Camille Pissarro seem disconcertingly naked."[6] Focusing on Pissarro's vast canvas, *The Jallais Hill*, Zola declared: "The temperament of the painter has taken from ordinary existence a rare poem of life and force" (pl. 31).[7] For his part, Cézanne had tried his hand at similar kinds of effects in a group of dark and brooding landscapes in the 1860s. That Cézanne was already in dialogue with Pissarro on questions of landscape depiction at this point is evident in a letter that he wrote to Pissarro in 1866, in which he stated: "You are completely right in what you say about gray, it alone prevails in nature, but it's frightfully hard to capture."[8] In a letter to Zola from about the same time, Cézanne expressed his enthusiasm for outdoor landscape painting: "You know, any picture done indoors, in the studio, never equals things done outdoors. In pictures of outdoor scenes, the contrast of figures to ground is astonishing, and the landscape is magnificent. I see superb things and I must resolve only to paint outdoors."[9]

When Cézanne moved to Auvers in 1872, therefore, he was no stranger to the appeal of outdoor landscape painting. Cézanne's own landscape canvases from 1870 to 1872 are close in mood and effect to Pissarro's Realist landscapes. Evidence of Cézanne's enthusiasm for large-scale landscape painting can be seen in *The Wine Market*, painted in Paris in the winter of 1871–72 (pl. 32). Depicting the view from his apartment on the rue Jussieu, it shows a wine depot, replete with stacked wine barrels, and framed by a roadway and ramp on the left. The view is partially blocked by a large, dark tree, which spreads like a stain into the middle of the canvas. Cézanne appears to have brought this canvas with him to Pontoise in the fall of 1872. It was probably this canvas that Pissarro had in mind when he wrote to a friend in September 1872: "Our Cézanne gives us some hope, and I have with me a painting of remarkable vigor and strength."[10] The chalky, gray sky calls to mind Cézanne's remark to Pissarro concerning the preeminence of gray in nature. By the time Cézanne arrived in Pontoise in 1872, however, Pissarro had abandoned the pursuit of gray and had begun to work in a spectral palette closely calibrated to the analysis of outdoor light into individual color sensations.

Before being chased from his home by the threat of invading Prussians in September 1870, Pissarro had lived in Louveciennes for a year and a half.[11] It was in paintings of this village, and neighboring Bougival, executed between summer 1869 and fall 1870, that Pissarro's approach to landscape underwent a shift from a Realist mode to one that would later come to be called Impressionist. Two things most clearly mark this transition. On the one hand, after 1868 the format of Pissarro's canvases became smaller, representing a turn away from the Salon *tableau* and towards the *morceau*, or "slice of life" (Stéphane Mallarmé claimed that the smaller scale of the Impressionist painting made it "easier to look at, and with shut

32 *The Wine Market*, 1871–72, oil on canvas, 28¾ × 36¼ in. (73 × 92 cm). The Portland Art Museum

eyes preserve the remembrance of"[12]). On the other hand, it was during this period that he replaced his manner of painting with broad areas of flat pigment oriented toward depicting architectural solidity, as seen in his work in the 1860s, with a lighter, atomized facture geared toward capturing the evanescent play of light and delicate atmospheric effects. This can be seen, for instance, in a series of canvases that he executed of the Versailles road in Louveciennes in 1870 (pl. 33). The road presented itself as a ready-made motif with a perspectival scheme already built into it, allowing the artist to drop concerns of arrangement and editing of the motif and to narrow his task to the transcription of the "effect" or "impression" witnessed before him. We observe the road alternately blanketed in a layer of snow, gleaming with a gloss of newly fallen rain, revealing the first green of oncoming spring, and, finally, baking under the warm rays of the summer sun.[13]

In his important review of the first exhibition of the Société anonyme des artistes, peintures, sculpteurs, graveurs, etc. in 1874, now known simply as the first Impressionist exhibition, the critic Castagnary described the characteristic quality of the landscapes on view by, above all, Pissarro and Claude Monet, the perceived leaders of the group, in the following terms: "If one tries to characterize them with a single word that explains their work, one must forge the new term *Impressionists*. They are *Impressionists* in the sense that they paint not the landscape but the sensation produced by the landscape."[14] Castagnary may not have coined the term "Impressionist" – this honor belongs to the critic Louis Leroy[15] – but he was one of the first to attempt to define it positively. As Castagnary noted, the shift to a looser facture in Impressionism belied a desire to achieve pre-conceptual, pre-predicative access to the sensory experience of nature. They sought, in essence, to depict in their paintings stripped-down impressions free of the conventions and

33 Camille Pissarro, *The Versailles Road, Louveciennes,*
1870, oil on canvas, 40.3 × 56.3 cm (15⅞ × 22³⁄₁₆ in.). Ster-
ling and Francine Clark Art Institute

partis pris of academic composition and technique. This understanding of
Impressionism is supported by remarks scattered throughout Pissarro's letters to his
eldest son, Lucien. Impressionism, Pissarro explained, is "purely a theory of obser-
vation."[16] In front of the motif, he counseled, "one should strive only for direct and
spontaneous sensations";[17] anything else, he was fond of insisting, is "philosophi-
cally outside the ideas of our time."[18]

The rhetorical force of this dedication to optical experience, to the "sensation"
of the landscape rather than the landscape itself, was invested not only in summary
facture, however, but also in the lightening of the painter's palette. According to
Lucien Pissarro, it was this aspect of his father's technique that most interested
Cézanne in the early 1870s. Lucien recalled: "Cézanne was doing mostly powerful
black pictures until he came to see us in 1870 [*sic*]."[19] "My father was then starting
to do light painting, he had banished black, the ochres, etc. from his palette . . .
He explained his ideas about this subject to Cézanne and the latter, to understand
this, asked him to lend him a canvas so that he could, in copying it, judge the pos-
sibilities of this new theory."[20] The act of copying a painting by Pissarro forced
Cézanne to revise his palette and, consequently, marked a turning point in the
development of his technique of oil painting. Indeed, he would embrace a chro-
matically expanded, prismatic palette for the rest of his career. In a letter to Pissarro
written in 1874, just as he returned to Aix-en-Provence after his sojourn in Auvers,
Cézanne recounted a conversation that allowed him to specify the lesson he had
taken from the older painter:

> I recently saw the director of the Musée d'Aix, who, impelled by a curiosity nour-
> ished by the Parisian newspapers . . . wanted to see for himself the extent to
> which Painting was being threatened . . . and when I told him that you were
> replacing modeling with a study of colors, and as I tried to explain this with
> reference to nature, he closed his eyes and turned his back.[21]

Cézanne's story is telling insofar as two conceptions of vision are juxtaposed, one
that turns its back on nature and another that beholds the natural prospect face to
face. In an authentic engagement with outdoor visual experience, noted Cézanne,
the model is dissolved into a flux of colors; the materiality and substantial presence

34 *The House of Père Lacroix, Auvers-sur-Oise*, 1873, oil on canvas, 24¼ × 20 in. (61.5 × 5 cm). Chester Dale Collection, National Gallery of Art, Washington, DC. Photo © The Board of Trustees, National Gallery of Art, Washington, DC

of the motif are suppressed in favor of an analysis of the optical impression. As late as 1904, Cézanne continued to voice his commitment to a chromatic rather than a tonal palette: "one should not say model (*modeler*), one should say modulate (*moduler*)."[22] The critic and painter Maurice Denis, who was friendly with Cézanne in later years, summed up Cézanne's procedure in similar terms: "He substitutes . . . contrasts of color for contrasts of tone."[23]

The paintings Cézanne made after he had settled in Auvers-sur-Oise evince his mastery of the new facture and focus on outdoor light and weather effects. *The House of Père Lacroix, Auvers-sur-Oise*, for example, shows a fresh and bright view of a rural home set in the midst of foliage, flowers, and the branches of trees (pl. 34). The execution of the painting is calibrated to the registration of the artist's sensations of shimmering, outdoor light. Like Pissarro, Cézanne uses a luminous palette and breaks up broad surfaces, such as the walls and segments of the roof of the house, into patterns of flickering color. The thatched roofs on the left, for instance, are not painted a uniform brown, but have instead been rendered as a

35 Camille Pissarro, *Bridge at Caracas, Venezuela*, 1854, graphite and watercolor on paper, 24 × 30.5 cm (9 × 11¾ in.). Collection of Mr. and Mrs. Paul Mellon, National Gallery of Art, Washington, DC. Photo © The Board of Trustees, National Gallery of Art, Washington, DC

shifting chromatic field of violets, greens, reds, and yellows. The broad, mono-chromatic strokes of paint in *The Wine Market* are replaced in *The House of Père Lacroix, Auvers-sur-Oise* with stippling and ticking brushstrokes, widely varied in tone and hue, which capture the flickering of light and the freshness of the outdoor scene. Pissarro noted in retrospect when he looked at work that Cézanne had done during this period of dialogue that however close the two of them had been at this time, they retained their own manner of seeing and painting. Noting the similar-ity of what they were seeking to accomplish at the time, Pissarro exclaimed: "Naturally, we were always together!" "But what cannot be denied," he added, "is that each of us kept the only thing that counts, our own 'sensation.'"[24]

Although most of their work together was done in the medium of oil painting, watercolor also played an important role in the dialogue between Cézanne and Pissarro. In fact, Pissarro had been using watercolor as a tool for capturing effects of light and atmosphere for several years before Cézanne came to Pontoise. Pissarro's first known watercolors were executed in the mid-1850s, during a trip to Caracas, Venezuela, with his friend and fellow artist, Fritz Melbye. These early watercolors reflect a taste for picturesque subject matter, as can be seen in a charming view of a bridge in the countryside outside Caracas. Inscribed with the date of January 5, 1854, it focuses on the stone bridge with its pointed arch flanked on either side by a group of modest houses and, on the left, a single coconut palm (pl. 35). The view, like others made by Pissarro during the trip, are essentially touristic in nature. In the 1860s, once Pissarro had moved definitively to France, his treatment of land-scape shifted in the direction of Realism. Following the advice of the landscape painter Camille Corot, he worked outdoors in the French landscape, seeking to render effects of light and form. Like Cézanne, Pissarro worked at the Atelier Suisse, where Realism was generally embraced as the most contemporary and relevant mode of landscape depiction. The impact of this turn toward Realism is clear in Pissarro's shift from picturesque and exotic motifs to everyday views of the local countryside, as displayed in the views of the Hermitage neighborhood in Pontoise,

36 Camille Pissarro, *Factory on the Oise at Pontoise*, 1873, graphite and watercolor on paper, 17.7 × 25.1 cm (7 × 9⅞ in.). Collection of Mr. and Mrs. Paul Mellon, National Gallery of Art, Washington, DC. Photo © The Board of Trustees, National Gallery of Art, Washington, DC

described above, which Zola admired at the Salons of 1866 and 1868. Only one watercolor clearly relates to this series of Hermitage views. It shows a woman working in fields not far from a group of solid village buildings and appears to be a compositional exploration that was never taken up in a final canvas.[25]

Pissarro continued to make watercolors after his turn to Impressionism in the late 1860s and early 1870s, including a view of the Versailles Road in Louveciennes, which relates to the series of oil paintings discussed earlier, and a view of a factory on the banks of the Oise river, which also relates to a series of oil paintings (pl. 36). Pissarro produced four oil paintings of the motif seen from a series of different perspectives on the opposite bank. In contrast to his early penchant for picturesque motifs, this motif suggests an interest in an intensely contemporary and distinctly unpicturesque one.[26] As in the views of Louveciennes, however, the real focus of the canvases is on weather, light, and atmospheric effects. The watercolor relates most closely to the canvas in which a leafless tree emerges in the middle of the river between the viewer and the factory (pl. 37). That the watercolor and the oil painting were executed at about the same time is suggested by the fact that, in each, the same barge is pulled up to the opposite bank on the river. Moreover, the pattern of ripples and reflections in the water is virtually identical in the two works, as is the direction of the wind, indicated by the angle of the smoke and steam emitted by the factory. This does not mean that the oil painting was extrapolated directly from the watercolor, but rather that the watercolor was a means for Pissarro to study effects of light and air in a rapid, shorthand manner before turning to oil. This was indeed how he described the usefulness of watercolor in a letter to his eldest son: "Remember that watercolors help the memory, and enable you to retain the most fugitive effects – watercolors render so well the impalpable, the powerful, the delicate. And drawing is always indispensable."[27] With watercolor, he explained in another context, "one can manage in a few minutes to take notes that are other-

37 (above left) Camille Pissarro, *Factory on the Oise*, 1873, oil on canvas, 39 × 47 cm (15½ × 18½ in.). Private collection

38 (above right) *Hillside*, 1873–77, graphite, watercolor, and gouache on paper, 14⅛ × 11⅞ in. (36 × 30 cm). Private collection

wise unthinkable, the fluidity of a sky, certain effects of transparency, many little things that slower work cannot give."[28]

Just as the lightening of palette in Cézanne's oil paintings in the 1870s can be traced to the dialogue with Pissarro, so too can the lightening of palette and the increase of transparency in his watercolors. A pair of watercolor views of the Jallais Hill in Pontoise, a motif that Pissarro frequently represented in oil paintings, indicates a new orientation in Cézanne's use of the medium. Neither of these watercolors seems to be a study for a specific oil painting, however, as was the case with Pissarro's watercolors. Although they cannot be identified with specific paintings, these watercolors reveal an enthusiasm for the medium as a lively and transparent means for depicting the fleeting and transparent qualities of motifs witnessed outdoors. In the first, a vertical view of the hillside, Cézanne's facture reflects his greater attention to the play of outdoor light, which he rendered with stippling and hatching of the paintbrush (pl. 38). He perched himself on a high promontory where he could look out over a group of foreground houses nestled on a hillside and, beyond them, a second, more gently rising hill. A second view of what seems to be the same area reveals an even greater quality of transparency (pl. 39). This time drawn back away from the hills, Cézanne now looks down on a verdant plain that is hemmed in on the left and right by stands of trees. The light palette and flickering touches of translucent pigment capture the artist's enthusiasm for the intense sensations produced by the brightly lit, verdant countryside. The quality of the pigments in this watercolor suggests that he was using dried cakes of color rather than body color. Cézanne has diluted his colors in places to nearly transparent washes, where thin areas of emerald and yellow-green bleed into one another while allow-

ing the luminosity of the light paper surface to shine through. This represents a move toward a purer use of the medium. As I noted in Chapter One, the mixture of body color with watercolor pigments was generally considered to be a violation of medium specificity. Cézanne had embraced dense and painterly effects in his early work as a way to enhance the expressive force of his watercolors. Here, conversely, he has limited the use of body color to a minimum, including only a few touches of Chinese white to pick out the tree trunks in the foreground and a few more barely perceptible additions in the distant hillside, where faint indications of body color help pick out the switchback of the roadway that zigzags up and over the hillside.

Watercolor as Shorthand

Pissarro's remarks emphasize the fact that rendering landscape effects was among the tasks most frequently assigned to watercolor in France in the mid-nineteenth century. Such was noted already in Nicolas-Toussaint Charlet's famous letter on watercolor, written in 1845, addressed to his students at the Ecole Polytechnique.

Facing page: detail of pl. 39

Watercolor, he explained, is a useful way to make shorthand studies of nature:

> On a journey or country outing, watercolor can provide a kind of shorthand of the things that strike us and which we want to remember; a light wash should be used to convey effects and the feel of color. Since shades of light change swiftly in nature, the overall picture must be promptly constructed and care must be taken to give a strong outline, putting down only general shapes . . . One must therefore make up one's mind immediately, capture a moment, an effect, and then work at it. Hence the necessity to forego details and to see only general lines and main masses of light and shade.[29]

In the face of nature's changing light and weather effects, the watercolorist was able to make rapid notes and summary indications of the spectacle unfolding before him. Like Baudelaire's Guys, the landscape watercolorist works fast to keep up with rapidly changing subject matter. The portability of watercolor also worked in favor of the roaming landscapist. As Charlet explained: "Watercolor is a pleasant and convenient medium: pleasant because it causes little fuss or mess, and all the requisites can be kept in a box six inches by four, which makes them easy-to-carry when traveling. Add to this box a pad of stretched paper, and you are equipped for exploring forests and mountains."[30]

In the 1860s two of the most prominent watercolorists in France, Eugène Boudin and Johan Barthold Jongkind, made landscape watercolors that focused specifically on capturing in rapid shorthand light and atmosphere effects for future oil paintings. Boudin's views of Parisians vacationing on the windswept beaches at Trouville and Deauville are a kind of way station between Guys's Parisian views and Jongkind's depictions of humid river and ocean vistas in Normandy. Both exploit the medium's resources as a fast and telegraphic mode of documentation. In a small study of women seated on the beach, for instance, Boudin rapidly noted the shapes and colors of their dresses as well as their different postures (pl. 40). Similarly, in a work by Jongkind showing sailboats on the ocean near L'Escault, the artist has focused on the effect of lapping waves and the vast, cloud-filled sky (pl. 41). For both Boudin and Jongkind, watercolor was primarily a memory aid for use in the execution of oil paintings. Their watercolors functioned as an archive of impressions and effects that could be consulted later at crucial moments during sessions of oil painting in the studio.

In his book on Jongkind, the painter Paul Signac described his process of working in a way that recalls Charlet's terms. Jongkind, he explained, headed out into the fields and to the edges of rivers "armed with his easy-to-carry materials, his box and his folding chair under his arm, his watercolor box and his bottle of water in the pockets of his jacket, rolling his pencil between his excited fingers, his eye furtive under his rumpled hat."[31] He continued: "He arrives at his hunting grounds, he stops, scans the horizon, reflects, takes stock, steps to the left and the right, forward and backward. His point of view decided upon, he unfolds his chair, opens his box, sharpens his pencil, and the game begins."[32] The portability and ease of watercolor, in other words, were the keys to its resources for the landscape painter:

> Nature is against the oil painter: the barometer and the thermometer are in league against him. The cold chases him away, the wind overturns his easel, dust and rain sully his palette, the ocean recedes: there where there was a beautiful boat floating on the blue water, a half an hour afterwards there is nothing but a sad

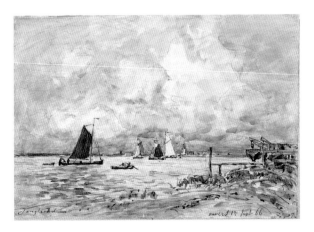

wreck grounded in the mud. The watercolorist, by contrast, can record all that takes place, everything that brings life and variety to the permanent motif. His simplified materials permit him to triumph over the elements and to record, even in the most unfavorable exterior conditions, the most fugitive effects. In the studio afterwards he can, fighting to his heart's content with the dense and supple materials of oil paint, develop the *éclat* and the splendor of the spectacles of which he has registered [in watercolor] the general organization and the constitutive elements.[33]

In short, observed Signac, "watercolor is but a means of notation, a kind of memorandum, a rapid and fruitful medium, allowing a painter to enrich his repertoire of elements that are too fleeting to be fixed by the slow medium of oil painting."[34]

It was not only color that the watercolorist had at his disposal to render his sensations; as I showed in Chapter One, drawing also played an important role in the watercolorist's process of execution. Boudin and Jongkind both used liberal amounts of drawing in their rapid, note-like watercolors. Looking a second time at Boudin's watercolor of women on a beach, it is clear that he first established the shapes and forms with the pencil before he filled them in with washes of color. Jongkind used drawing as well, but in a bolder and more assertive manner. Signac mentioned this in his study: "Jongkind enlivens his drawing, strongly indicated with a black pencil, with just a few touches of color; he repeats a line and makes it more precise with the paintbrush; he infuses the blank surface with a broad play of lines that delimits the spaces to be colored."[35] Signac broke down the sequence of Jongkind's process into four stages:

1. With a few curved lines, put down rapidly, he sets down the *mise-en-place* and the general appearances. On the smooth paper, the pencil moves freely, slowing, applying itself to the principal forms. The context is established. With the side of his pencil, he scrubs in the darkest volumes and indicates the main shadows.

2. Quickly, fearing that the effect will not last, he opens his watercolor box and, with a brush as dexterous as his pencil, he indicates first with large touches the most important local colors and seizes hastily the general effect . . . One never knows what may happen.

3. Then, if circumstances allow, with a colored line, applied with the brush – sepia, most often, sometimes with a local or dominant color – he takes up his drawing, accentuates it, adding to his first indications details to characterize and distinguish the objects . . .

4. Then, if he has time, what he has just done for the precision of form he will do for the precision of color, reinforcing his first coloring through the juxtaposition of new touches that are smaller in the spaces that are still open. . . .

He repeated these four operations throughout his life, varying simply their relative proportions according to the circumstances of weather and of place and according to whether he places more importance on form or on color.[36]

What this sequencing suggests is an elementary alternation between the rendering of form and color, a sequence that was also suggested in Charlet's letter, in which he speaks of using lines and washes to capture different elements of the outdoor effect.

If drawing was something Jongkind proudly applied in his watercolors, it nevertheless worried Boudin, who exhorted himself in a journal entry: "Splash on the color, use fewer contours! . . . Apply color in all its glory, in generous proportions."[37] Boudin seems to have worried about precisely the kind of sequencing that Signac described above. Drawing, he suggested, delayed the artist in his ambition to capture light and atmospheric effects. If watercolor's speed was a way of harnessing quickly changing subject matter, then the point was to get to the color as soon as possible. Although he generally used the pencil to begin his watercolors, Pissarro's watercolors also exhibit only very light drawing, suggesting that he agreed at least in part with the kinds of concerns expressed by Boudin. In his letter to his son, cited above, however, he made clear that, although watercolor can "render so well the impalpable, the powerful, the delicate," drawing was "always indispensable." For Signac, it was precisely the combination of firm line and fleeting color that made watercolor interesting:

The professors of watercolor, the pure ones, allow only a light sketch with a no. 3 lead pencil, which must disappear completely under the work of the brush and the last traces of which will be carefully removed with a bread crumb.

Now, the Japanese always outline their contours with a broad synthesizing line in Chinese ink; Turner affirms his contours with sepia, ultramarine blue, or even red chalk; Jongkind adds only a few tints to a strongly indicated drawing in blank pencil, takes up again the contour and repeats it with the brush, and introduces into his empty areas a whole range of lines to delimit the spaces to be colored; Cézanne, with the caresses of his Conté pencil, indicates the contrasts and the volumes that he wishes to study. Choose your teaching: that of the masters, or that of the professors.[38]

It is telling that Cézanne is included in this list. Indeed, his watercolors also embrace the back and forth sequence of drawing and color that Signac celebrated – a division of labor, in which the pencil or pen becomes accountable for formal values and the paintbrush for local color and light effects.

Although Cézanne occasionally experimented with softening drawing or leaving drawing out altogether in some of his watercolors in the 1870s, most retain a strong, assertive drawing.[39] Each of his views of the Jallais Hill, described above, contains at least some element of drawing. Especially in the horizontal view, drawing plays a dominant role in the overall effect of the sheet. Some of the drawing was applied with sweeping gestures of the hand, but most was applied with a controlled and analytical touch. Another watercolor, either executed in Pontoise with Pissarro or, perhaps more likely, in Paris in the company of Armand Guillaumin, a fellow enthusiast of Impressionism and mutual friend of Pissarro, shows an equally assertive use of the pencil (pl. 42).[40] This watercolor took the painter down to the level of the river where he captured a view of a barge working its way upstream against a background of municipal-looking buildings on the distant shore. The attentiveness to linear detail is visible under the application of colorful washes of translucent watercolor. The outlines and forms of the barge and the buildings were first sketched in with a sharpened, graphite pencil before the brush was applied. The complementary relationship between line and color can be seen, for instance, in the doorway of the barge, which was first inscribed neatly with the pencil and then painted in a turquoise green to suggest the painted frame. The roof of the distant building likewise was first drawn and then colored in a diluted red-orange hue. A wooden dinghy, similarly drawn and painted brown, pulled up to the side of the barge, seems to bob gently in the water and bump up against the larger vessel. The tiny vertical ridges of the laid paper have generated a pattern of small gaps in the strokes of the pencil where it has skipped over the valleys in the paper texture. A similar effect is evident in places where strokes of the paintbrush have run out of pigment and left a trace of the paper's peaks and valleys in its path. A related watercolor view of what appears to be the outskirts of Paris also emphasizes the importance of drawing as a record of formal values (pl. 43). The attention to architecture and the contours of the land are all communicated by the dedicated attentions of the sharp, incisive strokes of a controlled pencil. There is nothing left here of Cézanne's earlier, *couillard* drawing, in which gestural marks became signs of the artist's passion and indexes of his violent temperament. Here, by contrast, the only zigzag marks are the indications of shadow achieved with a rudimentary hatching technique.[41] The subsequent washes of color have been applied in a translucent fashion, indicating the artist's dedication to rendering not only form but also the play of light and shadow across the landscape.

In Cézanne's watercolors of the 1870s, therefore, drawing and color divide the work of rendering sensations into phases that supplement one another. The back and forth movement between the pencil and the paintbrush is predicated on the alternate picking out of edges and other structural patterns, on the one hand, and fleeting light and color effects, on the other. We see the process of this division especially clearly if we look at three renditions of a single motif of a garden wall and house seen from a pathway in a village. These works are generally thought to date from the late 1870s. Based on the similarity of the motif to the kinds of motifs taken up in canvases Cézanne executed in 1873–74, however, they could also date from this first sojourn in the Pontoise region. In these three views, Cézanne has selected a motif that is structured around layered architectural shapes, including a closed gate and wall, a shed, and a house. Several tree trunks add strong vertical vectors to the composition. That it was the formal character of the motif that first

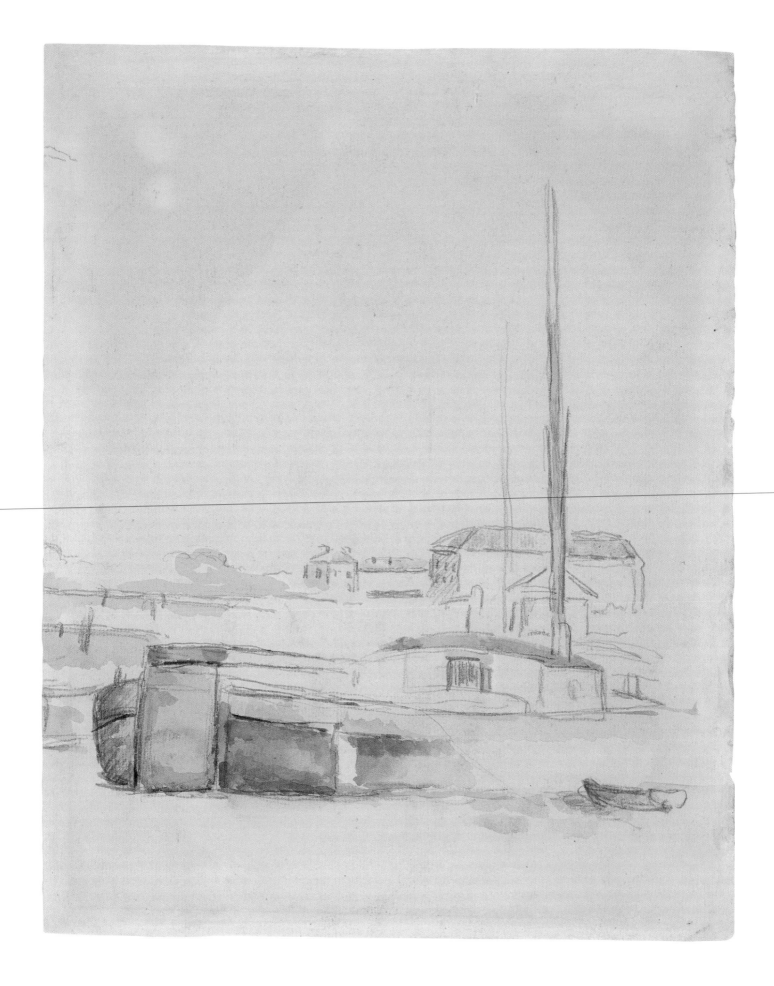

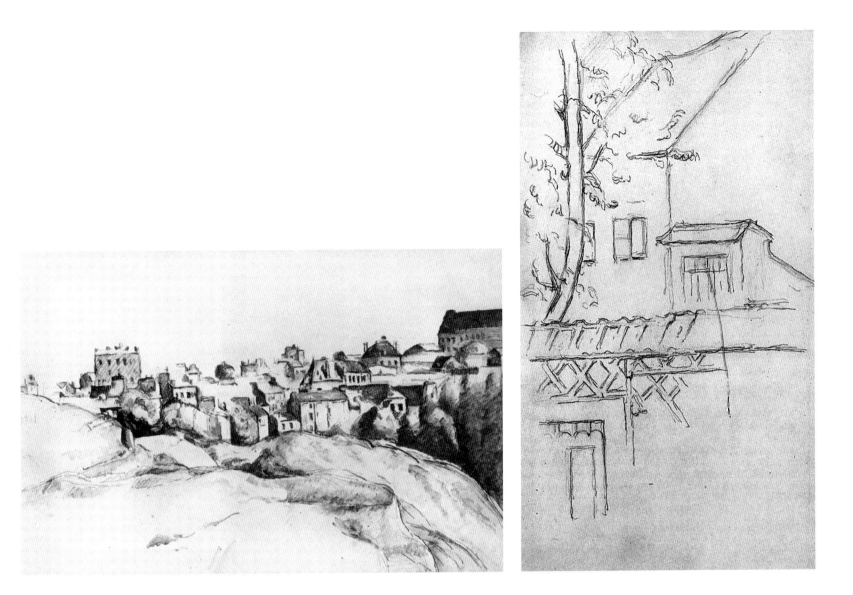

attracted Cézanne to it is made clear by the two sketchbook drawings that appear to precede the watercolor. The first captures the motif from a closer vantage point, producing a cropped point of view and a greater sense of telescopic spatial compression (pl. 44). The focus of the drawing is on the repetition of shapes and patterns in the motif, following closely the semicircles on the top of the door, the criss-cross pattern of the trellis, and the ridge and valley pattern of the tiles running along the top of the wall. As if to underscore his enthusiasm, Cézanne pressed heavily on the pencil as he picked out the interlocking and overlapping lines of the motif. The rhythm of the repeated sloping roofs of the wall, shed, and house leads the eye along a lateral relay into spatial depth.

The second drawing, which shows the motif from a position slightly further away and to the left, evinces a similar overriding interest in structure, pattern, and form (pl. 45). Now, however, Cézanne has taken the additional step of adding a few elementary washes of red and green watercolor pigment to the page. This addition of color represents a qualitative shift from a study of sensations of colorless form to a study of sensations of formless light. These soft, transparent washes of color begin but do not finish the work of differentiating the various surfaces into different sub-

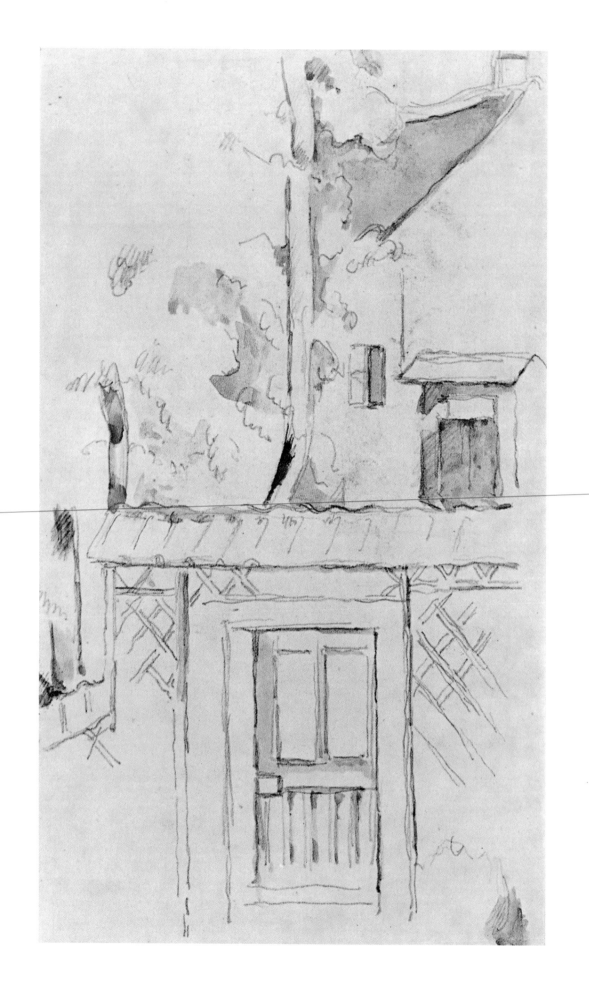

46 *Garden Entrance*, 1872–77, graphite and watercolor on paper, 18¹³⁄₁₆ × 12⁵⁄₁₆ in. (47.8 × 31.2 cm). The Metropolitan Museum of Art, New York. Photo © 1988 The Metropolitan Museum of Art, New York

45 (facing page) *Garden Entrance*, 1872–77, graphite and watercolor on page of sketchbook. Collection of Dr. Reinhold Hohl, Basel

stances, red standing for the clay of the tiles on the roof of the wall and violet for the slate roof of the house (the roof appears a more convincing slate-blue in the final watercolor). Touches of green, conversely, indicate the soft, leafy foliage of the trees to the left. Putting down the pencil and picking up the paintbrush, therefore, represented for Cézanne a shift from one order of sensation to another. In the final, large watercolor, *Garden Entrance*, Cézanne fused his careful drawing with a lively and luminous application of color (pl. 46). The drawing here is much less detailed and assertive, allowing for a more balanced, complementary relationship between the drawn and the colored marks on the sheet. Drawing remains the grounding element, providing an initial sense of structure and detail. Certain patterns, however, like the tile roof of the garden wall and the trellis, have been indicated only lightly. The watercolor pigment follows these drawn patterns, in some cases

repeating the drawn lines, as in the hatching of the trellis and the curlicues that denote branches and foliage in the trees. In other places, it fills in forms or shapes that have been outlined with pencil, such as the yellow window on the house and the red roof on the shed-like structure.

In these three studies, as in the canvas of *The House of Père Lacroix, Auvers-sur-Oise*, architecture provides a sharp sense of formal structure as a ground for the accumulation of color sensations. The choice of such motifs suggests on Cézanne's part a taste for compositional and perceptual order. They allowed his eyes to pause, to grasp things with the satisfaction of a hand locked firmly on an object, and to appropriate them as confidently known. If his Impressionist watercolors reveal a new focus on sensations of transparency and light, they also make room for an equal enthusiasm for the opposite sensations of firm, sharply delineated form. The pencil captures aspects of the motif that lie beyond the scope of color, such as sharp lines and details; the paintbrush, likewise, accounts for things that stand out of the reach of drawing, such as the range of local color and effects of transparency. As he turned toward Impressionist concerns, therefore, the counterpoint between pencil and paintbrush was not lost in Cézanne's watercolor technique but rather was redeployed as a resource for the shorthand rendering of sensations of form and color.

Watercolor and Impressionism

In a letter to Pissarro, dated June 24, 1874, posted from Aix, Cézanne apologized for leaving Auvers without saying goodbye. "Thank you," he wrote, "for not holding against me my breaking my promise to come to see you in Pontoise before I left."[42] This marked the end of the first and most consequential phase of their dialogue, which would be taken up again only in shorter visits over the next seven or eight years. Before departing for the south, Cézanne had taken part in the first Impressionist exhibition in spring 1874. He decided to show only three oil paintings, which were listed in the catalogue as *Study: View of Auvers* (this was most likely *The House of Père Lacroix, Auvers-sur-Oise*), *House of the Hanged Man, Auvers-sur-Oise*, and *A Modern Olympia*, an adaptation of the subject matter of Manet's painting *Olympia*. That he had come fully into the camp of the Impressionists is evident in the responses to his work in the exhibition. Critics described his paintings as some of the most extreme examples of the group. Only *A Modern Olympia* suggested a continuation of the imaginary themes from his youth.

Cézanne did not participate in the second Impressionist exhibition in 1876. He was kept informed of the show, however, through his friend and admirer Victor Chocquet, who sent him clippings of the published reviews. Cézanne was again in the north in 1877 and exhibited in the third Impressionist exhibition. Moreover, in 1877 he expanded his number of submissions to sixteen, including at least one oil painting, *Corner of the Woods*, which was executed in Pontoise in Pissarro's company.[43] Most important for this discussion, however, is the fact that three of the works that Cézanne exhibited in 1877 were watercolors. Curiously, however, they were not recent works. In the catalogue, the first watercolor was listed as *Bouquet of Flowers*, and the second and third simply as *Impression after Nature* (*Impression d'après nature*). These are generally thought to be *Still Life: Flowers and Fruit*, *The Climbing Road*, and *Landscape with Rocks*, all of which I discussed in

47 Zacharie Astruc, *The Chinese Gifts*, circa 1873, water-color on paper, 38 × 55 cm (14¹⁵⁄₁₆ × 21⅝ in.). Private collection

Chapter One. It is difficult to fathom why Cézanne would have chosen to exhibit early rather than recent watercolors in 1877. The best explanation that has been offered is that it was Chocquet who prevailed upon Cézanne to include the works.[44] In fact, Chocquet was the owner of all the works by Cézanne submitted in 1877 and Cézanne may simply have asked the collector to send to the exhibition all of the works by him that he owned. Not only were they some of his strongest recent works, but they were also all conveniently framed and ready for hanging.

Cézanne was not the first to show watercolors in the Impressionist exhibitions – watercolors made up an integral part of each of the eight shows.[45] Watercolor was especially prevalent among the works hung in the first exhibition in 1874. Zacharie Astruc, a friend of Edgar Degas and Manet, exhibited no fewer than eight water-colors, six of which were hung together in a single frame. They mainly depicted highly detailed genre scenes, the best known of which is *The Chinese Gifts* (pl. 47). The critic Léon de Lora wrote of Astruc's watercolors: "M. Zacharie Astruc has a whole collection of brilliant watercolors – lively, bursting with color and light, they fix the attention of the visitors."[46] E. Drumont also referred to the "magnificent watercolors of Zacharie Astruc, the Old Bullfighter, a veritable painting, the Japanese interior, and the white dolls . . ."[47] Philippe Burty also singled out Astruc's water-colors: "M. Z. Astruc paints brilliant and amusing watercolors. His Japanese dolls [*sic*] has the same living immobility of the originals and his landscapes are full of flavor."[48] The critic Carjat noted with pleasure that he "stopped for a long time in front of the brilliant watercolors of M. Astruc."[49] In addition to Astruc, lesser-known artists also exhibited watercolors in 1874, including Antoine-Ferdinand Attendu, who showed three still-life watercolors; Edouard Brandon, who exhibited watercolors that were listed under entry number 31 simply as *aquarelles*; Leopold Robert, who had an undisclosed number of watercolors listed under number 160 in the catalogue as "Cadre: aquarelles"; Ludovic-Napoléon Lepic, who exhibited four watercolors, including a view of the Gulf of Naples; and Degas' friend, the industrialist and amateur painter Stanislas-Henri Rouart, who exhibited three watercolors of village scenes in Brittany and the Béarnais. Tellingly, Boudin was also invited to exhibit with the Impressionists in 1874, including, along with canvases and pastels, a group of four watercolor views of the beach at Trouville, hung together in a single frame.

48 Berthe Morisot, *On the Cliff*, 1871, graphite and watercolor on paper. Musée du Louvre, Paris. Photo © Réunion des Musées Nationaux / Art Resource, NY

Among the core group of Impressionists, it was only Berthe Morisot who exhibited watercolors in 1874, listed in the catalogue as "On a beach cliff," "In the woods," and one without a name indicated only by a series of dots (pl. 48). Each watercolor depicted Morisot's sister, Edmé, and her daughter in outdoor settings. "Berthe Morisot," wrote the critic Jean Prouvaire, "takes us into fields that are damp with the spray of the ocean. In her watercolors, as in her oil paintings, she likes the tall grass where, a book in her hand, a woman sits next to a child. She brings the artifice of the *parisienne* into confrontation with the charm of nature." "Mlle Berthe Morisot," he continued, "is certainly not a perfect artist. But what a sense of rightness in the way that muslin scarf brings its pink border up against a blue or green umbrella, and what charming vagueness in the distant ocean, where one sees the lean of little ship masts."[50] In his review of the exhibition written for the British public, Burty sought to convey the fugitive quality of Morisot's watercolors with an analogy that captures the general association of her watercolors with fleeting experience: "Mlle. Morizot [*sic*] . . . can give us an admirable sketch of a landscape with figures, as a young mother in a muslin dress playing with her daughter in a garden. This may be compared with the page of a novel read at haphazard in a review or on a railway journey. It is exquisite and unfinished."[51]

A distinction is registered in the responses to the watercolors shown in the first Impressionist exhibition, one that separates those who used the medium to make finished pictures – this was the aim of the majority of the artists, including, most importantly, Astruc – and those who used watercolors to make fleeting sketches and studies, like Boudin and Morisot. Astruc's watercolors were described as "brilliant," "real painting," and capable of "fixing the attention" of the viewer. Morisot's watercolors, conversely, were by no means "real painting," but contained some "rightness" and "charming vagueness." In contrast to the fixed attention encouraged by Astruc's detailed watercolors, Morisot's "unfinished" sketches, to use Burty's terms, offer something like the fleeting experience of fragmented, distracted reading. The opposition between tight and loose watercolors was reinforced in reviews of the next exhibition in 1876. This year, Lepic expanded the number of his watercolors

to sixteen, many of which continued in the vein of tourist views of famous places. He included more views of the Bay of Naples, five watercolors "d'après nature" of Pompeii, a view of the Cava fountain at Naples, and others, again stressing the association of watercolor with tourism and the sketching of picturesque sites (one critic called them "picturesque and emotive watercolors"[52]). At least one critic remarked on how out of place the work of Lepic was in the context of the *plein-air* Impressionists. His "series of pretty little pictures," explained the critic, "seem to be entirely taken aback at finding themselves here."[53] They were especially the five watercolors of rustic views exhibited by Jean-Baptiste Millet, the younger brother of the recently deceased Barbizon painter, that were held up as correctives to Impressionist looseness of handling. The critic Léon Mancino wrote of Millet: "The watercolors of Mr. J. B. Millet, the brother of the master whom the French school is mourning, make an impact with their tight handling, their so carefully developed and sincere sentiment, in the midst of this horrible debauchery of drawing and color."[54] The critic Arthur Baignières made a similar point in his review of the 1876 exhibition: "One must give special mention to M. Jean-Baptiste Millet, the son [*sic*] of the great painter who died two years ago. Why has he gotten mixed up with this group? His watercolors are highly developed and bear witness to real talent, and it is very possible that one day the son will be worthy of his father."[55]

The opposition between fleeting, evanescent watercolors – "exquisite and unfinished" – and watercolors with "tight handling," watercolors that are "highly developed," watercolors that "fix the attention of the visitors," recalls the opposition, discussed in Chapter One, between summary watercolor and watercolor that sought to achieve the finish and effects of oil painting. As I have suggested, watercolors that could rival oil painting were a development of British watercolor practice, which was generally criticized in France as leading to violations of medium specificity. This was made clear in the remarks of About, who, revealing his assumptions about the "feminine" essence of watercolor, criticized the painterly British watercolors as resembling young, pretty women dressed up as musketeers to escape their boarding schools. It was also made clear in Blanc's exclamation that the essence of the medium was its status as a form of "colored drawing." Such sentiments were voiced again by the critic Louis Gonse in the pages of the *Gazette des Beaux-Arts*, in reviews of the Salons of 1875, 1876, and 1877. In his review of the Salon of 1875, Gonse lamented the fact that, in his opinion, there were no great watercolorists in France. The best watercolors, he explained, came from the hands of oil painters who had paused to render fleeting ideas in this more suggestive medium: "We have had many painters, like Decamps, like Delacroix, like Regnault, who have made admirable watercolors; we have not had, however, except perhaps for Eugène Lami, watercolorists properly speaking."[56] In a review of the next year's Salon, Gonse again bemoaned the lack of a coherent school of French watercolor. And again, the best watercolor on display was that of an oil painter, Gustave Moreau. Like About and Blanc, Gonse identified watercolor's essence in the loose, spontaneous rendering it allows. "Watercolor," he explained, ". . . by its very nature, admits better than oil painting a certain overflowing of fantasy, a certain disorder of handling, a certain violence of ideas."[57] Moreover, he added, when such things appear in oil painting, they become suspect, whereas in watercolor they are perfectly at home. Referring to Moreau's watercolor sketch, entitled *The Apparition*, which depicts the theme of Salome confronting the severed head of John the Baptist, Gonse pointed out that

49 Gustave Moreau, *The Apparition*, 1874–76, water-color on paper, 4⅛ × 28⁵⁄₁₆ in. (10.6 × 72.2 cm). Musée du Louvre, Paris. Photo © Réunion des Musées Nationaux / Art Resource, NY

it was in this watercolor rather than in the finished, worked-up oil painting, shown in the same exhibition, depicting Salome dancing before Herod, that the theme appeared in its most acceptable form: "it is for this reason that *The Apparition* would thus give rise to fewer criticisms than the *Salomé* [pl. 49]."[58] In 1877 Gonse returned to the issue of medium specificity, complaining that, aside from the few adepts, most French watercolorists were unaware of what he termed "the essential conditions of this light and charming art."[59]

Although Gonse did not mention the Impressionist exhibition of 1877, it was here that he would have been able to find more readily watercolor in accordance with its "essential conditions." In 1877 only three artists exhibited watercolors, all of whom generally embraced the fleeting, evanescent use of the medium: Cézanne, to whom I will return, Ludovic Piette, a friend of both Pissarro and Cézanne, and, once again, Morisot. Piette exhibited, in addition to fourteen paintings, no fewer than seventeen watercolors of scenes around Montfoucault and Pontoise. The titles of the watercolors give a sense of their subject matter: "Prairie at Dusk," "Road at Lassy, Melting Snow," "Pork Market at Lassy," "Forest in Autumn," "Frost," etc. In a letter to Pissarro, Piette referred to himself as a specialist in "l'aquarelle en plein air."[60] He was, he explained, "a watercolorist, that is, a painter of the random, of the unexpected."[61] Despite these associations, the only critic to remark on Piette's watercolors saw in them a corrective to the summary work of the Impressionists: "There is air and also perspective in the *Markets* of M. Piette, who takes his revenge against intransigent Impressionism with his watercolors."[62]

The fleeting use of the medium was clearest in the work of Morisot, just as it had been in 1874 and, indeed, in 1876, when she also showed watercolors with the Impressionists. In the 1877 exhibition, Morisot included three watercolors, none of which carried a title in the catalogue. One critic, however, spoke of a "little portrait of a woman,"[63] a second referred to "a little portrait of a woman in a black dress,"[64] and a third to a "seascape" and "a portrait of a woman sitting on a couch."[65] Critical responses to Morisot's watercolors were generally positive and stressed the lightness and delicacy of her work. "Mlle Berthe Morisot," the critic Léon de Lora declared, "excels in watercolor."[66] For some, it was only natural that it should be a woman who made use of this medium, reflecting stereotypes about the essential femininity of the medium. One critic noted: "For several years now she has been showing us in detail her so charming and feminine talent; her watercolors, her pastels, her oil paintings, have all those spontaneous qualities, that soft allure without pretensions, that makes us admire her."[67] It was "especially in the pastels and watercolors," he added, "that the sensibility of the eye of Madame Morisot" was felt.[68] He continued, giving the subjects of two of the watercolors:

> It is in her seascape, with the large blue boat, in the portrait of a woman sitting on a couch, in these little watercolors where a few notes tossed with wit give to things a particular charm. Unfortunately, this art that is so charming is limited to these fugitive notes, it stops with the brio of touch, with the summary nature of the colors, and as a result it is only acceptable when it is an amusing witticism.[69]

This association of Morisot's art with sophisticated wit was repeated in remarks by the critic Jacques, who suggested that it was a specifically feminine sophistication that was captured in Morisot's handling. Morisot, he noted, is "a *mondaine*," she is

"very young and charming, or so I have been told,"[70] and in her art she "celebrates the coquettishness of her sex."[71] The critic Bigot made a similar point, noting of Morisot: "There is in her brush an incontestable charm, grace and elegance," adding of her watercolors that "she seems particularly well suited to succeed in this medium."[72]

Critics were generally less sympathetic when it came to Cézanne's three watercolors in the 1877 exhibition. Jacques, who had praised Morisot's feminine watercolors, declared of Cézanne's watercolors that they resembled "rotten cheese."[73] Bigot, who also praised Morisot, exclaimed of Cézanne's watercolors: "One must also look at two watercolors (numbers 30 and 31) entitled *Impressions from nature* in order to understand up to what point artistic dementia can go. Sign painting has now been outdone."[74] Léon de Lora was equally critical: "Cézanne's Impressions from nature are not pleasing to look at; to me they resemble unscraped palettes."[75] The most vehement account of Cézanne's watercolors was penned by the critic Ernest Fillonneau. With tongue firmly planted in cheek, he wrote:

> We recommend to our readers above all two watercolors, which are certainly the most outrageous attack that has ever been brought against art in general and the impression in particular. If this is the aim of painting, it is not only useless, but dangerous as well, to know how to draw and paint. And if the Louvre of the future should have to show such things to future generations, the French language will need to resign itself to changing the name of fine arts (*beaux arts*) that it has had the weakness to conserve until now.[76]

Finally, the critic Louis Leroy captured the general consensus of critics when he spoke of Cézanne's "bleeding" watercolors that were "no more than fleeting flickers (*ne sont que papillotages oiseux*)."[77]

The implicit opposition that emerged in reviews of the first two Impressionist exhibitions between the finished and detailed work of conservative watercolorists, on the one hand, and Morisot's fleeting watercolors, on the other, was generally replaced by the third Impressionist exhibition by another implicit opposition, this time between the feminine and charming watercolors of Morisot and the "rotten," "bleeding," and "not pleasing to look at" watercolors of Cézanne – "the most outrageous attack that one has ever brought against art in general and the impression in particular." This last point is worth emphasizing, because it suggests that Cézanne's *couillard* watercolors, although entitled "impressions," were seen by some to do violence to the delicacy of the impression that was better rendered in the watercolors of Morisot. Cézanne's watercolors, in other words, could not be categorized with the highly developed and detailed work of Astruc or Millet, on the one hand, nor could they be aligned with the "delightful" and "exquisite" work of Morisot, on the other. They were a third kind of watercolor that came closest to the effects Gonse associated with the medium: "a certain overflowing of fantasy, a certain disorder of handling, a certain violence of ideas." By the time that Cézanne's *couillard* watercolors were hung in the 1877 Impressionist exhibition, however, they were no longer an accurate measure of his current work in the medium. As I have indicated, through exposure to Pissarro's transparent use of the medium, Cézanne had recalibrated his use of watercolor to reflect his shift toward Impressionism. The watercolors he was making in the 1870s were, in fact, much closer to Morisot's fleeting work than the work in the 1877 exhibition suggested.

Watercolor and Oil Painting

50 *The Château of Médan*, 1880, oil on canvas, 23¼ ×
28½ in. (59 × 72 cm). The Burrell Collection, Glasgow.
Photo © Glasgow City Council (Museums)

In the late 1870s and early 1880s Cézanne developed a new manner of oil painting
that was meant to adapt the dematerializing facture of Impressionism to a devel-
oping set of personal priorities. Although already in evidence starting as early as
1876, it came to fruition in *The Château of Médan*, painted in August 1880 (pl. 50).
Cézanne made the painting while staying with Emile Zola at his newly acquired
summer home in Médan. The date of the canvas is secured by the correspondence
between the two men. In a letter dated June 19, 1880, in response to an invitation
to visit, Cézanne replied to Zola: "I'm not sure if it is going to get really hot, but
whenever I won't be a bother, write to me to tell me and I'll come to Médan with

pleasure." "And if you think you can put up with the amount of time I'm likely to take," added Cézanne cautiously, "I shall presume to bring a small canvas with me and paint something, all this of course only if it's convenient to you."[78] In a letter dated August 22, sent from Zola to Antoine Guillemet, we read that Cézanne is finally in Médan, "working hard."[79]

The Château of Médan shows a prospect looking from an island in the Seine toward a cluster of buildings near Zola's residence, which itself falls just outside the right edge of the horizontal view offered by the painting. Cézanne concentrates his attention on the lateral spread of the motif as it unfolds in an alternating pattern of trees and architecture. Several open windows, rendered as black rectangles, suggest the invisible, unilluminated interior space of the rooms into which they open. Outside, the landscape is bathed in brilliant midday sunlight. A few billowy clouds sink silently behind the poplars as Cézanne, ensconced on his side of the river, mixes his paints and applies them to the canvas, stroke by rectangular stroke. Pavel Machotka has recently listed the criteria that Cézanne seems to have brought to bear on his selection of landscape motifs, including a slowing of perspectival recession, an assimilation of illusionistic depth to surface, and a preference for "integrated" motifs.[80] Machotka rightfully objects to the notion, made popular in early twentieth-century Formalism, according to which Cézanne's aim in his landscapes was to reduce his motifs to elemental geometry. To the contrary, Machotka insists, Cézanne hews closely to the actual appearance of his motifs. What is clear, then, is that far from seeking to reduce his landscape motifs to elementary geometry, Cézanne sought out within the natural and man-made landscape motifs that were, as Machotka puts it, "integrated," meaning internally structured according to vertical and horizontal axes, as well as offering a high degree of formal complexity. As I have suggested above, such concerns were already visible in his landscape views of the 1870s. Such structured compositions offered Cézanne the satisfaction of clear forms, regular patterns, and symmetries, as well as bright chromatic and luminous effects witnessed in the outdoors. These interests seem to culminate in *The Château of Médan*, in which crisp form and vibrant color are closely integrated with one another in the texture of the motif.

Just before coming to Médan, Cézanne and Zola had been in contact for a rather different reason. Knowing the close friendship between Cézanne and Zola, Auguste Renoir and Monet had approached him with a request for help in securing Zola's support for a petition to the arts administration demanding that their work be included in that year's Salon. Despite Zola's pessimistic response – "You know that their letter will have no effect"[81] – he agreed to the request: "If it's an article they want from me, tell them I'm doing a Salon for Russia, to appear in *Le Voltaire* next month. I will devote a whole chapter to Impressionism."[82] The resulting article, entitled "Naturalism at the Salon," appeared in installments throughout mid-June. On June 19 Cézanne wrote to thank Zola: "I thank you very much, I was able to find the issue dated the 19th. I will go by Le Voltaire to get hold of the issue for the 18th of the month."[83] In his discretion Cézanne does not mention that, in this article, Zola did not in fact defend the Impressionists but instead began the slow process of withdrawing his support from their cause. In the installment Cézanne already had in his possession, for instance, the critic can be found complaining that "[t]he most unfortunate thing [about the Impressionists] is that not one artist among this group has achieved a powerful and definitive realization

of the new formula they have all proclaimed and scattered throughout their works."[84] "They are all precursors," concluded Zola, "the man of genius has not yet been born."[85]

In addition to these remarks concerning the perceived failings of the Impressionists, Zola made a short, passing reference to Cézanne, whom he included in his general critique of the Impressionists. Perhaps wary of Cézanne's brittle emotions, however, he conceded that Cézanne had "the temperament of a great painter." For the time being, however, insisted Zola, he was "still struggling with experiments in technique."[86] It is noteworthy that these remarks appeared in print just two months before Cézanne's visit to Médan. In this sense, *The Château of Médan*, the only oil painting that Cézanne appears to have executed during this visit, seems to be something like a pictorial response to Zola's remarks. We might even say that the painting represents a kind of demonstration, carried out in Zola's presence, showing the degree to which what Zola described as Cézanne's struggles with technique had issued into a powerful solution.

As Richard Shiff has noted, Cézanne's new technique was a "technique of originality."[87] It was as much the result of Cézanne's search for a manner of painting that would be his own invention and, therefore, would signify originality, as it was the result of a desire to bring formal order to his paintings. Indeed, Cézanne was just as focused at this point in his career as at any earlier moment on infusing into his paintings a personal and original mode of seeing and feeling. In a letter to Pissarro, in which he consoled his friend about the negative press received by the Impressionist exhibitions, Cézanne pointed to one published review of the exhibition of 1876, written by the critic Emile Blémont, that in his estimation best captured Impressionism's thrust: "Blémont's article in *Le Rappel* seems to me to be much more clear-sighted (*bien mieux vu*), despite his too frequent moments of reticence and a long preamble in which he gets a bit lost."[88] Blémont's "more clear-sighted" description of the Impressionist enterprise reads as follows:

> What is an Impressionist artist? We have hardly heard a satisfactory definition; but it seems to us that the artists who unite or are united under this term pursue by different methods of execution an analogous goal: to render with absolute sincerity, without arrangement or attenuation, by means of a simple and broad technique, the impressions awakened in them by the aspects of reality.
>
> Art is not for them a minute and stippled imitation of that which we once called "the beauty of nature." They concern themselves neither with reproducing beings and objects in a more or less servile manner, nor with laboriously reconstructing, tiny detail by tiny detail, a view of a whole. They do not imitate at all, they translate, they interpret, they seek to capture the effect of the multiple colors and lines that, all at once, the eye perceives before an aspect [of reality].[89]

Because each person sees the world slightly differently, Blémont went on to state, "they see no reason to modify according to this and that convention their personal and direct sensation."[90] One of the "too frequent moments of reticence" that Cézanne complained about in Blémont's review follows directly upon these observations: "In principle, in theory, we therefore believe that we can fully approve of them. In practice, however, it is a different story." Like many of the other critics writing about the Impressionist exhibitions, Blémont criticized the Impressionists

for a lack of resolution and skill in the works on display. The fruits of their labors, he declared, are "still green and tart," but with experience, he added, "their work will become more and more satisfying, we are convinced of it."[91] Such moments of reticence notwithstanding, it is clear why the critic's description of the ambition of Impressionism as a rendering of personal sensations by means of a personal means of execution would ring true, would appear "clear-sighted," to Cézanne. These were, in fact, the same terms that Cézanne himself had used to describe his own efforts in art as early as the 1860s – strong sensations, personal temperament, and refusal of conventions. By the late 1870s his sense of his distinctive sensations had become more pronounced than ever, and it was largely as an attempt to signal the distinctive quality of his sensations and temperament that he developed the highly personalized facture visible in *The Château of Médan*.

Cézanne also made a watercolor of roughly the same motif shown in *The Château of Médan* (pl. 51). The wide, rectangular sheet looks from a vantage point somewhat to the right of that of the oil painting. The chateau, which appears in the oil painting on the right, is here shifted over to the left side of the page. The change in viewpoint allowed Cézanne to expand his field of vision sufficiently to the right

52 *A Turn in the Road at La Roche Guyon*, c. 1885, oil on canvas, 25¼ × 31½ in. (64.135 × 80.01 cm. Smith College Museum of Art, Northampton, Massachusetts. Purchased with the Tryon Fund

to include the red roof of Zola's house peeking over a high wall at the very edge of the sheet. The greatest differences between the oil and watercolor views are technical: the watercolor is a work on paper, in which the white paper surface plays an active role in the image, whereas the oil painting is covered entirely, or almost entirely, with pigment. The transparency of the watercolor pigments is also opposed in quality to the opacity of Cézanne's oil pigments. Finally, the visibility of drawing in the watercolor brings to the fore the process of Cézanne's watercolor technique, which, as we have seen, was divided between drawing and painting. His technique of oil painting during this period also usually included a first pencil lay-in, as can been seen in less-developed canvases such as *A Turn in the Road at La Roche Guyon* (pl. 52). Here Cézanne's technique is laid bare, showing how he first used a graphite pencil to establish the main lines of the subject before returning with paintbrushes.

As he built up the composition, he worked between brushes with long, supple bristles, in order to achieve clear contours, and flatter, blunt-nosed brushes for the application of the hatching strokes of color. We can assume that this same process was at the basis of Cézanne's technique in the oil painting of *The Château of Médan*, which was made just five years earlier. This canvas must also have been begun with a light pencil underdrawing. Moreover, the kind of drawing one sees beneath the oil paint in *A Turn in the Road at La Roche Guyon* and, therefore, the kind of drawing that we can assume subtends the oil painting in *The Château of Médan*, is very close in character to the kind of sinuous, stenographic penciling evident in Cézanne's watercolor view of Médan. This suggests a closer relationship between Cézanne's practice of oil painting and watercolor than is usually admitted. In both mediums, Cézanne first made use of a schematic drawing that set out the main lineaments and light/dark patterning of his motif before advancing to the application of color and contours with paintbrushes. In his oil paintings, the drawing was destined to disappear behind the opaque field of "constructive" brushstrokes; in his watercolors, conversely, drawing was destined from the outset to play a visible, complementary role to the touches and washes of color applied with the paintbrush. It is this crucial difference, and the dramatically different visual effects it gives rise to, that ultimately sets apart the oils and watercolors most decisively. Perhaps most importantly, Cézanne's watercolor does not present itself as a complete account of his sensations of the motif, but rather as a summary, shorthand record that leaves much to the imagination.

It is easy to imagine the range of gestures and bodily inclinations that the artist would have been engaged in as he worked on the sheet, his hand moving this way and that, sweeping downward or in staggered semi-circular movements, with the pencil; and in zigzag and dabbling, stipple-like movements with the brush. He likely bent close toward the page to set down his gentle and halting strokes of the pencil. Indeed, there is a kind of shyness in Cézanne's use of his pencil in this watercolor. The silvery graphite lines have been applied in a hesitant and noncommittal manner, generating repeated edges that do not insist on but merely suggest the location of objects in space. Then, with the paintbrush in hand, Cézanne would certainly have first leaned slightly backward to get a sense of the overall effect of the page before moving close in again to render local colors and effects of light. Cézanne was more assertive in this watercolor with his pigments than with his pencil, seeking to lend a more definitive presence to trees and architecture. The rich greens used to build up the foliage of the three trees in the left foreground, which descend in size like three siblings of decreasing ages, is remarkably consistent with the treatment of the same three trees in the canvas, except, of course, for the very different qualities of transparency and opacity of watercolor and oil pigments. The impulse in both works is clearly to capture a sense of the physical presence of the trees. Such moments as these, where watercolor and oil painting come close to one another in ambition, remind us that Cézanne's efforts in all mediums, no matter how distinct in physical makeup, belonged essentially to a singular artistic enterprise of rendering his personal sensations according to the dictates of his temperament. Nevertheless, if his oil painting was the result of a struggle with facture that was aimed at arriving at a complete and total accounting for the his sensations, Cézanne's watercolor, conversely, seems not to have been born of the same kinds of grappling and instead allowed for a summary, partial, and porous rendering of his sensations.

Watercolors of the South

53 *Rooftops of L'Estaque*, 1876–82, graphite, gouache, and watercolor on paper, 12½ × 18⅝ in. (30.6 × 47.2 cm). Museum Boymans-van-Beuningen, Rotterdam. Photo © Museum Boymans-van-Beuningen, Rotterdam

In a group of watercolors executed in the late 1870s and early 1880s, Cézanne sought to adapt his Impressionist watercolor technique, which he had developed in the northern climate of the Ile-de-France region, to the rather different and more intense light of his southern, home region, representing yet another way in which he sought to personalize Impressionism. Several of these watercolors were made in the vicinity of L'Estaque, a small town located south of Aix on the northern rim of the Bay of Marseilles. *Rooftops of L'Estaque*, generally thought to date from between 1878 and 1882, depicts a view over an array of imbricated rooftops to the Bay of Marseilles beyond (pl. 53). The soft, translucent touches of violet, crimson, orange, green and yellow, suggest attentiveness to the complexity of light and shadow. Shifts along the tonal scale are all rendered in terms of different chromatic hues. Drawing too can be discerned on the sheet, as it carries out the work of first determining the general outlines of the roofs over which Cézanne was looking. A hint of the mountain of Marseilleveyre can be seen at the very top edge of the sheet, delimiting the limit of the sweep of the bay. The brightness of the sheet already suggests the glaring sunlight of the Midi. But it is especially in the sharp figure–ground contrasts that the intensity of the light becomes evident.

Already in a letter to Pissarro in 1876, while Cézanne was working on oil paintings in L'Estaque, he expressed enthusiasm for the intensity of southern light and the sharp figure–ground effects it generated. The letter was apparently written in

response to a letter that Cézanne had received from Pissarro. Dated July 2, 1876, the letter reads:

My dear Pissarro,

I am forced to reply to the elegance of your magic pencil with an iron tip (that is, a metal pen). If I dared, I'd say that your letter is stamped with sadness. Pictorial affairs go badly, I'm afraid that your morale must be under a gray influence, but I'm convinced that it's only temporary.

I would like not to speak of impossible things, and yet I'm always engaged in the projects that are the most unlikely to be realized. I think that the landscape where I am now would suit you marvelously. There are some formidable drawbacks, but I believe they're purely accidental. This year, it's been raining two out of seven days every week. It's terrible in the Midi. No one has ever seen anything like it.

I must tell you that your letter caught up with me in L'Estaque, on the coast. I haven't been in Aix for a month now. I began two small motifs showing the sea for Monsieur Chocquet, who spoke to me about it. It's like a playing card. Red roofs against the blue sea. If the weather improves, I might be able to push them to completion. For the time being, I've done nothing yet. But there are motifs here that could require three or four months of work, since the vegetation does not change – the olive trees and pines always retain their leaves. The sun here is so vivid that it appears to me that objects become silhouettes, not only of white or black, but also of blue, red, brown, violet. I may be wrong, but it seems to me that it is the opposite of modeling. How happy our gentle landscape painters from Auvers would be here, and that great . . . (fill in the three letter word here) Guillement. As soon as I can, I am going to spend at least a month in this area, because it begs for paintings of at least two meters, like the one by you sold to Faure.[92]

The letter continues with reflections about the fate of the Impressionist group and their exhibitions, ending with sentiments of solidarity: "My dear friend, I shall conclude by saying like you that since there is a common tendency with a few of those among us, let's hope that necessity will force us to act together, and that interest and success will strengthen the bond that goodwill has often not been sufficient to consolidate."[92]

There is no evidence that Cézanne made any watercolors in the area around L'Estaque in 1876 (the motifs he mentions that he is working on for Chocquet are oil paintings). His comments, however, are revealing and give insight into the effects he felt were specific to the southern landscape, a landscape that he felt would be highly appropriate for an investigation by his Impressionist friends. The taste for static motifs is clearly relevant to the watercolor that I have been discussing here: *Rooftops of L'Estaque*. The watercolor, indeed, focuses on the permanent and unchanging aspects of the place more than any rapidly changing weather or light effects. So too does a second watercolor, *The Bay of L'Estaque*, dating from the same period, in which Cézanne reveals a broader expanse of the bay while offering a more developed articulation of the profiles of the town's red rooftops against the distant water (pl. 54). In each, the stability of the motif becomes the condition for a careful and unfolding study of sensations, one that allows for both a clear sense of form and

54 *The Bay of L'Estaque*, 1876–82, graphite, gouache, and watercolor on paper, 11½ × 17¹⁵⁄₁₆ in. (29.1 × 45.5 cm). Kunsthaus, Zürich. Photo © Erich Lessing / Art Resource, NY

a subtle perception of light effects. These light effects, however, are described by Cézanne not in terms of subtle and shifting atmospheric nuances but rather as dramatic, vivid effects of silhouetting: "The sun here is so vivid that it appears to me that objects become silhouettes, not only of white or black, but also of blue, red, brown, violet." We have already heard Cézanne articulate a preference for sharp figure-ground oppositions in his letter to Zola in 1866, cited above, in which he explained that the appeal of outdoor landscape for him lay in the "magnificent effects" of figure to ground opposition witnessed outdoors. In his remarks to Pissarro a decade later, the "magnificent" effects of the landscape were again associated with silhouetting. And it is precisely this kind of silhouetting that is rendered in these two watercolors, in which the gabled roofs and other architectural structures are made to stand out against the bright expanse of the distant bay. In each, Cézanne has sought to capture the chromatic subtleties that he notes in his letter, rendering the roofs not simply as dark or light forms, but as violet and reddish ones. Moreover, Cézanne has gone so far as to wash white gouache up around the chimneys and roofs as a means to intensify the silhouetting effect. A similar use of gouache can be seen in a contemporaneous watercolor, known as *Row of Houses*, perhaps executed in the town of L'Estaque itself, in which Cézanne's main concern was to render the stark shifts from illumination into shadow as architectural planes move into depth (pl. 55). On the walls of the closest house, Cézanne has washed white gouache up to the drawn edges of the darker forms, intensifying the effect of bright, outdoor light seen

against areas of shadow. The same has taken place in the rendering of the central house, where the shadows of the eaves fall jarringly against a brightly illuminated wall. When Cézanne returned to L'Estaque with his paintbrushes and canvases, he continued to privilege the sense of clear form and sharp figure-ground oppositions already captured in his watercolors, as can be seen, for instance, in a canvas of the motif depicted in *The Gulf of Marseilles Seen from L'Estaque* (pl. 56).

Cézanne was not alone in his sense of a difference between the light of the south and that of the north. This distinction was given its clearest articulation by the Positivist philosopher and historian Hippolyte Taine. In his lectures at the Ecole des Beaux-Arts, published subsequently as *Philosophie de l'art*, Taine noted that an artist was presented with very different spectacles in the north and the south:

> Note the difference in appearance of things depending on whether you are in a dry country, like Provence and the environs of Florence, or in a watery flatland, like the Netherlands. In dry country, line predominates and is the first to attract attention; mountains cut out against the sky their stepped architecture in a noble and grand style, and all objects stand out with sharp edges in the limpid air. Here [in the Netherlands], the flat horizon is without interest, and the contours of things are softened, gradated, blurred by the imperceptible vapor, which always fills the air.[94]

For the artist seeking to capture the sharp formal sensations of the south, he suggested, all that was needed was a drawing heightened with a few pale colors: "In truth, a town of the south of France, a landscape in Provence or Tuscany, is but a simple drawing; with a sheet of white paper, a pencil, and the basic hues of colored pencils, one can render it entirely."[95] In the south, he explained, "a color will remain stable: the unchanging light of the sky holds it in place for hours on end, and it was the same yesterday as it will be tomorrow. If you leave and come back, you will find it just as you rendered it a month ago."[96]

The clarity of light in Provence was also noted by other artists, including the landscape painter Paul Huet, who moved to the south of France in the early 1860s and was at first repelled by the intensity of light there.[97] During a visit to Antibes in 1868, the painter Ernest Meissonier was more positive: "I'm happy to bathe myself in this beautiful light of the Midi, instead of walking like a gnome in the fog." He added: "I am convinced that these views of Antibes resemble those of Greece . . . but they are so hard to render! It demands a vast science, because the atmosphere here is of such a limpidity that nothing escapes, everything is drawn with an extreme clarity."[98] In a study of an olive tree in Antibes, Meissonier sought to convey this sense of fresh and limpid atmosphere and the sharp, clean, and twisted forms of the branches and their shadows (pl. 57). A painter who made a career of presenting the Midi in this manner, Paul Guigou, also tried to capture the intense light of the south in a watercolour entitled *The Road in the Valley* (pl. 58). As the critic Théodore de Wyzewa declared later in the century, in the south of France, unlike in the north, "the contours of my thoughts are drawn with a singular clarity, as are the twisted forms of olive trees and the pink triangles of sailboats on the ocean on the horizon of my vision."[98] For de Wyzewa, southern light did more than just provide clear sensations, it also promoted intellectual clarity.

55 (facing page top) *Row of Houses*, 1876–82, graphite, gouache, and watercolor on paper, 12⅞ × 19¹¹⁄₁₆ in. (32.7 × 49.9 cm). Smith College Museum of Art, Northampton, MA. Bequest of Charles C. Cunningham in memory of Eleanor Lamont Cunningham, class of 1932, through the kindness of Priscilla Cunningham, class of 1958. Photo © Smith College Museum of Art, Northampton, MA

56 (facing page bottom) *The Gulf of Marseilles Seen from L'Estaque*, 1885, oil on canvas, 28¾ × 39½ in. (73 × 100.3 cm). The Metropolitan Museum of Art, H. O. Havemeyer Collection, Bequest of Mrs. H. O. Havemeyer, 1929, 29.100.67. Photo © The Metropolitan Museum of Art, New York

59 (above) *Allée of Chestnut Trees at the Jas de Bouffan*, 1878–80, graphite and watercolor on paper, 11¹³⁄₁₆ × 18½ in. (30 × 47 cm). Staedelsches Kunstinstitut, Frankfurt am Main. Photo © Ursula Edelmann

57 (facing page top) Ernest Meissonier, *Olive Tree, Antibes*, 1868, graphite, gouache, and watercolor on paper, 7⁹⁄₁₆ × 11 in. (19.4 × 29.1 cm). Musée du Louvre, Paris. Photo © Réunion des Musées Nationaux / Art Resource, NY

58 (facing page bottom) Paul Guigou, *The Road in the Valley*, 1862, graphite, gouache, and watercolor on paper, 11⅝ × 14¾ in. (29.6 × 37.5 cm). Musée du Louvre, Paris. Photo © Réunion des Musées Nationaux / Art Resource, NY

Taine's suggestion that things stay the same in the south recalls Cézanne's remarks to Pissarro, according to which large, time-consuming canvases could be executed in the Midi because the motifs never changed. So too do Meissonier's remarks about the "extreme clarity" of contours in the south recall Cézanne's remarks about silhouetting. Cézanne's concern, however, was specifically to adapt the technique of Impressionism to the context of the south of France. As John House has pointed out, Cézanne's remark that these effects seemed to him to amount to the opposite of the traditional method of modeling in light and dark was Cézanne's way of showing Pissarro that he had adapted his lesson, which Cézanne described in his letter to Pissarro from Aix in 1874 as "replacing modeling with the study of colors," to the distant landscape of the Midi.[100] For Cézanne, however, the turn to Impressionism, both in the north and the south, involved a celebration of clear perceptions of form as much as it did perceptions of shimmering light and color. In fact, as Cézanne noted in his letter, the perceptions of form are themselves chromatic in nature – "The sun here is so vivid that it appears to me that objects become

silhouettes, not only of white or black, but also of blue, red, brown, violet." Moreover, it was specifically in the south, Cézanne suggested, that these formal perceptions, based on clear silhouetting, were most impressive and intense. Such interests can be seen in a final example of a watercolor executed in the south during this period: *Allée of Chestnut Trees at the Jas de Bouffan* (pl. 59). In his study on Cézanne, Georges Rivière, who knew Cézanne in the 1870s, reported that he was particularly satisfied with this work:

> Among his watercolors of relatively large format, we can cite *Allée of Chestnut Trees at the Jas de Bouffan*. Cézanne, who was so severe toward his own work, liked this [watercolor]. . . . The majesty of these hundred-year-old chestnut trees, the noble lines of their trunks, the soft light that falls from their foliage canopy: everything of interest to the spectator has been noted by the painter with simultaneous intensity and discretion, to the extent that one wonders what sort of magic he has used to attain such a powerful impression of reality.[101]

The powerful impression of reality generated by this watercolor is largely based on its assertive drawing and sharp light and dark contrasts. There is a clear desire to evoke sensations of bright southern sunlight in the crisp edges of the basin, seen at left, and the sharp contrast between shaded areas, which themselves still retain a high degree of luminosity, and the bright, blank areas of the page, indicating sunlit areas, such as the patch of rectangular illumination in the distance. The drawing renders form in an assertive first lay-in, while the overlapping, translucent touches of blue-green and yellow-green pigment indicate the flickering effect of light filtering through a canopy of leaves. This watercolor represents something of a culmination in the shift in Cézanne's watercolor technique from his earlier, *couillard* concerns to his Impressionist ones. Cézanne's earlier views of the grounds of the Jas de Bouffan had focused on the moody and strange corners of the property, such as in the watercolor, discussed in Chapter One, that shows a corner of a large, rectangular stone basin to the side of the *allée* of chestnut trees (the corner of this same basin appears in the right foreground of *Basin at the Jas de Bouffan*). Rather than finding in the motif an invitation to Poe-like fantasies, Cézanne's view of the chestnut trees and basin now becomes subject to new concerns to render sensations of form and color.

In these watercolors of the south, just as in his Impressionist watercolors from the north, the viewer never loses sight of what sets Cézanne's work in this medium apart from his work in oil – namely, the position of watercolor between drawing and painting. "Cézanne's watercolors," explained Georges Rivière, "are composed of light and transparent colors, and they differ clearly, in their general appearance, from the usual look of his oil paintings."[102] If Cézanne's watercolors differ from his oil paintings, he added, they nevertheless come close to the effects of another art form – namely, stained glass:

> In their transparency, Cézanne's watercolors call to mind the sumptuous stained-glass windows that once decorated the aisles of dark cathedrals and gave so much richness to the naves they illuminated with a flamboyant glow. These watercolors give off light, it seems, as if the sun had penetrated them. It is not only in their color that some of his watercolors recall the stained-glass windows of the past, but also in their drawing, in the counterpoint of the composition.[103]

Through an analogy with the leaded network and the colorful panes of glass in stained-glass windows, Rivière drew attention in these remarks to the counterpoint of drawing and color in Cézanne's watercolors that I have been describing in this chapter. Implied in watercolor, therefore, is a sequential temporality. The watercolorist draws and paints his motif, a process that is punctuated by setting down one tool – the pencil – and taking up another – the paintbrush. In the next chapter, I will consider in more detail the sequential temporality of watercolor and the resource it offered Cézanne to decelerate his sensations and perceptions of nature.

Three

Layered Sensations:
Watercolor, Completeness, and Duration

Recalling the circumstances surrounding the first exhibition of Cézanne watercolors in the United States, held in 1911 at the 291 gallery in New York, Alfred Stieglitz explained that upon inspecting the works, which had just arrived from the Bernheim-Jeune gallery in Paris, he found them more realistic than he had remembered, whereas the "custom house man" was shocked by how little there was to see in these fragmentary works:

> The box of framed Cézannes was opened and lo and behold, I found the first one no more nor less realistic than a photograph. What had happened to me? The customs house man looked up; "My lord, Mr. Stieglitz," he said, "you're not going to show this, are you – just a piece of white paper, with a few blotches of color?" I pointed to the house, the rocks, trees and water. The appraiser asked, "Are you trying to hypnotize me into saying something is there that doesn't exist?"[1]

The exchange between the noted photographer and the anonymous customs agent raises the question of finish as it relates to Cézanne's watercolors. Stieglitz seems to have taken a certain pleasure in his ability to perceive something where the appraiser could not, suggesting an initiation into a modern form of seeing that was acquired rather than immediately available. Charges of a lack of conventional finish were leveled at Cézanne's oil paintings as early as 1866, when a member of the Salon jury declared that the *Portrait of Antony Valabrègue* was painted with a pistol. Moreover, critics attacked his paintings in the Impressionist exhibitions of 1874 and 1877 as crude and unfinished. Questions of finish and completeness were raised with increasing frequency with regard to Cézanne's art starting in the 1880s and culminated in 1895 in the remarks of critics reviewing his solo exhibition at Ambroise Vollard's art gallery in Paris. Cézanne's mature watercolors, dating from the mid-1880s to the early 1890s, also evince a range of degrees of development, some seeming to have been abandoned at early stages of execution while others are more

Facing page: detail of pl. 63

extensively worked on. While such effects can be seen already in his *couillard* and Impressionist watercolors, the sense of uneven states of development becomes a hallmark of his work in the medium only in his mature career. During this period, Cézanne came increasingly to treat the drawn and painted phases of his watercolors as parallel transcriptions of his sensations in different visual languages. This allowed him to underscore the recursive, repeated contact with the motif made possible by the medium. It also enabled him to foreground the shifting patterns of attention that characterized his experience of the motif in each successive phase of his execution.

In this chapter, I explore the significance of the uneven, partial rendering in Cézanne's watercolors. The customs agent referred to sheets of paper with "a few blotches of color." What I hope to have begun to show, however, is that it is the combination of both drawing and color that is the most consistent aspect of Cézanne's watercolors. Overlooking drawing in order to focus on color is to miss the important relationship between line and color, the pencil and the paintbrush, that stands at the heart of these works. The fragmentation of Cézanne's mature watercolors, consequently, must be understood to reside not simply in the spotty appearance of his "blotches of color," but also in the relationship of these scattered color spots to the equally discontinuous, subtending network of pencil lines. Cézanne's mature watercolors emphasize the duration and layering of watercolor as a process made up of multiple encounters with the motif in alternating tactile and optical modes.

Partial Accounts

Three Pears, dating from between 1888 and 1890, depicts a focused, close-up view of a trio of pears arranged on a slightly tilted white plate (pl. 60). The plate itself lies on a shelf or table that appears to be covered with a piece of drapery decorated with a floral pattern. Cézanne most likely executed *Three Pears* in his Paris studio on the rue du Val-de-Grace, which he rented from December 1888. During this period of his career, he continued to spend part of his time in Paris and the surrounding region and part of his time in Aix-en-Provence and its neighboring landscape. These moves, however, were made with less subterfuge than in the past, thanks to the fact that he was now married to Hortense and had recognized Paul *fils* as his legitimate son. Cézanne, who had hidden or at least sought to hide Hortense and his son from his parents throughout the 1870s and early 1880s, finally made his family known to his parents in 1886. This was probably because of the declining health of Cézanne's father. Wishing to normalize relations before his father's death, Cézanne formally introduced his mistress and son to his parents and was married in their presence at the Aix town hall on April 28.[2] The death of Cézanne's father later that same year brought Cézanne and his two sisters a sizeable inheritance. During his subsequent periods in Aix, he now stayed with his family at the Jas de Bouffan, something that would have been impossible in previous years. He also arranged a studio on the top floor, where he executed a range of paintings and watercolors.

That *Three Pears* was probably executed in Paris and not in the studio at the Jas de Bouffan is suggested by the fact that it was in Paris that Cézanne executed a

60 *Three Pears*, 1888–90, graphite, gouache, and water-color on paper, 8⅝ × 12¼ in. (22 × 31 cm). Princeton University Art Museum, Lent by the Henry and Rose Pearlman Foundation. Photo © Bruce M. White

range of contemporary oil paintings in which appears the same piece of decorative drapery, including the monumental costume piece, *Mardi Gras*.[3] In *Three Pears*, the fabric serves as a partially indicated backdrop of swirls and arabesques, a field of looping and serrated forms against which appears the immobile, stable forms of the pears. The centrifugal energy of the arcing patterns of black creates a powerful contrast with the centripetal huddle of pears they circumscribe and surround. The transparency of *Three Pears* allows the viewer to reconstruct imaginatively the process of its execution. Beginning with a rectangular sheet of laid paper, Cézanne first carefully sketched out the plate, the pattern of ridges in the texture of the paper creating perceptible breaks in the graphite line as the pencil was swept across the surface in repeated, sweeping strokes. Turning next to the paintbrush, he applied a range of greenish-yellow and reddish-orange touches to the pears, suggesting the local color of ripe fruit from the countryside. The white hue of the paper – here yellowed somewhat with age and exposure to light – has been used to signify areas of highlight where sunlight, perhaps streaming in through a window behind the artist, plays across the skin of the pears and washes out their local colors. As a result, the pears seem carved from ivory rather than having the texture of actual fruit. The paper surface has also been left exposed to signify the local hue of the plate, which picks up reflections of the greenish tints of the pears. The use of blank paper in this way was generally understood to be one of the essential procedures in the process of executing a watercolor (more on this in Chapter Four). In contrast to the exposed paper, the black pigment, which picks out the patterns of the drapery as well as serving to reinforce contours around the pears and the plate, totally obscures the white of the page. Cézanne added touches of opaque white, infused

with a hint of blue, as a means to recover a sense of luminosity in the midst of the dark arabesques in the fabric background.

The presence of black and white body color in the watercolor is worth emphasizing. Some watercolor boxes sold in France in the second half of the nineteenth century included as many as twenty pigments, including black and white. In Cassagne's manual, a *boîte à puce*, or *boîte palette* – a watercolor case with a thumbhole to facilitate use – was identified as containing the following wide range of hues (pl. 61):

Bruns
1. Noir d'ivoire
2. Sépia
3. Sienne brûlée
4. Brun de madder (garance foncé)
5. Brun rouge

Jaunes
6. Sienne naturelle
7. Jaune Indien
8. Ocre jaune
9. Gomme-gutte

Bleus
10. Cobalt
11. Outremer
12. Indigo

Verts
13. Emeraude
14. Véronèse

Couleurs supplémentaires
15. Garance rose
16. Cadmium
17. Vermillon de Chine
18. Blanc de Chine
19. Bleu de Prusse
20. Jaune brillant[4]

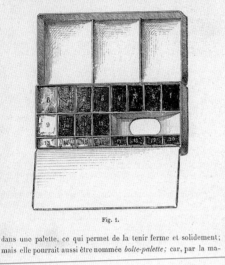

stances peuvent nécessiter un déplacement brusque : est-on dans un chemin, il faut quelquefois se retirer précipitamment pour éviter une voiture ou un cavalier; quelques gouttes d'eau commencent-elles à tomber, il faut vivement couvrir l'aquarelle, etc., etc.; dans tous ces cas de dérangement subit, la boîte, n'étant qu'en équilibre sur la main, se renverse neuf fois sur dix; donc elle est imparfaite.

LA BOITE A POUCE

La commodité de la *boîte à pouce* se devine au premier aspect. Nous l'appelons ainsi, parce que le pouce peut s'y introduire comme

Fig. 1.

dans une palette, ce qui permet de la tenir ferme et solidement; mais elle pourrait aussi être nommée *boîte-palette*; car, par la ma-

61 *Boîte à puce*, or *boîte palette*, illustration in Cassagne, *Traité d'aquarelle*. Deuxième edition, 1886 (1874). The Getty Research Institute. Photo © The Getty Research Institute

Cézanne acquired his pigments mainly from Père Tanguy's art materials shop on rue Clauzel in Paris and, during his early career, he even traded Tanguy works of art for supplies. Cézanne often jotted down in his sketchbooks the names of the pigments he needed to buy, some of which coincide with those listed in Cassagne's manual: *ocre jaune, blanc d'argent, brun rouge, laque fine, bleu cobalt, bleu outremer, sienne naturelle, terre verte, vert Véronèse, vermillion, noir péche, blue mineral, jaune brillant, emeraude,* and *laque garance foncé.*[5] It is not clear, however, if these names referred to oil or watercolor pigments, but the list suggests that Cézanne was familiar with and used a wide range of hues.[6] Although watercolors could be purchased in tubes, there is no evidence that Cézanne did so; he probably used dried watercolor cakes that required the addition of water to give them fluidity. Buying cakes of color – *couleurs en pastilles* – was less expensive than purchasing tubes one by one, but these cakes had the disadvantage of cracking as they dried and of collecting dust.[7]

62 *The Green Jug*, 1888–90, graphite and watercolor on paper, 8⅝ × 9¹¹⁄₁₆ in. (22 × 24.7 cm). Musée du Louvre, France. Photo © Réunion des Musées Nationaux / Art Resource, NY

A wide-ranging palette appears in a second still-life watercolor, *The Green Jug*, which is thought to date from roughly the same period as *Three Pears* (pl. 62). It shows a squat, green Provençal pitcher standing on the edge of a table. Because of the southerly associations of the vessel, it is generally assumed that this watercolor was executed in Aix. We are given a few hints of the context of the studio space in the form of the canvas shown leaning against the table and the reddish hue of the wall or floor in the distance. Cézanne used a softer pencil in this work than he did in *Three Pears*, which is evident in the way in which it has deposited a granular pattern of crumbling, velvety graphite on the paper. He seems even to have drawn

with the flat side of the graphite point of his pencil in order to achieve a sense of broad, flat patterning, such as in the deep, light-absorbing shadow that falls against the canvas. Touches of the paintbrush have returned to the areas of drawing and have differentiated the otherwise monochromatic information of the initial pencil sketch into areas of variously concentrated or diluted cobalt and ultramarine blue, emerald green, a tint of what may be yellow ochre or *gomme-gutte*, and what looks like a red brown or madder red. A highly diluted area of reddish-brown pigment, applied just below the jug to suggest the local color of the table, has run and pooled near the bottom edge of the page. The ridge of concentrated particles of pigment accumulated at the edge of the dried area of pigment attests to the pull of gravity and, consequently, to the inclination of the sheet as Cézanne worked on it. The areas of paper left blank on the surface of the pitcher suggest something of its glazed, reflective surface. Like the highlight on the fruit in *Three Pears*, this area of blank paper must be understood as a point of brightest light, which Cézanne has left to the paper surface itself to signify.[8]

These still-life watercolors recall Cézanne's concern to invoke sensations of both form and color in his Impressionist watercolors. Here too we see a counterpoint between the incisive, assertive work of the pencil, with its focus on rendering formal and spatial clues, on the one hand, and, on the other, the transparent touches of color that capture the very different range of effects of light and local color, rendered in delicate and soft hues. The hatching, sweeping strokes of the pencil contrast markedly with the caressing, blotting touches of the paintbrush. There is also a great deal of variation in these watercolors in the priorities of the artist from areas of careful, close focus to contrastingly empty or ignored areas. In *Three Pears*, for instance, Cézanne has focused his attention on the central group of ripe pears, but has allowed the image to peter out in the peripheral zones, where the decorative patterns around the plate fade into a void nimbus of non-semantic white paper. This variation in focus corresponds to a variation in the calibration of the work of the pencil and paintbrush to one another. Drawing and color are pulled tightly together in the central part of the composition, but toward the edges of the page the pencil lines and dark washes of black pigment line up only intermittently. The same is true in *The Green Jug*, where the form of the jug itself is carefully indicated in pencil and color, but where other areas, such as the local color of the table top and the shadows on the canvas behind the jug, are rendered only with casual blotches of color and no drawing whatsoever.

The variations that I am pointing to here are perhaps more clearly seen in a contemporary still-life watercolor, *Ginger Pot with Fruit on a Table*, depicting a table loaded with a range of objects from the kitchen (pl. 63). The ginger pot, with its willow handles and mesh, is partially blocked from view by a rumpled tablecloth and two pears of different sizes. Other fruit appears spread about the table, including apples of various proportions and a gargantuan pear on the far right side of the table, which is at least twice the size of the larger of the other two pears. Behind the table can be seen a complex interplay of spatial planes: the back wall with wainscoting enters the space from the left and then jogs diagonally toward the viewer before returning on its lateral, rightward course. Just past the midpoint of the sheet, the wall disappears behind a painted screen that has been identified as a work of Cézanne's youth.[9] Cézanne appears to have spent much more time working up the drawn portion of the watercolor than he spent applying color, which has been

63 *Ginger Pot with Fruit on a Table*, 1888–90, graphite and watercolor on paper, 9½ × 14¼ in. (24 × 36 cm). Private collection. Photo © Lefevre Fine Art Ltd., London / The Bridgeman Art Library

restricted to a few touches of orange, red, and blue. Blue has been used to pick out shadows in the background, under plates and the drapery, and under the fruit. A clean brush has been used to add first orange and then red tints, which indicate the local colors of the fruit and table. But most of the page is uncolored. Some objects that have been drawn never received a local color. Likewise, some passages have been painted in color without any preliminary drawing.

These kinds of lyrical, fragmentary effects have long fascinated scholars of Cézanne's watercolors. In a discussion of *Ginger Pot with Fruit on a Table*, John Rewald also focused on the partial application of color. In this and related watercolors, he explained, Cézanne was engaged in a deliberate process of chromatic balancing: "That the resulting images are so complete is due to the fact that each tint is applied in total harmony with whatever has previously been put down, so that at every stage a perfect balance of all elements is achieved."[10] Rewald's comments seem at first to be supported by the fact that, at least in this watercolor, there is a sense of harmony in the relationships between the blues and yellows and reds, all of which are mediated by the empty spots of untouched, luminous paper. But Rewald's claim that Cézanne was concerned with the overall pictorial balance of his

watercolors reflects assumptions about Cézanne's art that derive more from early twentieth-century Formalism, according to which Cézanne was focused on pictorial structure first and foremost, than they do from Cézanne's own recorded views on his art. Indeed, this claim that Cézanne was first and foremost interested in the formal balance of his pictures ignores his stated representational priorities. As I have pointed out several times in this study, Cézanne was consistently focused in his art in all mediums on the rendering of his sensations according to his personal temperament. It was the rendering of these sensations, not the achievement of formal balance, that was Cézanne's top priority. And this is evident in his watercolors as well, in which the fragmentariness of their appearance is best understood when traced back to his personal sensations and temperament. In order to grasp the importance of the fragmentary and unfinished look of Cézanne's watercolors, and the intermittent relationship between drawing and color that this involves, his work in this medium first needs to be linked to his attitudes toward completeness and finish in his art in general.

Sincerity, Attention, and Completeness

In reviews of the Impressionist exhibitions, critics often objected to the work of the participants and, especially, the work of the *plein-air* landscapists as unfinished. In a review of the first exhibition in 1874, the critic Ernest Chesneau admired the "new perspectives" opened up by "a dozen or so" of the canvases on display, but he qualified his praise by noting that they were all only sketches: "Of course, this is not the last word in art, nor even the last word in this art. They'll need to transform their sketches into finished works."[11] Likewise, Philippe Burty referred in his review of the same show to works by Monet that betrayed "a lamentable want of finish."[12] In another review of the exhibition, the critic Castagnary pointed to the lack of conventional finish in the work of the Impressionists, but suggested that it was nothing new: "Following Courbet, Daubigny, and Corot, one cannot say that the Impressionists invented unfinish (*le non-fini*). They vaunt it, they exalt it, they set it up as a system, they make it the keystone of their art, they put it on a pedestal, they adore it; but that's all."[13] "The common attitude that links them as a group and makes up their collective force in the midst of this disconnected epoch," explained Castagnary, "is the commitment not to go after sharp focus but to go only for a general aspect. Once the impression has been grasped and fixed, they declare their job done."[14]

That "le non-fini" was not new with Impressionism is confirmed by Baudelaire's defense of Corot's paintings in his review of the Salon of 1845. Baudelaire insisted that those critics who contented themselves with dismissing Corot's paintings as insufficiently resolved had missed a crucial fact: "there is a great difference between a work that is complete (*complète*) and a work that is finished (*fait*)."[15] Moreover, he added, "in general what is complete is not finished, and a thing that is highly finished need not be complete at all."[16] For Baudelaire, the sketchy handling of Corot's paintings was not a lacking of some kind, but constituted instead a deliberate decision to invite poetic reverie. Sketchy rendering constituted an invitation to the imagination to expand freely into the poetic spaces hinted at by the canvases. Delacroix shared this conception of sketchy handling as a means to invite

the spectator to participate imaginatively in the work of art. Writing in his Journal on April 13, 1853, he remarked: "One always has to spoil a picture a little bit in order to finish it." "The last touches," he added, "which are given to bring about harmony of the parts, take away from their freshness." Returning to this insight a week later, he elaborated on this point with an analogy:

> The same is true of the ruin, which is the more striking because of the lost parts. Its details are defaced or mutilated, just as in the building that is going up one does not yet see more than the rudiments and the vague indications of moldings and the ornamented parts. The finished building encloses the imagination within a circle and forbids it to go beyond that. Perhaps the sketch of a work gives so much pleasure just because each one finishes it to his liking.[17]

Sketchy handling, therefore, was understood as an invitation to the imagination of the spectator to finish the work of art to his or her "liking."

In the context of Impressionism, however, sketchy handling was generally identified with a calibration of painting to the rendering of rapidly perceived effects in nature. In a recent study of Impressionism and the appearance of rapid painting, Richard Brettell has underscored the relationship between the rapidly shifting effects that became the subject matter of the *plein-air* Impressionists and the rapidly painted look of the paintings that sought to capture these effects, or, what Brettell refers to as "an aesthetic accord between represented time and time of representation – a symbiotic link between style and subject in which the rushed or rapid quality of the former reinforces the corresponding qualities of the latter."[18] This sketchy, rapid-looking handling appeals to the spectator to enter into the work of art in a manner analogous to Romantic sketchiness. It represents an invitation to the viewer to re-experience the perceptions of the painter and to enter into the process of seeing that is captured in the work of art.

Like the Impressionists, with whom he exhibited on two occasions, Cézanne was criticized for leaving his paintings in an unfinished state. He was, according to Castagnary, one of the most extreme in the group. Cézanne's canvases in the exhibition of 1874, for example, were, complained the critic, an example of "the impression taken to excess (*l'impression à outrance*)."[19] In a letter to his mother dated September 26, 1874, Cézanne defended himself against such attacks. He started by complaining about the weather and then thanked his mother for sending along supplies. Then he launched into a defense of his paintings from the attacks in the press of the 1874 exhibition, which his mother must have read with alarm. Cézanne's tone is almost overconfident as he seeks to convince his mother and, apparently, himself as well, of his abilities.

> My dear Mother,
>
> First, let me thank you for having thought of me. The weather has been awful for several days now and very cold. But it doesn't bother me and I'm keeping warm.
>
> I look forward with pleasure to receiving the promised trunk. You can send it to 120, rue de Vaugirard. I should be here until January.
>
> Pissarro has not been in Paris for about a month and a half; he's in Brittany, but I know he has a good opinion of me, given my own good opinion of myself. I'm beginning to feel stronger than all those around me, and you know that the good opinion I have of myself has only come through careful consideration. I

must keep working, but not in order to achieve finish (*non pas pour arriver au fini*), which gives rise to the admiration of idiots. This quality, which is so appreciated by the vulgar, is no more than mere craftsmanship that makes the resulting work artless and unoriginal. I must instead only seek completeness for the pleasure of working in a more truthful and sound manner (*Je ne dois chercher à compléter que pour le plaisir de fair plus vrai et plus savant*). And believe me, a time always comes when one is recognized and gains admirers who are much more fervent and convinced than those who are attracted only to a vain appearance.

The times are bad for sales, all the *bourgeois* are loath to relinquish a cent, but that will change.

My dear mother, say hello to my sisters. Greetings to Monsieur and Madame Girard, and my thanks.

Yours, your son,

Paul Cézanne[20]

One of the most important criticisms that Cézanne makes of finish in the above comments is the charge that it "makes the resulting work artless and unoriginal." As we have seen, Cézanne emphasized originality in his art through the focus on working in a manner attuned to his temperament. Manifesting his temperament and sensations was the driving force behind his art, not the adoption of conventions of academic rendering or polish. "In art," the painter and critic Emile Bernard noted of Cézanne, "he speaks only of painting nature according to one's personality, not according to art itself."[21] Likewise, when the artists R. P. Rivière and J. F. Schnerb asked Cézanne why he left distortions and unfinished areas in ostensibly complete paintings, Cézanne's answer turned on sincerity to his personal experience:

> Since Cézanne denied himself, for better or for worse, the slightest insincerity, even if he regretted the fact that his bottles were not perfectly upright, he refused to correct them. In the same way, if areas of his canvas were left unpainted in the course of his work, he left them that way rather than rubbing in some random color.[22]

What emerges in all of these comments is a dedication to sincerity and to the foregrounding of the artist's personal, temperamental priorities in the work of art. Consequently, if finish is a convention of academic practice, then completeness suggests the refusal of these conventions through the calibration of the work of art to the personal experience of the artist. As Cézanne told his mother, he was not after finish in the conventional manner, which he refers to as "mere craftsmanship," but completeness achieved through "working in a truthful and sound manner."

These references to completeness are all oriented toward oil painting. And, in fact, they help account for qualities of apparent abandonment en route in oil paintings from this period. *Madame Cézanne in the Conservatory* reveals Cézanne's manner of foregrounding his sensations in the process of representation. The picture has been left at an intermediate stage of development, in which large areas of blank canvas or barely sketched forms are visible. Cézanne has spent more time, for instance, working up the face and head of his sitter than rendering her hands, which have been left as barely indicated strokes of pencil and paint. The form of the tree

64 *Madame Cézanne in the Conservatory*, 1891–92, oil on canvas, 36³/₁₆ × 28¹¹/₁₆ in. (92 × 73 cm). The Metropolitan Museum of Art, Bequest of Stephen C. Clark, 1960 61.101.2. Photo © The Metropolitan Museum of Art, New York

behind his wife has also occupied the artist's attention, as have the flowers and leaves to her left (pl. 64). Because the painting was abandoned en route it reveals the way in which Cézanne focused first on certain details or patterns in the motif before moving on to others. Cézanne was mainly interested in the sitter's face, the form of the tree behind her, and the shapes of the flowers. It is not only in less-developed canvases that the patterns of the artist's preferences and interests can be seen; they are also readily evident in more developed canvases, such as *Boy with a Red Vest* (pl. 65). Although empty areas of canvas have here been reduced to just a few, the patterns of the artist's interest and attention can be read in the distortions of shape and size in the form of the youth's body. The overly long arm and the outsized ear both call to mind a remark Cézanne reportedly made in his late life: "I am a primitive, I have a lazy eye: I applied twice to the Ecole, but I cannot make an ensemble. If a head interests me, I make it too large."[23]

For Cézanne, therefore, completeness meant emphasizing not only the artist's sensations and impressions, but also the patterns of his interest and attention. Jonathan Crary has recently explored the wide-ranging discussions of the psychology of attention in nineteenth-century Europe and the relationship these discourses may have had to developments in modern painting. As he shows, attention was

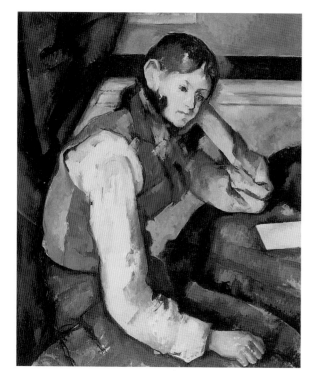

65 *Boy with a Red Vest*, 1888–90, oil on canvas, 31⅟₁₆ × 25⅝ in. (79.5 × 64 cm). E. G. Bührle Collection, Zürich, Switzerland. Photo © E. G. Bührle Collection, Zurich, Switzerland

66 (facing page) *Vase of Flowers*, 1885–88, graphite and watercolor on paper, 18⁵⁄₁₆ × 11¹³⁄₁₆ in. (46.6 × 30 cm). Fitzwilliam Museum, Cambridge University, UK

always tied dialectically to its opposite, distraction. "Attention and distraction," Crary explains, "were not two essentially different states, but existed on a single continuum, and thus attention was, as most increasingly agreed, a dynamic process, intensifying and diminishing, rising and falling, ebbing and flowing according to an indeterminate set of variables."[24] The radical suggestion here, Crary suggests, is that attention is not a normal state but an abnormal one, which seeks to hold together the sense of a stable world against the forces of mental relaxation: "Attention was described as that which prevents our perception from being an incoherent flood of sensations, yet research showed it to be an undependable defense against such disorder."[25] Cézanne is among the modern painters whose art Crary suggests engaged most directly with issues of attention and distraction. Cézanne, he argues, was not working with "a perceptual *tabula rasa* from which to build afresh the essential structure of the world; rather he has become open to engaging a discordant exterior which acts on him, jarring his hold on a recognizable world."[26] Cézanne, he continues, discovered that "attention was part of a dynamic continuum in which it was always of limited duration, inevitably decomposing into a distracted state or a state incapable of maintaining what had initially seemed like a grip on the object or constellation of objects."[27]

Although it is unlikely that Cézanne would have been aware of discussions of attention and distraction taking place in the quarters of European psychology and psychophysics, it is nevertheless clear that the psychological facts of attention and distraction are evident in his art. Moreover, Crary's suggestion that Cézanne's art records the dynamic continuum of attention and distraction accords well with the general emphasis on temperament and personal sensations in his art. This is, in fact, a good way to describe what can be seen in the oil paintings discussed above. Cézanne's attentiveness to certain aspects of his motifs, to the extent of exaggerating the size of ears and arms; or, conversely, his lack of concern for areas such as the hands in his wife's portrait, reflect the ebbing and flowing, to use Crary's terms, of Cézanne's own attentiveness. If such works are to be understood as complete, it is because they include a record of both the presence and absence of interest and attention, as determined by Cézanne's temperamental priorities and proclivities. "There are two things in the painter," Cézanne reportedly told Bernard, "the eye and the mind, which must support one another." "It is necessary to work at their mutual development," he added, "in the eye by looking at nature, in the mind by the logic of organized sensations, which provides the means of expression."[28] Cézanne's conception of completeness also takes account of the variations of attention, the succession of differing states of mind, and the breaks in the circuit between eye, hand, and mind.

As I have suggested above, Cézanne's watercolors also evince a sense of partial rendering. This was visible, as I have suggested, in *Three Pears, The Green Jug*, and *Ginger Pot with Fruit on a Table*. A fourth still-life watercolor, *Vase of Flowers*, a study of a bouquet of flowers in a transparent vase, reinforces Cézanne's desire to emphasize the patterns of his attention in this medium as well (pl. 66). Measuring approximately 18 by 12 inches (45.7 × 30.5 cm), the sheet, if placed vertically and either mounted on a board or held against a drawing portfolio, would have been large enough to fill Cézanne's lap. The sheet of paper presents a transcript of the process of slowly picking out the contours and hues of the motif. Cézanne seems to have focused on places where space is demarcated in terms of overlap or passage

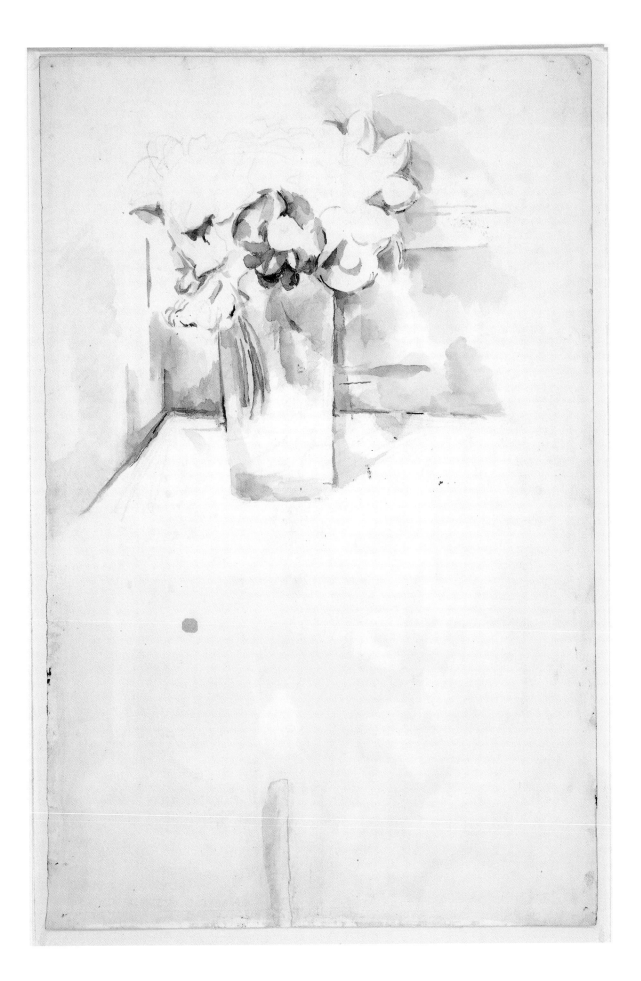

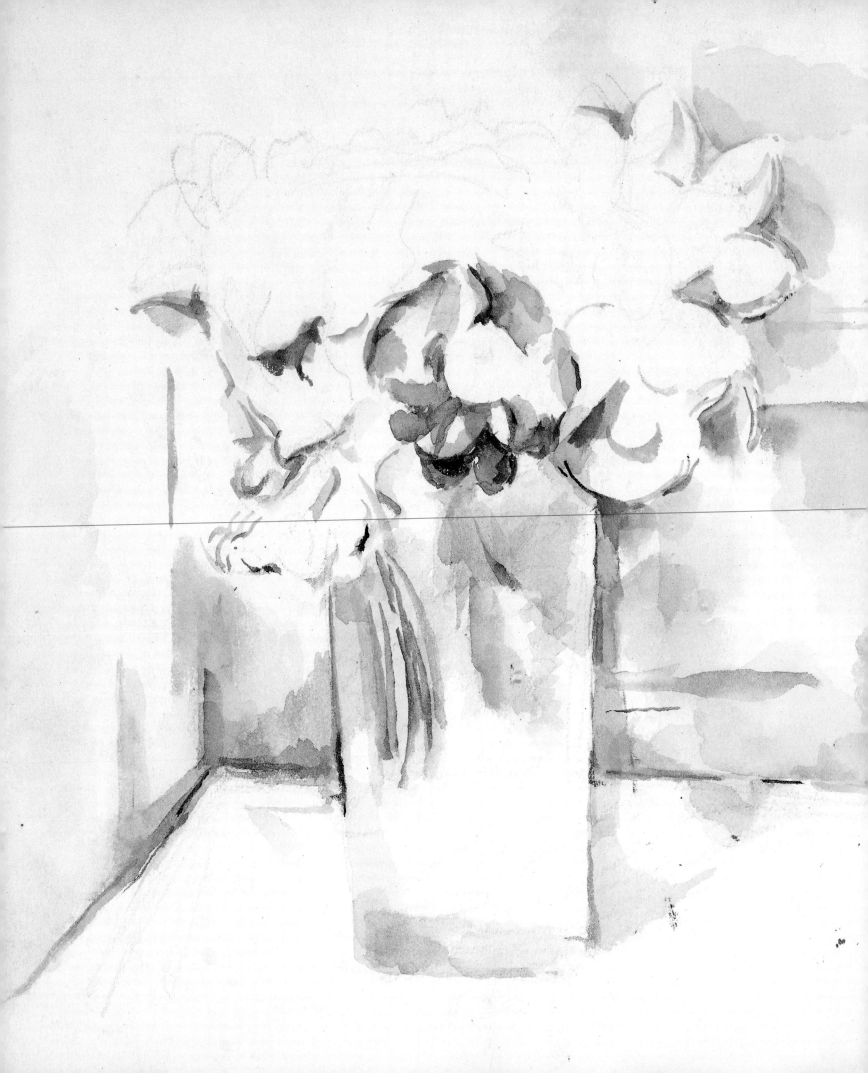

67 L. Eugène Lambert, *Kittens*, date unknown, gouache and watercolor on paper. Anthony Mitchell Paintings, Nottingham, UK. Photo © Fine Art Photographic Library, London / Art Resource, NY

between spatial planes – the edge of the glass vase as it overlaps with the corner of the table on which it stands, for example, or the profile of the flowers against the wall behind. He may have started on the right, moving leftward along the limit of the table until he reached the glass, where he would have moved up its contour to the flowers above. From here, his hand could have gone upward in an arc to the right, tracing the shapes of the flowers negatively by picking out the wall behind them; or, it could have continued on its leftward course, pausing to render the radial pattern of petals on the central, red flower, before heading down the left edge of the glass back to the meeting point with the plane of the table. Cézanne has also vaguely rendered the shapes of the flower stems as they float suspended in the water, an effect that is especially well suited to the diluted pigments of watercolor. As in the watercolor still lifes discussed above, here too the white of the page plays an important, active role. In the foreground, the unmarked page signifies as the continuation of the table surface into the viewer's physical space. In the upper reaches of the sheet, conversely, white paper emerges more erratically and designates areas that were never reached by the artist, such as in the drawn but unpainted shapes of flowers on the top edge of the bouquet. If the white paper in the foreground invites the viewer to read it as part of the picture, the blank spots of white paper in the bouquet, conversely, record the breaks and limits of the artist's interest and attention in the process of making the watercolor.

It should be recalled, of course, that watercolor, like drawing, was generally praised for effects of sketchy or fragmentary finish. This was one of the things that were understood to distinguish it from oil painting. This remained a crucial association of the medium well into the 1880s and 1890s. Such associations were repeated, for example, in response to the annual exhibitions of the Société des aquarellistes français, founded in 1878. These exhibitions were dominated by professional watercolorists, who made detailed and polished works that had much in common with miniature painting (pl. 67). In his review of the society's first annual exhibition in 1879, the critic Arthur Baignières divided the exhibiters into two groups:

On the one hand, there are the simple watercolorists, who treat watercolor as a means of direct expression, the advantage and pitfall of which is capturing the

Facing page: detail of pl. 66

L'EXPOSITION DES AQUARELLISTES A LA NOUVELLE SALLE DE LA RUE DE SEZE

impression of nature at a stroke by means of the application of a definitive tone. On the other hand, there are the virtuosos, who, proud of their skill and adroit at manipulating the paintbrush, render the caprices of light, the glow of flesh, the texture of fabric through recourse to thick pigment, scrapers, and gouache.[29]

The virtuosos were generally those who sought to make their work resemble oil paintings and who worked them up over a long period of time with "scrapers" and "thick pigment." Techniques such as stippling and scratching out were standard with these artists. Baignières betrayed a clear preference for worked-up watercolors, as did a handful of other critics, including Henri de Chennevières, who applauded the more detailed and painterly work by the members of the Société. The association of watercolor with "colored drawing" bothered Chennevières, who wrote: "In the history of the old French school, watercolor had a modest role. It was referred to as "colored drawing" (*le dessin coloré*). . . . Like red chalk, ink, and bistre, it made preparations for the works of masters, and animated their initial ideas (*leurs première pensées*)."[30] Against this use of the medium, he praised the efforts of the Société to make watercolors that were themselves great works of art. Speaking of Louis Leloir, one of the founders of the school, he noted: "he is not afraid to spoil the charm of his first impression and, by developing it, to compose genuine pictures (*des vrais tableaux*)."[31] By "genuine pictures," of course, the critic meant works on a par with finished oil paintings. An engraving of the society's show in 1882, held at Georges Petit's gallery on the rue de Sèze, illustrates the way in which these finished watercolors were framed and hung to suggest this sense of "real pictures" (pl. 68).

Most critics, however, raised familiar objections to the finished work, arguing that it lost contact with the specificity of the medium. Recalling the remarks of About and Blanc, discussed in Chapter One, the critic Henry Houssaye, in a review of the watercolor exhibition of 1882, asked: "Why try to do with watercolor what one can do more effectively with oil paints?"[32] In a review of the group's exhibition of 1891, the critic Jules Antoine complained:

Among the thirty or so artists who are participating in this exhibition, very few make real watercolors. This very delicate medium has limited resources, and the

majority of those who use it eliminate its very special flavor by trying to make it achieve effects that are above all the domain of oil painting. Watercolor demands a swiftness of execution that is very appropriate for sketches or improvisations, and the impossibility of achieving modeling or density requires a frankness of handling which conserves a freshness in the colors that oil painting cannot give. This is all one can expect of watercolor, and to want to make with it overly detailed works of large dimension is an absolute error.[33]

Perhaps the most adamant comments came from the pen of the Symbolist critic G.-Albert Aurier, who reviewed the watercolor society's exhibition of 1890 in the pages of *La Revue independante*. The works on display, he stated bluntly, were not real watercolors. "Watercolor," he exclaimed, "was not invented to do battle with oil painting . . . What we ask of [watercolor] is the subtlety and instantaneity of the impression, less thought than verve . . . less style than the extremely delicate notation of the most imperceptible undulations and the most ungraspable nuances."[34]

It is worth noting that similar remarks were made in response to the contemporaneous exhibitions of the Belgium watercolor society. Commenting on the work of the members of this society, the critic Octave Maus wrote in *L'Art moderne*: "We are well aware that recently this medium has fallen away from its original purpose, which consisted, for the painter, to fix by means of a rapid and uncomplicated procedure his inspirations or his documents." He continued:

> This attractive aspect of the sketch, these large strokes of the brush spontaneously set down, these hues with uncertain edges, all these qualities that belong to watercolor, are more seductive than any others; but when we see it, conversely, degenerate little by little into a pastiche of oil painting but necessarily without solidity, one feels something like the impression that would be made by a tenor singing the part of a baritone. One doesn't dare, indeed, cannot say that it is bad, but one knows that it is wrong. One grasps the talent and patience it takes to bring so close to a painting a medium that is proximate only to drawing. The enormous tension necessary to produce this phenomenon causes the satisfaction of a surprise. But this is not the kind of sensation that one asks of art and in the end one leaves disappointed and unhappy.[35]

Consequently, because watercolor was at its best, at least according to most of these critics, when calibrated to the shifting and fragmentary experience of the artist, catching sensations on the fly, it was expected to exhibit qualities of fragmentariness. Where effects of *non-fini* were generally shocking in oil paintings, they were broadly celebrated in watercolor and drawing. As one critic put it: "It is more or less understood that watercolor presents a lightness of appearance and casualness refused to oil painting; it is like the younger sister of oil painting, of whom one forgives all sorts of impishness thanks to her grace and freshness."[36]

Returning to Cézanne and recalling Aurier's terms, if they were indeed "imperceptible undulations" and "ungraspable nuances" that Cézanne was after in his mature watercolors, these were the delicate and shifting patterns of his attention – his "logic of organized sensations" – as his eye and mind intermittently linked up in the process of representation. Unlike the work shown at the exhibitions of the Société des aquarellistes français, Cézanne's watercolors emphasize their status as partial and fragmentary accounts of his sensations. But there is more at stake here

than just the "attractive aspect of the sketch, these large strokes of the brush spontaneously set down, these hues with uncertain edges," that Maus celebrated in watercolor; more, that is, than the "swiftness of execution that is very appropriate for sketches or improvisations," praised by Antoine. These positive appreciations of the fragmentariness of watercolor all identify its charm and appeal in its rapidity. Watercolor, they suggest, is an affair of the paintbrush wielded with speed. In his poem "Watercolor in Five Minutes," published in 1886, the poet and critic Jules Laforgue captured the general association of watercolor with rapidly shifting effects. His poem renders the visual impression of a downpour in the city seen from a window. Focusing on the distance, the poet describes the opening of the clouds, then notes the appearance of umbrellas on the street, and finally focuses close up on the fuchsia outside his window, which "feels revived" from the rain.[37]

Cézanne's watercolors, however fragmentary and intermittent, cannot be aligned with this general enthusiasm with speed of perception and execution. This does not mean, however, that they can therefore be aligned with the slower, more worked-up watercolors exhibited by the Société des aquarellistes français. Although corresponding fully with the claims of the above-cited critics that watercolor is best when trained on subtle and momentary sensations, Cézanne's execution itself was anything but fast and spontaneous. This is already partially evident in his subject matter in his watercolor still lifes, in which his subjects were static objects, not flickering effects of light and weather. What watercolor allowed Cézanne to accomplish was not a single, rapid rendition of fleeting sensations but a slower, intermittent accounting for the ebb and flow of his sensations. In contrast to the usual associations of watercolor with rapidity, Cézanne slows down his watercolors and, instead of capturing quick impressions, exploits the medium's division into moments of drawing and painting as a means to prolong his interface with his motif through repeated contact.

Itineraries of Drawing and Color

Vase of Flowers is one of the many watercolor sheets that Cézanne used more than once.[38] A watercolor landscape on the verso of the page, probably dating from about the same time as the still life on the recto, depicts a view looking from the base of a group of young pine trees toward a distant clearing (pl. 69). The watercolor sheet suggests that the limit between the studio and the landscape was porous for Cézanne. Indeed, during his mature career, he frequently explored the landscape around Aix and rendered its various aspects in works of art, such as this landscape watercolor. Cézanne's registration of the intermittence of his "logic of organized sensations" is as clear in landscape watercolors as it is in his watercolor views of still-life motifs. One of the places that Cézanne frequented in his mature career was the Bellevue heights west of the Jas de Bouffan, where his sister and her husband had bought a farm with the inheritance received after Cézanne's father's death in 1886. The views from Bellevue had already provided him with a wide range of motifs in the early 1880s, including views over the Arc valley toward the majestic form of Montagne Sainte-Victoire in the distance.

Some of these watercolors relate closely to oil paintings. A large watercolor of a view from the Bellevue heights out over the Arc valley toward Montagne Sainte-

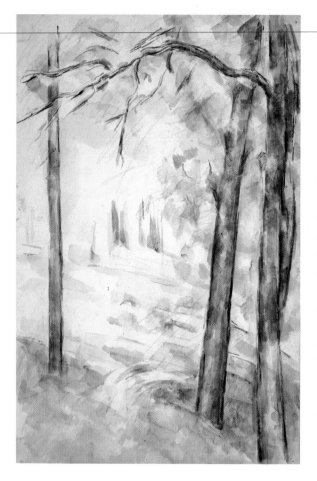

69 *The Woods, Aix-en-Provence*, 1890, graphite and watercolor on paper, 18⅜ × 11¹³⁄₁₆ in. (46.6 × 30 cm). Fitzwilliam Museum, Cambridge University, UK. Photo © Fitzwilliam Museum, Cambridge University, UK / The Bridgeman Art Library

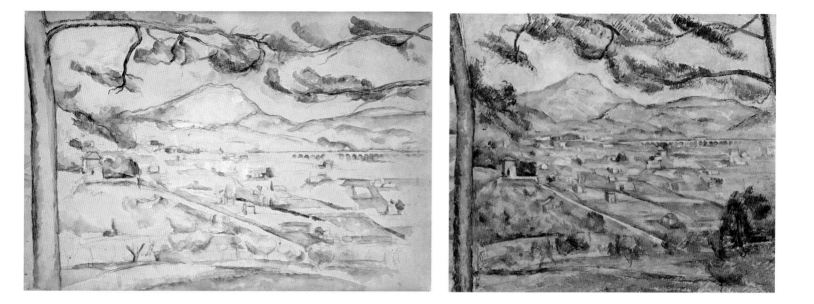

70 (above left) *Montagne Sainte-Victoire*, 1885, graphite, gouache, and watercolor on paper, 13⅝ × 20⅞ in. (34.7 × 53.1 cm). The Art Institute of Chicago, Gift of Marshall Field IV, 1964.199. Photo © The Art Institute of Chicago

71 (above right) *Montagne Sainte-Victoire*, 1886–87, oil on canvas, 26 × 25½ in. (66 x 90 cm). Phillips Collection, Washington, DC. Photo © Phillips Collection, Washington, DC / Lauros / Giraudon / The Bridgeman Art Library

Victoire, for instance, can be related closely to two oil paintings of virtually the same view (pl. 70). The watercolor seems to relate most closely to the canvas in the Phillips Collection, in Washington, DC, with which it shares several compositional peculiarities, including the steep angle of the long diagonal of the roadway in the foreground and the position of the farmhouse perched on a hill on the left (pl. 71). At the same time, it shares certain compositional details with the canvas in the Courtauld Institute of Art Gallery in London, such as the suppression of the tree trunk on the left, allowing for only wispy branches to be seen on this side of the sheet, as well as the broader, horizontal format of the sheet (pl. 72). The watercolor, therefore, stands, in a manner of speaking, between the views of the two canvases. Perhaps a better way of stating this point is to say that the watercolor cannot be understood to have operated as a dry run for either painting and instead represents a separate, unique rendition of the view in its own right. Joseph Rischel has perhaps best described the relationship between this watercolor and the Courtauld and Phillips canvases not as one of preparation but instead as one of shrinking: "A sense of miniaturization, at once charming and a little perplexing, suffuses the sheet, as if the huge vistas familiar to us through the paintings are here seen through the wrong end of a telescope."[39]

During the following decade, Cézanne made three watercolor studies of a pine tree that likely stood on the property of his sister's farm. Dating from between 1890 and 1895, they are also closely related to an oil painting of the same motif, which I will discuss shortly. The first watercolor, in the Kunsthaus Zurich, positions the tree to the right side of the page, which allowed Cézanne to explore the reach of the tentacular branches to the left (pl. 73). The second watercolor, in the Virginia Museum of Fine Arts, shifted the tree to the center of the page, where the trunk itself became the focus, with hints of branches leading away from the tree in all directions (pl. 74). The third and last watercolor, jointly owned by the Fogg Art Museum and the Metropolitan Museum of Art, shows the tree on the left side of the page, which enabled Cézanne to explore the tangle of branches extending to the right (pl. 75). These shifts in perspective are attended by shifts in the ratio between color and drawing. The first watercolor has no drawing whatsoever; the second is virtually all drawing with a few, scattered touches of color; and the third

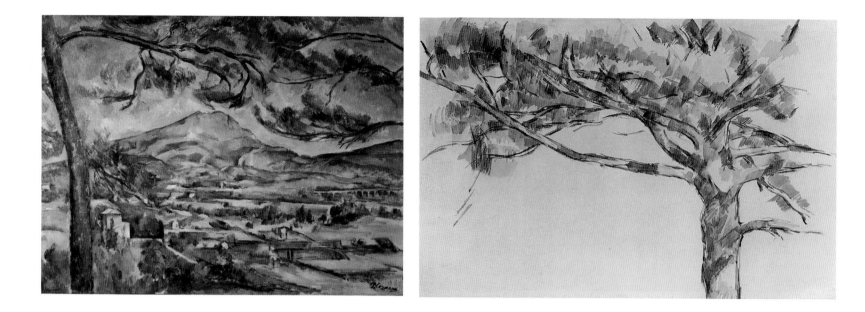

72 (above left) *The Montagne Sainte-Victoire*, 1887, oil on canvas, 26 × 35½ in (66.8 × 92.3 cm). Courtauld Institute of Art Gallery, London. Photo © The Samuel Courtauld Trust, Courtauld Institute of Art Gallery, London

73 (above right) *The Large Pine*, 1890–95, watercolor on paper, 10⅞ × 17¼ in. (27.7 × 43.7 cm). Kunsthaus, Zurich. Photo © 2007 Kunsthaus, Zurich.

watercolor includes both a worked-up, assertive drawing and an extensive application of color. The first watercolor, therefore, is something of an anomaly, since Cézanne almost always began his watercolors with a pencil drawing. As a result, one wonders why he decided to forego the graphic phase of execution. Is the answer as simple as his having misplaced or forgotten his pencil on the particular day he made this watercolor? Or was he making a more deliberate and experimental step here, testing out the effect of painting directly on the page to generate more fluid and transparent effects without the linear insistence of the pencil? I will return to these questions shortly, but for the time being I want to consider the third watercolor view of the tree, in which drawing and color are more evenly balanced. This will provide the conditions for offering some answers to these questions.

In order to understand the process that Cézanne used to generate these watercolors we again need to imagine him with a bare sheet of paper and his watercolor box opened and ready for a session of work. The concentration of Cézanne's pencil and brushwork in the upper regions of the page in the Fogg/Met watercolor, for instance, suggests something basic about the experience of sitting with a page of paper on one's lap. The arm works with greater ease when comfortably extended and is cramped and less dexterous when drawn in close to the body. The touches of the pencil and paintbrush trail off a few inches before reaching the lower edge of the page, which reinforces this sense of the proximity of the lower edge to Cézanne's body. It indicates the limit at which the wrist, twisting downward with pencil or paintbrush in hand, reached a point of tension that the artist deemed sufficient to abandon the marks to move back upward to areas of greater ease and control. Both the Virginia and the Zurich watercolors offer similar testimony to the artist's preference to work with his arm outstretched in the middle and upper reaches of his page.

If the Fogg/Met watercolor is typical of Cézanne's process of execution, this is also due to his sequential mediation of the blank paper surface first in terms of tonal drawing and then in terms of color contrasts. The volume and form of the tree have been indicated by two basic gestures of the hand – short, ticking hatch strokes and longer, sinuous contouring movements, effectively dividing the means

74 *The Large Pine*, 1890–95, graphite and watercolor on paper, 9¾ × 16 in. (24.6 × 40.6 cm). Virginia Museum of Fine Arts, Richmond. Collection of Mr. and Mrs. Paul Mellon. Photo © Virginia Museum of Fine Arts, Richmond

of drawing into two basic operations, modeling of volume and inscription of edges. The accumulation of hatching strokes in certain areas suggests that here the tree is turning into shadow. In other areas where the hatching becomes more regular and consistent, Cézanne has sought to suggest the dark values and linear patterning of clumps of pine needles. The contours are equally varied. Those contours that snake along the edges of the branches describe the sweeping extent of the tree's arm-like extremities. Some of these contours are broken in places to allow for a sense of perceptual instability and flux, as if Cézanne had decided to leave the form in a state of near but not total focus. With pencil in hand, therefore, Cézanne first worked over the page according to a simple binary logic of light and dark, a system of tonal modeling that enlists the off-white luminosity of the paper surface as a resource and foundation.

Shifting attention to the color layer of the watercolor, one discovers that, now with the paintbrush in hand, Cézanne has set down a range of colored touches that repeat the basic division of his preliminary drawing into hatching and contours. Short, hatching strokes of color appear in the areas of foliage, now supplying color to the first tonal indications. Similar color hatching has been applied in places to the tree trunk, which reinforces the light/dark modeling of the drawing by adding

75 *The Large Pine*, 1890–95, graphite and watercolor on paper, 12 × 18⅛ in. (30.5 × 46 cm). Fogg Art Museum, Harvard University, Cambridge, MA, and the Metropolitan Museum of Art, New York. Bequest of Theodore Rousseau, 1974

Facing page: detail of pl. 75

contrasts of warm and cool colors, in this case blue and yellow. Painted contours also return to places where Cézanne's drawing first indicated edges and linear forms, repeating the initial information in a new register. Cézanne's color translates his drawing into a new visual language. If we look again at the rendering of the trunk of the tree, we see that a first articulation of its volume has taken place in a tonal system of light and dark and then, with the shift to color, these light and dark oppositions have been rendered again, but this time in terms of warm and cool color contrasts. Touches of yellow and blue translate the light and dark contrasts into a chromatic register without effacing them. Both systems of representation – tonal and chromatic – remain visible to the eye and supplement one another, but without completely fusing into a single, final image. Awareness of the palpable gap, both temporal and representational, between these two stages of rendering is an essential part of the experience of viewing the watercolor.

One reason why the two levels of the watercolor remain palpably distinct, despite their shared division into hatching and contours, is purely technical. Unlike the opaque graphite, Cézanne's translucent color touches filter the lightness of the paper in a way that selectively blocks the light rays that it reflects. A green touch, for

76 *Forest Scene*, 1890, graphite and watercolor on paper, 12⅜ × 19 in. (31.5 × 48.3 cm). Museum Boymans-van-Beuningen, Rotterdam. Photo © Museum Boymans-van-Beuningen, Rotterdam

instance, subtracts all light rays except those that are reflected by green light. When Cézanne superimposes on this green touch a red touch, the reflected light is additionally filtered by red, subtracting additional wavelengths and producing a brownish hue. The only light rays that reach the eye are those that are allowed through both red and green hues. Shifting from the drawing to the painting phase of his watercolor, therefore, Cézanne shifted between two different ways of mediating the luminosity of the paper surface. Both are subtractive, but both subtract the light of the support in different ways. The hatching of the pencil reduces and screens the light without altering its quality, whereas the touches of color alter the quality of the white page by filtering out certain wavelengths. In the drawing, it is the quantity of exposed paper that is managed, more hatching representing darker areas; in the translucent color touches, it is the quality of the light reflecting from the paper surface that is managed and filtered.

A second reason why the drawing and painting in Cézanne's watercolor retain a sense of autonomy from one another is because they do not fully line up with one another on the sheet – an effect that is familiar to us from his still-life watercolors, discussed above. As in his still lifes, here too some areas of pencil hatching and contouring have not been revisited with the paintbrush. The hatching of the paintbrush on the trunk of the tree, for instance, follows the pencil hatching only loosely, generating a second, competing hatching pattern in color. Where the first branch on the lower right emerges from the trunk, a sequence of pale blue strokes of the brush indicates shadow, but no pencil hatching is there to confirm it. The shadow on the lower left side of the tree trunk, conversely, is rendered with both graphite marks and blue hatching applied with the paintbrush. Such effects can be seen as well in other, contemporary landscape watercolors such as *Forest Scene* (pl. 76). In this watercolor, Cézanne's drawing is concentrated on the left side of the page, where it has been used to pick out the form of a thicket of young trees, and has gradually become less and less attentive to detail as it moves to the right side of the

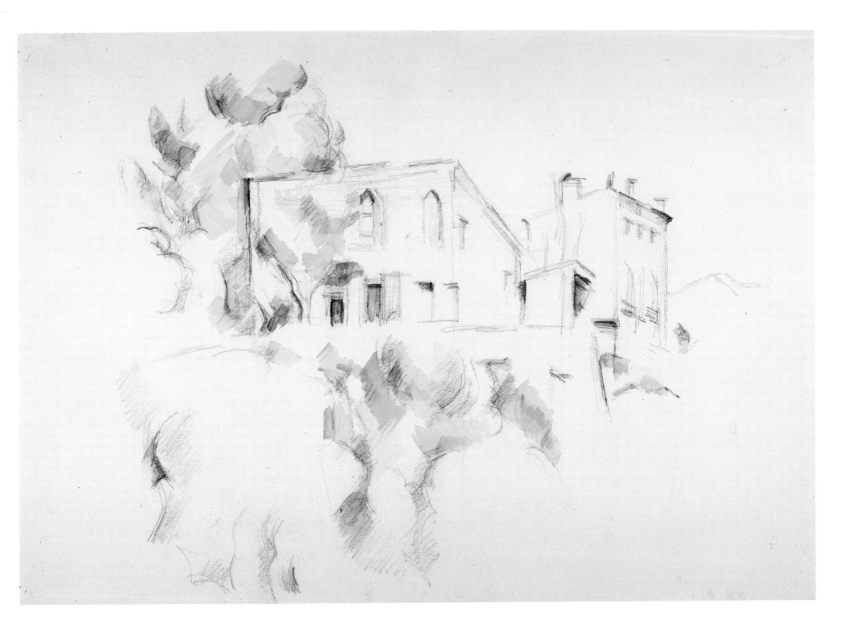

77 *The Château Noir*, 1890, graphite and watercolor on paper, 14½ × 20¼ in. (36 × 52.6 cm). Museum Boymans-van-Beuningen, Rotterdam. Photo © Museum Boymans-van-Beuningen, Rotterdam

sheet. Cézanne appears to have begun with the paintbrush on the right, conversely, where it has been applied with a great deal of attention in the rendering of the trees on the right side of the thicket and has slowly petered out just as it reached the carefully drawn trees on the left side of the page. The two versions of the motif in drawing and painting fundamentally reverse one another's attentive priorities.

A last example, *The Château Noir*, gives additional evidence of the effects of non-alignment of drawing and color in Cézanne's watercolors during this period (pl. 77). Cézanne painted often in the vicinity of this property, located to the east of Aix on the road to Le Tholonet, with its vast areas of rock and *sous-bois*, and even tried to purchase the property in the late 1890s, when the Jas de Bouffan was sold after his mother's death, and the proceeds were divided between him and his two sisters. Beginning in the late 1880s, Cézanne rented a small room at the Château Noir in which he kept his painting supplies used during his explorations of the property. This watercolor view – Cézanne's first known view of the building – shows the strange pseudo-gothic façade of the west-facing wing of the building and

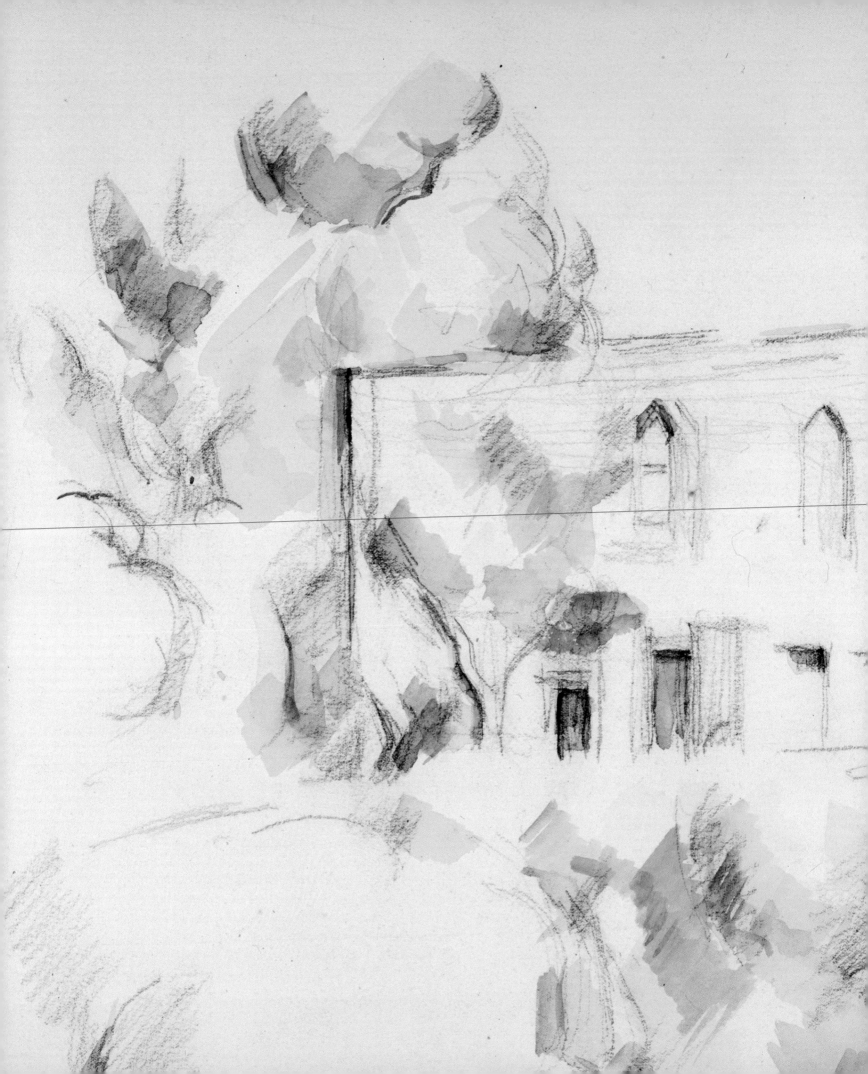

the profile of the south-facing wing, all seen from the path leading to the Maison Maria. Cézanne's hand has first moved over the page with the pencil and has picked out contours and shaded undersides of pine trees in the foreground and upper left, and the profiles and architectural details of the building itself in the middle distance. Next, armed with the paintbrush, his hand has passed over the page in a second, subsequent phase, and has in places picked up on and reinforced some of the same information indicated by the pencil, such as the billowing shapes of the pine tree to the left and a few of the architectural details as well. At the same time, however, he has painted parts of the motif that were not first rendered with the pencil, such as a prominent contour indicated in blue on the slope below the south-facing wing of the building. Likewise, the paintbrush has also ignored or only partially revisited certain areas that were rendered by the pencil, such as certain crucial details of the architecture and areas of the pine trees. In the left foreground, for instance, the hatching strokes of the pencil are in places repeated by the hatching of the paintbrush. In other areas they are either not repeated, or the hatching of the paintbrush falls where there is no previous pencil hatching.

The discontinuities between the work of the pencil and the paintbrush may be partially due to contingent factors like the movement of shadows as Cézanne worked. There is, of course, no rule that says that an artist must make the pencil drawing and the painted portion of his watercolor in a single sitting. Cézanne may well have made the drawing part of his watercolor one day and the painting another. He may also have returned to the painted part on multiple occasions, adding color and building up the image. Finally, there is evidence in watercolors throughout his career that he would at times even return with the pencil and add drawing on top of already applied watercolor pigments. But such variables cannot account for all the instances of discontinuity between the drawn and painted accounts of the motif in these watercolors. Following Cézanne's repeatedly voiced concern to be sincere in his art, it seems likely that the lack of total correspondence between the drawing and painting layers of these watercolors is yet another example of his desire to foreground the patterns and rhythms of his perceptions. What becomes visible in the breaks and disconnections between the pencil and paintbrush is the fact that Cézanne's interests and priorities in one phase of execution were not always repeated in the subsequent phase. This may have something to do with the fact that the shift from tonal drawing to color contrasts led him to focus first on areas of formal interest and then on areas of chromatic interest. Or, it may suggest something more fundamental, like a sense of the shifting and changing attentive patterns of the artist in the temporal unfolding of the process of execution. These watercolors announce clearly, both in the technical differences between drawing and painting and in the intermittent alignment of these two aspects of his process of working, that they record not one but multiple encounters with a motif.

Tactile and Optical Sensations

One of the results of the increased autonomy of drawing and color in Cézanne's mature watercolors is a divergence between the tactile associations of drawing and the optical associations of watercolor pigments. Implied in the division between the two systems of notation that I have described above is a division between two orders

of sensation, to which these two modes of rendering refer. Returning to the three watercolors of the pine tree, the watercolor with the most extensive drawing emphasizes the haptic presence of the tree, inviting the viewer to imagine reaching out and touching its volumetric forms. The watercolor with no preliminary drawing, at the opposite end of the spectrum, emphasizes the optical vibrations of light and color that effectively transform the tree into an insubstantial image that seems to float unanchored to the page. The Fogg/Met watercolor once again, becomes a middle ground, in which assertive tactile drawing is overlaid with an application of light, optically oriented color. The tactile sensibility of Cézanne's drawing in this watercolor underscores the general association of drawing with touch. Cézanne emphasizes here an order of sensation that was usually excluded from *plein-air* Impressionism, which was generally characterized as an art of pure opticality.[40]

In his essay on Impressionism in 1876, for instance, Mallarmé declared that Impressionism left "the massive and tangible solidity [of nature] to its fitter exponent, sculpture," declaring that Impressionism contented itself with a summary "aspect" of nature.[41] The association of Impressionism with pure opticality was made even more assertively by Laforgue, the author of the poem "Watercolor in Five Minutes," in an unpublished manuscript in 1883. Laforgue offered a complicated, teleological argument that put Impressionism in the position of restoring the human eye to its rightful purity after a long fall into tactility. The issue at stake here, he explained, was developmental:

> The primitive eye, knowing only white light with its indecomposable shadows, and so unaided by distinguishing coloration, availed itself of tactile experiment. Then, through continual association and interdependence, and the transference of acquired characteristics between the tactile and visual faculties, the sense of form moved from the fingers to the eye. Fixed form does not originate with the eye: the eye, in its progressive refinement, has drawn from it the useful sense of sharp contours, which is the basis of the childish illusion of the translation of living non-dimensional reality by line and perspective.[42]

Armed with this logic of decline, Laforgue identified in line the sedimentation of error: "Line is an old and deep-rooted prejudice whose origin lies in the first experiments of human sensation." A "natural eye," he argued:

> . . . before moving ahead, must first become primitive again by ridding itself of tactile illusions – a natural eye forgets tactile illusions and their convenient dead language of line, and acts only in its faculty of prismatic sensibility . . . Such is the first characteristic of the Impressionist eye.[43]

The Impressionist painting par excellence – Laforgue identified Monet and Pissarro as his exemplars – is free of line, modeling, and other aspects of drawing that call forth tactile, sculptural values that are not, at least according to this view, proper to the sensations of the eye. Already in 1880 a similar point had been made by the critic Diego Martelli, in a lecture on Impressionism delivered in Livorno:

> The sensation of solidity is not given to us by the eye; and the sense of distance would be lacking in us if our steps had not measured it. If you imagine a human body that had retained all its faculties except for its sense of touch, you would understand that this individual would live in a world of color harmonies, but he would completely lose contact with the measurements and contours of things.[44]

78 (above left) Claude Monet, *Cows on a Riverbank*, 1885–90, pencil, 14½ × 20¼ in. (36 × 52.6 cm). Musée Marmottan, Paris. Photo © Musée Marmottan, Paris, France / Giraudon / The Bridgeman Art Library

79 (above right) Georges Seurat, *At the Gaîté Roche-chouart*, 1887–88, conté crayon heightened with white, 12¹⁄₁₆ × 9³⁄₁₆ in. (30.7 × 23.4 cm). Harvard University Art Museums, Fogg Art Museum, Bequest of Grenville L. Winthrop, 1943.918. Photo © Imaging Department and President and Fellows of Harvard College

Nicholas Wadley has pointed out that, despite this general denigration of line and modeling, the Impressionists were all active draftsmen. This does not contradict the general thrust of these arguments, however, since, as Wadley has argued, the Impressionists used drawing in a way that was calibrated to optical rather than tactile effects. The trembling and fluid drawing of Monet, Pissarro, and, later, the diffused tonal drawings of Georges Seurat, he rightly suggests, suppress tactile associations in favor of rendering impressions of light and air (pls. 78 and 79). For his part, however, Martelli argued differently in his lecture in 1880, stating that, although tactile associations were banned from Impressionist paintings, Impressionist drawings pick up these now excluded associations and make them their own special subject matter. He explained:

> Once these ideas have been accepted, however, drawing does not simply disappear. Because scientific revolutions are not the product of regressive thinking, but result from the very noble intention of improvement, they do not destroy what is good. Thus drawing, remaining what it is, is reconceived by the Impressionists, and acquires a new function and importance. Drawing no longer belongs to visual sensations, but passes over in part to the sensation of touch; it becomes the graphic and mathematical expression of measures.[45]

Wadley has challenged Martelli's account of Impressionist drawing as aligned with tactility and measure as a misunderstanding, given the fact that Impressionist drawing is so patently focused on optical experience. "So remote is this interpreta-

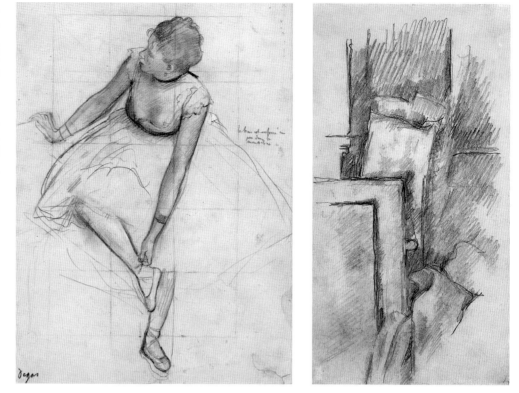

80 (right) Edgar Degas, *Dancer Adjusting her Slipper*, 1873, graphite heightened with white chalk on pink wove paper, 13 × 9⅝ in. (33 × 24.4 cm). The Metropolitan Museum of Art, H. O. Havemeyer Collection, Bequest of Mrs. H. O. Havemeyer, 1929, 29.100.941. Photo © The Metropolitan Museum of Art, New York

81 (far right) *Corner of a Studio*, 1877–81, graphite on cream paper, 8⁹⁄₁₆ × 4⅞ in. (21.8 × 12.4 cm). Harvard University Art Museums, Fogg Art Museum, Bequest of Marian H. Phinney. Photo © Imaging Department and President and Fellows of Harvard College

tion from any consensus view that we might arrive at today," Wadley asserts, "that we can only wonder whose drawings, apart from those of his friend Degas, he may have seen."[46] Martelli's account, however, should not be so quickly dismissed. Wadley is right to suggest that Martelli probably had in mind Degas' drawings, which are adamantly formal and based on the kind of tactile apprehension of things that most *plein-air* Impressionists avoided (pl. 80). But it was not only Degas who sought such effects in his drawings. Cézanne too focused his drawings, at least through his mature career, on the rendering of tactile sensations of form and volume. A drawing from a sketchbook dating from 1877–81, in which Cézanne renders the overlapping edges of a pile of stacked canvases seen against a wall with wainscoting, captures this emphasis clearly and recalls the layering and fanning out of overlapping architectural planes in his oil paintings made in Auvers (pl. 81). A second drawing of a milk jug and stove, also suggests the slow, tactile palpation of touch as Cézanne rendered edges, shapes, and volumes with a controlled hand, taking evident pleasure in tracing the surfaces of the forms and structures of the objects (pl. 82).

It is this same kind of tactile drawing that is evident in the two watercolors of the pine tree that have drawing, discussed above. A similarly tactile focus is evident in the drawing in Cézanne's mature still-life watercolors, also discussed above, in which the forms of fruit and vessels are rendered with an evident concern to capture their haptic aspects. And as in the watercolors of the pine tree, in these still-life watercolors there is also a wide variation between the ratio of drawing and color. In *Vase of Flowers*, for instance, there is almost no drawing whatsoever. The almost exclusive focus on the paintbrush in the rendering of this watercolor, as in the Zurich watercolor of the pine tree discussed above, in which there is no drawing

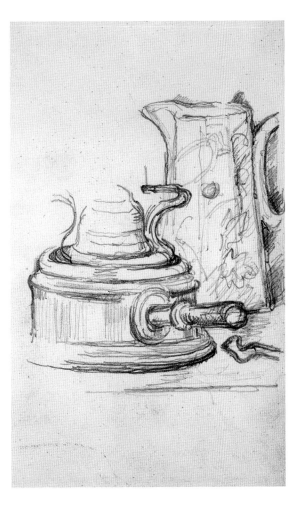

at all, indicates a focus on the optical effects of light and color. Here, Laforgue's description of Impressionism as a rejection of line and as an embrace of the optical flux of light and color rings true. The touches and strokes of greens, blues, violets, yellows, browns, and reds all seem to hover as an optical impression without substance and fixed form.

The variation in emphasis on drawing and color in Cézanne's three watercolor studies of pine trees, therefore, must also be understood as shifts between emphasis on tactile and optical sensations. This can be compared with the opposite effect of the oil painting that relates most closely to these watercolors and for which they were probably studies: *Large Pine and Red Earth* (pl. 83). In this painting, Cézanne's "constructive stroke" is again in evidence, but now in a way that appears more fluent and flexible than in canvases from the early 1880s, such as *The Château of Médan*. Rather than dividing tactile and optical sensations, Cézanne's paintings from his mature period have generally been described as fusing these two orders of sensation. In his landmark article "Cézanne's Doubt," the French philosopher Maurice Merleau-Ponty argued that Cézanne sought to recover in his oil paintings a primary unity of embodied experience before its specialization into isolated sensory systems. Merleau-Ponty claimed that Cézanne's paintings demonstrated a kinesthetic intertwining of the senses and, especially, of the optical and tactile senses: "Cézanne does not try to use color to *suggest* the tactile sensations which would give shape and depth. These distinctions between touch and sight are unknown in primordial per-

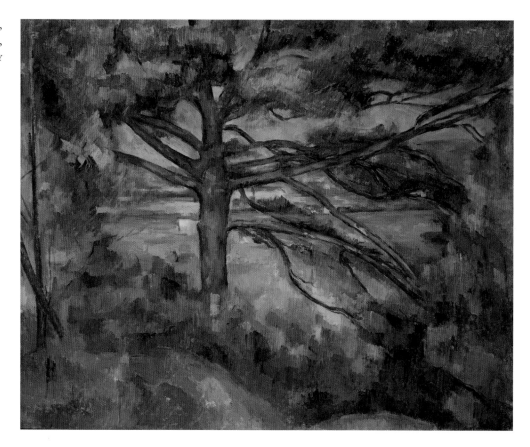

83 *Large Pine and Red Earth*, 1890–95, oil on canvas, 28⅜ × 35¹³⁄₁₆ in. (72 × 91 cm). The Hermitage Museum, St. Petersburg. Photo © Erich Lessing / Art Resource, NY

ception. It is only as a result of a science of the human body that we finally learn to distinguish between our senses."[47] Following Merleau-Ponty's lead, Richard Shiff has argued that Cézanne's "constructive stroke" constituted more than just a synthesis of form and color, but also a synthesis of tactile and optical sensations. "Cézanne's touch," writes Shiff, "returns vision to the primordial experience of immediate physical contact, and perhaps even to a time before the body is distanced from objects, before it requires language or a symbolic order to negotiate a constructed reality."[48] Also following Merleau-Ponty's lead, Yve-Alain Bois has recently suggested that Cézanne's collapsing of vertical and horizontal space one onto the other in crucial canvases such as this one implied on the painter's part a desire "to invent a tactile vision."[49]

There is some proof for these claims in a little-known anecdote from an account of a visit with Cézanne, written by the poet Edmond Jaloux, who met the artist in the mid-1890s in Aix, through their mutual friend Joachim Gasquet. Jaloux recalled sitting with Cézanne in a café:

> Hardly having taken his seat, Cézanne caught sight of a fruit dish, half full of peaches and apricots. He looked at it carefully and exclaimed: "Oh, look how the apricot loves the sun! It is shot through entirely with it. The peach is more defensive, and only takes in half as much." He said this while holding his arms out in front of him, making a wide gesture, with open hands, as if he wanted to caress something.[50]

The anecdote suggests a reflexive combination of seeing and touching much like that described by Merleau-Ponty, Shiff, and Bois. This fusion of tactile and optical

sensations is reinforced by Cézanne's refusal to oppose line and color, drawing and painting, to one another in his process of oil painting. As Cézanne reportedly declared: "There is no difference between drawing and painting: as you paint you draw. The more color becomes harmonious, the more precise becomes the drawing. When color is at its most rich, form reaches its fullness."[51] Although it was Bernard who reported this comment, it was in fact the artist Maurice Denis, in an article on Cézanne published in 1907, who grasped the significance of these words, distilling from an examination of Cézanne's technique just how he was able to fuse line and color in his oil paintings. Denis wrote: "in his essentially concrete perception of objects, form is not separated from color; they condition one another, they are indissolubly united. And as a consequence, in his execution he wishes to realize them as he sees them, by a single brush stroke."[52] "Each modulated object," Denis concluded "manifests its contour by the greater or less exaltation of its color."[53]

If such a fusion is evident in *Large Pine and Red Earth* in, for instance, the rendering of the physical presence of the tree trunk with color, or in the collapsing of horizontal and vertical planes into a compression of depth, or in the simultaneous rendering of edge and color with the single stroke of paint, then, in Cézanne's watercolor studies of the same tree, conversely, form and color and, therefore, tactility and opticality, remain divided into separate aspects of the artist's process. This comes as no surprise, since a division of labor between the pencil and the paintbrush in the rendering of form and color was already evident in Cézanne's Impressionist watercolors. What takes place in Cézanne's mature watercolors, however, is that a wedge seems to have been driven between the tactile and the optical accounts of his motif. This also implies a difference between close-up, haptic experience and distanced, optical experience. The art historian Alois Riegl divided these modes of seeing into a haptic mode of *nachsichtig*, close-up looking, and an optical mode of *fernsichtig*, distanced looking.[54] The sculptor Adolf von Hildebrand, writing in the early 1890s, also identified two basic tactile and optical modes of seeing.[55] For both Riegl and Hildebrand, the first of these two modes of looking was associated with sculpture and the second with painting or painterly qualities. Mallarmé's remarks about leaving the "massive and tangible solidity" of objects to their "fitter exponent, sculpture" also imply an opposition between the tactile information of sculpture and the optical information of painting. If Cézanne collapses these two modes of sensation in his paintings, generating a "tactile vision," then in his watercolors he maintains their distinction and, as a result, invites the viewer to see in a constantly varying manner, changing gears between different visual attitudes as the eye moves to different parts of the picture. As we focus on the drawing, we are invited into a haptic, close-up mode of seeing, one that is associated with palpation; as we next focus on the color, we are invited to adopt a very different, distanced mode of optical perception.

In an article entitled "Les Aquarelles de Cézanne," published in 1924 in *L'Amour de l'art*, Bernard – the only person known to have watched Cézanne execute a watercolor – expressed surprise over this phenomenon:

Apples, tablecloths, landscapes, and imaginary compositions: they all display a schematic completeness, in which the permanence of drawing is at odds with the fleetingness of color. It is surprising, in following the cursive, firm, willed drawing, to discover the capricious and uncertain birth of colors, which develop

into deep shadows and bright light. An effort of logic struggles with awakened sensibility, and the resulting contradiction between the thing in itself and what nature presents to the eye creates a strange drama on the page of these watercolors.[56]

Bernard's term "schematic completeness" recalls the association of watercolor with summary, partial rendering. More than this, his reference to a "strange drama" in Cézanne's watercolors suggests that he was acutely aware that their uniqueness was located in the relationship between drawing and color on the sheet. The strangeness of this drama, for Bernard, had to do with the very different accounts of the motif rendered by Cézanne's "cursive, firm, willed drawing," on the one hand, and his "capricious and uncertain birth of colors," on the other. There is a "struggle," he suggested, between two different accounts of the thing rendered, one that refers to material objectivity – the haptic *première pensée* of the drawing – and another that evokes optical sensations that "awaken" in the eye the scintillation of "fleeting color."

Perpetual Transformation

Cézanne's first solo exhibition took place in November 1895 at Ambroise Vollard's gallery on the rue Lafitte in Paris. The exhibition reportedly consisted of roughly one hundred and fifty works hung in rotation. One of the most frequently voiced comments about Cézanne's oil paintings in reviews and recorded comments about the exhibition was a general perception of *non-fini*. As the critic Thadée Natanson noted in his review of the show, "almost all are in agreement on the point of the unfinished nature of these paintings."[57] Even Pissarro, who visited the show on several occasions, singled out a sense of a lack of conventional finish in the work on display. In a letter to his son Lucien, dated November 21, 1895, he referred to still lifes that were "much worked on and yet unfinished," noting as well "landscapes, nudes, portraits, that are unfinished yet grandiose, and so painted, so supple . . . why? Sensation is there!"[58] Among the reviewers of the exhibition, the critic Gustave Geffroy gave the most positive and sensitive interpretation of the absence of conventional finish in Cézanne's oil paintings. Geffroy warned his reader of the disconcerting aspect of Cézanne's paintings: "You who read these lines and who will perhaps go in search of the beauty and grace that I am describing, do not become fixated on this or that moment of awkwardness, or this or that lack of perspective, equilibrium, or at this or that unfinished aspect."[59] These apparent elements of distortion, he explained, are in fact signs of sincerity: "He does not try to disguise or cover up, he trembles with joy and fear, he presses nature to deliver herself to him, he takes from her what she gives him, and he stops when he has run out of energy."[60] "He is a great authentic," he concluded, "ardent and ingenious, raw and nuanced."[61]

Geffroy did not mention watercolor, although Vollard included examples of Cézanne's work in this medium in the exhibition. Thought to have been in the show was *The Diver*, dating from the 1860s and discussed in Chapter One; and a scene of a murder in Provence that Julie Manet (Berthe Morisot's daughter) bought during the run of the exhibition.[62] There were also a handful of crucial works from the early 1880s. From his mature career, only two watercolors shown in the exhi-

bition can be established with assurance: *The Green Jug* and *Three Pears*.[63] Edgar Degas, who had admired Cézanne's art already in the 1870s, when he made sketches after a painting by Cézanne in the Impressionist exhibition of 1877, purchased *Three Pears* during the run of the exhibition. He faced competing interest for the same work from Renoir; the two artists reportedly drew lots for the work and Degas emerged the victor.[64] Despite the partial and uneven rendering in Cézanne's watercolors, the charge of unfinish in reviews of the exhibition were not directed specifically at his work in this medium. This was most likely due to the fact that fragmentation and summary effects were expected of watercolor, a point that was made clear in the reception of the exhibitions of the Société des aquarellistes français, discussed above.

Although Geffroy's comments were penned in defense of Cézanne's oil paintings, they can, I think, usefully be expanded to include all of Cézanne's artwork, including drawings and watercolors.[65] His suggestion that signs of awkwardness and unfinish should not be seen as failings but as evidence of sincerity is in agreement with Cézanne's own description of his enterprise. Geffroy had not yet met Cézanne, but by 1895 he had clearly understood the focus on sensation and sincerity in his art. In remarks on Cézanne published in 1901, Geffroy made a similar argument in defense of Cézanne. Referring again to the criticism of Cézanne's paintings as unfinished, he wrote:

> Some say that some of Cézanne's canvases are unfinished. What does that matter if they express the beauty, the harmony that he has felt so deeply? Who can say at what point a canvas is finished? Art is never without a certain unfinished quality because the life that it reproduces is in perpetual transformation. One must give an idea of the whole and of duration with an instantaneous image (*Il faut donner une idée de l'ensemble et de la durée par l'apparition d'un instant*).[66]

For Geffroy, the patterning and irregularity of the work of art were reflections of and testimonials to the patterning and irregularity of the unfolding experience of the artist. There is no end or conclusion to this unfolding experience, only moments that may be selected from its continuum. Especially in Cézanne's watercolors, these moments overlap and create something like a sensory palimpsest of tactile and optical information. Life, Geffroy explained, is always in a state of becoming and it is this that emerges in Cézanne's paintings. In Geffroy's evaluation, *non-fini* becomes both an analogy for becoming and the most intimate expression of the artist's "life." "In such a practice," Shiff has written, commenting on Geffroy's terms, "the passage of time, as registered by human consciousness or states of mind, is exchanged for movement in space, the register of a material environment or states of nature."[67]

Geffroy's use of the term "duration" calls to mind the description of mnemonic accretion in the writing of the French philosopher Henri Bergson. In the first pages of *Creative Evolution*, Bergson explained:

> I say that I change, but the change seems to me to reside in the passage from one state to the next: of each state, taken separately I am apt to think that it remains the same, during all the time that it prevails. Nevertheless, a slight effort to attention would reveal to me that there is no feeling, no idea, no volition which is not undergoing change every moment: if a mental state ceased to vary, its duration would cease to flow. Let us take the most stable of internal states, the visual perception of a motionless external object. The object may remain the same, I may

look at it from the same side, at the same angle, in the same light; nevertheless the vision I now have of it differs from that which I have just had, even if only because the one is an instant older than the other. My memory is that which conveys something of the past into the present. My mental state, as it advances on the road of time, is continually swelling with the duration which it accumulates: it goes on increasing – rolling upon itself, as a snowball on the snow.[68]

There is, Bergson concluded, "a succession of states, each of which announces that which follows and contains that which precedes it." George Heard Hamilton was the first to explore in detail the possible links between Bergson's notion of *durée* and the apparent accumulation of time in Cézanne's oil paintings through the inclusion of multiple perspectives. He argued that Cézanne's paintings, especially in the 1880s, offered "the pictorial equivalent of the Bergsonian concept of space as known only in and through time."[69] Cézanne's paintings, he claimed, captured Bergson's notion of the unfolding continuum of duration in their status as "records of the experience of continuous movement through space in time."[70] For Hamilton, duration emerged in Cézanne's paintings in the concatenation of various points of view, resulting in distortions in the overall coherence of his motifs. This model of temporal accumulation is like that of making a puzzle, in which pieces are gradually added to create a whole.

Hamilton did not mention Cézanne's watercolors, so it is left to us to think through the relationship of Cézanne's work in this medium to Bergson's comments about duration. In the watercolors, indeed, the slow accumulation of pencil drawing and painting generates a layered space that includes the kind of spatial concatenation of moments of rendering that Hamilton discerned in his oil paintings, while adding the additional factor of the overlaying of patterns of drawing and painting on a single sheet of paper. Following Hamilton's lead, I wish to propose a parallel between Bergson's description of the experience of the passage of time as a vectoring of mental experience backward and forward along an implied timeline and the layering of itineraries of attention in the watercolors described in this chapter.

Consider, in this regard, a last group of watercolors, dating from the late 1880s, this time showing views of Montagne Sainte-Victoire seen from the floor of the Arc valley. There are five such views, but the similar point of view in these watercolors should not tempt us to overlook their important differences. Between a view in the Fogg Museum of Art and the view in the Courtauld collection, for instance, Cézanne shifted the amount of the mountain and its surrounding ridges that he included in his watercolor. In the Fogg watercolor, both the left-hand slope of the mountain and the slow rise of the Montagne de Cengle on the right are included (pl. 84). The Courtauld watercolor, however, cuts off the left ridge and most of the one on the right, focusing on the face of the mountain (pl. 85). These watercolors do not make up a coherent series in the sense of this term that has come to be associated with Monet, for example, in his views of the Saint-Lazare train station in Paris of the late 1870s. In addition to shifting vantage points, there are also physical differences in scale: the smallest measures approximately 9 by 12 inches (22.9 × 30.5 cm) and the largest approximately a huge 19 by 24 inches (48.3 × 61 cm). There are also salient differences in technique. There is distinct pencil drawing in three of the works, whereas the preliminary drawing is very weak in the remaining two watercolors. These variations are evident in the Fogg and Courtauld watercolors.

84 (facing page top) *Montagne Sainte-Victoire*, 1885–88, graphite and watercolor on paper, 12³⁄₁₆ × 18³⁄₈ in. (30.9 × 46.7 cm). Harvard University Art Museums, Fogg Art Museum, Gift of Joseph Pulitzer, Jr. in honor of Agnes Mongan, 1977.173. Photo © Imaging Department and President and Fellows of Harvard College

85 (facing page bottom) *Montagne Sainte-Victoire*, 1885–88, graphite and watercolor on paper, 12³⁄₈ × 18³⁄₄ in. (31.5 × 47.5 cm). Courtauld Institute of Art, London. Photo © The Samuel Courtauld Trust, Courtauld Institute of Art Gallery, London

120

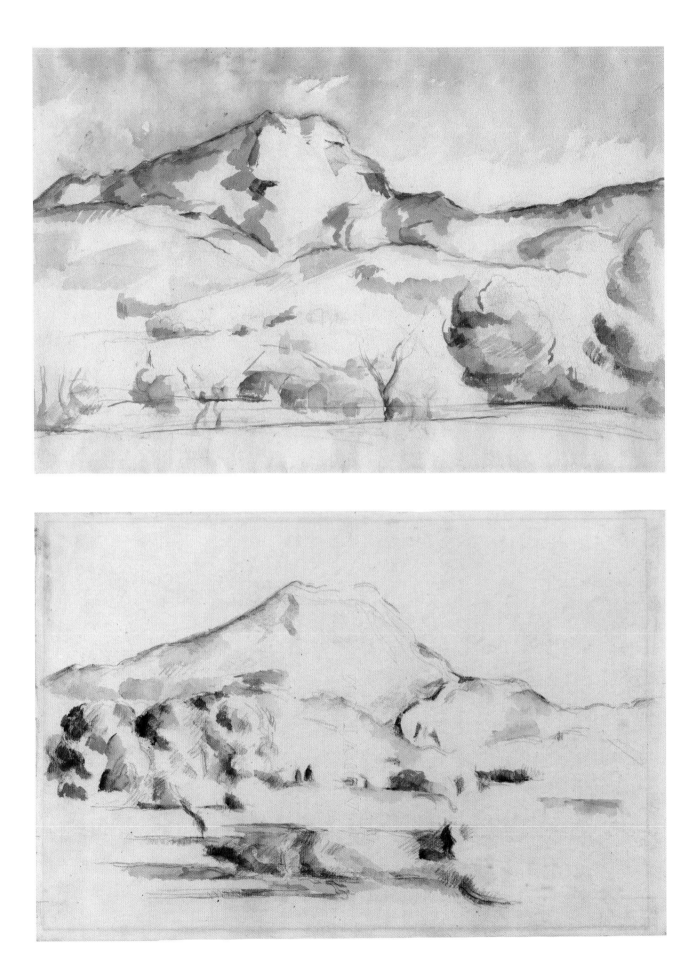

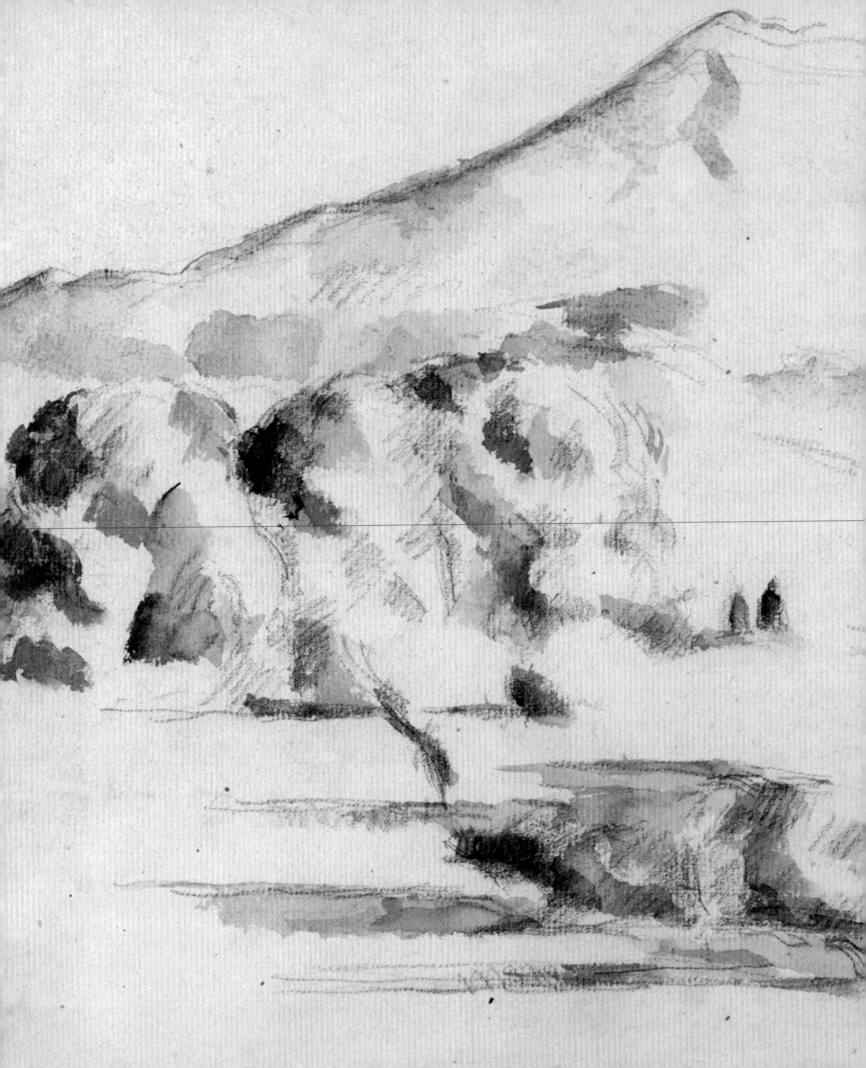

The first watercolor is made up of a series of broad washes of color over sinuous contours. There is no extensive hatching of the pencil in this watercolor, suggesting that Cézanne wanted to leave suggestions of shadow and volume to the optical effects of his watercolor washes set down with the paintbrush. In the second watercolor, conversely, an extensive, tactile drawing with tonal hatching and linear contours subtends the touches of green, orange, red, blue, and violet watercolor pigment. As in some of the watercolors discussed in this chapter, here too there are areas in which the hatching of the paintbrush does not overlap areas that have been hatched in with the pencil, such as, for instance, an area of shadow on the craggy face of the mountain to the left of the central v-shape; likewise, an area of extensive pencil drawing on the rock face, but lower on the right, has not been revisited by the paintbrush. Not only do these two views present very different accounts of the mountain, but so too, ultimately, do the two levels of the watercolor out of which they are generated evince different sensory priorities and attentive itineraries.

It is especially the temporal gap between the stages of working, however, that is of special relevance to the analogy with Bergson. Experience, Bergson suggests, is ever changing, so that with each new contact with the outside world, the mental state of the viewing subject has always already undergone variations. There is, I think, no better way than this to understand what is at stake in the unevenness in drawing and color in these watercolors, which become as a result something like records or palimpsests, in which the successive encounters with the motif, now with the pencil, now with the paintbrush, and perhaps again with the pencil and again with the paintbrush, accumulate on the sheet. The crucial elements of the analogy here lie in the retention of the past in the present and in the continually shifting priorities and emphases that are registered from one instant to the next. Against Rewald's assumption that Cézanne was seeking formal balance in his watercolors, therefore, I have been arguing in this chapter that the fragmentary quality of Cézanne's watercolors indicates a careful calibration of the pencil and the paintbrush to the rhythms of the artist's attention and the patterning of his sensations, rendered as tactile drawing and optical color. These watercolors are complete, to return to Cézanne's term, insofar as they retain the shifts and changes in his unfolding perceptual experience as they emerge in the process of rendering the motif. The discontinuities are as much a part of this record as are the moments of alignment and continuity between drawing and color. These watercolors are complete because they register not only sensations, but also their temporal ebb and flow. The first look at the motif, its first rendering, differs from a subsequent one, to recall Bergson, "even if only because the one is an instant older than the other." In the interval of this instant, which consists in putting down the pencil and picking up the paintbrush, a whole range of changes takes place, a "perpetual transformation," to recall Geffroy's term.

The Play of the Imagination

Stieglitz's story about the customs official's consternation, with which I started this chapter, took place in the presence of the Courtauld watercolor of Montagne Sainte-Victoire, since it was in the box that was opened on that day. Stieglitz's colleague

and friend, the photographer Edward Steichen, was responsible for securing twenty watercolors from the Bernheim-Jeune gallery in Paris for the loan exhibition in New York in 1911. Rewald has described the circumstances surrounding the loan, including Steichen's frustration that he could not also borrow from Vollard for the show.[71] In a letter to Stieglitz, Steichen wrote:

> Well, the Cézannes are out at sea on the *Savoie*. It meant a certain amount of "manoeuvre" to get them, so they did not get off as soon as I hoped . . . The Cézannes are a really fine lot, the cream of what the Bernheims have. – And I managed to get the collection as varied as possible; in that way I did sacrifice a few corking things I might otherwise have included.[72]

Responses to the watercolors were varied, but they all singled out their fragmentary qualities. The reviewer for the *New York Evening World* described the watercolors on display in Stieglitz's gallery as "fragmentary drawings washed in here and there with spots and patches of flat tint."[73] The critic writing for the *Evening Mail* saw in this fragmentation a failing. "The Cézanne watercolors here shown," he grumbled, "are merely artistic embryos – unborn, unshaped, almost unconceived things, which yield little fruit for the eye or the soul."[74] The critic writing for the *New York Globe* made the point in terms that went right to the heart of the matter: "our objections take the form of a protest at the painter stopping just where the real difficulties begin. Here are innumerable delightful suggestions, beginnings, indications, or spottings-in, but stopping there when the spectator has a reasonable right to ask for a logical conclusion."[75] The gaps and breaks in Cézanne's watercolors, however, reminded at least one reviewer of the economy of Japanese and Chinese painting. Singling out the Montagne Sainte-Victoire watercolor, the critic for the *New York Times* wrote:

> One fine little landscape, a mountain that might be Fujiyama, but appears in the catalogue as "Mount Victoire" rising very solid, very dignified, and serene, is modeled with a few forcible strokes of pale greenish grayish neutral color. There is so little to say about the picture, and it is so potent to stir the imagination of the lover of nature, that one is tempted to leave the rest of the exhibition alone and go an inch or two into the cause and effect of this kind of art. . . . The Chinese and Japanese as a people love nature more consistently than any of the Western races, and many of their greatest works in essence resemble this by Cézanne – they are executed, that is, almost in monochrome and with an extreme economy of treatment, on the ground, to quote a Japanese critic, that "the provision of too many sensible attributes is apt to hinder the play of the imagination on the part of beholders," and "in the ultimate analysis painting is, aesthetically speaking, but a product of the imagination, and is to be enjoyed by the same faculty."[76]

The above commentaries suggest that, in the eyes of a sympathetic reviewer, the fragmentation of the watercolors could be understood to be a kind of reticence and economy that allowed a role for the imagination of the spectator. The breaks and open areas of unpainted paper were invitations to the spectator to enter into Cézanne's sensations of nature and to add to them, filling them out in their own way.

If Geffroy's notion of unfolding duration materialized in instantaneous works of art captures what is at stake in Cézanne's mature watercolors, in which the layered rendering of the motif in drawing and color represents an accumulation of shifting states of mind and sensory priorities, then it should be added that these fragmentary and layered watercolors also invite the viewer to enter into the layered experience of sensation that is set forth in the works themselves. The visual effect of Cézanne's watercolors, therefore, is predicated on a process of to and fro movement between the drawn and painted levels of the image that repeats Cézanne's own back and forth movement between the pencil and the paintbrush, between optical and tactile sensations, and between close-up and distanced modes of seeing. The "perpetual transformation" of the artist's experience is in this way reflected in that of the spectator, who experiences the shifting between layers as a continual movement and transformation with no clear end or conclusion. For the critic writing for the *New York Globe*, "the spectator" was justified in demanding what he termed "a logical conclusion"; for the critic for the *New York Times*, conversely, the suppression of any conclusion was precisely what opened the watercolors to the spectator's perceptual imagination.

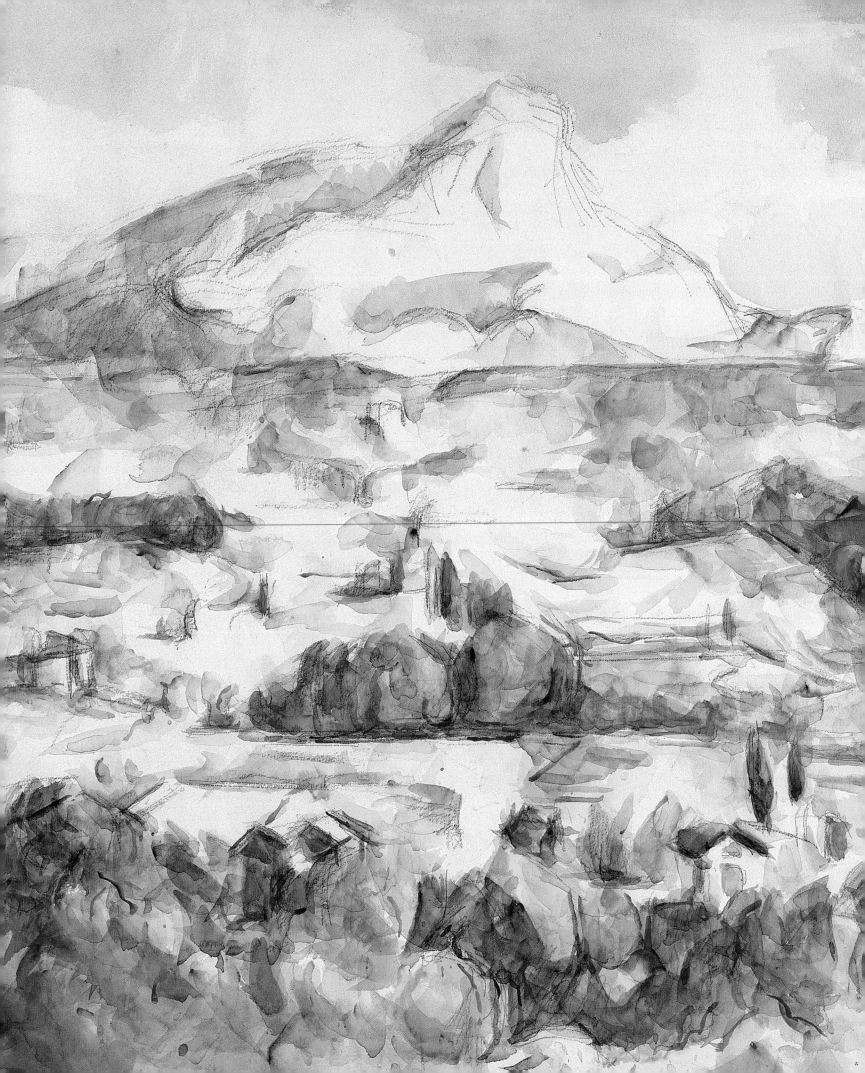

Four

Sensations of Light and Air:
Watercolor and the "Envelope"

In a letter to Ambroise Vollard dated November 11, 1904, Cézanne's son explained that his father was "doing some watercolors," adding that "the weather helps, it's very fine."[1] Indeed, during his late career watercolor played a proportionally larger role in Cézanne's art than it had in earlier periods. This increased importance corresponds with a change in the appearance of Cézanne's watercolors. During his late career, dating from roughly 1895 until his death in 1906, his watercolors became intensely vibrant, while the motifs they depicted progressively dissolved into a flux of kaleidoscopic color and increasingly repetitive contours. The purpose of this chapter is to explore Cézanne's late watercolors and their strategies for materializing what he termed "the envelope," that is, the reflections and refractions of light that take place in the atmosphere that intervenes between the artist and his motif. Cézanne's interest in the envelope was not limited to landscapes but also can be seen in still lifes and portraits. Even at close range, Cézanne treated the motifs in his late watercolors as opportunities to explore effects of light and air.

During this part of his career, Cézanne treated watercolor at least in part as a means to sensitize himself to the subtle flux of the envelope in preparation for his oil paintings. At the same time, however, his late watercolors produce very different records of the envelope than do his oil paintings. More than just a means to prepare for the work of oil painting, watercolor provided an alternative means of rendering the envelope that, in crucial respects, exceeded the capacities of oil painting. "If watercolor as a preparatory study belongs to [Cézanne's] method as a painter in oils," wrote the art historian Meyer Schapiro, "it also realizes a vision of nature, or at least an aspect of his vision of nature, that is less evident in the oils."[2] Part of this was due to the continued presence of both drawing and color in Cézanne's watercolors. As we will see, however, it was more than just the combination of drawing and color that contributed to the unique resources of Cézanne's late watercolors – it was also the increasingly important role of the "reserve," or blank paper surface, that allowed

him to accomplish a "vision of nature" that was "less evident in the oils." Precisely how he gave pictorial form to this other vision is the subject of this chapter.

This Sun-Filled Country

One of the places where Cézanne worked most frequently in his late career was his studio in the Les Lauves heights (pl. 86). He had the studio constructed after the death of his mother in 1899 and the subsequent sale of the Jas de Bouffan, which had been his primary residence since 1886. Immediately following the sale, he moved to a house on the rue Boulegon in the center of Aix, where he organized the attic into a studio.[3] The space was stuffy and insufficiently illuminated, however, and Cézanne's thoughts seem rather quickly to have turned to the project of building a new studio.[4] Once the blueprints were agreed to, construction began in 1901 and was complete by the end of the following year. In a letter to his niece penned in September 1902, Cézanne noted that he was "settling in" to the new studio.[5] In a letter to Vollard written roughly five months later, he referred to his "large studio in the country," adding that he was "better off there than in the city."[6] One of the main reasons Cézanne selected this site appears to have been the impressive, southerly view it commanded of Aix and, beyond it, the distant mountain range of La Chaîne de l'Etoile.

The view was mentioned in accounts written by several of the visitors who came to Cézanne's studio. In a record of his visit in 1902, the archeologist Jules Borély recalled that, after having sought out the painter at his home in Aix, the two men walked together to the hillside studio:

> We arrived at the studio. He pushed open the gate and offered me one of the white, wooden chairs abandoned on the terrace under the pale acacias. He put down his bag, his paint box, and canvas and came to sit next to me facing the view. Beyond the mass of olive trees and dried foliage, the town of Aix appeared in the light, mauve and framed by the surrounding hills, which were cerulean and ethereal . . .[7]

87 *The Garden Terrace at Les Lauves*, 1902–06, graphite and watercolor on paper, 17 × 21 1/16 in. (43.2 × 53.4 cm). The Pierpont Morgan Library, New York, The Thaw Collection. Photo © The Pierpont Morgan Library, New York, 2008

A second visitor, the German art collector Karl Ernst Osthaus, who came with his wife in 1905, also mentioned sitting on the terrace, but this time at the end of a brief stay:

> At the end of our visit to the studio, the master brought chairs to the terrace in front of the house, where there was a splendid view of the city surrounded by mountains. We spoke at length of the beauty of the landscape and the roots that tie his art to this sun-filled country.[8]

Finally, a third visitor, the painter and critic Emile Bernard, recalled in his important article "Souvenirs sur Paul Cézanne," published in 1907, that, after meeting the Aix master at his home in town, they too walked up to the studio: "He opened the wooden gate and we entered the garden, which sloped down to a creek, with dusty olive trees and pines beyond."[9] During his stay of more than a month in early 1904, Bernard, who managed to become closer to Cézanne than most of his visitors, had more than one occasion to sit with Cézanne on his terrace with the view before them. "We looked out before us at Aix, in the sun, with its church tower rising toward the sky," recounted Bernard, "and we talked about atmosphere, color, the Impressionists, the problems that tormented him, and color transitions."[10]

A series of watercolors, executed between 1902 and 1906, depicts the view either from the terrace or from the upper windows of Cézanne's Les Lauves studio. *The Garden Terrace at Les Lauves*, for instance, shows a view of a staircase that leads down the slope toward the creek at the southern limit of the property (pl. 87). Plants in terracotta pots stand sentry and frame the view, while a dematerialized tree (an acacia or olive tree) flickers like a flame licking skyward. A screen of foliage

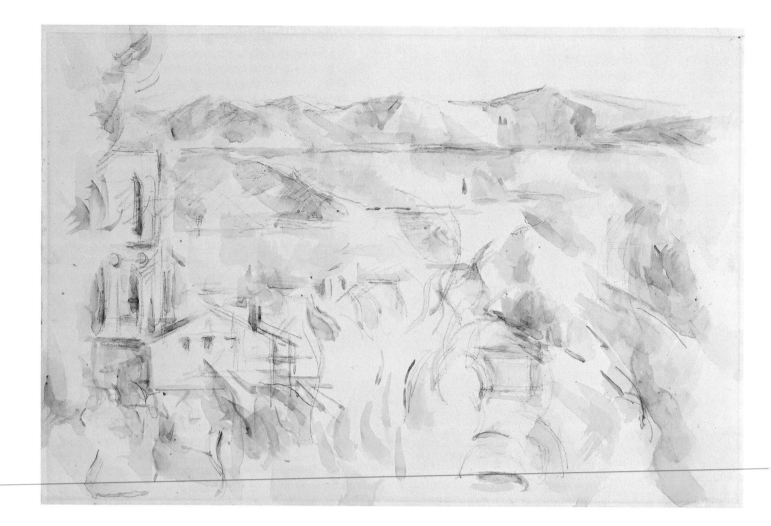

88 *Aix Cathedral Seen from Les Lauves*, 1902–06, graphite and watercolor on paper, 12½ × 18¾ in. (31.7 × 47.6 cm). The Philadelphia Museum of Art, The Louise and Walter Arensberg Collection, 1950. Photo © The Philadelphia Museum of Art

along the lower edge of the descending steps stands between the artist and the view of the city beyond, which, aside from a partially indicated rooftop in the distance to the left, is washed out in the glare of what seems to be morning sunlight. In the final register of the image, the ethereal mountain range appears as a diluted, floating ribbon of ultramarine blue. Several additional watercolors, executed from the three south-facing windows on the second floor of the studio, capture the view from a higher standpoint, from which Cézanne could see the graceful form of the cathedral of Saint-Sauveur. *Aix Cathedral Seen from Les Lauves* depicts the view from one of the two leftmost windows and shows the bell tower of the cathedral peeking over the triangular façade of an intervening building (pl. 88). A second view, *Landscape: Aix Cathedral*, shifts rightward to capture the cathedral's long ochre-hued nave (pl. 89). The complex topography of architectural angles and planes suggests the huddle of houses and buildings that were built up over time around Saint-Sauveur. A third view, *The Cathedral of Aix Seen from the Studio*, displaces the cathedral to the center of the page (pl. 90). In this view, the terrace wall is visible in the foreground, implying a slightly inclined vantage point. A citrus tree, heavy with fruit, stands to the left as a *repoussoir*: like the tree in *The Garden Terrace at Les Lauves*, it seems to dissolve in the scorching southern sunlight.

Cézanne's watercolor views from the studio convey his affection for Aix and the surrounding "sun-filled country," to recall Osthaus' terms. An enthusiasm for the

89 (right) *Landscape: Aix Cathedral*, 1902–06, graphite and watercolor on paper, 12¼ × 18⅝ in. (31.2 × 47.3 cm). Musée Picasso, Paris. Photo © Réunion des Musées Nationaux / Art Resource, NY

90 (below) *The Cathedral of Aix Seen from the Studio*, 1902–06, graphite, gouache, and watercolor on paper, 12½ × 18½ in. (31.8 × 47 cm). The Metropolitan Museum of Art, Lent by the Alex Hillman Family Foundation. Photo © The Metropolitan Museum of Art

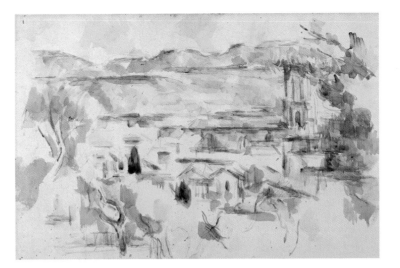

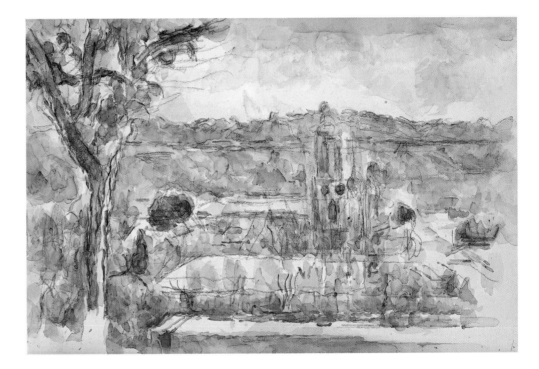

brightly lit landscape surrounding Aix is also evident in a wide range of additional watercolors that Cézanne made in the south during his late career. Some of these depict trails and thoroughfares that wend their way through the pine forests and into the hilly countryside to the east of Aix in the direction of Le Tholonet. *Road with Trees on a Hill* probably shows a view of this roadway at a point somewhere along its extent where a rise in the terrain is bordered by a stand of young trees (pl. 91). To the left is a mass of foliage and branches, while on the right the hillside falls away to reveal a few hints of a distant prospect of low-lying pastures and fields. The same roadway appears to be the subject of *Forest Path* (pl. 92). This watercolor now captures the byway as it cuts across the artist's visual field and creates a sweeping, rightward perspectival vector. Unlike the former view, in which Cézanne chose a spot that was open to the beating rays of the sun, here he has selected a site where the roadway is enclosed in a foliage vault. Trees standing on either side of the road

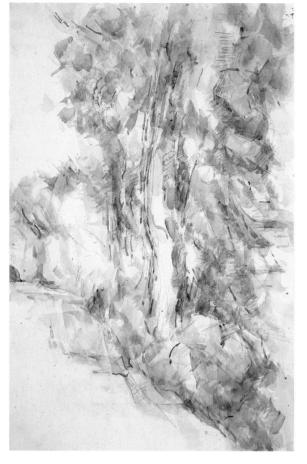

91 (above left) *Road with Trees on a Hill*, 1904, graphite and watercolor on paper, 18¹¹⁄₁₆ × 12⅛ in. (47.5 × 31 cm). Beyeler Collection, Basel

92 (above right) *Forest Path*, 1904–06, graphite and watercolor on paper, 17½ × 24½ in. (44.5 × 62.2 cm). Princeton University Art Museum, Lent by the Henry and Rose Pearlman Foundation. Photo © Bruce M. White

frame the view and indicate a sense of stepped recession into space away from Aix and toward the storehouse of motifs beckoning in the eastern countryside.

One of the places located along the road to Le Tholonet that Cézanne frequently visited during this period is the Château Noir. In Chapter Three I discussed a watercolor that Cézanne executed in the grounds of the imposing residence in the early 1890s. In the late 1890s and early 1900s he returned to the place and made watercolors both around the building itself and in the surrounding forest. Some of these watercolors render motifs he discovered while exploring the forested hillside to the north of the building, which is sculpted with rocky outcroppings and is choked in places by dense thickets of underbrush. Cézanne also hiked up the hillside to where the claustrophobic crush of foliage gives way to exposed walls of rock and made a series of impressive studies of the sun-baked cliffs he found there. A horizontal sheet depicting one of these exposed rock faces focuses on the pattern of light and shadow generated by the protrusions and hollows of the eroded surface of the rock (pl. 93). Finally, he also explored the building itself, rendering in two watercolors the gnarled pistachio tree in its courtyard and, in a third, once again trained his attention on the form of the Château Noir as it rises up above the surrounding pine forest (pls. 94 and 95).

As I showed in Chapter Two, in watercolors, drawings, and paintings executed in the 1870s, Cézanne had already celebrated the bright light of the south. This was evident in *Rooftops of L'Estaque, The Bay of L'Estaque, Row of Houses,* and *Allée of Chestnut Trees at the Jas de Bouffan.* I also noted that Cézanne was not alone in his appreciation of the light of the Midi and his characterization of that light as giving rise to sharp, concise sensations. In his letter to Pissarro, written in 1876, Cézanne praised the vividness of these light effects: "The sun here is so vivid that it appears to me that objects become silhouettes, not only of white or black, but also of blue,

red, brown, violet." He continued to praise the specific light of the south in his late career. This is especially evident in the letters he wrote to friends in 1896 from the town of Tailloires on the Lac d'Annecy, where he was vacationing with his wife. Cézanne voiced repeated complaints about the place. "It's still nature, of course," he told one friend, "but a little like we've been taught to see it in the travel books of young ladies."[11] Tailloires, located near the Swiss border in the Haute-Savoie region, offered a very different kind of landscape from that of Provence. "It's a temperate zone," explained Cézanne, "The altitude of the surrounding hills is considerable. The lake, narrowed at this point by two gorges, seems to lend itself to the linear exercises of young misses."[12] Cézanne's criticism of the prettiness of this northeastern landscape is tinged with a distinct overtone of regionalism. "It's not as good as our country," he told one friend back home, "but it's alright as far as it goes."[13] Or, as he explained in the same letter:

> When I was in Aix, it seemed to me that I should be better elsewhere, now that I am here, I think with regret of Aix . . . To relieve my boredom, I paint; it is not so much fun, but the lake is very good with the big hills all around, two thousand meters high they say, not as good as our home country, although without exaggeration it is really fine. But when one was born down there, it's all lost – nothing else means a thing . . .[14]

95 *Château Noir*, 1904, graphite and watercolor on paper, 16½ × 21¾ in. (41.9 × 55.2 cm). Private collection. Photo © The Philadelphia Museum of Art

A strong emotional attachment to Provence was a constant theme throughout Cézanne's career and it emerged with insistence in the last decade of his life. Furthermore, his renewed attachment to Aix during his later life was accompanied by the renewal of relationships with old childhood friends, including Henri Gasquet, by then a retired baker, and Philippe Solari, a sculptor. Cézanne's increased attachment to Provence during this period is especially underscored by his friendship with Henri Gasquet's son, Joachim, a poet who was an active member of the Félibrige. This regionalist literary group, centered in Avignon and led by the poet Frédéric Mistral, aimed at reviving and promoting Provençal literature, language, and culture.[15] Gasquet and his friends participated in Félibrige meetings and festivals, as well as publishing a regionalist literary review, *Les Mois dorés*, to which Gasquet himself contributed, and which he sent to Cézanne, along with other publications, during the last ten years of the painter's life.[16] Contact with Joachim Gasquet and his wife, Marie Gérard, along with the coterie of poets and writers that he met through them, stimulated Cézanne's own regionalist sentiments, giving rise in his correspondence to exclamations such as "Long live Provence!"[17]

Facing page: detail of pl. 95

One of the most important letters that Cézanne sent from Talloires was to Joachim Gasquet, dated July 21, 1896. He wrote: "I have left our Provence for a while. After considerable shilly-shallying, my family, in whose hands I find myself at the moment, has persuaded me to settle temporarily where I now find myself."[18] The second paragraph of Cézanne's letter, however, appears to respond to Gasquet's request that Cézanne become more actively linked to his regionalist group. Cézanne politely declined, but asked that his friend keep him in his thoughts.

> I am too far away from you, both in age and in the knowledge that you are advancing each day; nevertheless, I recommend myself to you and your good thoughts so that the links that keep me attached to our old native soil, so vibrant, so harsh and so reverberant with light that it makes your eyes squint while enchanting your sensory receptors, will never break and set me loose as it were from the land where I felt, even without realizing it, so much.[19]

Cézanne ended the letter by encouraging his friend to continue sending him his review: "I cherish the hope of being able to read more from you and your ardent collaborators."

Cézanne's relationship to regionalism has recently been the subject of extensive scholarly investigation.[20] Although he appears to have supported the general aims of his younger friends, he does not appear to have participated directly in their regionalist activities. Cézanne's regionalism was in fact a private one, based on his memories of his youth and his attachment to the landscape around Aix. Crucial to this personal regionalism was his enthusiasm for the light of the south, which he specifically mentioned in his letter to Gasquet. Rather than "vivid," however – the term Cézanne used to describe this light in his letter to Pissarro in 1876 – Cézanne now spoke of the light as "vibrant," "harsh," and "reverberant." This is, I think, an important shift in vocabulary. Vivid light is piercing and stunning, whereas "vibrant" and "reverberant" light is flickering and scattered. This subtle distinction suggests that Cézanne's sense of the distinctive quality of the light of his home region had also subtly changed by the mid-1890s. No longer for Cézanne a source of sharp figure–ground distinctions, southern light was now something vibrant and scattered, which generated unstable and indistinct perceptions.

It was not only southern light that Cézanne sought to capture in his late work, however, but also the atmosphere in which it rebounds. In a letter to Bernard dated April 15, 1904, Cézanne explained: "For us men, nature is [experienced] more as depth than as surface, from which comes the necessity of introducing into our light vibrations, represented by reds and yellows, a sufficient amount of blue to render the air."[21] Moreover, in a second letter to Bernard, Cézanne confirmed that it was no longer stark oppositions of figure and ground that interested him, but the diffused network of reflections that made up the envelope. "Draw, but remember that it is the reflection of light that defines things," he counseled: "Light, through the laws of reflection, becomes the envelope."[22] Cézanne also reportedly explained to his son: "Atmosphere is the basis and the screen on which all oppositions of color and all accidents of light are distributed. It forms the envelope, which contributes synthesis and general harmony to the picture."[23] Finally, it should be recalled that one of the topics about which Cézanne and Bernard reportedly spoke as they looked out over the vista afforded by the studio terrace was "atmosphere," confirming that it was specifically the southern atmosphere that was on Cézanne's mind.

Returning to Cézanne's watercolors, the shift from bright, sharp sensations of figure and ground and of light and dark to the exploration of the envelope of light reflections and atmosphere is evident in Cézanne's view of the Château Noir from 1904 (see pl. 95). In this work, like the views from the studio, southern light and air no longer affirm form but dissolve it instead. This is evident, moreover, at all levels of his execution. Cézanne used the pencil in this watercolor in a way that is less incisive than in the past and more summary in its approach to shapes and edges. The tree in the foreground, for instance, has been rendered as a tangle of interwoven graphite lines, which results in a series of suggestions of branches and trunks without establishing their forms with any certainty. Likewise, the shape of the building is drawn in a way that hints at its form without taking a firm grasp of it. The taste for clear knowledge of shapes and edges has here been replaced with a general shifting and displacement between repeated lines, none of which gives the position of the architecture with any finality. Cézanne has drawn no contours without returning with additional strokes of the pencil, not to reinforce but to diffuse edges instead. At the same time, the hatching of the pencil has been applied in looser sequences that in turn reinforce the loosening of Cézanne's hold on his motif. The soft pencil has left granular patterns of graphite on the page in places that indicate soft, velvety shadows. Drawing has given up its tactile hold on the world and joins the fleeting and transparent touches of watercolor pigment in an effort to capture vibrant, optical sensations.

Shifting attention to the painted level of *Château Noir*, one finds a reinforcement of the focus on effects of light and air, but now rendered with translucent color applied with a paintbrush. I noted in Chapter Three that Cézanne's technique of applying color in his watercolors in the 1880s evinced a general repetition of the syntax of drawing in the subsequent layer of color application. The strokes of the paintbrush were divided into two basic types following the model of drawing: hatching and contours. This remains true in his late career, as is evident in this watercolor. The sequences of hatching and repeated contours visible in Cézanne's drawing are echoed by the paintbrush, which Cézanne has applied in short sequences of color and fine, sinuous contours. The mass of foliage in the foreground, for instance, has been articulated in green, blue, and red strokes of fluid pigment, which preserve the shape of the brush that discharged them. These color patches are in places applied as soggy and saturated imprints that, in their wateriness, have run, bled, dripped, or succumbed to capillary action in drying, thus producing touches that display a higher concentration of pigment at their edges than at their more diluted centers. Where particularly wet touches of pigment have been applied to areas of the paper already inscribed with a dense hatching of graphite, the liquid has here and there dislodged the graphite and redistributed it in unforeseen trickles that slip down the paper surface. In yet other places, pigment has met the page in concise and controlled touches that, in comparison with those just described, are highly viscous and stable. Multiple tack holes in the upper corners of the sheet attest to the fact that it was worked on multiple times in front of the motif.

It was certainly a watercolor such as this one that the artists Rivière and Schnerb saw in Cézanne's studio in 1905. These watercolors, they observed, resembled "badly registered proofs of three-color impressions, such as isochromatic photography obtains."[24] As in such prints, in which "the blending by superimposition is imper-

fect,"[25] they remarked, so too does the space of such a watercolor seem to shift and come apart into different units of color passing one over the other in physical space. Likewise, the surface of *Château Noir* fairly crackles with activity as brushstrokes pile up in clusters that depict bushes, clumps of pine needles, and leaves. The focus on light and air, rather than sharp formal perceptions, is evident in the detachment of colors and lines from their referents, not as a step toward abstraction, but as a pictorial means of rendering an autonomous unity of light and air between the artist and his motif.

Rendering the Envelope

It was not only in views of landscape that Cézanne sought to render vibrant sensations of light and air, but also in views of still-life arrangements executed inside the Les Lauves studio. Cézanne's focus on the envelope is perhaps most striking in these still lifes because it was in this genre that the tactile appeal of form usually was at its greatest. In *Still Life with Sliced Watermelon*, for instance, Cézanne brings the viewer down close to the objects he depicts, an effect that is emphasized by the extension of bottles and other tall objects out of the pictorial field at the top of the page (pl. 96). A counterpoint of linear and rounded forms punctuates the arrangement of objects, all of which refer either to the kitchen (knife, sliced melon, cooking pot) or to the table (silver spoon, teapot, wine bottle, carafe of water). Carol Armstrong has recently pointed out the degree to which such studio still lifes suggest contiguity with the domestic space of the kitchen.[26] Her suggestion that Cézanne's late still lifes appeal to the tactile sense, however, is not borne out by the visual evidence. The familiar uses of these objects are absent in this and related watercolors, largely because the tactile interface with them – which is their traditional working interface (slicing, spooning, pouring, lifting with a handle) – has been suppressed. The spoon no longer suggests its domestic function but becomes instead a brilliant, reflective surface that picks up blue reflected light. Moving in close to familiar objects on a table paradoxically does not result in a greater sense of the tactile availability of the objects. To the contrary, the closer Cézanne gets, the more the objects he studies recede and fragment into a flux of vibrating touches of drawing and color.

Four additional watercolors include a prominently placed watermelon. In these watercolors, however, the watermelon is intact, suggesting that the residual reference to slicing and cutting in the *Still Life with Sliced Watermelon* called forth too many associations of tactile use for Cézanne, which he suppressed in these other works. Two of these works seem to have been executed at about the same time, as suggested by their very similar compositions and their shared perspective of the flank of the watermelon. In *Still Life with Pomegranates, Carafe, Sugar Bowl, Bottle, and Watermelon*, the rounded flank of the watermelon is only partially visible behind the two pomegranates, the water carafe, the sugar bowl, and the empty wine bottle indicated in the title (pl. 97). In *Still Life with Watermelon and Pomegranates*, the watermelon has been brought forward, while the same supporting cast of objects appears shifted around the watermelon to the right, with the result that the wine bottle now appears behind the hump of the watermelon on the left (pl. 98). Two additional watercolors include watermelons seen head on. *Still Life with Milk Pot, Melon, and Sugar Bowl*, now in the collection of the Edsel and Eleanor Ford House,

96 *Still Life with Sliced Watermelon*, 1902–06, graphite and watercolor on paper, 12⅜ × 18¹¹⁄₁₆ in. (31.5 × 47.5 cm). Beyeler Collection, Basel. Photo © Beyeler Collection, Basel

Grosse Pointe Shores, Michigan, sets the watermelon in a complicated architecture of drapery folds, rounded forms of apples, and the linear and rotund shapes of cooking and serving vessels (pl. 99). In *Still Life with Green Melon*, Cézanne brings the viewer back in to a close-up view of a few objects distributed on a table, including the spheroid form of an emerald-green watermelon seen head on (pl. 100). No longer for eating, these watermelons have been absorbed into the world of the studio, where the study of the envelope takes precedence over domestic associations.

One of the most striking aspects of these watercolors is the presence of repeated, displaced contours, both drawn and painted. They can be seen, for instance, in *Still Life with Green Melon*, in which parabolic contours appear to radiate out from the watermelon, generating as a result a sense of rippling, like the expanding, concentric rings on the surface of a still pond where a pebble has just been tossed. A watercolor that is shot through with such repeated, displaced contours is *Blue Pot with Bottle of Wine*, in which a group of objects on a table – apples, blue pot, knife, bottle, formless tureen or other object – appear to be undulating as drawn and painted contours strip away from the objects they ostensibly define as if exfoliat-

97 (above left) *Still Life with Pomegranates, Carafe, Sugar Bowl, Bottle, and Watermelon*, 1902–06, graphite and watercolor on paper, 12⅜ × 17 in. (31.5 × 43.1 cm). Musée du Louvre, Paris. Photo © Réunion des Musées Nat-ionaux / Art Resource, NY

98 (above right) *Still Life with Watermelon and Pomegranates*, 1902–06, graphite and watercolor on paper, 12 × 18½ in. (30.5 × 47 cm). The Metropolitan Museum of Art. Photo © The Metropolitan Museum of Art, New York / Art Resource, NY

99 (right) *Still Life with Milk Pot, Melon, and Sugar Bowl*, 1902–06, graphite and watercolor on paper, 19 × 24½ in. (48.2 × 62.2 cm). Edsel and Eleanor Ford House, Grosse Pointe Shores, MI. Photo © Edsel and Eleanor Ford House, Grosse Pointe Shores, MI

ing (pl. 101). One of the principal effects of such repeated contours is the refusal of any sense of their specific location. The handle on the almond-shaped lid of the blue pot seems to shift gradually to the left in a series of staccato, blue-violet contours. Likewise, the positions of the apples in the foreground of the still life have been lightly indicated with repeated, freely applied, silvery pencil lines that do not line up with the contours and local hues applied by the paintbrush. The same is true of the bottle, which is drawn in one position but painted in another. Recent conservation has shown that Cézanne brought back the pencil after the application of color in some of his late watercolor still lifes to render further the edges of objects

100 (right) *Still Life with Green Melon*, 1902–06, graphite and watercolor on paper, 12⅜ × 18¾ in. (31.5 × 47.5 cm). Private collection. Photo courtesy of Sotheby's, London

101 (below right) *Blue Pot with Bottle of Wine*, 1902–06, graphite and watercolor on paper, 18¾ × 24⁵⁄₁₆ in. (47.6 × 61.7 cm). The Pierpont Morgan Library, New York, The Thaw Collection. Photo © The Pierpont Morgan Library, New York. Photo © Joseph Zehavi

diffused and spatially undecidable.[27] This may also be true of this watercolor, in which drawing seems to have been applied at a series of moments in the unfolding of Cézanne's execution. These linear displacements, however, do not necessarily represent changes in Cézanne's thought process about where the final contours of the objects should be located in space. Rather, the addition of drawn and painted contours has the effect of denying any sense of a final position, giving rise to a sense

of instability around the edges of things.[28] The repeated and broken, blue contours, applied with watercolor pigment, seem to have been Cézanne's preferred resource for representing circulating air. As he told Bernard, blue allowed him to "render the air."[29] And in both of these watercolors, blue contours effectively render the fluid and corrosive integument of air that breaks down firm boundaries and links objects together in an embracing envelope. This explains Cézanne's late attitude toward contour as reported by Rivière and Schnerb: "Cézanne did not seek to represent forms by a line. The contour only existed for him as the place where one form ended and another began. In principle there is no line, a form only exists in relation to the forms next to it."[30] Another way of saying this is that line, in Cézanne's late watercolors, does not refer to form but to something else. This "something else," as I have suggested, is nothing other than the air that envelopes forms and dissolves them in optical perception.

Cézanne was not the first artist to make the link between inside and outside spaces as a single envelope of light and air. In a journal entry dated January 25, 1857, Delacroix wrote: "When we cast our eyes on the objects about us, whether in a landscape or an interior, we observe between the objects that offer themselves to our eyes a kind of binding produced by the atmosphere that envelops them and by the reflections of all kinds which makes, so to speak, each object participate in a kind of general harmony."[31] Cézanne was probably unaware of Delacroix's remarks; it was only in 1906 that he was given a copy of Delacroix's *Journal* by the painter Ker-Xavier Roussel.[32] Delacroix's reference to the movement of the eyes around a landscape or interior is worth emphasizing. Indeed, colorist drawing and painting were generally associated with a dispersed, roving mode of seeing in France in the nineteenth century. This was due to the colorist's interest in tracing all the complexity of light and its reflections, as opposed to the "linearist" concern for the presence of clearly defined form. In his book of 1885, *Du dessin et de la couleur*, Félix Bracquemond argued that the defining trait of a colorist is his focus not on the way that light carves out objects, but on another kind of luminous action:

> This luminous action is represented by the word *reflection*. The word helps show and make clear that the light rays, after having touched a body, partially rebound and *reflect* onto objects that surround the body, and this is the case until the light carried by reflection is completely extinguished in the very deepest reaches. It is this rebounding, this reflection that, penetrating even there where direct light cannot reach, modifies to infinity the aspect of things.[33]

Whereas the linearist "does not concern himself with the context in which his object is placed,"[34] the colorist "leaves his subject in the context in which he encounters it or conceives of it, under active light which, through reflections, circulates and influences everything that surrounds it."[35] Consequently, in contrast to the linearist, whose aim is to "lead the eye of the spectator to the place where it should come to rest," the colorist, explained Bracquemond, invites the eye of the spectator to "circulate everywhere and to verify every incident that light provokes."[36] "Here, if one might permit me another exaggeration to make a point," he concluded, "there is no main subject: everything has the same interest; because everything has been brought to light by direct light first, and by reflections second."[37]

If these interests suggest a link between Cézanne and Delacroix, they also brought Cézanne back to the territory of *plein-air* Impressionism, which had been focused

on rendering the flux of light and atmosphere in outdoor landscape views since the early 1870s. Bernard noted that one of the things that were on his mind in his late career was Impressionism ("we talked about atmosphere, color, the Impressionists . . ."[38]). In a letter to his son, Cézanne reinforced this sense of his renewed interest in Impressionism and its priorities, exclaiming: "Long live the Goncourts, Pissarro, and all those who love color, the representative of light and air."[39] Cézanne had, in fact, become estranged from Pissarro in his late career and began to speak positively of him again only after Pissarro's death in 1903. Among the Impressionists, it was Monet with whom Cézanne was most friendly in the 1890s. He had been to visit Monet in Giverny and was deeply impressed with his series of canvases of Rouen Cathedral, which he viewed at Durand-Ruel's gallery in 1895.[40] Further evidence for Cézanne's return to Impressionism in his late career appears in Charles Camoin's response to Charles Morice's "Enquête sur les tendances actuelles des arts plastiques," published in *Mercure de France* in August 1905. Camion, who knew Cézanne in the late years, concluded his contribution to the discussion with the following comment: "I ought to say, since Cézanne wants it known, that he has the greatest admiration for Monet."[41] Monet and Cézanne were also linked in an article by the conservative critic Raymond Bouyer, who singled both of them out as promoters of what he termed "the tyranny of sensation" in modern landscape painting.[42] Cézanne's turn to the envelope in his late career, therefore, can be seen as a belated embrace of the shimmering and atmospheric effects of *plein-air* Impressionism. Monet had also identified the envelope as his main object of interest. In a letter to Geffroy, written on October 7, 1890, Monet explained that he was working on haystacks and that he was seeking to achieve "above all, the envelope, the same light spread over everywhere."[43] By the end of the nineteenth century, Impressionism had become synonymous with optical flux and the demolition of form. In his *Notes sur l'art moderne*, published in 1896, the art critic and historian André Michel explained that Impressionism "sought to render the play of light vibrations through an increasingly pointed analysis and to dissolve, so to speak, drawn form into an exasperated brilliance, a sort of universal flux of colored molecules."[44] Focusing on the envelope was also identified with Impressionism by Robert de la Sizeranne in "The Balance Sheet of Impressionism," published in 1904: "Its principle being to paint the luminous envelope of objects rather than the objects themselves, [Impressionism] made everything vibrate in an all-over shimmering effect."[45]

Cézanne's interest in flowing light and air is brought home by a last group of watercolors made in the context of his studio in his late career – a series of portraits made on the terrace of the studio, a kind of intermediary space between the studio and the landscape. One of these watercolors shows an unidentified man, perhaps one of Cézanne's many visitors, such as Borély, Osthaus, Maurice Denis, Bernard, Rivière, or Schnerb, wearing a straw hat and sitting in a cross-legged pose with a newspaper or raincoat folded over his left arm (pl. 102). He sits on a small wooden chair that seems almost too small to carry his weight while he grips with his left hand the handle of a cane or walking stick, his right hand resting idly on his lap. Behind him can be seen the trunks of two trees rising skyward, as well as the low wall that appeared prominently in *The Garden Terrace at Les Lauves*. Cézanne has not sought to render the character of his sitter. His facial features are all but ignored and any details of dress that might speak of his profession or personality are lost in

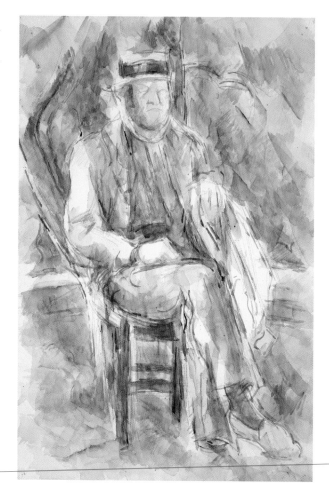

102 *Man Wearing a Straw Hat*, 1906, graphite and water-color on paper, 47.9 × 31.5 cm. The Art Institute of Chicago, Gift of Janis H. Palmer in memory of Pauline K. Palmer, 1983.1498. Photo © The Art Institute of Chicago

103 (facing page) *Portrait of Vallier*, 1906, graphite and watercolor on paper, 18½ × 12⅜ in. (48 × 31.5 cm). Museum Berggruen, Berlin. Photo © Bildarchiv Preussischer Kulturbesitz / Art Resource, NY

the animated flickering of repeated contours, graphic hatching, and the myriad strokes of kaleidoscopic color.

Two additional watercolors of Cézanne's gardener, Vallier, also seated on the terrace, increase this sense of reverberant light. The first shows Vallier sitting in what appears to be roughly the same place on the terrace as the first sitter. Seated on the same yellow-brown chair, the gardener also crosses his legs and wears a hat, his long overcoat falling down the sides of the chair. In a second portrait of Vallier, he appears seated on the same chair and in the same pose, but this time by the wall of the studio under a linden tree and stripped of the long jacket (pl. 103). Cézanne has applied especially assertive, triangular strokes of color in the rendering of the shadows and reflected light on the studio wall behind the gardener and in the foliage of the tree. The sitter's bright, white shirt shines intensely in contrast to this layered build up of watercolor pigment. The dissolution of form is here also a blurring of familiarity, as if Cézanne were trying to forget what he had in front of him in order to render his immediate sensations of light and air. Drawing and color shift and move on the page independently of one another. The fleeting touches of green and pink and orange shift over the initial pencil sketch in a way that affirms the difference between drawing and color at the same time that they work together to generate an impression of overall flux. As Theodore Reff once noted of Cézanne's late watercolors: "The old antagonism of drawing and color is resolved in a new kind of pictorial unity where each preserves its intrinsic quality."[46] The opposition

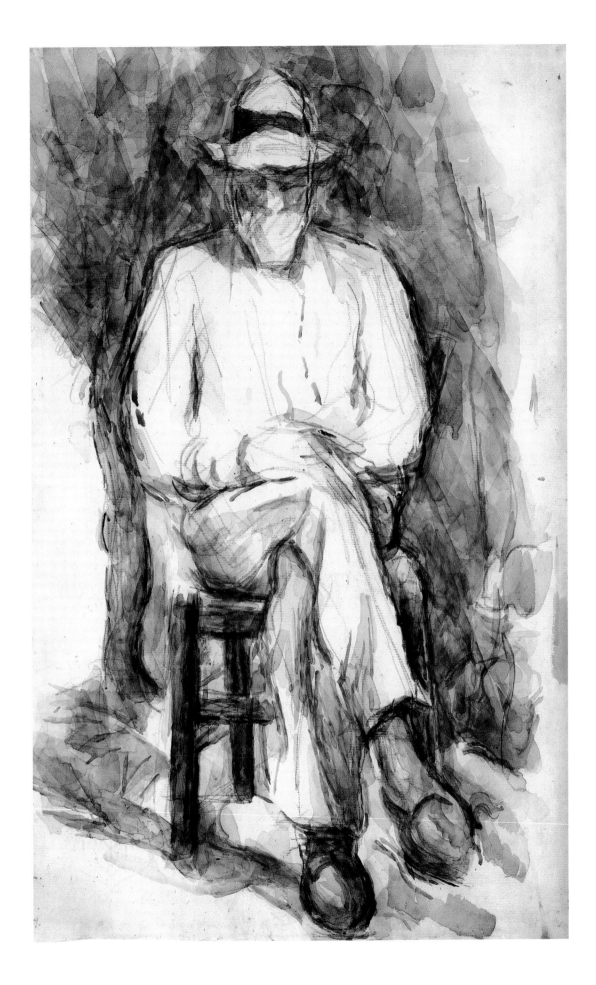

of tactile drawing and optical color is here overcome in the envelope of shimmering, vibrating touches of line and color. When one reaches a contour in these watercolors, an area where the eye traditionally is allowed to come to rest, one discovers instead that edges have been splintered into groups of successive, repeated contours, nudging the eye into circulatory movements. Both the zones of reiterated contours and the increasingly fragmented touches of color have the function of reproducing the experience of seeing in flux, keeping the eye aloft, as it were. These watercolors suggest that the envelope was something that Cézanne understood to circulate through the studio and around it, on the terrace, as well as through the open countryside.

Watercolor, Drawing, and Oil Painting

When Borély visited Cézanne in 1902, he noted that he saw in the vestibule of his studio "twenty blue and green tinted watercolors thrown haphazardly on the ground."[47] Renoir also noted Cézanne's apparent nonchalance regarding watercolor, reporting that it was not uncommon to discover watercolors from his hand discarded in the fields around Aix-en-Provence, sprouting here and there like the forgotten verses of an absent-minded poet.[48] In his few references to watercolor, Cézanne confirmed this general sense of watercolor as a sideline activity in his art. This was evident in his letter to Zola in the summer of 1866, in which he referred to his desire to buy a watercolor box to occupy his attention while he was not at his oil painting.[49] Similarly, in a letter to his son, dated October 13, 1906, Cézanne noted that he was working in the vicinity of his studio, where "the path is quite steep, very picturesque but wide open to the Mistral." He added: "At the moment, I'm going on foot with just the bag of watercolors, putting off painting in oil until I've found somewhere to leave my gear."[50]

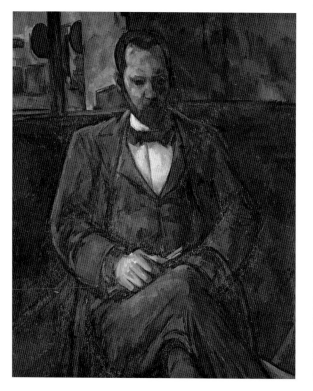

104 *Portrait of Ambroise Vollard*, 1899, oil on canvas, 39⅜ × 31⅞ in. (100 × 81 cm). Musée du Petit Palais de la Ville de Paris. Photo © Réunion des Musées Nationaux / Art Resource, NY

However important watercolor may have become for Cézanne in his late career, it was never in a position to rival his work in oil. What, then, was the function of watercolor vis-à-vis Cézanne's oil paintings in his late career? An answer is suggested by a document that has so far not received the attention it deserves in scholarship on Cézanne. I am referring to an entry in Maurice Denis' journal, dated October 21, 1899, in which Denis reports a conversation with Vollard, who was currently posing for a portrait by Cézanne in his studio on the rue Hégésippe-Moreau in Paris (pl. 104). Denis wrote:

> For an eternity Vollard has been posing every morning at Cézanne's studio. . . . To prepare himself for painting the next morning, he goes in the afternoon to the Louvre or the Trocadéro in order to draw the statues – either the antiques or the Pugets – or he makes a watercolor outdoors. He believes that this prepares him to *see* well [*bien voir*] the following day.[51]

When Vollard wrote his memoirs many years later, he too recalled sitting for the portrait. Vollard's portrait is a stiff image of the dealer seated with crossed legs, reflecting the tension of the reportedly 115 sittings, throughout which Cézanne insisted that Vollard sit still "like an apple."[52] Denis refers to Cézanne's use of drawings and watercolors as aids in preparing him to "*see*" well in his subsequent sessions of oil painting. Vollard also recalled Cézanne's use of studies as a means to

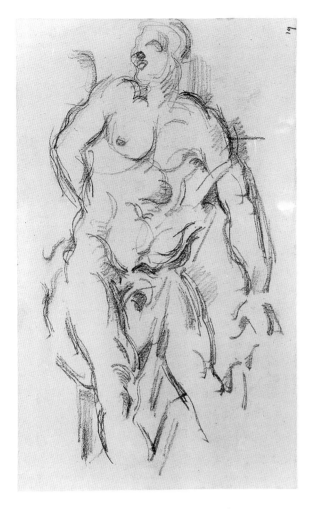

105 *Milo of Crotona* (*after Puget*), date unknown, 12⅜ × 17 in. (31.5 × 43.1 cm). Kunstmuseum, Basel. Photo © Kunstmuseum, Basel – Martin Bühler

train his eye and hand in advance of oil painting. "Every afternoon Cézanne would be off to copy in the Louvre or Trocadéro." He continued: "Not infrequently he would stop in to see me for a moment about five o'clock, his face radiant, and would say, 'Monsieur Vollard, I have good news for you. I'm pretty well satisfied with my work so far; if the weather is clear gray tomorrow, I think the sitting will be a good one!' "[53]

Denis mentions that Cézanne was drawing both antique and Baroque sculptures, including works by Pierre Puget. One of the Pugets that Cézanne frequently studied in the Louvre was the *Milo of Crotona*, a scene of an athlete with his hand stuck in a tree trunk being attacked by a lion (pl. 105). Lawrence Gowing has puzzled over the relationship of these drawings of sculpture to Cézanne's oil painting of Vollard. The painting, which is so stiff and immobile, he rightly observes, is the opposite of the Baroque drama of the sculpture. The answer, concludes Gowing, must lie in the analogous activities of rendering formal incident in line and color incident in painting: "For Cézanne, the relationships of color . . . were evidently akin to the physical articulation of forms that he drew in line in the museum."[54] Formal articulation is clearly not what Cézanne sought to render in this drawing, but rather something more insubstantial – the envelope. Indeed, the analogy to be made between drawing and painting is precisely here in Cézanne's focus in each on rendering the flux of light and air that surrounds and envelopes his motif.

Denis mentions that it was not only drawing but also watercolor that served Cézanne as a means of exercising his eye and hand in rendering the envelope. Vollard also mentioned the presence of watercolors in the studio during the sittings, which he reportedly encouraged Cézanne to pin up on the wall of the studio. He soon regretted doing so:

> I can never forgive myself for having insisted on Cézanne putting some of his own work on the walls of his studio. He pinned up about ten watercolors; but one day, when the work was going badly, and after he had fretted and fumed and consigned both himself and the Almighty to the devil, he suddenly opened the stove, and tearing the watercolors from the walls, flung them into the fire. I saw a flicker of flame. The painter took up his palette again, his anger appeased.[55]

This kind of dramatic embellishment is typical of Vollard's memoirs. There is no reason, however, not to believe him either regarding the presence of watercolor in Cézanne's studio or in the calamity of their consignment to the stove. One or more of these watercolors may have been a study of the sitter, but Vollard gives no specifics. If he did make a watercolor study of Vollard, it would not be the first time that he had rendered a sitter in both watercolor and oil.[56] But Denis mentions watercolors done outdoors, *en plein air*, not works done in the studio, in his diary entry. Like the drawings at the Louvre, the watercolors that Cézanne understood to be training him to see well in his sessions of oil painting were not specific studies for the painting but rather views of outdoor subject matter. A watercolor that was probably made in Paris during these sessions is *The Balcony*, the cool blues and greens of which suggest a cool, northern sky and the presence of lush vegetation (pl. 106). This watercolor, although at first seemingly unrelated to the Vollard painting, nevertheless deals with the same subject: the envelope.

One of the things that becomes evident in the consideration of Cézanne's late drawings, watercolors, and oil paintings is that, despite the fact that they all repre-

106 *The Balcony*, date unknown, 24 × 17¾ in. (61 × 45.1 cm). The Philadelphia Museum of Art: A. E. Gallatin Collection, 1943. Photo © The Philadelphia Museum of Art

sent efforts to render the envelope, the accounts they give of the envelope are ultimately very different from one another. These differences derive from variations in medium, drawing reducing the envelope to a tonal scale, oil painting generating light and air through color contrasts, and watercolor combining drawing and painting to create an account of the envelope that shifts between summary graphic marks and transparent touches of color. The differences between Cézanne's watercolor and oil paintings have been established in earlier comparisons, such as between the watercolor and oil versions of *The Abduction*, between the watercolor and oil versions of *The Château of Médan*, and between the watercolor and oil versions of *The Large Pine and Red Earth*. In each case, the physical differences in medium allowed Cézanne to accomplish very different effects in watercolor and oil. This is also the case with watercolors that Cézanne was making in his late career, such as those made in the fall of 1906 in the vicinity of his studio, which he mentioned in his letter to his son, cited above. He was working, as he explained, in an area where "the path is quite steep, very picturesque but wide open to the Mistral." A landscape watercolor, executed in the fall of 1906, *Chemin des Lauves: The Turn in the Road*, was most likely executed during these excursions (pl. 107). Painted a short distance from Cézanne's studio, it shows the road to Les Marguerites. Evidence of the wind can be seen in the watercolor, in which colorful splatters suggest the scattering spray of pigment in the sudden and unexpected whipping of the Mistral. The watercolor relates closely to an oil painting of the same motif (pl. 108).

Involved in the general opposition between watercolor and oil painting is an apparent difference in effort. Accounts of Cézanne's process of oil painting in his late career suggest that he brought to his canvases an enormous intensity of intellectual and visual effort. This is evident, for example, in Vollard's account of sitting for the portrait, and especially when he recounts pointing out the two blank spots in his portrait to Cézanne:

> In my portrait there are two little spots of blank canvas on the hand which are not covered, to which I called Cézanne's attention. "If the study I am making at the Louvre turns out well," he replied, "perhaps I will be able tomorrow to find the exact hue to cover up those spots. Don't you see, Monsieur Vollard, that if I put something there by guesswork, I might have to paint the whole canvas over starting from that point?"[57]

This remark captures not only the painstaking work that Cézanne brought to painting his canvases, but also his uncompromising precision. A similar sense of effort was noted by Gasquet, who accompanied Cézanne to the motif on at least one occasion in the mid-1890s. "Cézanne," he reported,

> . . . applied himself without reserve, he put everything he had into each of his brushstrokes. One has to have watched him painting, painfully tense, his whole face suggesting prayer, to conceive how much of his soul he put into his labor. His whole being trembled. He hesitated, his forehead congested as if swollen with his visible thoughts, his head and shoulders braced, his neck low in his shoulders, and his hands quivering until the moment when – solid, spontaneous, delicate – they placed the stroke, assured and always from right to left. He drew back a little then to consider, and his eyes referred again to the objects; slowly they passed around them, related them to one another, penetrated and grasped

107 *Chemin des Lauves: The Turn in the Road*, 1906, graphite and watercolor on paper, 18⅞ × 24⅞ in. (48 × 63 cm). Princeton University Art Museum, Lent by the Henry and Rose Pearlman Foundation. Photo © Bruce M. White

them. With a wild look, they fixed on one point. "I can't tear them away," he said to me one day . . . "they're so tightly glued to the point I am looking at that it seems to me they are going to bleed."[58]

Bernard confirmed this image of Cézanne as an intense oil painter in his comments about a still life that he saw in Cézanne's studio during his visit in 1904:

> He was working on a painting of three skulls on an oriental rug. He had been working on it for a month from six until ten-thirty every morning, returning to Aix to have lunch, and then coming back to paint again at his motif until five o'clock. Then he had supper and went immediately to bed. At times I saw him so exhausted from work that he could no longer talk or listen. He went to bed in a disturbing coma-like condition but the next day he had always come out of

108 *Chemin des Lauves: The Turn in the Road*, 1906, oil on canvas, 25⅝ × 31⅞ in. (65 × 81 cm). Beyeler Collection, Basel. Beyeler Collection, Basel

it. . . . I saw him agonize in this way over the painting of the skulls, which I believe is part of his great testament, during the entire month I was in Aix. The colors and shapes changed in this painting almost every day, and each day when I arrived at his studio, it could have been taken from the easel and considered a finished work of art. In truth, his method of study was a meditation with brush in hand.[59]

This image of intensely focused working and reworking, therefore, had become closely tied to Cézanne's oil paintings by his late career.

In contrast to the painful and exhausting experience of working in oil, watercolor was light and even refreshing. This is the impression one takes from a comparison like the one between the watercolor and oil views of *Chemin des Lauves: The Turn in the Road*. In the oil painting, the motif has been rendered in dense, tar-like streaks of dark pigment, which calls to mind Cézanne's remark to Bernard that the oil painter must be in touch with the material side of his art: "One must be a painter by means of the qualities themselves of painting. One must use coarse materials."[60] It is also a reminder of his remark to Rivière and Schnerb during his visit with Cézanne in 1905 concerning the fact that he wanted to work with "thick paint" like Courbet.[61] The smoldering intensity of the dark browns, reds, and greens in the oil painting is directly opposed to the light and brilliant effects presented by the watercolor, despite the fact that the watercolor is also highly developed. If watercolor was a means for Cézanne to sensitize his eye to the subtleties of light and air in preparation for his oil paintings, therefore, it also provided him with an opportunity to give an alternative, lighter, and less obsessively built-up account of the envelope in a medium that, in its physical and aesthetic qualities, was the very opposite of opaque oil painting.

Facing page: detail of pl. 107

Vollard's Exhibition of Cézanne's Watercolors in 1905

The first exhibition devoted to Cézanne's watercolors was planned for 1902. It was Vollard who had the idea and who suggested holding the exhibition in his gallery. Cézanne's watercolors had been shown publicly only twice before. Three of his early, *couillard* watercolors had been shown at the Impressionist exhibition of 1877. A handful of watercolors had also been included in his first solo show in 1895, organized by Vollard. That Vollard was making plans for the new show as early as January is evident in the following letter written to the dealer on the twentieth of the month by Cézanne's son. He begins with expressions of gratitude for a case of wine that the dealer had delivered to the Cézannes during a recent visit, then pauses to give news of two oil paintings that his father was currently working on, and finally mentions the planned watercolor show:

> My dear Monsieur Vollard,
>
> Yesterday evening we received your delightful gift. We tasted it immediately and under its beneficent influence declared unanimously that you were *indeed a fine man*. So I send you the warmest thanks of the whole family for the pleasure of tasting your precious liquid. I fear that it will not acquire much age.
>
> The bouquet is still progressing, and it seems to me better than when you saw it two weeks ago, when it was still transitional. I haven't seen the landscape again, but it is supposed to be going quite well.
>
> I am digging through the paternal packages right now. I hope to find some watercolors in a finished state to add to those you plan to exhibit at my return to Paris.
>
> My parents send you cordial greetings, and I, dear Mr. Vollard, my best wishes,
> Paul Cézanne f.[62]

This letter gives insight into the cordial relations between Vollard and the Cézanne family. Vollard had a stake in retaining Cézanne's loyalty with gifts, and Cézanne was happy to limit his exposure to the art market to his interactions with this "at once sincere and serious" dealer.[63]

The idea for an exhibition of Cézanne's watercolors was probably discussed during Vollard's January visit to the Cézannes.[64] It may have been inspired by the gift that Vollard made to Cézanne, during his visit, of a watercolor by one of Cézanne's favorite painters, Delacroix. The work in question was *Bouquet of Flowers*, a watercolor dating from 1848–49 (pl. 109). Cézanne probably first saw the watercolor in the posthumous auction of Delacroix's drawings and watercolors in 1864, in which it figured prominently; and he would certainly have seen it in Chocquet's personal collection in the 1870s. Something of the scale of the deep and lasting impression that this watercolor made on Cézanne is indicated by the fact that, among all the works in Chocquet's extensive collection, it was only this watercolor that Cézanne advised Vollard to acquire at the posthumous auction of Chocquet's collection in 1899.[65] Vollard followed Cézanne's advice, won the bid for the watercolor and, subsequently, made a gift of it to Cézanne during his visit in 1902.[66] Bernard also noted Cézanne's interest in the watercolor: "He had always admired it at the home of his old friend the collector, and had often drawn from it fine lessons in harmony. He took very great care of this watercolor; it was framed and, to avoid discoloration by light, he had turned it toward the wall, within easy

reach."[67] In his own letter to Vollard, following his visit, dated three days after his son's missive, Cézanne made reference to the watercolor:

> Dear Monsieur Vollard,
>
> We received the case of wine you were kind enough to send us a few days ago. Since then, your last letter has arrived. I am still working on the bouquet of flowers, which will probably take me up to around the fifteenth or twentieth of February. I will have it carefully packed and send it off to you, rue Laffitte. When it arrives, please be so good as to have it framed and to submit it officially.
>
> The weather is very changeable; sometimes good sun, followed by unexpectedly heavy, slate-gray clouds, which makes landscape work difficult.
>
> Paul and my wife join me in thanking you, and I very much on my behalf, for the magnificent gift of the great Master's work you have given me.
> Best regards,
>
> Paul Cézanne[68]

I will return to Cézanne's reference to a canvas of a bouquet of flowers momentarily, but for the time being it is the reference to the gift of the "great Master's work" that indicates that Vollard had not come to Aix bearing only a gift of wine.

It seems only natural that the excitement surrounding the gift of Delacroix's watercolor would lead to conversations about Cézanne's watercolors and, indeed, to hatching the idea of an exhibition devoted to them. Although Cézanne's approval was certainly essential to move forward with such an idea, it was most likely a conversation held mainly between Cézanne's son and the art dealer. It was the son who, in the above letter, mentioned that he was "digging through the paternal packages" in search of "watercolors in a finished state" for the planned exhibition. It is noteworthy that Cézanne's son's search was for "finished" watercolors. Given the fact

that Cézanne rejected conventional notions of finish as anathema to his art, his son must have meant something more like "worked up" or "complete" than finished, in the sense of polished and brought to a conclusion.

Cézanne's apparent lack of involvement in planning the exhibition repeated his pattern of generally staying out of the business of exhibiting his work, unless it was to send canvases to the annual Salon. As I showed in Chapter One, in his early career Cézanne's artistic efforts were dominated by working on canvases to be submitted to the annual Salons, from which they were invariably rejected. Cézanne was also certainly responsible for deciding which works he contributed to the Impressionist exhibition of 1874, although he was probably influenced by conversations with friends and, especially, Pissarro. In 1877, however, Cézanne bowed out of the decision-making process, allowing the collector Chocquet to make a selection from among his collection of Cézanne's canvases and watercolors to hang in the exhibition. Likewise, there is no evidence that Cézanne was in any way involved in the decisions about what would be included in or excluded from Vollard's 1895 exhibition. And he exhibited the same nonchalance in a letter to Denis, who had asked him to submit a work to the Salon des Indépendants in 1902. In response to Denis' request, he replied: "This is to inform you that upon receiving your letter of the fifteenth [of March], which touched me very much, I immediately wrote to Vollard instructing him to place at your disposal any canvases that you find suitable for showing at the Independents."[69] It must be noted, however, that all of this contrasts strikingly with Cézanne's enthusiasm for submitting a canvas to the upcoming Salon. During his visit to the Cézannes in 1902, Vollard seems to have encouraged Cézanne to make another attempt at official recognition. Cézanne *fils'* remarks about a mysterious canvas of a bouquet that was "progressing" and was "better than when you saw it two weeks ago" is a reference to this Salon-bound painting. Cézanne also referred to it in his letter to Vollard on January 23, in which he noted that he was still working on the canvas but would soon be sending it to Vollard so that he could frame and "submit it officially." In a letter dated April 2, Cézanne wrote again to Vollard, however, explaining that the canvas, which he now referred to as *Roses*, would not be ready in time for the Salon: "Although I would very much have liked to have submitted something to the 1902 Salon, I am putting off that plan again this year. I am not happy with the final result."[70]

Although no evidence exists to explain the delay, the watercolor exhibition was postponed and did not ultimately take place until the summer of 1905. Once again, it was Cézanne's son who was the main liaison with Vollard. In a letter to Vollard, dated April 20, 1905, Paul *fils* speaks about photographs of Cézanne's work that have recently arrived, as well as a list composed by his father of works that he was offering for sale – "very reasonable!," he exclaims, like a seasoned salesman. He also makes reference to framed watercolors and drawings that Vollard is planning to exhibit:

Dear Mr. Vollard

The case with the five albums of photographs arrived three days ago in good shape. I haven't told you sooner because of a bit of rheumatism in my right shoulder.

I have just heard from Guillaume that you have picked up the watercolors and drawings from the framer that you are planning to use in the forthcoming exhi-

bition. I have been asked to send you the enclosed list of a collection of good pictures, more or less authentic, for sale, very reasonable!

I must ask you to hold on to the still lifes you have on consignment, my father being not at all sure he wants to part with them just yet.

My father and my mother say hello, and a cordial handshake from me.

<div align="right">Paul Cézanne f.[71]</div>

The show took place in June. The first notice made of the exhibition in print appeared in the June 17 number of the supplement to the *Gazette des Beaux-Arts*, the *Chronique des arts de la curiosité*. Under "Expositions nouvelles," the anonymous author lists among other concurrent exhibits the following: "Exhibition of watercolors by M. Paul Cézanne, galerie Vollard, 6, rue Laffitte, until June 17."[72] Given the date of the publication, however, not much time was left for the interested reader to squeeze in a viewing. In the issue of July 1 of the same chronicle, a second notice appeared on the show, suggesting that it may have been extended. Under the rubric "Petites expositions," the author, this time identified as Roger Marx (the article is signed R. M.), wrote under the heading "Exposition Paul Cézanne (Galerie Vollard)" the following appreciative lines:

> Watercolor is for M. Paul Cézanne a pastime and at the same time a form of preliminary documentation for his paintings. Intimate works, made by the artist for himself, they are noteworthy for their intensity of vibrant and soft color. At the same time, the artist's unique ability to animate matter in limpid atmospheres is also in evidence. The imperious and accessible beauty of these watercolors will not fail, I imagine, to gain for M. Paul Cézanne the appreciation of those whom his oil paintings have been, to our taste, too slow to conquer.[73]

Exactly what watercolors Vollard exhibited in 1905 has not been determined and there was no catalogue published.[74] There do not appear to have been drawings included in the exhibition, despite Paul *fils*' reference to them in his letter.

Only two additional references to the exhibition appeared in the press. A review by the Belgian critic André Fontainas appeared in the Symbolist journal *Mercure de France* on July 1, 1905:

> Cézanne's watercolors are revealed to us at a time that is propitious for the artist's glory and for our pleasure. Works that are precious, gracious. The master amuses himself. But his diversions are wondrous marvels and beautifully instructive. They make play with bold blues, pure whites, clear yellows – still lifes, flowers, landscapes, and they sometimes give the illusion of painted porcelain, of delicate iridescent opals. Others, with only a few touches of color, are admirable drawings marked with that novel primitive character discerned everywhere by eyes that are, one might say, forever newborn. There are also female nudes, or scenes with numerous figures. These little pictures come from a broad span of time and many were refused from certain exhibitions. Today they look like synthetic vignettes illustrating the margins of the vast book written by the artist each day of his unfolding life: an unfinished and interminable book, but one that is finished with every page.[75]

The second reference, by Denis, appeared in a review of the Salon d'Automne of 1905, in the course of which the author paused to refer to the recent exhibition of Cézanne watercolors:

110 Maurice Denis, *Homage to Cézanne*, 1900, oil on canvas, 71 × 97⅝ in. (180 × 240 cm). Musée d'Orsay, Paris. Photo © Réunion des Musées Nationaux / Art Resource, NY

Recently we saw from him, at Vollard's, a collection of watercolors solidly based on vivid contrasts against backgrounds washed with Prussian blue; the definitive tone of these sketches, as composed and constructed as his paintings, was already quite developed, powerful, and admirably resonant. One would have said they were old faience. Landscapes in the same group showed extensively drawn trees and buildings over which played a white light rendered more intense by violet and deep yellow shadows, nuanced and shimmering.[76]

Denis had been an admirer of Cézanne since the late 1890s and had made his sentiments known in a large canvas, *Homage to Cézanne*, exhibited in 1900, in which a group of young painters, including Denis, gathers around a canvas by Cézanne in Vollard's gallery (pl. 110).

The common theme of these reviews is the uniqueness of Cézanne's watercolors as at once carefully constructed and vibrantly luminous. Marx wrote of the "vibrant and soft" color in the "intimate" watercolors on display, in which could be seen the artist's ability "to animate matter in limpid atmospheres." Fontainas also mentioned the colors in the watercolors, speaking of the "play" of "bold blues, pure whites, clear yellows." And Denis spoke of the Prussian blue backgrounds that included "vivid contrasts" of violet and yellow, "nuanced and shimmering." Both Fontainas and Denis also noted the presence of drawing in the watercolors: Fontainas spoke of watercolors "with only a few touches of color" that were "admirable drawings"; Denis referred to landscapes "in the same group" that showed "extensively drawn trees and buildings." For all three writers, there was a clear sense that the watercolors offered something unique that could not be found in the artist's oil paintings. Marx suggested that their "imperious and accessible" beauty would be more amenable to a public that was still hostile to his oil paintings. Fontainas suggested that the watercolors were "like synthetic vignettes illustrating the margins of the vast book written by the artist each day of his unfolding life." They were "marked with that novel primitive character discerned everywhere by eyes that are, one might say, forever newborn." This mode of easy and unbiased seeing must be contrasted with the comments, cited above, about the difficult, exhausting, and even painful experience of

seeing embedded in Cézanne's oil paintings. And although in his remarks Denis spoke of Cézanne's watercolors as being "as composed and constructed as his oil paintings," the rest of his description highlights precisely those aspects of Cézanne's watercolors that are farthest from the opacity and density of his oils.

I want to underscore Denis' reference to white light in the last line of his remarks: "Landscapes in the same group showed extensively drawn trees and buildings over which played a white light rendered more intense by violet and deep yellow shadows, nuanced and shimmering." Fontainas also noted the play of white light in the watercolors in the exhibition: "They make play with bold blues, pure whites, clear yellows." One of watercolor's greatest resources was, indeed, the "reserve," or blank paper surface. In some respects, it is this element of watercolor that sets it most definitively off from the physical conditions of oil painting. It is the active role played by the exposed, untinted paper sheet that presents the most convincing evidence of all that Cézanne's watercolors were not only a tool to help him train his eye for his oil paintings, but that they were also a compelling means to generate a very different, in some ways opposed image of the envelope of light and air. In the next part of this chapter, I will consider the way in which Cézanne exploited the brightness of the paper surface in order to generate effects of luminosity that reached far beyond what he could achieve in his oil paintings. In order to do this, I now want to turn to what is in many respects the most impressive group of Cézanne's late watercolors and oil paintings, namely, his multiple views of Montagne Sainte-Victoire seen from the Les Lauves heights near his studio.

Brilliance, Blindness, and the "Reserve"

When Bernard appeared at Cézanne's door for the first time in 1904, Cézanne was on his way to make a watercolor of the impressive view of Montagne Sainte-Victoire afforded by the eastern slope of the Les Lauves hill. In his memoirs of the visit, Bernard recounted that he reached Cézanne's house on the rue Boulegon just as the artist was setting out for the motif and that Cézanne invited him along. They walked first to the studio, explained Bernard, where Cézanne collected his water-color materials, and then headed out *sur le motif*: "It was two kilometers away, a view of a valley at the foot of Sainte-Victoire, a powerful mountain that filled him with admiration and that he never ceased to paint in watercolor and oil."[77] That first day, Bernard reported, he chose not to remain with Cézanne "so as not to bother him in his work."[78] The next day, Cézanne set out again with Bernard *sur le motif*: "That day he was going off to work again on his watercolor of Sainte-Victoire."[79] Feeling more at ease with the Aix master, Bernard decided this time to stay. "'I have rented a room in Aix for a month,' I told him, while he was apply-ing color with care and reflection to his watercolor, 'Where?' he asked – 'At Madame de S . . .'s, rue du Théâtre.' It turned out she was one of his friends."[80] Peering over his shoulder while talking, Bernard watched as Cézanne built up his watercolor with patches of translucent color applied with "care and reflection":

> His method was unique, excessively complicated, and totally different from usual techniques. He began on the shadows with a single patch, which he then over-lapped with a second, larger one; and then with a third one, until these patches, which produced screens, modeled the object by way of coloring it.[81]

III *Montagne Sainte-Victoire Seen from Les Lauves*, 1902–06, graphite and watercolor on paper, 18 ⅞ x 25 in. (48 × 63.2 cm). Oskar Reinhart Collection, Am Römerholz, Winterthur, Switzerland

It is unclear which of the nineteen known watercolor views of Montagne Sainte-Victoire seen from Les Lauves Bernard watched Cézanne work on in 1904.[82] It may have been the watercolor illustrated here, now in the Oskar Reinhardt Collection, am Römenholz, Winterthur (pl. III). The prospect offered by the watercolor moves precipitously over a group of foreground trees and rapidly passes over a patchwork of intervening fields and clusters of trees, punctuated here and there by farmhouses. The landscape flattens and fades as it reaches the base of the towering mountain, the triangular shape of which leads up toward the craggy summit, where it then drops off to the right as it meets the Montagne de Cengle.

The watercolor appears at first to be in broad agreement with Bernard's description of Cézanne's technique: there is clear evidence of a procedure of overlapping, independent strokes of color. It is also evident that, at least in some places, such as the mountain face, Cézanne began with shadows. The term screens, or, in

French, *écrans*, which Bernard uses to describe the linking of the patches into sequences, captures well Cézanne's habit of building up certain areas in terms of repeated strokes of varying hues. This is visible in this watercolor in the right foreground, where bunches of variously green, blue, and yellow touches of color have been set down in an effort to evoke the dense foliage of pine trees as they cluster around the form of a red-roofed house. But this reference to screens by no means is an exhaustive account of the range and variety of marks Cézanne applied in making the watercolor. Cézanne also used individual strokes of color, for instance, in certain key places, such as those that appear here and there in the middle distance representing the conical forms of cypress trees, a fortuitous analogy between the tapered shape of the brush and the shape of the trees. Still other strokes of the brush were put down in a more diluted manner and perhaps even with a broader paintbrush, such as the sopping wet strokes that have stained the page along its lower edge and also those that appear in the sky. To indicate the recession of the landscape, Cézanne applied color in short, horizontal or diagonal strokes throughout the receding plane to suggest the lay of the land as the eye steps slowly into depth. Some of these strokes seem to have been made with the tip of a thin brush, such as the emerald green line just below and to the right of the centermost clump of trees. Similarly saturated and incisive strokes of the paintbrush have been used to apply madder red and Prussian blue lines in other places in the middle ground, where Cézanne sought to convey topographical breadth and spatial recession. Other such strokes of the brush have been brought to bear with much less density and, as a result, they seem to float unanchored above the paper sheet, such as the broad touches of emerald green that appear in places on the far left side of the page, some of which point vertically and others of which rotate diagonally and horizontally. Add to these marks the squiggly contours in the foreground and right middle ground, lines rendered in the full gamut of Cézanne's palette and that indicate the limits of arboreal forms, and one begins to get a sense not only of the wide range of saturation of pigment but also the variety of directionality and thickness of mark that the artist employed in the process of working up his watercolor.

If Bernard said nothing about the preliminary drawing in the watercolor he was watching, it was because Cézanne had already moved on from this first stage of working to color by the time Bernard had a chance to watch him work. And if Cézanne brought back the pencil on top of his color in this watercolor, Bernard either did not see it or did not consider it to be noteworthy. It is perhaps more curious, then, that he made no mention of the active role of the reserve in Cézanne's watercolor technique. The use of the paper surface as "reserve" was frequently identified as one of the defining elements of pure watercolor. Already in Blanc's *Grammaire des arts du dessin*, he noted that the difference between opaque gouache and pure watercolor turned on the use of the white ground as a source of illumination:

> What distinguishes gouache from watercolor is that with gouache one may paint on a colored ground, producing highlights with thick touches, which is to say that the painter covers the entire surface of the picture with color. With watercolor, the artist, working on a white ground, reserves the whiteness of this ground to produce his highlights. Because there is no density to his medium, the watercolorist washes his colors onto the paper rather than building them up.[83]

112 Eugène Delacroix, *Cloud Study*, 1824–26, watercolor on paper, 10¹¹⁄₁₆ × 15⅝ in. (27.2 × 39.8 cm). Musée du Louvre, Paris. Photo © Réunion des Musées Nationaux / Art Resource, NY

The difference that Blanc is insisting upon here is at once one between density and diaphanousness, as well as between active and inactive paper support. A watercolorist traditionally had several means to reserve the lightness of the paper surface: he or she could lift out, rub out, or even scratch out pigment. To avoid these retroactive steps and the possible damage they might cause to the delicate paper surface, one could also stop out pigment in advance or simply leave patches of the paper untouched from the beginning. This last procedure was considered the most difficult, but also the best method of reserving the white of the paper. In her handbook on watercolor, published in 1851, Madame Cavé reported conversations with Delacroix, in which he noted the difficulty of managing the white of the paper and especially in making clouds and skies:

> The most skillful watercolorists approach [skies] with trepidation. One must achieve both color and form with but a single stroke of the brush. A retouched sky is a ruined sky. Because clouds are indicated by reserving the white of the paper, one must outline them precisely while painting the background of the sky, which should be flawless. So you see, all the difficulty lies in the execution.[84]

We can see something of what Delacroix had in mind in a watercolor study of a sky with clouds, which gives a clear sense of the way in which washes of color outline areas of reserve negatively, using the unpainted paper as the positive form of the cloud (pl. 112). The presence of ample areas of white paper was generally considered to be one of the ways to tell real watercolor from false watercolor. As one handbook put it in the 1880s: "According to the rules of true watercolor, that is, of transparent colors, it is the paper itself that must be used for highlights and for pure whites."[85]

In his early career, Cézanne tended to alternate between gouache and the paper surface as the source of highlights in his watercolors. Looking back to *The Climbing Road*, discussed in Chapter One, this combination is clearly visible in the use of the beige paper and the bright, chalky highlights applied with white gouache, or Chinese white. Cézanne continued to mix gouache and watercolor in his Impressionist watercolors, such as *The Château of Médan*, in which he used white gouache to depict clouds, rather than following Delacroix in the difficult use of the

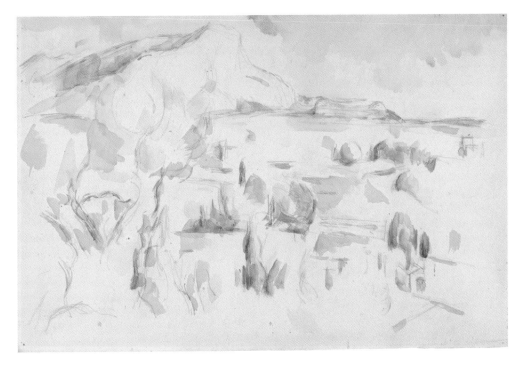

113 *Montagne Sainte-Victoire*, 1904–06, graphite and watercolor on paper, 12¼ × 18¾ in. (31 × 47.6 cm). Princeton University Art Museum, Lent by the Henry and Rose Pearlman Foundation. Photo © Bruce M. White

white of the paper. Although he never entirely abandoned white gouache as a means to generate highlights, in the 1890s he turned increasingly to the lightness of the watercolor paper as his main resource of brightest illumination. This was visible in the still lifes discussed in Chapter Three, including *Flowers in a Vase* and *Three Pears*. In the Winterthur view of Montagne Sainte-Victoire seen from Les Lauves, Cézanne continued to use the white paper surface as an active element. The active role of the reserve is evident in the way in which Cézanne has left white parts of the face of the mountain, which suggests that these are the lightest parts of the picture. We can detect Cézanne's process of building areas of reserve into his watercolors if we consider a watercolor view of the mountain that has been left at an earlier state of development. The view appears to have taken Cézanne further up the road, where his perspective on the mountain became more oblique. The watercolor, now in the Henry and Rose Pearlman Foundation, is very slight and leaves a great deal of the paper surface untouched (pl. 113). First the pencil and then the paintbrush picked over the page to establish rhythms of shadow, local colors, and full light. Intense cobalt blue touches, like the vibrant blue contours in Cézanne's still-life watercolors, punctuate the expanse of paper with a pattern of airy shadows. To these shadows have been added a subsequent application of mainly green, and also red and yellowish strokes of the paintbrush, all of which indicate local hues and reflections. The ample pattern of white paper signifies as areas of full light that fall off the chromatic scale. Cézanne has given the blank paper surface an active role in the image in at least two distinct ways: on the one hand, spots of exposed paper indicate bright areas in the image, as in the exposed face of the mountain in the distance or in the walls of the farmhouses below it; on the other hand, other areas of blank paper function not as references to bright areas, but as a structural integument that enhances the overall luminosity of the watercolor. We can compare this second, structural use of the paper surface to the similar use of the paper surface in Paul Signac's roughly contemporary watercolor views of the south of France, such as that of his garden in

114 Paul Signac, *The Garden of the Artist's House, Saint-Tropez*, 1900, watercolor and ink on paper, 12⅟₁₆ × 15¾ in. (30.6 × 40 cm). Arkansas Arts Center Foundation Collection, Gift of James T. Dyke. Photo © Arkansas Arts Center Foundation Collection

Saint-Tropez (pl. 114). The margin of white paper that appears between the strokes of color in Signac's watercolor does not refer to actual white light, but operates instead as an interconnecting tissue of luminosity that enhances the intensity of the watercolor. Signac described the function of the use of the reserve in the following way: "There can be no beautiful colors in watercolor if one does not bring the white of the paper into play, not only by means of transparency, but also in deploying it in various amounts as a margin around each touch of color. This luminous intermediary intensifies each hue and harmonizes it with its neighbor."[86] What comes into action here, he explained, is the perceptual phenomenon of the simultaneous contrast of colors:

> Two colors placed side by side modify one another in either advantageous or disadvantageous ways by means of contrast. In the latter case, the blank spot will function as a protective area. If one juxtaposes a blue and a red touch the combination will be inharmonious; but if, between these two hostile colors, one leaves a white margin of reserve, the two colors will harmonize and their reciprocal intensity will be increased through contrast with this white surface. This play of colors and blank areas is always pleasant to the eye. Certain colors only conserve their quality if they are surrounded by white. A yellow or an orange will lose all meaning, all force, if the eye cannot compare it to a surrounding white area. Contrary to the rules, therefore, one must not be afraid of leaving blank spots.[87]

Signac's remarks betray his familiarity with studies of the optical effects of color contrasts and, especially, the work of the chemist Chevreul, which had been one of the fundamental theoretical keystones of Neo-Impressionism in the 1880s.[88] Cézanne's use of the white paper as a luminous integument is less calculated and more intuitive than that of Signac. Cézanne appears never to have read color theory and he strongly disliked the idea of applying theoretical systems in the making of art. Nevertheless, the effect he arrives at is similar to that of Signac: an insertion of filaments of bright light into the intervals between colors, which enhances the overall luminosity and intensity of his watercolors.

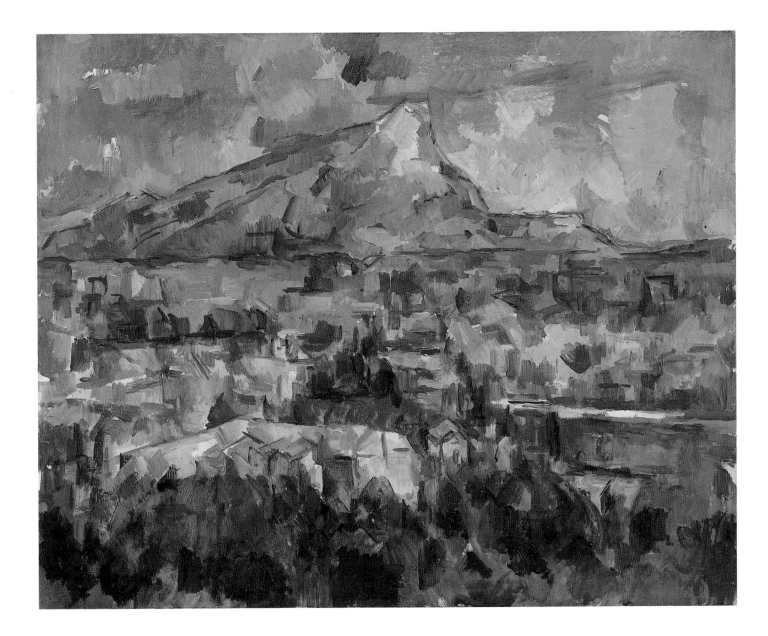

115 *Montagne Sainte-Victoire Seen from Les Lauves*, 1904–06, oil on canvas, 27½ × 35¼ in. (69.8 × 89.5 cm). The Philadelphia Museum of Art, The George W. Elkins Collection, 1936. Photo © The Philadelphia Museum of Art

Cézanne's watercolor views of the mountain relate to a series of oil paintings that he painted from roughly the same vantage point on the Les Lauves hill. One of these shows the mountain from much the same angle as shown in the Winterthur watercolor (pl. 115). The similarities between the watercolor and the oil painting are striking: the strokes of paint in the oil painting have been applied in essentially the same range of gestures and strokes as in the watercolor. The same impression results from comparison of two additional watercolor and oil views of the motif, in which Cézanne has used a vertical format to capture the imposing form of the mountain (pls. 116 and 117). Here again there is a close parallel in paint handling, including similar sequences of hatching strokes in the foreground and elsewhere, independent strokes of the brush representing trees, horizontal strokes that step the eye into space, and bluish contours that appear in broken dash-like sequences along the profile of the mountain and elsewhere. New in these views, however, are the indications of a foreground hillside and a *repoussoir* of trees on the left side of the picture, rendering this a more grounded point of view than the hovering perspective depicted in the first pair.

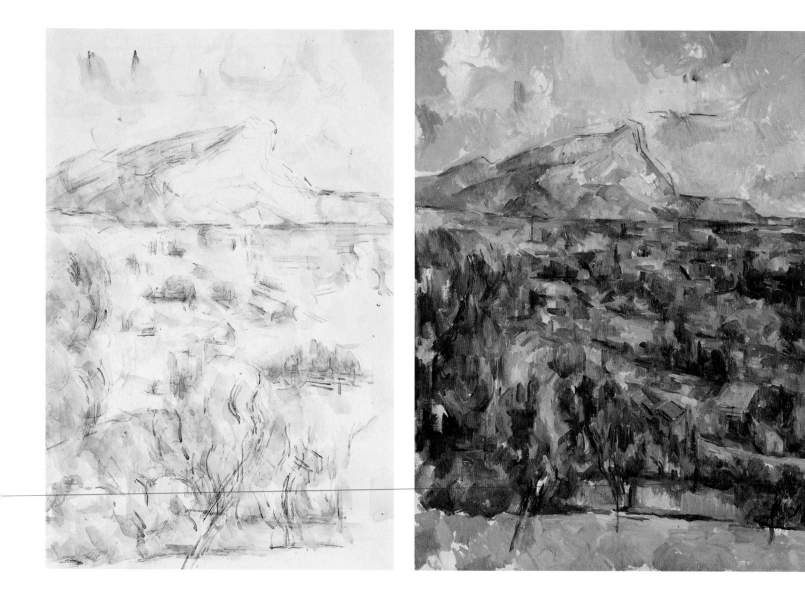

116 (above left) *Montagne Sainte-Victoire Seen from Les Lauves*, 1904–06, graphite and watercolor on paper, 18½ × 12⅜ in. (47 × 31.4 cm). The Philadelphia Museum of Art. Photo © The Philadelphia Museum of Art

117 (above right) *Montagne Sainte-Victoire Seen from Les Lauves*, 1904–06, oil on canvas, 33 × 25⅝ in. (83.8 × 65.1 cm). Princeton University Art Museum, Lent by the Henry and Rose Pearlman Foundation. Photo © Bruce M. White

Once the twinkling network of white paper has been added to Cézanne's repertoire of tools for rendering the envelope, however, it becomes clear how different the effect of Cézanne's watercolors is from that of his heavier, opaque oil paintings. Areas of exposed, unpainted canvas also appear in many of Cézanne's canvases of the view of the mountain seen from Les Lauves. They are visible, for instance, in the vertical, Pearlman canvas. They also appear in a view now in the Kunsthaus, Zurich (pl. 118). The areas of exposed canvas in these and other oil paintings, however, do not give rise to the same results as the white areas of blank paper in Cézanne's watercolors. Instead of becoming infused throughout the image as a brilliant network of luminosity, the areas of exposed canvas emerge as interruptions and breaks in the fabric of the painting. If it is much harder to see these breaks as an active part of the work of art in the oils than in the watercolors this is because the presence of the canvas is hidden from view in the rest of the painting. In watercolor, conversely, the presence of the paper surface is always present behind the translucent touches of color. As Roger Fry put it in his study of Cézanne's art: "In water-colour we can never lose the sense of the material, which is a wash upon the paper."[89]

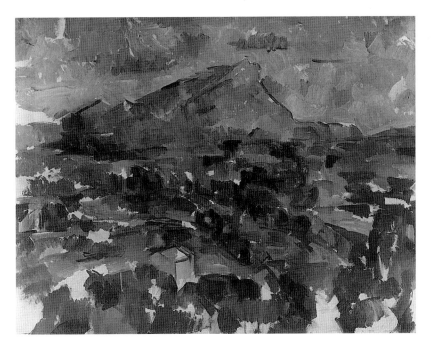

118 *Montagne Sainte-Victoire Seen from Les Lauves*, 1904–06, oil on canvas. Kunsthaus, Zurich. Photo © 2007 Kunsthaus, Zurich.

It was this luminous effect of the reserve, therefore, that Fontainas and Denis seem to have had in mind in their references to white light playing through Cézanne's watercolors in the exhibition of 1905. And in these watercolors of Montagne Sainte-Victoire, the bright, exposed paper captures something of the blinding intensity of the light of the south of France. One of the things that watercolor allowed Cézanne to accomplish that was barred from his denser and darker oil paintings was to achieve a closer approximation to the intensity and luminosity of the blinding light of the Midi. To recall the terms he used in his letter to Gasquet in 1896, this regional light "makes your eyes squint while enchanting your sensory receptors." Cézanne's use of the white paper in his watercolors enhances the effect of the envelope and, at the same time, it represents his interest in something more, something closer to the blinding effect of direct southern sunlight. The harsh, reverberant light of the south, Cézanne told Gasquet, dazzles the eye and exceeds its receptive capacity, causing the viewer to squint. But it also enchants the eye, drawing it closer like a moth to a flame, heightening sensation while exposing it to its limit.[90]

As Light as the Paintings Are Heavy

After Cézanne's death, his son sold the watercolors left in his studio to Vollard and to the Bernheim-Jeune brothers. While Vollard did not hold an exhibition of the watercolors, the Bernheim-Jeune brothers did decide to display them. One of the only references to the exhibition appears in a letter, dated June 28, 1907, written by the poet Rainer Maria Rilke to a friend. In the letter, he described his experience of viewing the selection of Cézanne watercolors. "Bernheim Jeune is exhibiting Cézanne watercolors," he explained to his friend, "which I saw yesterday." "The watercolors are very beautiful," he continued, "Just as confident as the paintings, and as light as the paintings are heavy. Landscapes, very light pencil outlines, and,

here and there, as if just for emphasis and confirmation, there is an accidental scattering of color, a row of spots, wonderfully arranged and with a security of touch: as if mirroring a melody."[91] This seems to have been Rilke's first exposure to Cézanne's watercolors. He had first seen paintings by Cézanne seven years earlier at an exhibition at Paul Cassirer's gallery in Berlin, but seems not to have been much attracted by the work of the "peculiar Frenchman," as he described Cézanne at the time.[92] It was not until 1907 that Rilke developed an enthusiasm for Cézanne's art. He was, for instance, a frequent visitor to the retrospective of Cézanne's art at the Salon d'Automne in Paris in the fall of 1907. In a series of celebrated letters to his former wife, Clara Westhoff-Rilke, the poet detailed his developing grasp of Cézanne's canvases in the exhibition. "For a long time nothing," he confided, "and suddenly one has the right eyes."[93]

Rilke's remarks about the watercolor exhibition are brief but suggestive. In their lightness and precision, he told his friend, Cézanne's watercolors exuded equal amounts of deliberateness and spontaneity, preserving the strong sense of purpose that is usually associated with Cézanne's art while offering relief from the intensity of the oil paintings. They are, he explained, "as light as the paintings are heavy." With the term "heavy" Rilke called forth a sense both of the physical build up of oil paints and their dense opacity. In contrast, the watercolors, he explained, are "light," which suggests as much a sparse use of drawing and color as it does lightness and transparency of pigment. The transparency of Cézanne's watercolor pigments allowed the network of linear marks that shared the page to show through them and play a crucial role. Indeed, Rilke spoke of "very light pencil outlines" that were confirmed and emphasized with "an accidental scattering of color." Looking at a watercolor by Cézanne, Rilke proposed, was like listening to the drifting notes of an enchanting melody.

A handful of watercolors was also included in the retrospective exhibition devoted to Cézanne in two of the rooms of the Salon d'Automne of 1907, but Rilke made no mention of them in his letters commenting on this other exhibition (the Bernheim-Jeune show, which lasted from June 16 to 29, was closed by the time the Salon d'Automne opened on October 1).[94] The sense of lightness and delicacy in Cézanne's watercolors that Rilke witnessed in June gave way in his letters of October to a sense of the density and intensity of his oil paintings. In his letters to his former wife, he spoke of the monumental effect created by the paintings when seen together: "Today I went to see his pictures again; it's remarkable what an environment they create. Without looking at a particular one, standing in the middle between the two rooms, one feels their presence drawing together into a colossal reality."[95] The Salon-going public, however, he complained, seemed to be oblivious to the charms of Cézanne's art: "You should only see the people going through the two rooms, say on a Sunday; amused, ironically irritated, annoyed, outraged. And when they finally arrive at some concluding remark, there they stand, these Monsieurs, in the middle of this world, affecting a note of pathetic despair, and you hear them saying: il n'y a absolument rien, rien, rien."[96] In contrast, he stood in front of the Cézanne canvases with "unrelenting attention,"[97] a mode of reception that mirrored, he believed, the artist's own contemplative intensity: "an animal alertness which entertains an untiring, objective wakefulness in the unblinking eyes."[98] Rilke was not alone in discovering a demand for intense attention in Cézanne's oil paintings at the Salon d'Automne of 1907. As one critic wrote:

A painting by Cézanne is a willful and isolated object, which is sufficient to itself and which finds its highest expression within the boundaries of its frame; the handling is usually labored and stubborn, the effect conquered at the price of numberless recommencements. No facility, for Cézanne everything is a problem, and the answer, never established once and for all, is posed again with each stroke of the paintbrush. . . . From such a mode of painting results an impression of considerable strength, but also rather quickly one of tension as well, which can fatigue the spectator.[99]

Cézanne, he concluded, paints "like Sisyphus rolls his rock."[100]

The opposition that emerges between such references to rapt attention and fatiguing difficulty, on the one hand, and Rilke's remarks about the light and melodic effects of the watercolors, on the other – comments that agree with the consensus of the reviewers of the Cézanne watercolor exhibition held by Vollard just two years earlier – reinforces the opposition between the kinds of effects generated by Cézanne's work in the two mediums. What I have been stressing in this chapter is the unique means that watercolor offered Cézanne for rendering the insubstantial flux of light sensations as they rebound and refract in the atmosphere. Watercolor offered a range of strategies for achieving this that were distinct from oil painting or drawing *tout court*, and that mixed drawing, color, and the "reserve" in rendering the envelope. The result is an impression of a circulating, formless envelope of light and air, and a sense of naive wonder that is captured in Fontainas' expression: "eyes that are, one might say, forever newborn."

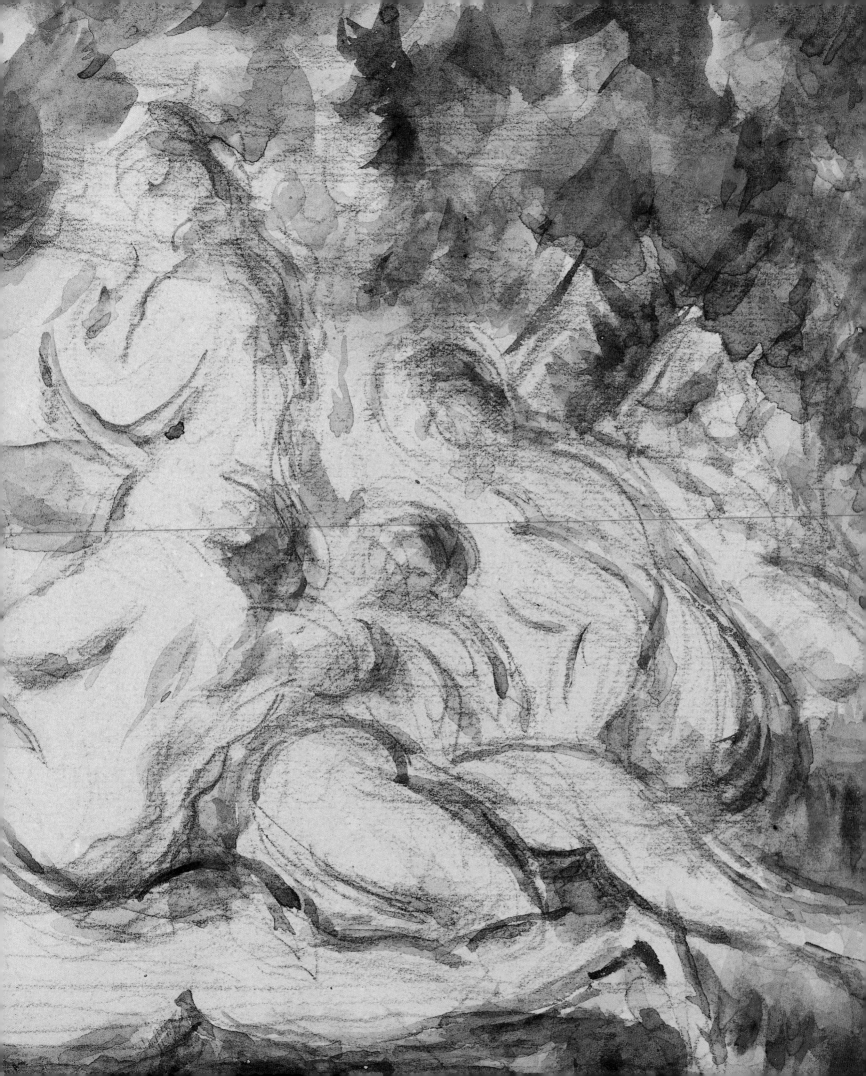

Five

Vital Sensations:
Cézanne's *Bather* Watercolors

In addition to working in the landscape near Aix and making still lifes and portraits in and around his Les Lauves studio, Cézanne also worked in his late career on the conception and execution of three large, ambitious paintings of female bathers in idyllic outdoor settings. These paintings were Cézanne's attempt to show that he was capable of more than representing nature and recording his sensations. They were meant to show that he was also an imaginative painter who could develop complex compositions based on the human form. Indeed, Cézanne never abandoned his desire, manifested in his early career, to execute large-scale, ambitious paintings. Moreover, bathing had already emerged in his early career as a favorite theme. The three bather canvases from his final decade, all of which are known by the title *Les Grandes Baigneuses* – the large female bathers – are among the largest works that Cézanne executed, suggesting that he had especially grand aspirations for them. It may be that he intended to send them to the Salon in Paris, to which he reportedly longed to be accepted.[1] Or, perhaps he hoped that by showing them at Vollard's gallery, the Parisian public would finally be won over by his art and would accept him as a great painter. As he told Bernard in a letter dated September 21, 1906, the goal of the painter was not only to express "what we see and feel through studying nature," but also "to make the public feel what we feel and to accept us."[2] Still an expression of his personal temperament – indeed, "temperament" remained a crucial term in his vocabulary in his late career[3] – these canvases were no longer aimed at confronting or challenging the viewer, as was the case with his early *couillard* art. They were now designed with the hopes of soliciting a sympathetic response.

This chapter focuses on the watercolor sketches that Cézanne executed in preparation for and in conjunction with these three canvases. Some relate directly to a specific canvas while others propose variations on the theme that were never taken up in oil. These watercolor sketches function in much the same way as did the early

Facing page: detail of pl. 130

watercolor sketches, discussed in Chapter One. Like these early sketches, Cézanne's late watercolors of bathers capture his *première pensée*. The vibrant combination of drawing and color that he developed in his late watercolor landscapes, still lifes, and portraits as a means to render his sensations of the flux of the envelope, discussed in Chapter Four, appears again in these contemporaneous watercolor sketches. The difference, however, is that, in these sketches, the shimmering and dynamic marks on the page refer to more than light and air: they also generate an effect of dynamic human movement. Cézanne's late watercolor sketches of bathers come to life with frolicking and reclining figures, variously standing, kneeling, crouching, walking, diving, etc. The differences between watercolor and oil painting emerge again in this final chapter as crucial to understanding Cézanne's attraction to watercolor and to understanding the unique insight his watercolors offer into the harmonious ideal that stood at the origin of *Les Grandes Baigneuses*.

Baigneuses and Baigneurs

In his book on Cézanne, Vollard recalled that it was around 1895 that the artist had begun working on his large canvases of female bathers[4]; Rivière and Schnerb reported a more precise date for the beginning of the project: "'I hardly dare admit,' he told us, 'but I've been working at it since 1894.'"[5] The two canvases now in the Barnes Foundation and the National Gallery of London respectively appear to have been begun at about the same time and were probably worked on simultaneously over the course of the ensuing decade. The third canvas, now in the Philadelphia Museum of Art, appears to have been taken up only a year or so before Cézanne's death in October 1906 (pls. 119–21).[6] Each painting shows a group of nude women gathered in a forest clearing near the edge of a body of water. The water is only implied in the Barnes and London canvases, whereas in the Philadelphia version a broad expanse of water – perhaps a river or a lake – can be clearly seen in the middle distance. In the immediate foreground of the Barnes and London pictures, apples in a basket and scattered on the ground, either plucked from the branches of nearby apple trees or brought along as part of a picnic, suggest the bounty of nature. A black-and-white dog dozes in the foreground of the first two canvases. In the less-developed Philadelphia version, three women reach toward an undefined object in the foreground, which we can safely assume was destined to be the dog. Finally, trees frame the figures in all three of the compositions, providing a proscenium under which they act out their drama of bathing.

In all of the canvases, the bathers are organized into two groups on either side of the composition. There are, however, important variations of pose and the number of figures among the canvases. In the Barnes painting, for example, the group on the left is made up of just three women: a striding figure, who enters the glade from a stand of trees on the left; a kneeling woman with her back to the viewer; and a third woman, who moves forward toward the viewer as she exits the water. In both the London and Philadelphia canvases, the group on the left is augmented by two additional figures, one standing and one either sitting or kneeling on the ground. The figures on the right side of the canvases range between six and eight figures, and their poses are subject to more variation from canvas to canvas than those of the figures on the left. In the Barnes and Philadelphia canvases, for

119 (right) *Large Bathers*, 1894–1906, oil on canvas, 133 × 207 cm (52⅜ × 81½ in.) The Barnes Foundation, Merion, PA. Photo © The Barnes Foundation, Merion, PA / The Bridgeman Art Library

120 (below left) *Large Bathers*, 1894–1906, oil on canvas, 50 1/16 × 77 3/16 in. (127.2 × 196.1 cm). National Gallery, London. Photo © Erich Lessing / Art Resource, NY

121 (below right) *Large Bathers*, 1906, oil on canvas, 82 × 99 in. (208.3 × 251.5 cm). The Philadelphia Museum of Art: Purchased with the W. P. Wilstach Fund, 1937. Photo © The Philadelphia Museum of Art

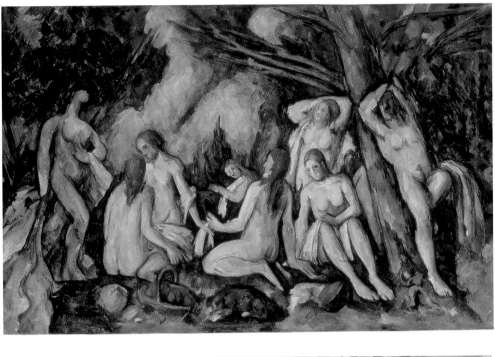

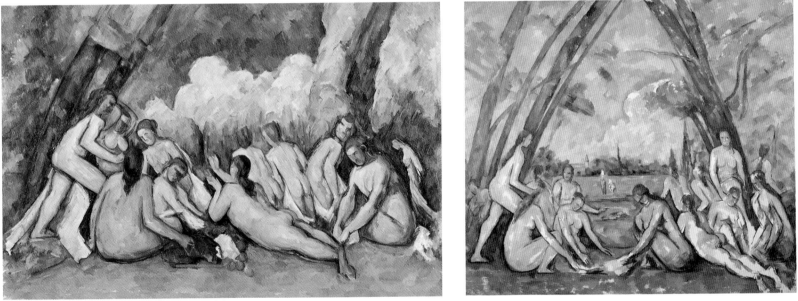

instance, a woman leans against a tree trunk, whereas in the London one this figure crouches and turns to look in the direction of the spectator. The rest of the figures on the right range in all three canvases between standing, seated, and kneeling figures, shown either entering the water in the distance or drying off after a dip. Finally, a prone figure appears only in the London and Philadelphia canvases. Although I have been describing the two sides of the composition as separate, Cézanne included in each canvas at least a minimal connection between them. In the Barnes canvas, it is a kneeling redhead who makes this connection, gesturing in response to her arriving friend on the left. In the London canvas, it is the prone figure – also a redhead – that functions as a hyphen, linking the two sides by dint of her posture and the fact that she faces to the left. Only in the Philadelphia canvas

do the two sides seem almost entirely shut off from one another. Contact is still made, however, through the intermediary of the still-unpainted dog in the foreground, which is caressed by figures from both left and right sides of the canvas. Consequently, despite crucial differences between the canvases, including an increase in the contingent of *dramatis personae* from nine in the Barnes canvas to eleven in the London picture to fourteen in the Philadelphia patinting; and an increase in the sizes of the canvases, from approximately 4 by 6 feet (1.2 × 1.8 m) for the Barnes canvas to approximately 4 by 6 feet 6 inches (1.2 × 2 m) for the London canvas to approximately 7 by 8 feet (2.1 × 2.4 m) for the Philadelphia canvas; the general theme remains constant: a multi-figure scene of imaginary female bathers swimming, drying off, or relaxing in imaginary landscape settings.

In order to grasp the significance of Cézanne's decision to make these major canvases of female bathers in his late career, we need first to consider his earlier explorations of the subject. Cézanne's interest in the theme of swimming and bathing dates back to his early career. In Chapter One, I mentioned the nostalgic references to youthful swimming excursions to the Arc river outside Aix-en-Provence in letters exchanged between Cézanne and Zola in the 1860s. As late as 1894, while filling out a society questionnaire most likely supplied to him by his friend Gasquet, Cézanne revealed his continued nostalgia for these swimming excursions: to the question "What is your favorite pastime?" he replied: "Swimming."[7] Nostalgia, therefore, was part of Cézanne's enthusiasm for the subject of outdoor swimming and bathing. As I argued in Chapter One, this is a good way to understand the impulse behind one of his earliest watercolors, *The Diver*, in which a lone swimmer is captured in mid-dive as he plunges into a body of water. Cézanne's treatment of the theme of male bathing continued in the 1870s with such canvases as *Bathers at Rest*, which he exhibited in the third Impressionist exhibition in 1877 (pl. 122). The static poses of the four male figures called to mind for at least one of Cézanne's supporters the grace of ancient Greek sculpture.[8] Detractors, conversely, found the figures ungainly and lacking in anatomical precision.

Cézanne would have known the male nude intimately, of course, from his studies at the Atelier Suisse, where he worked in the late 1860s. The drawings that he made at this studio were almost exclusively studies of the male nude in a range of non-traditional postures, from diving to reclining to striding. In the 1870s he also made a handful of studies of a single male bather, with one arm outstretched. This figure reveals his continued exploration of unconventional poses even after he had left the Atelier Suisse. Cézanne discovered still other examples of the male nude in his studies of sculpture at the Louvre, including Michelangelo's *Dying Slave* and Puget's *Mercury*, which he reproduced in drawings. Some of these poses are in fact repeated in his canvases of nude and semi-nude male bathers. In *Bathers at Rest*, the figure standing with his back to the viewer in the distance, with his arm cocked over his head, for instance, is clearly based on the pose of Michelangelo's sculpture in the Louvre.[9] The looming form of Montagne Sainte-Victoire in the background suggests a desire on Cézanne's part to ground the scene in the familiar landscape of his home region. It also indicates that this canvas, too, is at least in part based on memories of his youthful bathing outings.

Cézanne's interest in the theme of male bathing was paralleled by an interest in the theme of female bathing. Images of the nude, female body, however, at least in

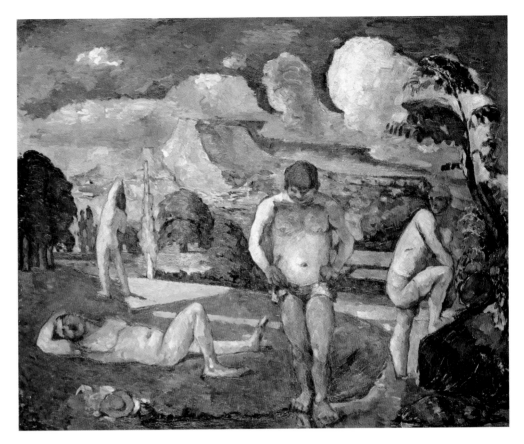

his early work, were usually associated with sexual violence or temptation. This is evident in early works such as *The Wine Grog* and *The Abduction*, and it remained the case in works executed during the next decade, such as *The Temptation of Saint Anthony*, *The Eternal Feminine*, and *The Battle of Love*. None of these images, however, is, strictly speaking, an image of bathing. Unlike the works just mentioned, Cézanne's studies of scenes of female bathers generally segregate them away from the opposite sex and set them in idyllic settings, as if such an operation were necessary to bracket carnal temptation.[10] Cézanne's first images of female bathers date from the 1870s. One of the earliest shows six nude women in the context of a river or pond framed by tall trees (pl. 123). The handling suggests a date in the mid-1870s, rendering it something of a pendant to *Bathers at Rest*. Some of the same poses seen in *Bathers at Rest* appear again in this painting, but now transposed to women. The low wall in the distance is reminiscent of the wall that ran the length of the property of the Jas de Bouffan. Such a reference to a specific architectural setting, and therefore to the contemporary world with its historical, social, and personal contingency, echoes the inclusion of the form of Montagne Sainte-Victoire in the distance in *Bathers at Rest*. The result is a blurring of the boundaries between Cézanne's contemporary outdoor landscape paintings, which were increasingly focused on rendering the experience of visual sensations, and the imaginary realm of his figure compositions, which had been integral to his art since his *couillard* period.

Such real-world references, however, are suppressed in Cézanne's later canvases of bathers, as if he had decided by the 1880s that the contingency and specificity of the real world was a hindrance to the full expansion of the idealized fantasy of

123 *Female Bathers*, 1877, oil on canvas, 15 × 18⅛ in. (38.1 × 46 cm). The Metropolitan Museum of Art, Bequest of Joan Whitney Payson, 1975 1976.201.12. Photo © The Metropolitan Museum of Art

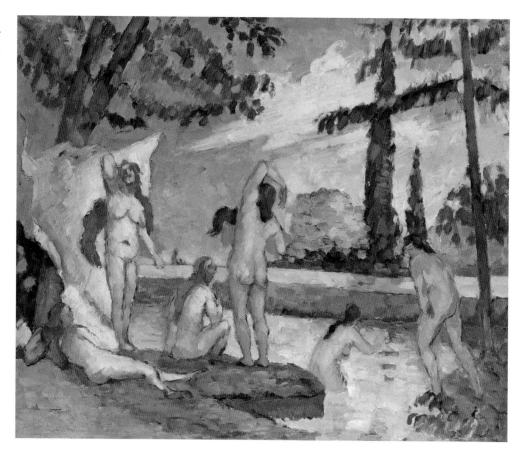

unselfconscious bathing that he sought to render in these canvases. Rather than a denial of contemporary reality, this strategy appears to have been a means for Cézanne to establish once and for all the status of these works as composed studio paintings based fully on the exercise of the imagination. *Five Female Bathers*, dating from slightly later, eliminates any suggestions either of a specific place or of specific weather effects (pl. 124). Void of observational specificity, the canvas is free to invoke a purely imaginary and even vaguely mythological realm. The complete detachment of these imaginary scenes from Cézanne's observational practice of landscape painting is indicated in *Five Female Bathers* in the obviously staged, stripped-down landscape setting of foreground earth, middle-ground water, and background hill. A woman enters from the left, while four women in seated, kneeling, and standing poses occupy the middle and background. A reduced landscape also appears in contemporary canvases of male bathers, such as *Five Male Bathers* (pl. 125). Here too, the space is simplified into a foreground bank, a middle-ground pond or river, and a distant shore. The men are arranged in a frieze-like row from left to right: a seated figure with his back against a tree, a standing figure with a towel, a figure in the water with arms crossed against his chest, a standing figure stretching his arms with his hands clasped behind his head, and a figure bending down toward the water.

Cézanne painted multiple variations on these compositions of male and female bathers over the course of his career, incessantly shifting poses and varying the number of figures. The reduction of the landscape setting to a generic space confirms the fact that they were the permutations and variations of poses and arrangements of figures that most interested him in these works. On the one hand, the

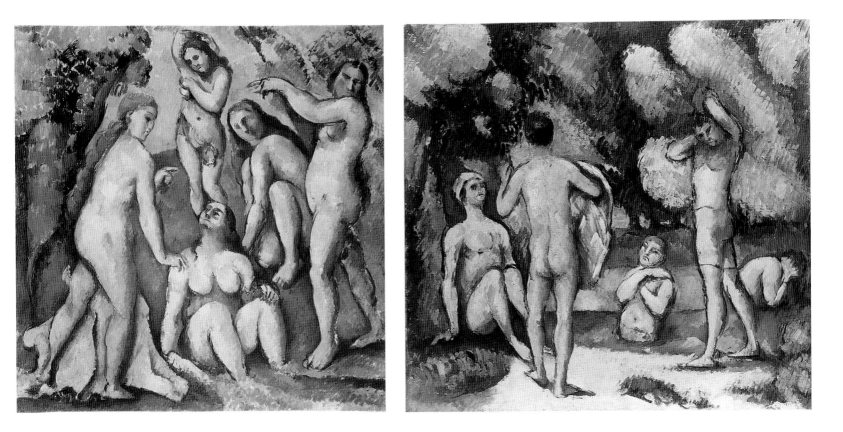

124 (above left) *Five Female Bathers*, 1877–78, oil on canvas, 25¹³⁄₁₆ × 25¹³⁄₁₆ in. (65.5 × 65.5 cm). Kunstmuseum, Basel. Photo © Kunstmuseum, Basel – Martin Bühler

125 (above right) *Five Male Bathers*, 1885–87, oil on canvas, 12⅜ × 17 in. (31.5 × 43.1 cm). The Detroit Institute of Arts, Bequest of Robert H. Tannahill. Photo © 1970 The Detroit Institute of Arts

endless editing and revising suggest that Cézanne never arrived at a definitive rendition of the bathing theme; on the other hand, it suggests that he never tired of the playful game of arranging and rearranging imaginary bathers in ever-new scenarios. The absence of any real narrative in these scenes tells us that no story is being told. As a result, the canvases are not developments in an unfolding drama, but repetitions of a single theme of vital harmony.

Returning to *Les Grandes Baigneuses*, if any canvases can be said to represent a culmination of this sequence of permutations and variations on the theme of harmony, they are certainly these three large canvases of female bathers. The psychological significance of these canvases has been the subject of much discussion in recent scholarship on Cézanne. T. J. Clark has recently argued that they instantiate concerns about sexuality that parallel discussions in early psychoanalysis.[11] I will return to the question of the psychological importance of Cézanne's late bather paintings at the end of this chapter, but for the time being my attention will focus on the function of the watercolor sketches as they relate to the large, final canvases. Cézanne made a range of sketches and studies in pencil, watercolor, and oil in relationship to these paintings. In his book on Cézanne, Gasquet recalled seeing in the 1890s a range of peripheral works relating to the large canvases of female bathers spread around his living quarters and his studio. "The subject that haunted him was a bathing scene," Gasquet recalled, "women under trees in a meadow." He continued: "He made at least thirty little studies of it, two or three of them extremely delicate and finished, a multitude of drawings, watercolors, albums of sketches that never left the drawer of the commode in his bedroom or the table in his studio."[12]

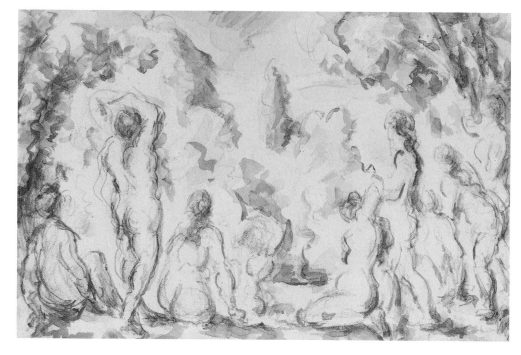

Watercolor and Les Grandes Baigneuses

There are nine known watercolor sketches that relate to these three paintings, most of which were executed in conjunction with the first and second canvases. A watercolor sketch, now in the Fondation Socindec, is a first suggestion of what would become the composition of the Barnes canvas (pl. 126). Most of the main figures are present, although not all of them are yet in their final positions. The standing and seated figures on the far left, for instance, would move over to the right side of the composition and turn to face the viewer. The other two figures on the left – the figure sitting near the water's edge and the figure in the water – would be retained more or less as they are shown here. On the right, the striding figure would be transposed to the other side of the composition, but the kneeling figure below her would hold her position. A series of three figures on the far right would also be rearranged: one would indolently lean against the right-hand tree, another would move behind the tree and appear only as a partial sliver of flesh, and the third would head out into the water, where, in the canvas, she looks back in the direction of her companions.

A second watercolor, now in the Oskar Reinhardt Collection, comes closest to the definitive Barnes configuration and shows much the same composition as a related oil sketch in the Musée Granet, Aix-en-Provence (pls. 127 and 128). The only pose that would still undergo substantial change between this sketch and the final canvas is that of the strider who enters the composition from the left: in the final canvas, Cézanne rotated her angle of entry into the scene to become parallel with the canvas surface (this shift can also be traced in drawings, where an early sketch of the three figures was modified in a second sketch to include the figure entering at an angle parallel to the paper surface). This striding figure recalls a cognate figure in *Five Bathers*, confirming that Cézanne was drawing on his previous repertoire of poses in his elaboration of the composition. The importance of

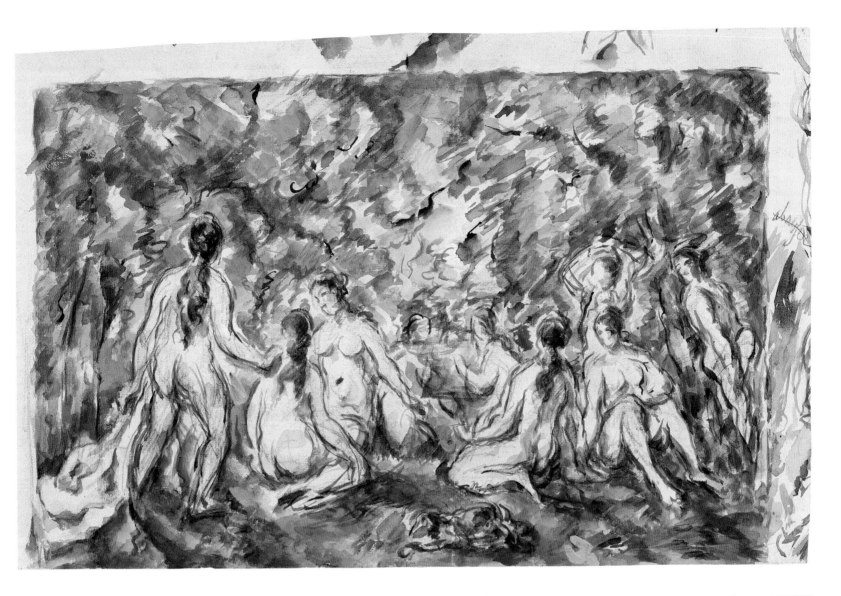

127 (above) *Bathers*, 1894–1906, graphite and watercolor on paper, 9 × 14⅛ in. (22.7 × 35.8 cm). Oskar Reinhardt Collection, am Römerholz, Winterthur. Photo © Oskar Reinhardt Collection, am Römerholz, Wintertur

128 (right) *Bathers*, 1894–1906, oil on canvas, 11 × 17⅜ in. (28 × 44 cm). Musée Granet, Aix-en-Provence. Photo © Bernard Terlay, CPA

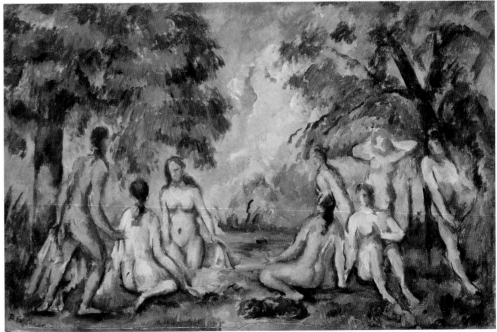

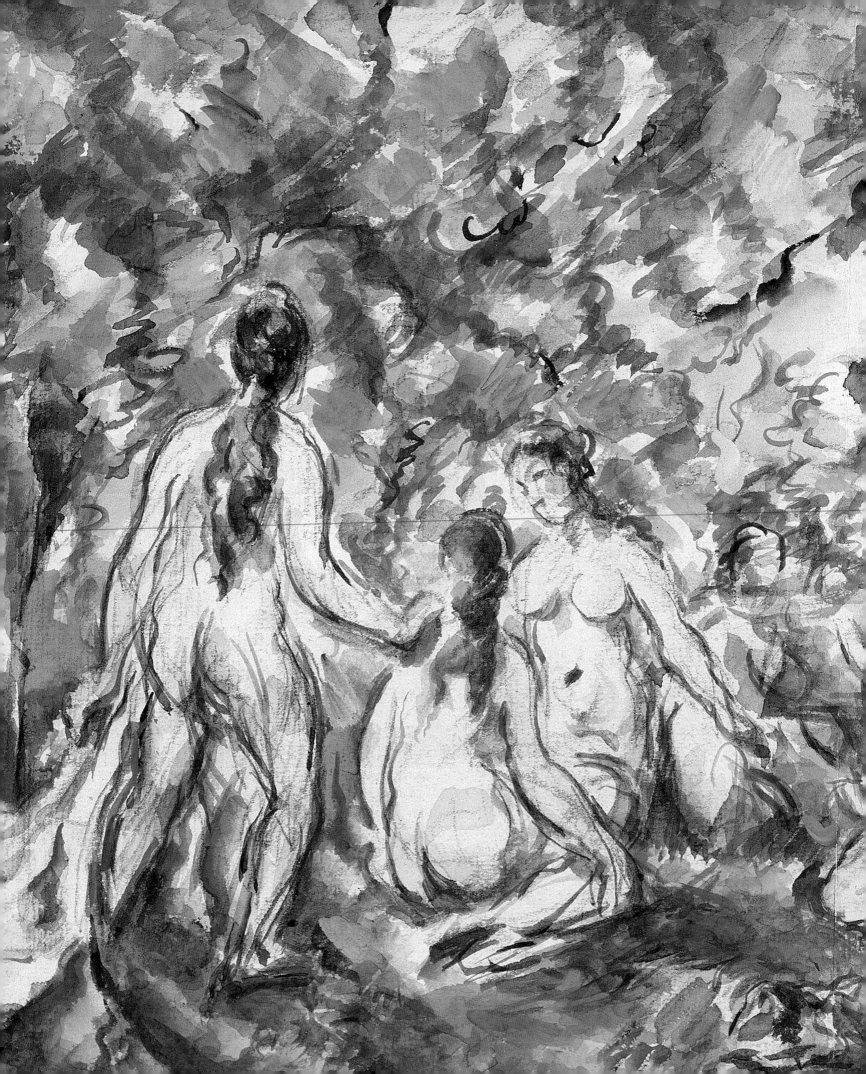

129 *Bathers*, 1894–1906, graphite and watercolor on paper, 7⅛ × 9⅞ in. (18 × 25 cm). Present location unknown

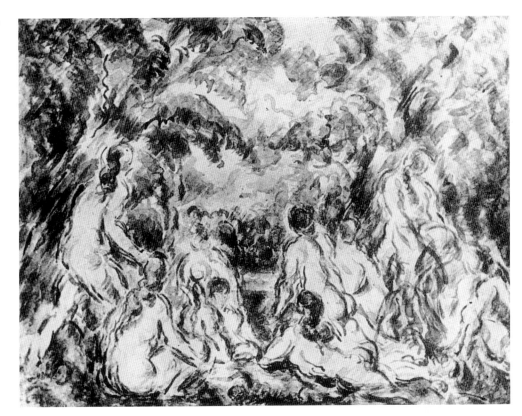

the striding figure is indicated by the fact that it would be carried through the rest of the canvases. Finally, a watercolor sketch of a kneeling woman seen from behind has recently been linked to the Barnes canvas.[13]

Closest to the London canvas, which was probably begun within a year or so of the Barnes picture, is a lost watercolor known only through a black-and-white photograph (pl. 129). The connection to the London painting is indicated by the presence in both the watercolor and the canvas of rightward-leaning trees on either side of the composition. The link between the watercolor and the oil is also evident in the inclusion of a new figure on the left side of the composition, located between the woman kneeling in the foreground with her back to the viewer and the woman facing the viewer emerging from the water in the distance. The attitude of this new figure is impossible to make out in the photograph, but in the final oil painting she turns diagonally toward the dog in the foreground, which she reaches out to touch. Also new in this watercolor are several figures on the right side of the composition: a prone figure, two figures heading into the water, and a seated figure on the far right, all of which are retained in the London canvas. The differences between the watercolor and the oil are only two: first, the watercolor does not yet include a second additional figure on the left, who with arms bent will reach behind her head in a stretching gesture; second, the figure shown in the watercolor on the right standing against the tree is, in the final oil painting, brought down into a crouching position, from which she looks back toward the viewer. Two additional watercolors, both in private collections, are more loosely related to the London composition (pls. 130 and 131). The first, to which Cézanne added a strip of paper on the left, is strangely off balance. All but one of the bathers are piled upon one another on the right side of the composition, while only the striding figure appears

Facing page: detail of pl. 127

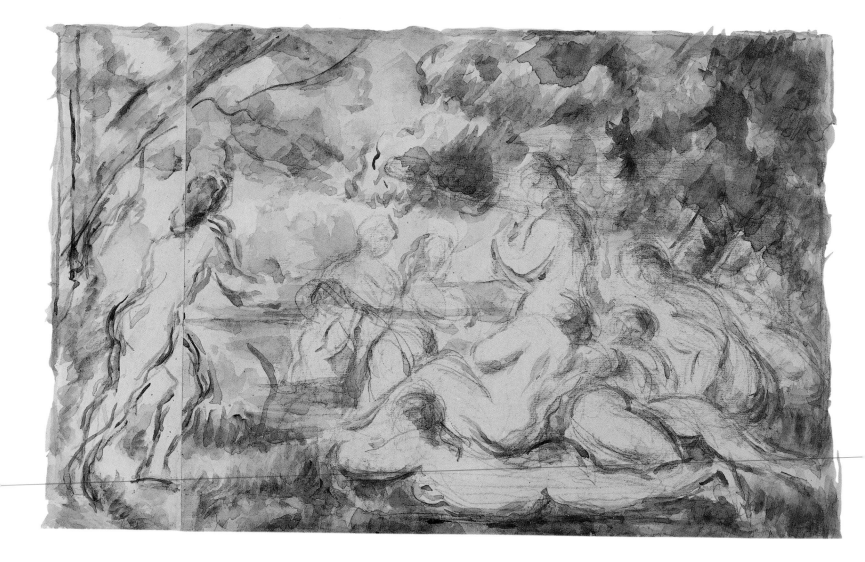

130 *Bathers*, 1894–1906, graphite and watercolor on paper, 6¾ × 10⅝ in. (17 × 27 cm). Private collection

on the left.[14] In the second watercolor, the prone figure in the foreground is now reversed, and seems to enter into conversation with a kneeling figure on the right.

Just one watercolor and a single oil sketch, both in private collections, can be related to the Philadelphia canvas, in which the number of figures has been expanded from the group of between nine to eleven figures in the paintings and sketches discussed so far to a contingent of between thirteen to seventeen figures (pls. 132 and 133). In the watercolor, oil sketch, and final canvas the sideline trees again lean inward and frame a view that now includes a prospect onto a distinct body of water. The watercolor and oil sketch, however, also exhibit important differences with respect to the Philadelphia canvas, including a suppression of the foreground expanse of riverbank and, in its place, the inclusion of a glimpse down what seems to be a tributary stream feeding into a lake or river beyond. The composition also breaks with the overall plan of the three large canvases by segmenting the figures into three rather than two groups. A new, central group of figures, all of whom seem to be focused on something at their feet, collectively wades in the stream, while the other two groups of bathers look on from dry land on the left and right. This shift of format is important. In the three canvases of large bathers, the spectator is placed in an implied position on the bank far from the water. The

180

131 (right) *Bathers*, 1894–1906, graphite and watercolor on paper, 8¼ × 10⅝ in. (21 × 27 cm). Private collection

132 (below left) *Bathers*, 1894–1906, graphite and water-color on paper, 5 × 8½ in. (12.7 × 21.6 cm). Private collection

133 (below right) *Bathers*, 1894–1906, oil on canvas, 8½ × 5 in. (21.6 × 12.7 cm). Private collection. Photo © Erich Lessing / Art Resource, NY

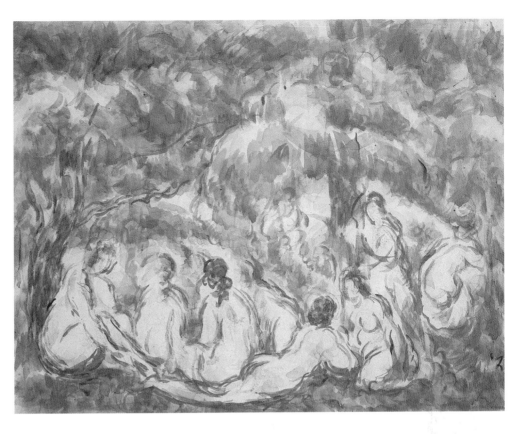

bathers, consequently, take up positions between the viewer and the water, with most of the figures lolling about out of the water rather than cavorting in it. In contrast, in the watercolor and oil sketch related to the Philadelphia canvas, Cézanne experimented with a new perspective, this time implying that the viewer is positioned somewhere in the water itself, as if wading along with the other bathers in the center of the composition. This experimental shift of perspective is sustained in two additional watercolors, both in private collections (pls. 134 and 135). The first shows a bather standing on the riverbank, framed by a dramatically arching

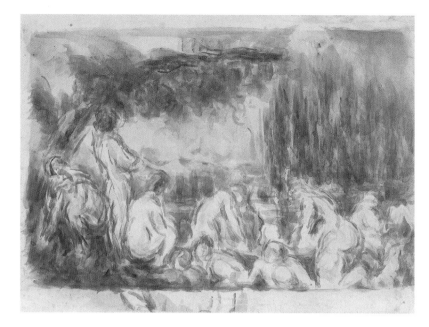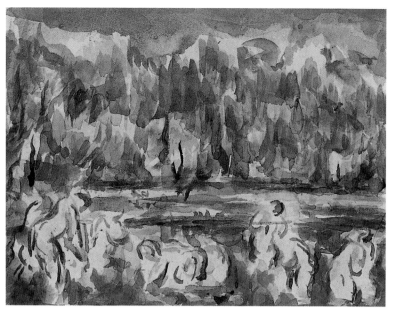

134 (above left) *Bathers*, 1894–1906, graphite and watercolor on paper, 8¹³⁄₁₆ × 12⅜ in. (22.4 × 31.5 cm). Private collection

135 (above right) *Bathers*, 1894–1906, graphite and watercolor on paper, 8¼ × 10⅝ in. (21 × 27 cm). Private collection

tree and accompanied by two figures seated or bending next to her. She gazes out at a scene of frolicking and swimming in the water on the right. In the next watercolor, the left shore has been reduced to just a vague hint, while most of the watercolor is dedicated to rendering swimming bathers. No longer blocked from the water, the viewer is, in both of these additional watercolors, invited to enter imaginatively into the swimming they depict.

These watercolor sketches played an important role in the generative work of exploration and testing poses and compositional possibilities that were either taken up or ignored in the arrangement of the final canvases. This seems to have been especially important in the case of the Barnes and London canvases. The important role played by these watercolors in the generative development of Cézanne's paintings recalls the function of watercolor sketches in Cézanne's early career, during which he often used watercolor to make sketches and to facilitate brainstorming in the first stages of working toward compositions for large-scale oil paintings. Such sketches as *The Wine Grog*, *The Gravediggers*, and *The Diver* were executed as part of the imaginative work of elaborating potential canvases for submission to the annual Salon. At the same time, as I suggested in Chapter One, these small, private works also allowed for a casual and spontaneous rendering of the images and ideas that Cézanne was considering for development on a large scale in oil. One of the ways this manifested itself was in his lively use of the pencil and paintbrush in the execution of watercolor sketches. This lively, gestural handling, I suggested, was as much a means for Cézanne to render a sense of the dramatic action taking place in his depicted scenarios as it was a means for him to register his own emotional participation in the subject matter. If Cézanne's handling in his watercolor sketches for the large bathers, dating from four decades later, calls to mind this kind of emotional participation, it also reflects more recent concerns developed in his contemporaneous watercolor views of landscape and still life. In these contemporary watercolors, Cézanne sought to render the visual sensations of vibrant light and air in the south of France. Although based on imagination rather than observation, Cézanne invokes in these bather sketches a similar quality of

shimmering light and air. More than this, he also adds to the vibrant envelope a quality of vital movement that sets these watercolors off from his contemporary landscape and still-life watercolors.

Such handling can be seen, for instance, if we look again at the sketch that comes closest to the Barnes canvas. The sense of a luminous flux of light and air is captured by the energetic and flickering strokes of predominantly green and blue hues that Cézanne has employed to render the canopy of foliage that presses around and envelops the figures. The blue contours suggest air and dissolved edges, much as was the case in his contemporary still lifes, such as *Still Life with Green Melon*. These lines, however, have an additional connotation in this watercolor sketch that they did not have in the still life. In the still life, these repeated, blue contours suggested the vibration of edges caused by the movement of air around fixed objects; in this sketch, conversely, these lines indicate, in addition to such effects of vibrating edges, the actual movement of living forms in space. Consider the standing woman on the right side of the watercolor, located behind the woman who sits facing the viewer, and who raises her arms above her head. Focusing on her arms, one can see how Cézanne has outlined them with three different blue contours in three different places, suggesting a sequence of successive positions in the unfolding of the reaching gesture. A similar effect can be seen in a second watercolor sketch, namely, the one with the added strip of paper on the left, which relates to the London canvas. The figure that strides into the picture from the left is rendered with repeated and displaced contours that surround and articulate the shifting form of her body, which generates a comparable sensation of movement. The figure's left, leading leg, for instance, is drawn and painted with a series of repeated contours that suggest a series of positions successively occupied in a lateral sequence. Yet more examples of such effects can be seen in another watercolor relating to the London canvas, namely, the sketch in which the prone figure faces to the right. The repeated and shifting contours along this figure's right shoulder and arm, as well as those along her back and legs, generate shifting indications of position. Likewise, along the shoulder of the second figure from the left – the one that peeks from behind a tree – there are at least five different contours. The result is an effect of upward or downward movement of the body in space, depending on what contour is read as first and what is read as last in the sequence. The shifting positions of the bathers, when viewed together and as part of an already vibrant and fluid context, generate sensations of expansion and contraction, as well as a general impression of continuous, simultaneous movement in all parts of the image.

We can compare Cézanne's interest in evoking a sense of movement in his images of bathers with the drawings and watercolors of his contemporary, Auguste Rodin, whom Cézanne met in Giverny during a visit with Monet in 1894 and whom he admired.[15] Like Cézanne, Rodin made watercolors that sought to capture the movement of the human form. He reportedly noted: "I like to draw because it is a process that captures movement more quickly than sculpture: it fixes the fleeting truth almost instantaneously."[16] It was especially with his drawings of Cambodian dancers made in 1906 that Rodin engaged in his most concerted effort to fix the "fleeting truth" of human movement. An article published by Georges Bois in *L'Illustration* on July 28, 1906 includes a photograph of Rodin drawing a Cambodian dancer, as well as a page of pencil sketches and a watercolor of King Sisowith (pl. 136). "Like the flight of a marvelous bird, passing for a moment across our gray skies," wrote

136 First page of article by Georges Bois, *L'Illustration*, July 28, 1906. The Getty Research Institute. © The Getty Research Institute

137 Auguste Rodin, *Cambodian Dancer*, 1906, 9³⁄₁₆ × 12½ in. (23.4 × 32 cm). Musée Rodin, Paris

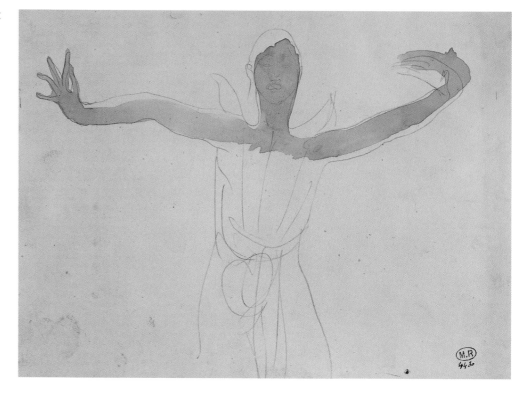

Bois, "the little Cambodian dancers have left never to return! The crowd saw nothing more in their dances than a delightful but futile shimmering of precious stones subject to the slow rhythm of monotonous movements. Their ears disturbed by the loud music, they quickly wearied of them." "It took an artist of genius such as Rodin," he explained, "to grasp this perfection and this beauty, always dreamed of, sought after, and now suddenly within reach."[17] Additional watercolors, executed at the same time, but not reproduced in the article, show more clearly that part of Rodin's fascination was with the exotic and unfamiliar movements and poses of the dancers (pl. 137). As Rodin's secretary Mario Meunier explained, Rodin's habit was to draw without looking at the page, in order to retain the integrity of the circuit of eye, hand, and mind in the process of representation; only afterward would he take the page up again at a quiet moment and add color:

> With his eyes fixed on the model, whose pose he never dictates, and without looking at his paper, he often captures a whole body in a single line. On other occasions, always at a stroke, the essence of the movement taking place; then, impatient to recapture the vitality of life, he limits himself to indicating cursorily the volumes generated around itself by this essential line and throws the sheet on the floor, only to begin at once to dwell on another, new aspect of the infinite aspects of the moving shapes. The sheets lie scattered across the floor. Only when the model is resting or at the end of the session does Rodin pick them up and put them in cardboard boxes, not to see them again, rework them, and sometimes color them until several days or months later.[18]

In the watercolor reproduced here, the loose color washes do not perfectly line up with the first drawing, suggesting a slight rethinking of the pose in the painting phase of the artist's execution. True, sometimes such effects in Rodin's watercolors

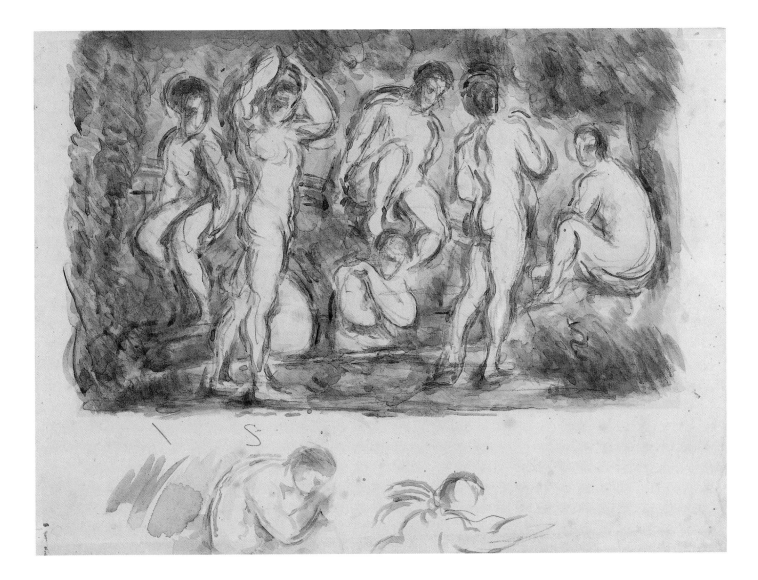

138 *Male Bathers*, 1899, graphite and watercolor on paper, 7⅞ × 10¾ in. (20 × 27.3 cm). The Pierpont Morgan Library, New York, The Thaw Collection. Photo © David Loggie

seem to be the result of simple casualness, the brush being applied to the page nonchalantly and without any intention of painting inside the drawn lines. In watercolors such as this one, however, the shift between the drawn and painted positions of the dancer's arm generates a sense of physical displacement in space. The left hand of the figure is drawn closer to his body than it has been painted, giving rise to a perception of movement as the eye moves from drawn to painted edges.[19]

Cézanne's interest in such effects of movement conveyed by displacement of position is evident already in early watercolors such as *The Diver* and *The Abduction*, in which swirling and repeated lines are mainly responsible for the powerful impression of dynamism that each work produces. Such effects can also be seen in Cézanne's watercolors of male bathers. A watercolor sketch dating from the late 1890s, which shows a variation on the theme established already in his earlier studies of male bathing, augments the group to include a seated figure on the left and two standing figures in the foreground (pl. 138). One or two figures appear in the water and, beyond them, perched on a rising slope that recalls the space of *Five Bathers*, Cézanne adds two additional figures that either dry off after a dip or prepare to enter the water. The shifting, blue contours that radiate outward from these figures suggest movement as much as they do the circulation of atmosphere. The familiar

Erratum
The publisher regrets that pl. 138 and its details on pg. 186 and back endpapers are printed in reverse

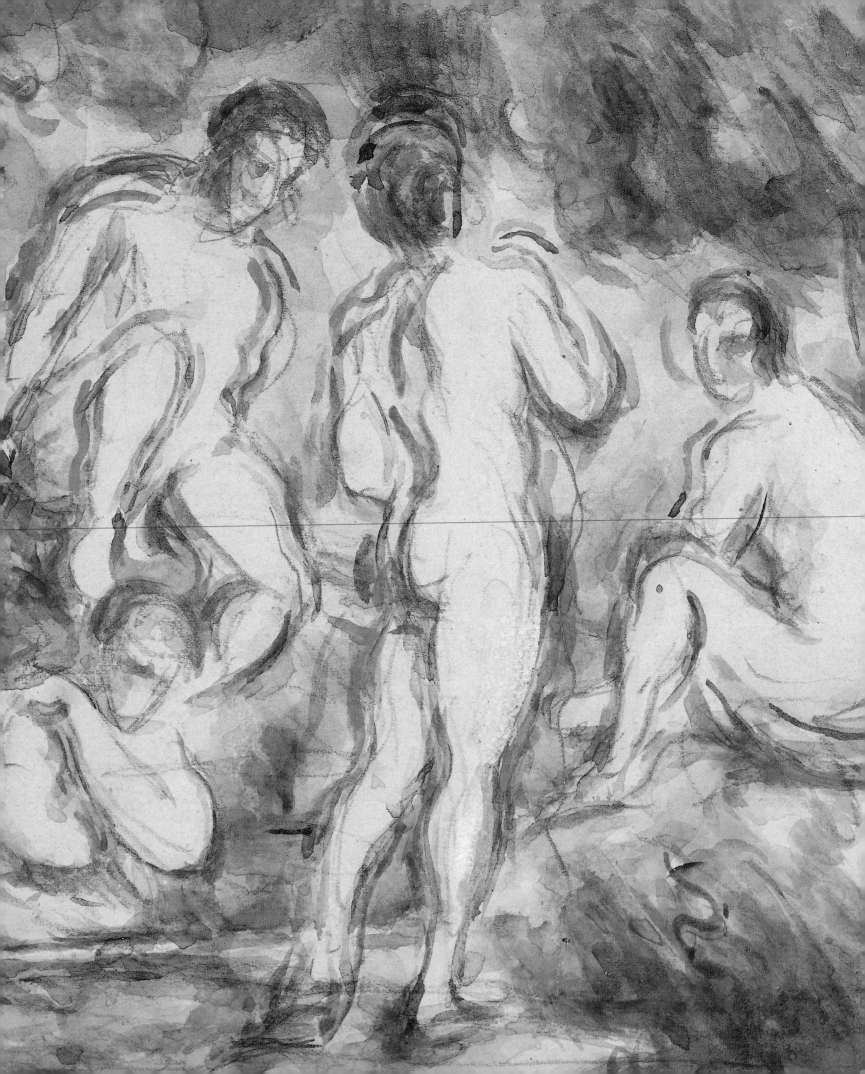

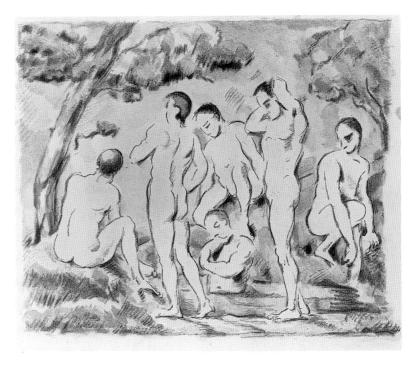

139 *Le Bain*, 1897, chromolithograph, (22.2 × 27.2 cm) 8¾ × 10¾ in.) Rosenwald Collection, National Gallery of Art, Washington, DC. Photo © The Board of Trustees, National Gallery of Art, Washington, DC

pose of the stretching figure in the foreground is drawn in a way that suggests unfolding movement. Likewise, the figure on the opposite bank scooting toward the water is rendered with a series of displaced lines, which read as the different positions successively occupied on the hillside as he moves down toward the water. Cézanne was sufficiently satisfied with this image to use it as the model for a lithograph commissioned by Vollard. Vollard invited Cézanne to submit three lithographs for publication in the late 1890s as part of a commercial venture into the publication of luxury folios of prints by contemporary artists.[20] In addition to a self-portrait, Cézanne made two lithographic prints after his studies of male bathers. The first was a copy of *Bathers at Rest*, which was never published; the second lithograph, which appeared under the title *Le Bain* in Vollard's second album, was based on his most recent compositional study of male bathers (pl. 139).[21]

If a shared focus on movement links Cézanne's and Rodin's watercolors, there is, nevertheless, at least one major difference between their working procedures. Unlike Rodin, Cézanne did not use models in the rendering of his bathers. He had no models before his eyes when he was making these sketches, no models whose movements he was tracking. Bernard noted this when he visited him in his studio in 1904:

I asked Cézanne why he didn't use models for his nudes. He responded that at his age one had the obligation not to make a woman undress to paint her, that it would be permissible for him, if absolutely necessary, to call on a woman in her fifties, but that he was almost certain he would never find such a person in Aix.... I divined that he was slave to an extreme sense of decorum, and that this slavery had two causes: the one, that he didn't trust himself with women; the other, that he had religious scruples and a genuine feeling that these things could not be done in a small provincial town without provoking scandal.[22]

Facing page: detail of pl. 138

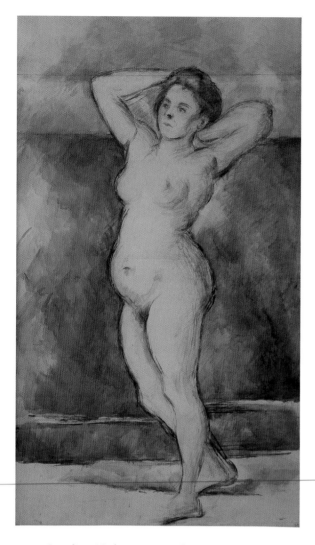

140 *Standing Nude*, 1900, graphite and watercolor on paper. 35 × 20⅞ in. (89 × 53 cm). Musée du Louvre, Paris. Photo © Réunion des Musées Nationaux / Art Resource, NY

Only once does Cézanne appear to have worked directly from the female nude in his late career, resulting in a watercolor and a canvas of a woman standing with her weight on her left leg and her right leg pulled backwards as if in mid-stride. Ironically, however, this study of an actual model conveys less of an impression of movement than Cézanne's imaginary sketches of bathers (pl. 140). That Cézanne's watercolors were not based on seeing movements, the way Rodin's were, does not change the fact that the end result is the same: Cézanne's watercolors, like those of Rodin, generate an impression of movement through the use of repeated contours and displaced indications of spatial position.

From Watercolor to Oil Painting

"The difficulty," explained the theorist Paul Souriau, "is not to impart movement to a sketch, but to a painting."[23] Indeed, when Bernard first saw the Barnes version of *Les Grandes Baigneuses* on Cézanne's easel in his Les Lauves studio in 1904, he mentioned no sense of vitality or movement but instead expressed shock at the deformation of the figures in the canvas: "On the mechanical easel, which he had just had installed, there was a large canvas of female nudes bathing, which was in a complete state of chaos." "The drawing," he added, "seemed to me to be rather deformed."[24] Bernard took two photographs of Cézanne seated in front of the Barnes canvas at the time of his visit in 1904, one of which is reproduced here (pl. 141). The photograph shows the canvas in a state that is significantly less developed than the final work. To begin with, the striding bather who enters from the left is shown much larger in the photograph than she will eventually appear. Denis seems to have seen the same canvas on Cézanne's easel in 1906 at the time of his visit. Standing before the painting, Cézanne reportedly explained to Denis: "My figures got too big, so I reduced them by this much (he measured with his hand)."[25] Cézanne may have had the figure of the strider on the left in mind, since it was radically reduced in size between the photograph and the final painting. This process of shifting and changing the scale of figures, however, was for Denis an insight into the general challenge that Cézanne faced with his bathers canvases. Denis wrote:

> What is most surprising in Cézanne's work is surely his search for form, or more precisely, his deformations: it is here that one discovers the greatest hesitations and repainting (*repentirs*) in the artist's work. The large painting of female bathers, left unfinished in his studio in Aix, is typical from this point of view. Taken up a countless number of times over the course of many years, it has varied little in aspect or color, and even the placement of strokes of paint remained almost the same. On the other hand, he reworked the dimensions of the figures many times. Sometimes they attained natural height, sometimes they shrunk to half size: arms, torsos, and legs were augmented and diminished to impossible proportions. This was the variable element in his work: his sense of form included neither silhouette nor fixed proportions.[26]

Denis' observation echoes Bernard's sense of the deformed drawing in Cézanne's canvas, but, unlike Bernard, who chalked the distortions up to Cézanne's lack of models, Denis identified the lack of a stable system of proportions as their cause.

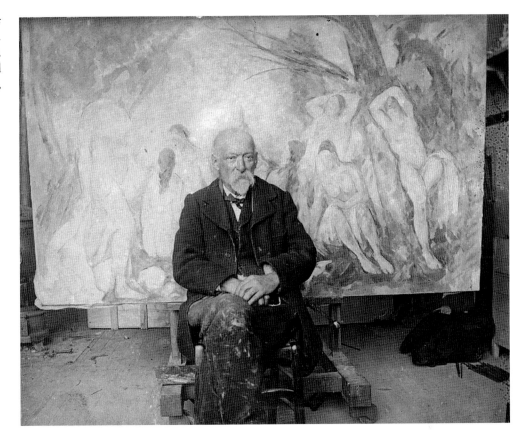

Rather than poor drawing, Denis suggested that the distortions in Cézanne's bather paintings were the result of endless reworking and "repentirs."[27]

A careful look at the photograph of the Barnes canvas, however, suggests less overworking and revision and something more like the lightness and freshness of Cézanne's watercolors. In the photograph, the bodies are roughly drawn with staccato contours that reverberate and vibrate in much the way that they do in his watercolor sketches. This is especially visible in the contouring around the body of the figure leaning against the tree at the right. The left edge of the figure's torso has been drawn and redrawn several times, creating an expansive zone of repeated contours that breaks down any sense of fixed form and suggests that the woman is moving as she leans back and raises her arms above her head. Her bent arms are also drawn in a way that suggests several positions in space rather than one definitive pose. At the early stage of painting, then, Cézanne seems to have sought to work in a way that captured the graphic liveliness of his watercolors. This is also evident in the Philadelphia canvas, which was left at an earlier stage of execution than the other two. Repeated, broken contours painted in blue-black pigment appear around the forms of many of the figures. The prone figure on the right is drawn in multiple, hooked contours, which enclose her form without nailing it down. Cézanne leaves his figures with breathing room along their contoured edges. This impression is confirmed by a remark that Cézanne reportedly made to Denis as they stood in front of the Barnes bathers: "When I begin, I work freely, and it's only afterward that I make corrections."[28]

The problem with the Barnes canvas, as it stood in 1906, then, was that it had succumbed to these "corrections" and had lost touch with the initial freedom of

handling. Looking again at the figure leaning against the tree, the repeated contours on the side of her torso have now coalesced into a single, dark shadow that sharply outlines her pale flesh. Her arms no longer seem to reach backward over her head in a successive movement, but are now cemented into place with dense pigment. At the same time, the appearance of repeated contours along the same figure's left thigh indicates that Cézanne retained at least a reminder of the expansive, vital movement rendered in the preliminary watercolors and the first *ébauche*, or lay-in of the canvas. But the tension between density, on the one hand, and freedom of movement, on the other, increased as Cézanne applied successive layers of paint to the canvas surface. In the London picture, however, he was much more successful in retaining a sense of the *première pensée* of the watercolors in the final canvas. This must be the canvas that Borély saw in Cézanne's Les Lauves studio in 1902, which he described as "a troupe of nude young women, pale bodies set against a lunar blue."[29] The "lunar blue" is probably a reference to the heavy use of Prussian blue in the rendering of the contours and shadows of the figures, as well as the blue sky in the distance. The striding figure on the left retains a great deal of repeated contours along her left leg, along her back, and around her curiously nose-less face. The woman who faces the viewer on the left as she leaves the water also has been painted in a way that exudes a sense of movement. A series of repeated contours along her shoulder suggests her rising movement as she comes out of the water and joins her companions on the bank. Perhaps the most powerful sense of spatial displacement is evident in the rendering of the woman on the right who turns to face the viewer as she bends to dry off after a swim. A series of repeated, Prussian blue contours along her back generates a sense of back and forth movement in space, while also implying the vibration and circulation of air in the outdoor landscape.

What I am suggesting, then, is that Cézanne seems to have sought to retain the vital movement generated in his watercolor sketches in his large bather canvases. As Denis observed, however, the incessant repainting and revision of the poses of the bathers – something that was not possible in the medium of watercolor – threatened this sense of free movement with hesitation and an overworked quality. That watercolor and other kinds of sketching should be more vital and fresh than worked-up oil paintings was a common assumption in nineteenth-century France. As I noted in Chapter One, the critic Lafenestre claimed of watercolor sketches that they exhibited "a spontaneity, a vivacity, a virtuosity, that is too often lost in the passage from the quick sketch to the laboriously worked canvas." Such works of less ambition, he added, reveal a hand that is "always more free" and "a more marked personality" than in the finished, worked-up oil paintings for which they prepare. In *L'Esthetique*, the art theorist Eugène Véron similarly lamented the fact that some painters tended to lose the vitality of their sketches as they moved to their final work. He singled out Paul Baudry as an example:

The *Gazette des Beaux-Arts* published the facsimile of a certain number of sketches by Paul Baudry for the great foyer of the Opéra. They were full of animation and life that have largely disappeared in the finished painting. Gestures are not lacking, however, in Baudry's work; one might even say they are overabundant, yet the composition does not move. All these characters, in spite of their big arms and spread-out legs, are fixed in a state of stillness all the more unpleasant because it is in contradiction with their implied movements. To what is this disastrous transformation due? To the fact that in the sketches, the

gestures are indicated vaguely by a multitude of little lines which, by their close-
ness, animate the figure by indicating several successive moments or attitudes
perceived simultaneously in each movement, whereas this mixture of succession
and simultaneousness has completely disappeared in the unique and precise line
of the final attitude.[30]

The currency of such associations right up to the year of Cézanne's death is made
clear by an exhibition of drawings and watercolors at the Petit Palais in Paris in
1906, which was billed as an exploration of the marginal work of oil painters that
provided insights into the processes of their thinking. The curator had gone to the
studios of artists in Paris and had asked for examples of their private work: "You
have made, over the course of your career, a body of work that you hold close to
your breast, that you cherish with a particular delectation, you keep it hidden on
the walls of your studio, it is this work that we ask of you."[31] In a review, the critic
Louis Vauxcelles wrote:

> A red chalk drawing, a sepia ink sketch, a charcoal drawing, a light rubbing of
> pastel, a lively and spontaneous notation in watercolor: are these not frequently
> the best documents for revealing to us the soul of an artist, better so than any
> vast and laboriously worked composition? The first sketch is the very flower of
> art. Spontaneous creativity makes its appearance in the hasty notations and bold
> syntheses, where "everything is already present," before all the secondary work –
> the squaring up of the sketch and the systematic development of the work of art
> – has cooled the artist's emotion. How many painters, the best of them included,
> lose the freshness of the sketch in passing to their final painting?[32]

Cézanne was not one of the artists invited to participate in the exhibition. But like
the sketches praised by Vauxcelles, his watercolor sketches for *Les Grandes Baigneuses*
capture a liveliness that is only partially translated into the large, final oil paintings.
This is in large part due to fundamental differences in the kinds of effects available
to either medium. Watercolor allowed for vibrating and dynamic effects through
the combination of graphite lines and transparent and semi-transparent pigments;
oil painting was limited to opaque pigments that gradually lost any hints of semi-
transparency or graphic spontaneity as they were built up in layers on the canvas
surface. The watercolor sketches, therefore, retain better than the oil paintings the
artist's reported enthusiasm, in his late career, for vitality and movement. In an
article published in 1907, based on his visit to Cézanne in 1906, Denis recalled: "he
liked exuberance of movement, relief of musculature, impetuosity of hand, and
bravura in the sweep of the pencil."[33]

As Much Harmony as Possible

Bernard's photograph of Cézanne seated before the Barnes canvas suggestively blurs
the boundary between the artist's space and the imaginary space of his canvas, an
effect that underscores the fact that these canvases were the product of an imagi-
nary ideal, a fantasy world of harmony, heath, and vitality. The old man in his
paint-splattered coat, however, looks completely out of place next to these youth-
ful, if barely legible figures of unclothed women. In fact, the image of human socia-

bility and physical well-being at the basis of *Les Grandes Baigneuses* was quite the opposite of the reality of the artist's life in his late career. Increasingly isolated and gripped by pain caused by diabetes, his experience at the time that he made these canvases was characterized by nothing akin to either social harmony or physical robustness. The contrast is driven home if we consider a very tentative moment in the watercolor sketch in the Oskar Reinhardt collection, in which the striding figure at the left reaches out and places her hand on the shoulder of her kneeling friend. Cézanne, as Bernard recounted in an anecdote, was himself repulsed by human contact, exploding in fury when Bernard took hold of the older painter's arm to steady him when he lost his footing. "No one ever touches me," he reportedly yelled, "never, never!"[34]

Cézanne was in a great deal of physical pain in his last years. This is apparent in letters he wrote to his son in the summer of 1906, which was especially hot and which seems to have aggravated the symptoms of his diabetes. In a letter dated August 12, 1906, he wrote to his son, who was then living in Paris with his mother: "It has been hatefully hot for days; today, it was fine from five o'clock, the time I got up, until around eight. I am racked with painful sensations (*les sensations douloureuses*) to the point that I can't control it, and it makes me keep away from people, which is the best thing for me."[35] To seek relief from the heat, Cézanne worked frequently along the shaded banks of the Arc river on the outskirts of Aix. In a letter dated August 14, he first mentioned his trips to the edge of the river. I quote the letter in its entirety to give a sense of the kinds of things on Cézanne's mind in his last summer. He speaks of the heat, of watercolors painted by the river, and then passes on to other topics that ultimately lead him back to the river:

My dear Paul,

It's two in the afternoon, I'm in my room; it's turned hot again, it's dreadful. I'm waiting until four o'clock when the car will pick me up and take me to the river at the Trois Sautets Bridge. It's a bit cooler there; yesterday I was quite comfortable there and I started a watercolor like those I did in Fontainebleau, it seems more harmonious to me, the whole thing is to put in as much harmony as possible. In the evening I went to congratulate your Aunt Marie on her saint's day, Marthe was there; you know better than I what I think of that situation, but it's up to you to manage our business. My right foot is getting better. But how hot it is, the air has a nauseating smell.

I received the slippers, I put them on, they fit very well, they're a success.

At the river a poor child, very lively, dressed in rags, came up to me and asked me if I was rich, and another one, older, told him that one didn't ask such questions. When I got back in the car to return to town, he followed me, when we got to the bridge I threw him two *sous*. If you could have seen how he thanked me.

My dear Paul, all that is left for me to do is to paint. I embrace you with all my heart, you and Mama, your old father.

Paul Cézanne[36]

Cézanne moved quickly between quotidian details – the reference to the slippers, the visit to his sister – and a rather meaningful anecdote of the poor boys and his charity. It is not clear if he was pleased or not with the child's excessive gratitude for the two *sous*, because Cézanne did not draw out a moral from the encounter.

142　*The Trois Sautets Bridge*, 1906, graphite and water-color on paper. 16⅛ × 21⅜ in. (40.8 × 54.3 cm). Cincinnati Art Museum, Gift of John J. Emery. Photo © Cincinnati Art Museum

The sight of the lively children appears to have made him think of his own old age, however, since he followed the anecdote with a rather bleak comment about having nothing left in his life but painting, ending with "your old father."

There is a striking contrast in Cézanne's letter to his son between the painful, nauseating, uncomfortable experiences he reported and the pleasures of working on watercolors by the riverside. In a letter dated August 26, he noted that working on the riverbank was one of his only means of relief, but even there he felt his age: "I go to the river in the carriage every day. It is nice there, but my weakened condition slows me down."[37] In a letter dated September 2, Cézanne again wrote of working by the river: "It's four o'clock, there's no air. The weather remains stifling. I'm waiting for the carriage to take me to the river. I spend a few pleasant hours there."[38] Moreover, Cézanne took advantage of the portability of watercolor to bring it along with him on these excursions. A watercolor that can be securely linked to these visits is a contemporary view of the Trois Sautets Bridge (pl. 142). The triangular and circular forms of the bridge reach over the water, which is hemmed in on either side by dense foliage. This watercolor is an impressive example of the kinds of interests that I discussed in the last chapter. The artist's focus on the vibrant

143 *Bathers by a Bridge*, 1906, graphite and watercolor on paper, 8¼ × 10¹¹⁄₁₆ in. (21 × 27.2 cm). The Metropolitan Museum of Art, New York. Photo © 1988 The Metropolitan Museum of Art, New York

Facing page: detail of pl. 143

light and air of the "envelope" in his late watercolors is everywhere evident. The pleasure of working in the shade of the trees and in the cool breezes of the riverbank is palpable in this watercolor, which nevertheless is as agitated and vibrant as any of his contemporary landscape watercolor views. Cézanne made a second watercolor of the site, but this time he allowed his imagination to participate. In *Bathers by a Bridge*, the bridge is more summarily rendered while, as if in a hallucination, the foreground becomes populated with the shadows and shapes of cavorting nude bathers (pl. 143).

This watercolor brings us back to the imaginary, fantastic ideal that is captured in Cézanne's many bather images, culminating in his three large canvases, *Les Grandes Baigneuses*. That Cézanne associated swimming with youth and vitality is evident in a letter he wrote to his niece in 1902: "The sky, which has become stormy, has cooled the atmosphere a bit and I fear that the water, no longer as warm as it was, will prevent

194

you from going swimming with as much pleasure, if in fact it allows you this healthy distraction (*cette hygiénique distraction*) at all."[39] Moreover, in *Bathers by a Bridge*, Cézanne comes full circle to the nostalgic images of bathing that he captured in his early watercolor, *The Diver*. As I suggested at the outset of this chapter, the move toward increasingly abstract settings in both the male and female bather canvases indicated a desire to move toward a more evidently imaginary presentation of the subject matter, in which specificity of place would recede before the overall sensations of living harmony. This watercolor breaks with this pattern, returning to a recognizable locale in the landscape around Cézanne's hometown of Aix-en-Provence. Not just any locale, *Bathers by a Bridge* recalls directly Cézanne's bathing excursions with his childhood friends along the banks of the Arc river. Here we see a return to a specific locus – a *locus aemoenus* – associated with his memories of youth. Already in his first known letter to Zola, from 1858, Cézanne referred warmly to the "pleasant banks of the Arc,"[40] that "cool river"[41] in which during summer breaks he would swim and fish with Zola and Baille. Coming back to the riverbank in the summer of 1906 would certainly have recalled to Cézanne's mind these youthful excursions.

In his three large canvases of female bathers, Cézanne has transposed this image of harmony and pleasure onto the opposite sex. Tamar Garb has argued that Cézanne's subtly different manner of composing his canvases of female and male bathing subjects is indicative of the artist's underlying assumptions about the social and sexual roles of women and men respectively.[42] The differences between the male and female bather compositions, however, are easily exaggerated, while what they share can become overlooked. Indeed, at issue in Cézanne's bather imagery is an ideal of social harmony and physical pleasure that is not specifically aligned with any one gender. In lieu of Cézanne's increasingly antisocial inclinations and increasingly uncomfortable physical condition, these images project a very different, even diametrically opposed vision that is best described as compensatory. The image of harmony he explores in these works transcends the differences of the sexes and unites female and male bathers in a single continuum of free and expansive vitality, engaged in Cézanne's favorite pastime, the "healthy distraction" that he associated with his youth.

A Genesis

As in his early work, Cézanne's ambition in his late canvases of bathers was to communicate his sensations and his personal temperament to the spectator. In a letter to Bernard, Cézanne warned his younger friend not to spend too much time trying to master the methods of the old masters in the Louvre. "The Louvre is the book from which we learn to read," he explained, "but we ought not be content with the formulas of our illustrious forebears. We must go out to study beautiful nature, we must try to free our minds, we must seek to express ourselves according to our personal temperaments."[43] Moreover, as Cézanne also told Bernard, his ambition as an artist was to make the viewer feel the way he feels and to accept him on his terms, not on the terms of general standards of reigning taste. Cézanne's hopes for public recognition and a position in the history of art are perhaps most clear in a letter he wrote to the critic Roger Marx in late January 1905. Marx had singled out his work in the Salon d'Automne of the previous year. Cézanne wrote:

I read with interest the lines you were so kind to devote to me in the two articles in the *Gazette des Beaux-Arts* . . . I shall always be grateful to the group of intelligent art lovers who have – in spite of my halting attempts – sensed what I was trying to do to renew my art. In my opinion, one does not replace the past, one only adds a further link to it. Along with a painter's temperament and an artistic ideal, in other words his concept of nature, there should be sufficient means of expression to make oneself intelligible to the public and to occupy a suitable rank in the history of art.[44]

These large bather paintings were Cézanne's most ambitious bid for official acceptance yet. Consequently, there was a great deal riding on this project, in terms of ensuring a position in the sequence of links in the history of art. His large canvases of female bathers were shot through with aspirations toward the monumental.

My suggestion in this chapter, however, has been that it was in the private watercolor sketches related to the theme of bathing that Cézanne managed most effectively to express his vision or, better, his dream of harmony. This does not mean that he was not dedicated to seeking to preserve a sense of the vital harmony that was the *première pensée* of his watercolors in the oil paintings, but that it was a difficult and hard-won sense of vitality that had none of the freshness and immediacy of the watercolors. This reinforces the sense that Cézanne's watercolors were always more than mere preparations for oil paintings and in fact became something of an alternative to oil painting as well.

In an interview in 1957, the Surrealist painter André Masson objected to the then-prevalent characterization of Cézanne as an artist who was a constructor of solid forms. "It's always the constructor," complained Masson, "in the end that annoys me." If one looks more closely, he insisted, we find that there is also a living, vital thrust in his art that breaks apart fixed form. "Look at Cézanne's freest things," he explained, "the forms come undone." "With the last watercolors of bathers," he added, "you no longer know if this is about bathers or if it's about . . . a genesis."[45] Masson hinted here that Cézanne may have been the originator of something entirely opposite to the kind of formal abstraction with which he had often been associated. Rather than recovering the formal foundation of composition, Cézanne, he suggested, did something else, something completely opposite to this grounding idea. Instead of fixing form, Cézanne allowed it to become unfixed and mobile. Masson's hesitation, captured by the ellipsis in the quote, suggests that he had to search for a term for what he had in mind: "you no longer know if this is about bathers or if it's about . . . a genesis." If this is a genesis, then it is a vital genesis, like a coming to life of art, not its ossification. This image of genesis, to use Masson's term, or, to use the terms we have been using – of vitality and harmony – is most evident in Cézanne's late watercolors of bathers. It is in these works, I have been arguing, that the flux of color and drawing brought within Cézanne's grasp by watercolor aligns itself with a vision of social harmony and sensory plenitude that was increasingly remote from what Cézanne was himself experiencing in his last years. Despite the fact that the three large oil paintings known as *Les Grandes Baigneuses* are usually singled out as the pinnacle of his late career, I have suggested here that it was rather the late bather watercolors that best captured the thrust of the image of youthful vitality and natural harmony that was at the origin of his bathing imagery.

Conclusion

This study has examined Cézanne's watercolors from the perspective of their combination of drawing and color, that is, from the perspective of their status as "colored drawing." I have argued that watercolor's appeal for Cézanne lay in its status as a hybrid medium in which drawing and color could be combined, but in a way that preserved the differences between drawing and color as qualitatively distinct stages in the process of execution. Moreover, I have argued that it was the position of watercolor between drawing and painting that specifically attracted Cézanne to the medium. Watercolor, I argued, offered Cézanne a more intimate and less freighted medium than oil painting in which to express his sensations in two different pictorial modes.

I developed this argument by tracing the development of Cézanne's watercolors over the course of his career and by setting them in a series of historical contexts. Thus, in Chapter One, I placed Cézanne's early watercolors in the context of discussions of watercolor in the 1860s that identified the medium's unique appeal in its expressive immediacy, visible in both the graphic and painterly aspects of the medium. In Chapter Two, Cézanne's Impressionist watercolors were shown to reflect a division of labor between form-giving drawing and light-registering color that was widely discussed in the context of outdoor watercolor painting. This division led in his mature career, discussed in Chapter Three, to greater autonomy in Cézanne's watercolors between drawing and color and their tactile and optical information, which deepened the medium's associations with partial and fragmentary rendering. As I argued, the layering and unevenness of these accounts in Cézanne's mature watercolors create a mnemonic record that has much in common with Bergson's notion of lived time as duration. In Chapter Four, I explored how Cézanne's late landscape, still-life, and portrait watercolors turned to focus on the flux of light and air, or the "envelope," a concern that was closely associated with colorist painting

Facing page: detail of pl. 144

from Delacroix to Impressionism. Finally, Chapter Five looked at Cézanne's water-color sketches for his three large canvases of female bathers, developed between 1894 and 1906, and their ambition to realize an image of vital harmony that was increasingly divergent from the artist's own experience in his last years.

At the same time, each chapter has explored the different ways in which Cézanne's watercolors became a compelling alternative to his work in oil painting. In each chapter, I have argued that, in addition to being a relief from oil painting, watercolor brought within Cézanne's reach a compelling, recursive means of expression in which he could render his sensations in both drawing and painting. Among other things, the combination of drawing and painting in his watercolors allowed him to prolong his enjoyment of the work of depiction by rendering the motif not once but multiple times. In each chapter, it has been the combination of drawing and color that has proven to be the pivot around which Cézanne's watercolors turn. Each development in his career is reflected in a new relationship between drawing and color, from the expressive counterpoint of drawing and color in his early career, to the opposition of drawing and color as a means to account for form and color and, indeed, tactile and optical experience in his Impressionist and mature watercolors, to the calibration of drawing and painting to optical flux and, finally, to the use of drawing and color to render a sense of implied movement and life in his sketches for bathers.

One of my ambitions in this study, therefore, has been to establish the specificity of Cézanne's watercolors by bringing the frequently overlooked drawn part of his watercolors back into focus. It is the dialogue between drawing and color, not color or drawing on its own, I have suggested, that is the most consistent and compelling aspect of his work in this medium. Another ambition, however, has been to shed greater light on the importance of watercolor to Cézanne's overall expressive ambitions, namely, to give form in his art to his sensations according to his personal temperament. What this translates into in his watercolors is a manner of working that, while closely related to historical precedents and parallels, ultimately becomes a unique treatment of the medium that, to recall Bernard's terms, is "totally different from usual techniques."

I wish to end with an anecdote reported by the critic Théodore Duret. In the chapter on Cézanne in his book on Impressionism, Duret, who became acquainted with Cézanne in the 1870s, published the details surrounding the artist's untimely death. Cézanne had been out painting in the fields around Aix-en-Provence in bad weather:

> One day in October 1906, when he was painting in the rain, he caught a chill and a congestion of the liver. He had to be carried back to his home from the distant spot where he was painting in a laundry cart. The day after he had his accident, he went out between 6 and 7 in the morning to work outdoors on a portrait he had begun of an old sailor. He again caught cold. He once again had to be brought back home and this time had to take to his bed definitively.[1]

These remarks agree generally with the details given by Cézanne's sister, Marie, to his son in a letter dated October 20, 1906:

> Your father has been ill since Monday; Dr. Guillaumont doesn't think he's in danger, but Madame Brémond is not up to taking care of him alone. You must come as soon as you can. At times he's so weak that a woman can't lift him by

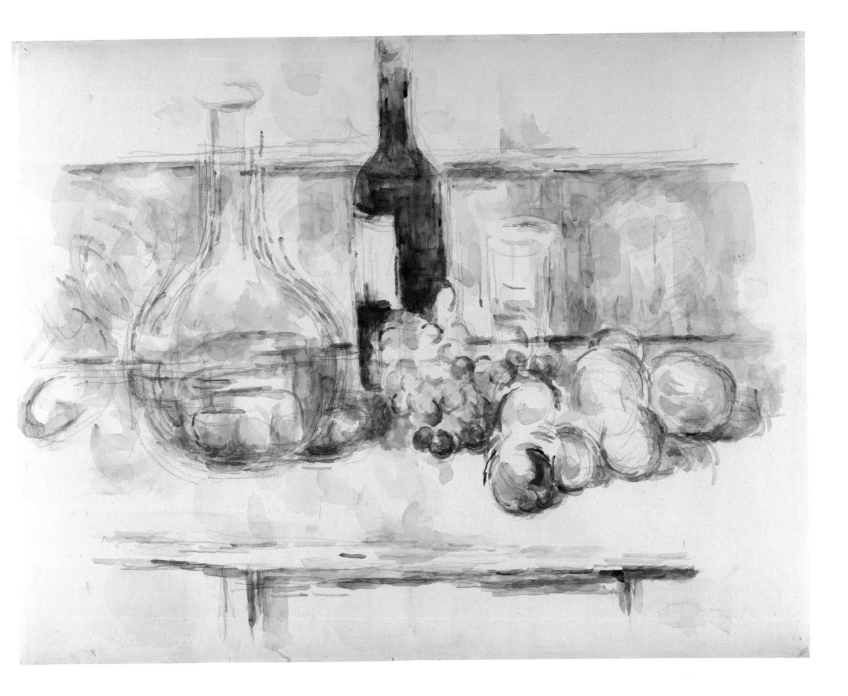

144 *Still Life with Carafe, Bottle, and Fruit*, 1906, grap-
hite and watercolor on paper, 18½ × 14½ in. (47 × 62 cm).
Princeton University Art Museum, Lent by the Henry and
Rose Pearlman Foundation. Photo © Bruce M. White

herself; with your help that would be possible. The doctor told us to get a male
nurse; your father wouldn't hear of it. I think that your presence is required so
that he can be as well cared for as possible.

He was out in the rain for several hours on Monday; they brought him back
on a laundry cart, and two men had to carry him up to his bed. The next day,
as soon as it was light enough, he went out to the garden [of the Les Lauves
studio] to work on a portrait of Vallier under the linden tree; he came back nearly
dead. You know your father; what can one say . . . I repeat, I think your pres-
ence is needed.[2]

This account clears up a bit of confusion in Duret's account – the portrait that
Cézanne was working on was of the gardener Vallier, not an old sailor. I discussed

a watercolor of Vallier seated under the linden tree on the studio terrace in Chapter Four (see pl. 103); it may have been this watercolor that Cézanne worked on the day after his accident, or perhaps it was one of the two related oil paintings of the same subject.[3] Cézanne's son did not make it to Aix in time to help, however, as his father passed away just three days later.

Duret added an interesting detail to the account of Cézanne's passing that is of significance, if purely symbolic, to this study. Even after having been permanently consigned to his sickbed, Cézanne, explained Duret, continued to work on a watercolor: "His passion to paint was such that, despite his pain, he got up from time to time in order to add some touches to a watercolor that was near his bed."[4] Duret provides no indication of which specific watercolor he added touches to, but a suggestion can be found in Georges Rivière's recollections of Cézanne. After examining Cézanne's watercolors as they developed over the course of his career, Rivière finished his brief account with a few words about his "last watercolor": "We now turn to Cézanne's last watercolor, the one that death prevented him from completing. A large crystal carafe with rounded forms, half-full with light-hued wine, a red apple, a glass, all only sketched in – nothing more."[5] The watercolor in question is *Still Life with Carafe, Bottle, and Fruit* (pl. 144). There has been some confusion about the identity of the rounded glass bottle in the watercolor: Rewald thought it was a bottle of cognac; Rivière suggested it was a decanter; and the current title of the work decides in favor of a water carafe.[6] The watercolor is an excellent example of the aspects of Cézanne's watercolors that have concerned me in this study, including the dialogue of drawing and color in his watercolor technique, his use of the "reserve," and the lightness of his watercolors in comparison with his increasingly dark oil paintings. If Duret was not mistaken in his recollection, then, Cézanne's last efforts as an artist were directed toward this watercolor, leading him to conclude his chapter on Cézanne with this rather dramatic sentence: "He died in Aix on October 22, one might say with a paintbrush in his hand."[7] Two things, however, need correction in this last sentence in Duret's account of Cézanne's life and art. First, Cézanne in fact died on October 23, not October 22.[8] And second, Cézanne died, "one might say," not just with a paintbrush, but, to be more specific, with a watercolor brush "in his hand."

Notes

Introduction

1 André Fontainas, "Les Aquarelles de Cézanne," *Mercure de France*, 56, 16e année (July 1, 1905), 133–34; quoted in Françoise Cachin et al., *Cézanne*, exh. cat., trans. John Goodman (New York: Harry N. Abrams / Philadelphia: Philadelphia Museum of Art, 1996), 41.

2 Rainer Maria Rilke, *Letters on Cézanne*, ed. Clara Rilke, trans. Joel Agee (New York: Fromm, 1985), 52–53 note 1.

3 Gustave Kahn, "Art," *Mercure de France* (December 16, 1913), 822. The critic Léon Werth similarly referred to Cézanne's watercolors not as *aquarelles*, but as *dessins aquarellés* – "watercolored drawings" (Léon Werth, "Dessins aquarellés de Cézanne," *L'Art vivant* [March 1, 1925], 18).

4 Lionello Venturi, *Paul Cézanne: Water Colours* (Oxford: Bruno Cassirer, 1943), 12.

5 Ibid.

6 Kurt Badt, *The Art of Cézanne*, trans. Sheila Ann Ogilvie (New York: Hacker, 1985), 40.

7 Lawrence Gowing, "The Logic of Organized Sensations," in *Cézanne: The Late Work*, ed. William Rubin (New York: Museum of Modern Art, 1977), 61.

8 Götz Adriani, *Cézanne Watercolors*, trans. Russell M. Stockman (New York: Harry N. Abrams, 1983); John Rewald, *Paul Cézanne: The Watercolors* (Boston, MA: Little, Brown, 1983).

9 Cézanne quoted in Gowing, "The Logic of Organized Sensations," 66.

10 Cézanne quoted in Emile Bernard, "Paul Cézanne," *L'Occident* (July 1904), 17–30; reprinted in *Conversations avec Cézanne*, ed. P.-M. Doran (Paris: Macula, 1978), 36.

11 An inventory of Cézanne's watercolors in John Rewald's catalogue raisonné reveals that roughly 95 percent of the 645 listed watercolors have both drawing and color. Rewald was not especially attentive to the drawing in Cézanne's watercolors. Of the 84 watercolors he listed as having no drawing, 45 actually do contain drawing. Only 39 known Cézanne watercolors, or roughly 5 percent of his overall production, appear to have no drawing whatsoever.

12 A recent exception to the trend of downplaying drawing in Cézanne's watercolors is Carol Armstrong's study of Cézanne's watercolor still lifes. Armstrong argues that Cézanne overcame in his watercolors the age-old division between drawing and color by intertwining line and color as part of a single, unfolding process. For Armstrong, it is not the distinction between drawing and color that is most important in Cézanne's watercolors but "the conflation of drawing and color, its inversion of *dessin* into *coloris*, color into design" (Carol Armstrong, *Cézanne in the Studio: Still Life in Watercolors* [Los Angeles: Getty, 2004], 139). My claim in this study, conversely, is that the difference between drawing and color is never overcome in Cézanne's watercolors and, instead, is continually affirmed in the separation of these two qualitatively different moments of rendering into distinct phases of expression. Even when Cézanne brings drawing back on top of color, as he does increasingly in his late watercolors, the categorical difference between these two modes of rendering is never lost.

13 Cézanne, letter to Paul Cézanne *fils*, October 15, 1906, in *Paul Cézanne: correspondance*, rev. edn., ed. John Rewald (Paris: Grasset et Fasquelle, 1978), 332.

14 See, for example, T. J. Clark, "Phenomenality and Materiality in Cézanne," in *Material Events: Paul de Man and the Afterlife of Theory*, ed. Barbara Cohen et al. (Minneapolis: University of Minnesota Press, 2001), 93–113.

15 Gustave Geffroy, "Paul Cézanne," in *La vie artistique*, vol. 3 (Paris: Dentu, 1894), 253–54.

16 Paul Cézanne, letter to Gustave Geffroy, March 26, 1894, in *Paul Cézanne: correspondance*, 237. Monet reinforced this point when he informed Geffroy that Cézanne had been "very sensitive to your article" (Claude Monet to Gustave Geffroy, November 23, 1894, in Daniel Wildenstein, *Claude Monet: biographie et catalogue raisonné, vol. 3: 1887–1898* [Paris: La Bibliothèque des arts, 1979], 278).

17 Wayne Andersen, "Watercolor in Cézanne's Artistic Process," *Art International*, vol. 5, no. 5 (May 25, 1963), 23.

18 Ibid.

19 See, for example, Anthea Callen, *The Art of Impressionism: Painting Technique and the Making of Modernity* (New Haven and London: Yale University Press, 2000); Richard Brettell, *Impressionism: Painting Quickly in France, 1860–1890* (New Haven and London: Yale University Press, 2000); John House, *Impressionism: Paint and Politics* (New Haven and London: Yale University Press, 2004).

20 This was especially evident in the important exhibition *Pioneering Modernism: Pissarro and Cézanne, 1865–1885*, held at the Museum of Modern Art in New York in 2006, in which paintings dominated. Surprisingly, watercolor figured neither in the exhibition nor in the catalogue, although both artists were active watercolorists throughout their careers.

One: Strong Sensations

1 Cézanne, letter to Emile Zola, June 30, 1866, in *Paul Cézanne: correspondance*, rev. edn., ed. John Rewald (Paris: Grasset et Fasquelle, 1978), 120.

2 Ibid.

3 There are no first-hand accounts of Cézanne's watercolor box. Bernard mentioned seeing a "carton" of watercolors in Cézanne's studio in 1904, but this probably refers to a box in which he stored his watercolors, not his *boîte d'aquarelle*. Cézanne mentioned to his son in a letter of 1906 that he was going to the motif "with just the bag of watercolors (*le sac d'aquarelle*)" (Cézanne, letter to Paul Cézanne, *fils*, October 13, 1906, in *Paul Cézanne: correspondance*, 331).

4 Cézanne, letter to Zola, 1858, in *Paul Cézanne: correspondance*, 26.

5 Ibid., 27.

6 Ibid., 26.

7 Cézanne, letter to Zola, July 26, 1858, in *Paul Cézanne: correspondance*, 34.

8 Cézanne, letter to Emile Bernard, July 25, 1904, in *Paul Cézanne: correspondance*, 304.

9 Zola, letter to Cézanne, March 3, 1860, in *Paul Cézanne: correspondance*, 67.

10 For details on Cézanne's biography, see John Rewald, *Paul Cézanne: A Biography*, trans. Margaret H. Liebman (New York: Schocken, 1968); see also Isabelle Cahn, "Chronology," in Françoise Cachin et al., *Cézanne*, exh. cat., trans. John Goodman (New York: Harry N. Abrams / Philadelphia: Philadelphia Museum of Art, 1996), 528–69.

11 Cézanne, letter to Joseph Huot, June 4, 1861, in *Paul Cézanne: correspondance*, 96.

12 Ibid.

13 On the Atelier Suisse, see John Rewald, *The History of Impressionism*, 4th edn. (New York: Museum of Modern Art, 1973), 48–50.

14 Edmond Duranty, "Pour ceux qui ne comprennent jamais," *Le Réalisme*, no. 2 (December 15, 1856), 1.

15 Zola, "Mon Salon [1866]," in *Ecrits sur l'art*, ed. Jean-Pierre Leduc-Adine (Paris: Gallimard, 1991), 125.

16 Ibid., 108.

17 Ibid., 107.

18 Ibid., 107–08.

19 See Albert Boime, "The Teaching Reforms of 1863 and the Origins of Modernism in France," *Art Quarterly*, vol. 1, no. 1 (1977), 1–39.

20 Zola, "Mon Salon [1866]," in *Ecrits sur l'art*, 127.

21 Ibid., 90.

22 Joachim Gasquet, who knew Cézanne in the 1890s, recalled that Cézanne was responsible for the ideas that Zola developed in his writing in the 1860s. See *Joachim Gasquet's Cézanne: A Memoir with Conversations*, trans. Christopher Pemberton (London: Thames and Hudson, 1991), 70 note 1.

23 Cézanne, letter to Joseph Huot, June 4, 1861, in *Paul Cézanne: correspondance*, 96.

24 See Lawrence Gowing et al., *Cézanne: The Early Years, 1859–1872*, exh. cat.

(New York: Harry N. Abrams, 1988), 82, 100.

25 Cézanne, letter to M. de Nieuwerkerke, April 19, 1866, in *Paul Cézanne: correspondance*, 114.

26 Fortuné Marion, letter to Heinrich Morstatt, April 12, 1866, trans. Margaret Scolari, quoted in Alfred H. Barr, "Cézanne in the Letters of Marion to Morstatt, 1865–1868: Chapter 2," *Magazine of Art*, vol. 31, no. 4 (April 1938), 220.

27 Edmond Duranty's remarks appear in "La Simple Vie du peintre Louis Martin," *Le Siècle* (November 13, 14, 15, and 16, 1872); reprinted in *Les Séductions du Chevalier Navoni* (Paris: Dentu, 1877). This is a revised version of an earlier and much shorter text, "Le Peintre Marabiel," *La Rue*, no. 8 (July 20, 1867), 6. The final text was reprinted with modifications as "Le Peintre Louis Martin," in *Le Pays des arts* (Paris: Charpentier, 1881). Maillobert is the revised version of Marsabiel, both of whom were modeled on Cézanne, as he appeared to Duranty in the mid-1860s, and both of whom speak of temperament. On these texts, see Marcel Crouzet, *Un méconnu du réalisme: Duranty (1830–1880)* (Paris: Nizet, 1964), 245–47.

28 John Rewald, *Paul Cézanne: The Watercolors* (Boston, MA: Little, Brown, 1983), 89.

29 Zola, letter to Cézanne, May 5, 1860, in *Paul Cézanne: correspondance*, 77.

30 Cézanne, letter to Zola, 1858, in *Paul Cézanne: correspondance*, 27.

31 On the relationship between Cézanne's composition and Manet's painting, see Götz Adriani, *Cézanne Watercolors*, trans. Russell M. Stockman (New York: Harry N. Abrams, 1983), 35–36.

32 Ibid., 35–40.

33 Quoted in Rewald, *Paul Cézanne: A Biography*, 66.

34 Quoted in ibid., 66–67. The misspelling of Cézanne's name in Mortier's article was probably caused by negligence on the author's part, but the misspelling in Zola's article can have been due only to misprinting, given Zola's intimacy with Cézanne.

35 Steven Platzman, *Cézanne: The Self Portraits* (Berkeley and Los Angeles: University of California Press, 2001), 25–63.

36 Ambroise Vollard, *Paul Cézanne: His Life and Art*, trans. Harold L. Van Doren (New York: Dover, 1984), 27. See also Jean-Claude Lebensztejn, "Les Couilles de Cézanne," *Critique*, vol. 44, no. 499 (December 1988), 1031–47.

37 Cézanne, letter to Camille Pissarro, March 15, 1865, in *Paul Cézanne: correspondance*, 113.

38 Charles Baudelaire, "Le Peintre de la vie moderne," in *Critique d'art*, ed. Claude Pichois (Paris: Gallimard, 1976), 346.

39 Ibid., 359.

40 Ibid.

41 Ibid.

42 Ibid.

43 Théophile Silvestre, *Eugène Delacroix: documents nouveaux* (Paris: Michel Lévy, 1864), 31. See also Ivan Bergol and Arlette Sérullaz, *Eugène Delacroix: aquarelles et lavis au pinceau* (Paris and Martel: Réunion des musées nationaux / Laquet, 1998).

44 Ibid., 32.

45 Ibid., 21.

46 Henri Lemaître, *Le Paysage anglais à l'aquarelle* (Paris: Bordas, 1955).

47 On the materials of watercolor, see Marjorie B. Cohn, *Wash and Gouache: A Study of the Development of the Materials of Watercolor* (Cambridge, MA: Fogg Art Museum, 1977).

48 See John Gage, *Turner and Watercolour: Exhibition of Watercolours from the Turner Bequest* (London: Arts Council of Great Britain, 1974); Andrew Wilton and Anne Lyles, *The Great Age of British Watercolours, 1750–1880* (London and Munich: Royal Academy of Art / Prestel, 1993); John Gage, "Turner: A Watershed of Watercolour," in *Turner*, ed. Michael Lloyd (Canberra: National Gallery of Australia, 1996), 101–27.

49 Thales H. Fielding, *On Painting in Oil and Watercolours for Landscape and Portraits* (London: Ackerman, 1839), 90.

50 Cited in Arlette Sérullaz, "Avant-propos" of the catalogue *L'Aquarelle en France au XIXe siècle* (Paris: Réunion des musées nationaux, 1983), 7.

51 There were exceptions to this rule, however, as is evident in the remarks penned by C. P. Landon in his review of the Salon of 1833, in which he singled out watercolor's new painterly ambitions for praise: "A revolution has just taken place in this interesting part of art that is called watercolor, or painting in water (*qu'on nomme aquarelle, or peinture à l'eau*). It has left behind its light and transparent hues, its timidity of effects, to adopt the density and the vigorous tonalities of oil painting. Artists of superior talent have shown that it can walk in step with its rival, and that it even has an advantage over it in being able to conserve very pure hues while elevating them to the highest level of tonality possible" (C. P. Landon, *Annales du musée et de l'école moderne des beaux-arts: Salon de 1833* [Paris: Pillet Ainé, 1833], 179).

52 Maxime du Camp, *Les Beaux-Arts à l'exposition universelle de 1855* (Paris: Librarie nouvelle, 1855), 315.

53 Edmond About, *Voyage à travers l'exposition des beaux-arts* (Paris: Hachette, 1855), 29–30.

54 Ibid.

55 Charles Blanc, *Grammaire des arts du dessin* (Paris: Renouard, 1867), 630.

56 Ibid.

57 Ibid.

58 Ibid. Once again, not every critic was in agreement with these sentiments. In a review of the Salon of 1846, Théophile Thoré singled out a watercolor of a lion by Delacroix and praised what he saw as its blurring of the boundaries of oil and watercolor painting: "Watercolor has never before been made so thick, for solid, and so colorful." He added: "The touch in this watercolor is broad like the touch of oil painting with the most deliberate brush. Delacroix hardly puts any water in his color, and the hues gain an extraordinary energy as a result" (W. Bürger [Théophile Thoré], ed., *Salons de T. Thoré: 1844, 1845, 1846, 1847, 1848* [Paris: Librairie internationale, 1868], 365–66). For his part, Baudelaire saw in Delacroix's watercolor a confirmation of the medium's difference from oil: "This lion painted with watercolor has a special merit for me, apart from the beauty of its drawing and attitude: it is painted with a great simplicity. Watercolor is restricted here to its modest role and does not try to rival oil painting." (Baudelaire, "Salon de 1846," in *Critique d'art*, 99–100).

59 Blanc, *Grammaire des arts du dessin*, 630.

60 Henri de Chennevières, "Maurice Leloir," in *Société des aquarellistes français*, vol. 2 (Paris: H. Launette, 1884), 299.

61 N. Paillot de Montabert, *Traité complet de la peinture*, 8 vols. (Paris: J.-F. Delion, 1829–51), vol. 8, 491; quoted and translated in George Levitine, "Growing Pains," in Alain de Leiris, *From Delacroix to Cézanne: French Watercolor Landscapes of the Nineteenth Century*, exh. cat. (College Park, MD: The University of Maryland, 1977), 13. In a manual published in 1876, Goupil wrote: "Above all for a woman watercolor has real advantages aside from any results: here there is no harsh smell of oil, no turpentine fumes to go to one's head, no risk to get dirty" (Frédéric Goupil, *Traité méthodique du dessin de l'aquarelle et du lavis* [Paris: Renauld, 1876], 20).

62 Emile Zola, *L'Oeuvre* (Paris: Hachette, 1968), 117.

63 Ibid., 22.

64 Jules-Antoine Castagnary, "Salon de 1868," in *Salons*, vol. 1 [1857–70] (Paris: Charpentier, 1892), 318.

65 Georges Lafenestre, "Le Salon de 1869," in *L'Art vivant: la peinture et la sculpture aux Salons de 1868–1877*, vol. 1 (Paris: G. Fischbacher, 1881), 142.

66 Ibid., 141.

67 Ibid., 142–43.

68 Castagnary, "Salon de 1869," in *Salons*, vol. 1, 381.

69 Albert Boime, *The Academy and French Painting in the Nineteenth Century* (London: Phaidon, 1971).

70 Vasari, quoted in Rudolf Wittkower, "Introduction," in *Masters of the Loaded Brush: Oil Sketches from Rubens to Tiepolo* (New York: Columbia University Press, 1967), xvii.

71 Diderot quoted in Boime, *The Academy and French Painting*, 84.

72 Silvestre, *Eugène Delacroix: documents nouveaux*, 9. On February 17, the first day of the sale after the previews, Silvestre wrote: "Today, the first day of the auction, the crowd returned, knocking an hour early at the doors of the exhibition, which was already a quarter full in advance by privileged people and well-known amateurs. At two o'clock: frenetic entrance. Sheep chased by wolves would rush less breathlessly back to the fold" (ibid).

73 Cézanne, letter to Numa Coste, February 27, 1864, in *Paul Cézanne: correspondance*, 111.

74 See Sara Lichtenstein, "Cézanne and Delacroix," *Art Bulletin*, vol. 46, no. 1 (March 1964), 55–67; Lichtenstein, "Cézanne's Copies and Variants after Delacroix," *Apollo*, vol. 101, no. 156 (February 1975), 116–27; Kurt Badt, *The Art of Cézanne*, trans. Sheila Ann Ogilvie (New York: Hacker, 1985), 279–99. See also Nina Athanassoglou-Kallmyer, "Cézanne and Delacroix's Posthumous Reputation," *Art Bulletin*, vol. 87, no. 1 (March 2005), 111–29.

75 Jules Adeline, *Peinture à l'eau: aquarelle–lavis–gouache–miniature* (Paris: Quantin, 1888), 23.

76 Ibid., 197.

77 Ibid., 197–98.

78 Ibid., 198.

79 Cohn, *Wash and Gouache*, 44–51.

80 Réné Ménard, "François-Louis Français," in *Société des aquarellistes français*, vol. 1, no. 8 (Paris: Goupil, 1883), 127.

81 Henri-Joseph Harpignies, cited in Henri Guerlin, *Le Dessin* (Paris: Henri Laurens, n. d.), 165–66.

82 Cassagne, *Traité d'aquarelle*, 112.

83 See, for example, Max Imdahl, *Couleur: les écrits des peintres français de Poussin à Delaunay*, trans. Françoise Laroche (Paris: Maison des sciences et de l'homme, 1996). See also Guerlin, *Le Dessin*.

84 Baudelaire, "Salon de 1846," in *Critique d'art*, 86.

85 Ibid.

86 Ibid., 94.

87 Ibid., 118.

88 Georges Rivière, *Le Maître Paul Cézanne* (Paris: Floury, 1923), 195.

89 See, for instance, Edgar Allan Poe, "The Fall of the House of Usher," in *The Complete Tales and Poems of Edgar Allen Poe* (New York: Random House, 1938), 231–45. Roger Fry also made an analogy between Poe's stories and the psychological intensity of Cézanne's early art (Roger Fry, *Cézanne: A Study of His Development* [Chicago: University of Chicago Press, 1989], 15).

90 Edgar Munhall, *François-Marius Granet: Watercolors from the Musée Granet in Aix-en-Provence* (New York: The Frick Collection, 1988), 68–69; see also Denis Coutaigne, "Les 'Eaux-Légères' de Granet," in *Granet: paysages de l'Isle de France: aquarelles et dessins* (Aix-en-Provence: Musée Granet, 1984), 15.

91 Emile Bernard, "Souvenirs sur Paul Cézanne," *Mercure de France* (October 1, 1907); reprinted in *Conversations avec Cézanne*, ed. P.-M. Doran (Paris: Macula, 1978), 75.

92 See Cézanne, letter to Camille Pissarro, June 24, 1874, in *Paul Cézanne: correspondance*, 146–47.

93 Marion to Morstatt, early summer 1867, trans. Scolari, quoted in Alfred H. Barr,, "Cézanne in the Letters of Marion to Morstatt, 1865–1868: Chapter 1," *Magazine of Art*, vol. 31, no. 2 (February 1938), 89.

94 For a provocative discussion of the role of themes of sexual violence in Cézanne's early work, see Robert Simon, "Cézanne and the Subject of Violence," *Art in America*, vol. 79, no. 5 (May 1991), 120–35, 185–86.

95 Marion to Morstatt, April 1868, trans. Scolari, quoted in Barr, "Cézanne in the Letters of Marion to Morstatt, 1865–1868: Chapter 1," 89.

96 Marion to Morstatt, June 1866, in ibid.

97 Stock, "'Le Salon' par Stock," *Album Stock* (March 20, 1870); trans. and quoted in John Rewald, with Walter Feilchenfeldt and Jane Warman, *The Paintings of Paul Cézanne*, 2 vols. (New York: Harry N. Abrams, 1996), vol. 1, 118.

98 Cézanne, letter to Justin Gabet, June 7, 1870, in *Paul Cézanne: correspondance*, 135–36.

99 Rewald, *Paul Cézanne: The Watercolors*, 88.

100 On the rhetoric of masculinity in the writing of Zola and the painting of Cézanne in the 1860s, see, for instance, Nina Maria Athanassoglou-Kallmyer, *Cézanne and Provence: The Painter in His Culture* (Chicago: University of Chicago Press, 2003), 26–28.

101 Henri Focillon, *The Life of Forms in Art*, trans. Charles B. Hogan and George Kubler (New York: Zone Books, 1989), 184.

102 Ibid.

Two: Shorthand for Sensation

1 Maurice Denis, "Cézanne," in *Theories, 1890–1910: du symbolisme et de Gauguin vers un nouvel ordre classique*, 4th edn. (Paris: Rouart et Watelin, 1920), 250.

2 For information on the dialogue between Cézanne and Pissarro, see Joachim Pissarro, *Pioneering Modern Painting: Cézanne and Pissarro* (New York: Museum of Modern Art, 2005); Richard Brettell, "Cézanne/Pissarro: élève/élève," in *Cézanne aujourd'hui*, ed. Françoise Cachin et al. (Paris: Réunion des musées nationaux, 1997), 32–36; Barbara Ehrlich White, *Impressionists Side by Side* (New York: Alfred A. Knopf, 1996), 107–47; Christopher Lloyd, "'Paul Cézanne, Pupil of Pissarro': An Artistic Friendship," *Apollo*, vol. 136, no. 369 (November 1992), 284–90.

3 Pissarro, letter to Guillemet, September 3, 1872, in *Correspondance de Camille Pissarro*, ed. Janine Bailly-Herzberg, 5 vols. (Paris: Presses universitaires de France, 1980–91), vol. 1, 77.

4 Pissarro, letter to Lucien Pissarro, March 23, 1898, in *Correspondance de Camille Pissarro*, vol. 4, 128.

5 Pissarro, *Pioneering Modern Painting*, 40.

6 Emile Zola, "Mon Salon [1868]," in *Écrits sur l'art*, ed. Jean-Pierre Leduc-Adine (Paris: Gallimard, 1991), 203.

7 Ibid., 205.

8 Cézanne, letter to Camille Pissarro, October 23, 1866, in *Paul Cézanne: correspondance*, rev. edn., ed. John Rewald (Paris: Grasset et Fasquelle, 1978), 125.

9 Cézanne, letter to Zola, October 19, 1866, in *Paul Cézanne: correspondance*, 116.

10 Pissarro, letter to Guillemet, September 3, 1872, in *Correspondance de Camille Pissarro*, vol. 1, 77.

11 For a useful chronology of Pissarro's life and career, see Bailly-Herzberg, "Chronologie Camille Pissarro," in *Cor-respondance de Camille Pissarro*, vol. 1, 24–54.

12 Stéphane Mallarmé, "The Impressionists and Edouard Manet," *Art Monthly Review and Photographic Portfolio*, vol. 1, no. 9 (September 30, 1876), 117–22; reprinted in Charles Moffett et al., *The New Painting: Impressionism, 1874–1886*, exh. cat. (San Francisco: The Fine Arts Museums of San Francisco, and Washington, DC: National Gallery of Art, 1986), 96.

13 See John Rewald, *The History of Impressionism*, 4th edn. (New York: Museum of Modern Art, 1973), 197–270. See also Ralph E. Shikes and Paula Harper, *Pissarro: His Life and Art* (New York: Horizon Press, 1980), 76–102; Christopher Lloyd, *Camille Pissarro* (Geneva: Skira, 1981), 37–53; Joachim Pissarro, *Camille Pissarro* (New York: Harry N. Abrams, 1993), 58–86.

14 Jules-Antoine Castagnary, "Exposition du Boulevard des Capucines: les impressionistes," *Le Siècle* (April 29, 1874), 3; reprinted in *The New Painting: Impressionism, 1874–1886: Documentation*, ed. Ruth Berson, 2 vols. (San Francisco: The Fine Arts Museums of San Francisco, 1996), vol. 1, 17.

15 Louis Leroy, "L'Exposition des impressionistes," *Le Charivari* (April 25, 1874), 79–80; reprinted in *The New Painting*, ed. Berson, vol. 1, 25–26.

16 Camille Pissarro to Lucien Pissarro, February 28, 1883, in *Correspondance de Camille Pissarro*, vol. 1, 178.

17 Camille Pissarro to Lucien Pissarro, May 13, 1891, in *Correspondance de Camille Pissarro*, vol. 3, 81.

18 Camille Pissarro to Lucien Pissarro, October 2, 1896, in *Correspondance de Camille Pissarro*, vol. 4, 266.

19 Lucien Pissarro quoted in John Bensusan-Butt, "Recollections of Lucien Pissarro in His Seventies," in *Lucien Pissarro, 1863–1944* (London: Anthony d'Offay, 1977), 21.

20 Lucien Pissarro, letter to Paul Gachet [*fils*], November 4, 1927, in Paul Gachet, *Lettres impressionnistes et autres* (Paris: Bernard Grasset, 1957), 54.

21 Cézanne to Camille Pissarro, June 24, 1874, in *Paul Cézanne: correspondance*, 146.

22 Cézanne quoted in Emile Bernard, "Paul Cézanne," *L'Occident* (July 1904); reprinted in *Conversations avec Cézanne*, ed. P.-M. Doran (Paris: Macula, 1978), 36.

23 Maurice Denis, "Cézanne," in *Théories, 1890–1910: du symbolisme et de Gauguin vers un nouvel ordre classique*, 4th edn. (Paris: Rouart et Watelin, 1920), 257.

24 Camille Pissarro to Lucien Pissarro, November 22, 1895, in *Correspondance de Camille Pissarro*, vol. 4, 121.

25 See Richard Brettell and Christopher Lloyd, *Catalogue of Drawings by Camille Pissarro in the Ashmolean Museum, Oxford* (New York and Oxford: Oxford University Press, 1980), plate 65 recto, ii.

26 See Richard Brettell, *Pissarro and Pontoise: The Painter in a Landscape* (New Haven and London: Yale University Press, 1990), 77–93.

27 Camille Pissarro to Lucien Pissarro, May 3, 1891, in *Correspondance de Camille Pissarro*, vol. 3, 81.

28 Camille Pissarro to Paul Signac, August 30, 1888; cited in Jean Leymarie, *L'Aquarelle* (Geneva: Skira, 1984), 125. This letter does not appear in *Correspondance de Camille Pissarro*, vol. 2, which covers the time span of 1886–90.

29 Nicolas-Toussaint Charlet, quoted in Armand Cassagne, *Traité d'aquarelle* [1875], 2nd edn. (Paris: Fouraut, 1886), 145.

30 Ibid.

31 Paul Signac, *Jongkind* (Paris: G. Crès, 1927), 119.

32 Ibid.

33 Ibid., 113–14.

34 Ibid., 111.

35 Ibid., 110.

36 Ibid., 119–20.

37 Boudin's notebook of 1887, quoted in Laurent Manoeuvre, "Boudin's Watercolours of Beaches," in *Boudin at Trouville*, ed. Vivian Hamilton (London: John Murray / Glasgow Museums, 1992), 151.

38 Signac, *Jongkind*, 110.

39 See, for instance, *Marshy Landscape*, in John Rewald, *Paul Cézanne: The Watercolors* (Boston, MA: Little, Brown, 1983), no. 99.

40 John Rewald, "Cézanne and Guillaumin," in *Studies in Impressionism* (New York: Harry N. Abrams, 1985), 103–19; On Guillaumin, see Théodore Duret, *Histoire des peintres impressionnistes*, 3rd edn. (Paris: H. Floury, 1922), 149–53. See also *Armand Guillaumin, 1841–1927: un maître de l'impressionnisme français* (Paris: Bibliothèque des arts, 1996).

41 For a discussion of Cézanne's drawing technique during his Impressionist years see Theodore Reff, "Cézanne's Drawings, 1875–85," *Burlington Magazine*, vol. 101, no. 674 (May 1959): 171–76.

42 Cézanne, letter to Pissarro, June 24, 1874, in *Paul Cézanne: correspondance*, 146.

43 Rewald observes that this painting relates closely to one painted by Pissarro in 1877, but he suggests that the two paintings do not show the same but rather similar motifs (John Rewald, with Walter Feilchenfeldt and Jane Warman, *The Paintings of Paul Cézanne*, 2 vols. [New York: Harry N. Abrams, 1996], vol. 1, 213).

44 See Rewald, *Paul Cézanne: The Watercolors*, 24; Rewald, "Chocquet and Cézanne," in *Studies in Impressionism*, ed. Irene Gordon and Frances Weitzenhoffer (New York: Thames and Hudson, 1985); and Richard Brettell, "The 'First' Exhibition of Impressionist Painters," in Moffett et al., *The New Painting*, 189–202.

45 In the exhibition catalogue for *The New Painting*, the essays devoted to the successive Impressionist shows unfortunately pay very little attention to the role of watercolor in the exhibitions.

46 Léon de Lora, "Petites nouvelles artistiques: exposition libre des peintres," *Le Gaulois* (April 18, 1874), 3; reprinted in *The New Painting*, ed. Berson, vol. 1, 27.

47 E. Drumont, "L'Exposition du boulevard des Capucines," *Le Petit Journal* (April 19, 1874), 2; reprinted in *The New Painting*, ed. Berson, vol. 1, 21.

48 Philippe Burty, "Exposition de la société anonyme des artistes," *La République française* (April 25, 1874), 2; reprinted in *The New Painting*, ed. Berson, vol. 1, 37.

49 Etienne Carjat, "L'Exposition du boulevard des Capucines," *Le Patriote français* (April 27, 1874), 3; reprinted in *The New Painting*, ed. Berson, vol. 1, 14.

50 Jean Prouvaire, "L'Exposition du boulevard des Capicines," *Le Rappel* (April 20, 1874), 3; reprinted in *The New Painting*, ed. Berson, vol. 1, 35.

51 Philippe Burty, "The Paris Exhibitions: Les Impressionnistes," *The Academy* (May 30, 1874), 616; reprinted in *The New Painting*, ed. Berson, vol. 1, 10.

52 E. F., "Le Groupe d'artistes de la rue Le Peletier," *Moniteur des arts* (April 21, 1876), 1–2; reprinted in *The New Painting*, ed. Berson, vol. 1, 84.

53 Bertall, "Les Impressionnalistes," *Les Beaux-Arts* (1876), 44–45; reprinted in *The New Painting*, ed. Berson, vol. 1, 58.

54 Léon Mancino, "Deuxième exposition de peintures, dessins, gravures faite par

un groupe d'artistes," *L'Art*, vol. 5 (1876), 36–37; reprinted in *The New Painting*, ed. Berson, vol. 1, 98 note 2.

55 Arthur Baignières, "Exposition de peinture par un groupe d'artistes, rue Pelietier, 11," *L'Echo universel* (April 13, 1876); reprinted in *The New Painting*, ed. Berson, vol. 1, 55.

56 Louis Gonse, "Aquarelles, dessins, et gravures au Salon de 1875," *Gazette des Beaux-Arts*, 2nd ser., 12 (August 1, 1875), 167.

57 Louis Gonse, "Aquarelles, dessins, et gravures au Salon de 1876," *Gazette des Beaux-Arts*, 2nd ser., 14 (August 1, 1876), 142.

58 Ibid.

59 Louis Gonse, "Les Aquarelles, dessins, et gravures au Salon de 1875," *Gazette des Beaux-Arts*, 2nd ser., 16 (August 1, 1877), 167

60 Ludovic Piette, letter to Camille Pissarro, October 8, 1872, in *Mon cher Pissarro: lettres de Ludovic Piette à Camille Pissarro*, ed. Janine Bailly-Herzberg (Paris: Valhermeil, 1985), 74.

61 Ludovic Piette, letter to Camille Pissarro, end of April–beginning of May 1873, in *Mon cher Pissarro*, 85.

62 Thomas Grimm, "Les Impressionnistes," *Le Petit Journal* (April 7, 1877), 1; reprinted in *The New Painting*, ed. Berson, vol. 1, 152.

63 Charles Bigot, "Causerie artistique: l'exposition des 'impressionnistes,'" *La Revue politique et littéraire* (April 28, 1877), 1045–48; reprinted in *The New Painting*, ed. Berson, vol. 1, 135.

64 Léon de Lora, "L'Exposition des impressionnistes," *Le Gaulois* (April 10, 1877), 1–2; reprinted in *The New Painting*, ed. Berson, vol. 1, 162.

65 Georges Rivière, "Les Intransigeants et les impressionnistes: souvenirs du salon libre de 1877," *L'Artiste* (November 1, 1877), 298–302; reprinted in *The New Painting*, ed. Berson, vol. 1, 186.

66 Lora, "L'Exposition des impressionnistes," in *The New Painting*, ed. Berson, vol. 1, 162.

67 Georges Rivière, "L'Exposition des impressionnistes," *L'Impressionniste* (April 14, 1877), 1–4, 6; reprinted in *The New Painting*, ed. Berson, vol. 1, 183.

68 Rivière, "Les Intransigeants et les impressionnistes," in *The New Painting*, ed. Berson, vol. 1, 186.

69 Ibid.

70 Jacques, "Menus propos: exposition impressionniste," *L'Homme libre* (April 12, 1877), 1–2; reprinted in *The New Painting*, ed. Berson, vol. 1, 157.

71 Ibid.

72 Charles Bigot, "Causerie artistique," in *The New Painting*, ed. Berson, vol. 1, 135.

73 Ibid.

74 Ibid., 134.

75 Lora, "L'Exposition des impressionnistes," in *The New Painting*, ed. Berson, vol. 1, 163. Curiously, this remark has often been thought to refer to his oil paintings, some of which were listed as "etudes d'après nature." The only works specifically listed as Impressions after nature, however, were the two watercolors. That a watercolor could look like an unscraped palette is perhaps counterintuitive, since one does not scrape a watercolor palette but washes it with water. One scrapes an oil palette, hence leading to the assumption that this remark refers to his oil paintings. For an example, see T. J. Clark, *The Painting of Modern Life: Paris in the Art of Manet and His Followers* (Princeton: Princeton University Press, 1985), 20.

76 Ernest Fillonneau, "Les Impressionnistes," *Moniteur des arts* (April 20, 1877), 1; reprinted in *The New Painting*, ed. Berson, vol. 1, 146.

77 Louis Leroy, "Exposition des impressionnistes," *Le Charivari* (April 25, 1874), 79–80; reprinted in *The New Painting*, ed. Berson, vol. 1, 159.

78 Cézanne, letter to Zola, June 19, 1880, in *Paul Cézanne: correspondance*, 193.

79 Zola, letter to Guillemet, August 22, 1880, in Emile Zola, *Correspondance*, ed. B. H. Bakker et al., 10 vols. (Montréal: Presses de l'université de Montréal, 1978–95), vol. 4, 94.

80 Pavel Machotka, *Cézanne: Landscape into Art* (New Haven and London: Yale University Press, 1996), 21–30.

81 Zola, letter to Cézanne, May 13, 1880, in *Paul Cézanne: Letters*, rev. edn., ed. John Rewald, trans. Seymour Hacker (New York: Hacker, 1984), 190 [this letter is not in the French version of Cézanne's letters].

82 Ibid., 191.

83 Cézanne, letter to Zola, June 19, 1880, in *Paul Cézanne: correspondance*, 192.

84 Emile Zola, "Le Naturalisme au Salon [1880]," in *Ecrits sur l'art*, 422.

85 Ibid.

86 Ibid.

87 Richard Shiff, *Cézanne and the End of Impressionism: A Study of the Theory, Technique, and Critical Evaluation of Modern Art* (Chicago: University of Chicago Press, 1984), 99–123.

88 Cézanne, letter to Pissarro, April 1876, in *Paul Cézanne: correspondance*, 151.

89 Emile Blémont, "Les Impressionnistes," *Le Rappel* (April 9, 1876), 2–3; reprinted in *The New Painting*, ed. Berson, vol. 1, 62.

90 Ibid.

91 Ibid., 63.

92 Cézanne, letter to Pissarro, July 2, 1876, in *Paul Cézanne: correspondance*, 152–53.

93 Ibid., 153.

94 Hyppolite Taine, *Philosophie de l'art*, 2 vols. (Paris: Hachette, 1946), vol. 1, 269.

95 Ibid., 271–72.

96 Ibid., 272.

97 Arlette Sérrulaz and Régis Michel, *L'Aquarelle en France au XIXe siècle: dessins du musée du Louvre* (Paris: Réunion des musées nationaux, 1983), 68.

98 Jean-Louis-Ernest Meissonier, quoted in ibid., 84.

99 Théodore de Wyzewa, "Du soleil, de la Provence, et de la mer Mediterranée," *Revue bleue* (January 13, 1894), 59.

100 John House, *Impressionism: Paint and Politics* (New Haven and London: Yale University Press, 2004), 149–50.

101 Georges Rivière, *Le Maître Paul Cézanne* (Paris: Floury, 1923), 122–23.

102 Ibid., 120.

103 Ibid.

Three: Layered Sensations

1 Quoted in John Rewald, *Cézanne and America: Dealers, Collectors, Artists, and Critics, 1891–1921* (Princeton: Princeton University Press, 1979), 144–45.

2 Isabelle Cahn, "Chronology," in Françoise Cachin et al., *Cézanne*, exh. cat., trans. John Goodman (New York: Harry N. Abrams / Philadelphia: Philadelphia Museum of Art, 1996), 546–49.

3 John Rewald, with Walter Feilchenfeldt and Jane Warman, *The Paintings of Paul Cézanne*, 2 vols. (New York: Harry N. Abrams, 1996), vol. 1, 408.

4 Armand Cassagne, *Traité d'aquarelle* [1875], 2nd edn. (Paris: Fouraut, 1886), 23–24.

5 Theodore Reff and Innis Howe Shoemaker, *Paul Cézanne: Two Sketch-books* (Philadelphia: Philadelphia Museum of Art, 1989), 132–33.

6 For a technical analysis of Cézanne's watercolor pigments based on X-ray fluorescence of nine watercolors at the Philadelphia Museum of Art, see Faith Zieske, "Paul Cézanne's Watercolors: His Choice of Pigments and Papers," in *The Broad Spectrum: Studies in the Materials, Techniques, and Conservation of Color on Paper*, ed. Harriet K. Stratis and Britt Salvesen (London: Archetype, 2002), 89–100.

7 Frédéric Goupil, *Traité méthodique de dessin de l'aquarelle et du lavis* (Paris: Renouard, 1876), 28–29.

8 Lawrence Gowing argued that this blank spot was a "culminating point," following Cézanne's claim that "in an orange, an apple, a sphere, a head, there is a culminating point, and that point is always – despite the terrible effect: light and shade, sensations of color – the one closest to our eyes" (Cézanne, letter to Emile Bernard, July 25, 1904, in *Paul Cézanne: correspondance*, rev. edn., ed. John Rewald [Paris: Grasset et Fasquelle, 1978], 304–05). Gowing claimed that this blank spot was not a highlight, but rather the logical culmination of the color sequences that Cézanne was applying to the page. He argued: "On either side of the point culminant, left blank on the paper – at first sight one could mistake it for the highlight on the pot, but it was nothing of the kind – the colors were arranged in order, first blue, then emerald green (to specify the material color of the pot), then yellow ocher. At this stage, one hardly notices that a deliberate system is being employed, but close inspection leaves no doubt of it. No pot ever produced this logical sequence arranged like the blue, green, and yellow bands of the spectrum and spread out on paper in its natural order" (Lawrence Gowing, "The Logic of Organized Sensations," in *Cézanne: The Late Work*, ed. William Rubin [New York: Museum of Modern Art, 1977], 58). The color sequences, he concluded, "convey the rounded surface

metaphorically" (ibid.). While Gowing's account of Cézanne's watercolors is one of the most sensitive and perceptive studies to be published, his claim that Cézanne's color in his watercolors is anti-natural and calibrated to the unfolding spectrum is unconvincing. Indeed, Cézanne's dedication to his "colored sensations," which he mentions in the same letter as the "culminating point," to which Gowing refers, reinforces the empirical focus in his art, no matter how simplified his colors became. In fact, the colors in *The Green Pot* very clearly refer not to the natural light spectrum, but to the local color and reflected light observed in the motif.

9 Theodore Reff, "The Pictures within Cézanne's Pictures," *Arts Magazine*, vol. 53, no. 10 (June 1979), 96–97.

10 John Rewald, "Introduction: The Watercolors of Paul Cézanne," in *Paul Cézanne: The Watercolors* (Boston, MA: Little, Brown, 1983), 31.

11 Ernest Chesneau, "A côté du Salon: II. Le Plein Air: exposition du boulevard des Capucines," *Paris-Journal* (May 7, 1874), 2; reprinted in *The New Painting: Impressionism, 1874–1886: Documentation*, ed. Ruth Berson, 2 vols. (San Francisco: The Fine Arts Museums of San Francisco, 1996), vol. 1, 18.

12 Philippe Burty, "The Paris Exhibitions: *Les Impressionnistes*," *The Academy* (May 30, 1874), 616; reprinted in *The New Painting*, ed. Berson, vol. 1, 10.

13 Jules-Antoine Castagnary, "Exposition du Boulevard des Capucines: Les Impressionnistes," *Le Siècle* (April 29, 1874), 3; reprinted in *The New Painting*, ed. Berson, vol. 1, 17.

14 Ibid.

15 Charles Baudelaire, "Salon of 1845," in *Critique d'art*, ed. Claude Pichois (Paris: Gallimard, 1976), 50.

16 Ibid.

17 Eugène Delacroix, *The Journal of Eugène Delacroix*, trans. Walter Pach (New York: Crown, 1948), 294–95.

18 Richard Brettell, *Impressionism: Painting Quickly in France, 1860–1890* (New Haven and London: Yale University Press, 2000), 17.

19 Ibid.

20 Cézanne, letter to his mother, September 26, 1874, in *Paul Cézanne: correspondance*, 148.

21 Emile Bernard, letter to his mother, February 5, 1904, in *Conversations avec Cézanne*, ed. P. M. Doran (Paris: Macula, 1978), 24.

22 R. P. Rivière and J. F. Schnerb, "L'Atelier de Cézanne," *La Grande Revue* (December 25, 1907), 811–17; reprinted in *Conversations avec Cézanne*, 87.

23 Cézanne, quoted in ibid.

24 Jonathan Crary, "Unbinding Vision," *October*, no. 68 (Spring 1994), 27.

25 Jonathan Crary, "Attention and Modernity in the Nineteenth Century," in *Picturing Science, Producing Art*, ed. Caroline A. Jones and Peter Gallison (New York: Routledge, 1998), 492.

26 Jonathan Crary, *Suspensions of Perception* (Cambridge, MA: MIT Press, 1999), 289.

27 Ibid.

28 Paul Cézanne quoted in Bernard, "Paul Cézanne," in *Conversations avec Cézanne*, 36.

29 Arthur Baignières, "Société d'aquarellistes français," *Gazette des Beaux-Arts*, 2nd ser., 19 (May 1, 1879), 492.

30 Henri de Chennevières, "Maurice Leloir," in *Société des aquarellistes français: vol. 2* (Paris: H. Launette, 1884), 299.

31 Ibid.

32 Henry Houssaye, *L'Art français depuis dix ans* (Paris: Didier, 1882), xxx.

33 Jules Antoine, "Galerie Petit: exposition de la Société des aquarellistes," *La Plume*, no. 45 (March 1, 1891), 98.

34 G.-Albert Aurier, "Les Aquarellistes," *Revue indépendante*, no. 40 (February 1890), 322–23.

35 Octave Maus, "Exposition des aquarellistes (premier article)," *L'Art moderne*, vol. 1, no. 8 (April 24, 1881), 58. This article was followed by a second (Maus, "Exposition des aquarellistes [secondième article]," *L'Art moderne*, vol. 1, no. 9 [May 1, 1881], 67–68). See also the referendum on the medium of watercolor that was held in the pages of *L'Art moderne* in 1890, in which the familiar positions were reinforced, some supporting watercolors as a rapid mode of sketching and others supporting detailed and finished work (Maus, "Referendum artistique," *L'Art moderne*, vol. 10, no. 52 [December 28, 1890], 409–12; Maus, "Referendum artistique,"

L'Art moderne, vol. 11, no. 2 [January 11, 1891], 11–14).

36 Alfred de Lostalot, "Exposition universelle: aquarelles, dessins, gravures," *Gazette des Beaux-Arts*, 2nd ser., 18 (October 1878), 634–35.

37 The poem reads:

OPHELIA: '*T is brief, my lord*
HAMLET: *As woman's love*
Oh ! oh ! le temps se gâte,
L'orage n'est pas loin,
Voilà que l'on se hâte
 De rentrer les foins ! . . .

 L'abcès perce !
 Vl'à l'averse !

 Ô grabuges
 Des déluges ! . . .

 Oh ! ces ribambelles
 D'ombrelles ! . . .

 Oh ! cett' Nature
 En déconfiture ! . . .

 Sur ma fenêtre,
 Un fuchsia
 À l'air paria

 Se sent renaître . . .

(Jules Laforgue, "Aquarelle en cinq minutes," *Le Décadent littéraire*, September 25, 1886).

38 Jane Munro, *French Impressionists* (Cambridge: Cambridge University Press, 2004), 124.

39 Quoted in Cachin et al., *Cézanne*, 264.

40 For the historical precedents of this opposition of tactile drawing and optical painting, see Max Imdahl, *Couleur: les écrits des peintres français de Poussin à Delaunay*, trans. Françoise Laroche (Paris: Maison des sciences et de l'homme, 1996), 71–97.

41 Stéphane Mallarmé, "The Impressionists and Edouard Manet," *Art Monthly Review and Photographic Portfolio*, vol. 1, no. 9 (September 30, 1876); reprinted in Charles Moffett et al., *The New Painting: Impressionism, 1874–1886*, exh. cat. (San Francisco: The Fine Arts Museums of San Francisco, and Washington, DC: National Gallery of Art, 1986), 34.

42 Jules Laforgue, "L'Impressionnisme," in *Jules Laforgue: mélanges posthumes* (Paris: Mercure de France, 1903); reprinted in *Laforgue: textes de critique*

d'art, ed. Mireille Dotin (Lille: Presses universitaires de Lille, 1988), 170; see also Michelle Hannoosh, "The Poet as Art Critic: Laforgue's Aesthetic Theory," *Modern Language Review*, vol. 79, no. 3 (July 1984), 553–56.

43 Ibid.

44 Diego Martelli, "Les Impressionnistes," in *Les Impressionnistes et l'art moderne*, ed. Francesca Errico, trans. Francis Darbousset (Paris: Vilo, 1979), 24.

45 Ibid.

46 Nicolas Wadley, *Impressionist and Post-Impressionist Drawing* (New York: Dutton, 1991), 14.

47 Maurice Merleau-Ponty, "Cézanne's Doubt," in *Sense and Non-Sense*, trans. Hubert L. Dreyfus and Patricia Allen Dreyfus (Evanston, IL: Northwestern University Press, 1964), 15.

48 Richard Shiff, "Cézanne's Physicality: The Politics of Touch," in *The Language of Art History*, ed. Ivan Gaskill and Salim Kemal (Cambridge: Cambridge University Press, 1991), 168.

49 Yve-Alain Bois, "Words and Deeds," trans. Rosalind Krauss, *October*, no. 84 (Spring 1998), 37.

50 Edmond Jaloux, *Les Saisons litteraires*, vol. 2 (Fribourg: Libraire de l'Université, 1942), 72.

51 Cézanne, quoted in Bernard, "Paul Cézanne," in *Conversations avec Cézanne*, 36.

52 Maurice Denis, "Cézanne," in *Théories, 1890–1910: du symbolisme et de Gauguin vers un nouvel ordre classique*, 4th edn. (Paris: Rouart et Watelin, 1920), 257.

53 Ibid.

54 Alois Riegl, *Late Roman Art Industry*, trans. Rolf Winkes (Rome: Giorgio Bretschneider, 1985), 24ff.

55 Adolph von Hildebrand, *The Problem of Form*, trans. Max Meyer and Robert Morris Ogden (New York: G. E. Stechert, 1932), 1–35.

56 Emile Bernard, "Les Aquarelles de Cézanne," *L'Amour de l'art* (February 1924), 34.

57 Thadée Natanson, "Paul Cézanne," *La Revue blanche* (December 1, 1895), 497.

58 Camille Pissarro, letter to Lucien Pissarro, November 21, 1895, in *Correspondance de Camille Pissarro*, ed. Janine Bailly-Herzberg, 5 vols. (Paris: Presses universitaires de France, 1980–91), vol. 4, 119.

59 Gustave Geffroy, "Paul Cézanne," *Le Journal* (November 16, 1895); reprinted in Geffroy, *Paul Cézanne et autres textes*, ed. Christian Limousin (Paris: Séguier, 1995), 60.

60 Ibid.

61 Ibid. Although he does not discuss this later text by Geffroy, Terrence Maloon notes that Geffroy's remarks on Cézanne's art "Marked a turning point in commentaries on 'unfinished' Cézannes" (Maloon, "Critical Responses to Cézanne's Unfinished Works," in Felix Baumann et al., *Cézanne: Finished/Unfinished*, exh. cat. [Ostfildern-Ruit: Hatje Cantz, 2000], 93).

62 Julie Manet noted in her diary: "With M. Degas and M. Renoir, we went to Vollard's where a Cézanne exhibition was being held. . . . M. Degas and M. Renoir drew straws for a magnificent watercolor still life of pears and [there was also] a small one representing an assassination in Provence which is not at all frightening, the figures detaching themselves in very harmonious reds, blue, and violet from a landscape that resembles Brittany of the Midi; round trees, masses of ground against a blue sea, in the distance some islands. M. Renoir also admired it. I bought it, thinking that it would not be stupid to do so. 'Look at that little collector,' M. Degas said to me . . ." (Rewald, *Paul Cézanne: The Watercolors*, 93).

63 Jane Warman, "List of Exhibitions," in Rewald, *Paul Cézanne: The Watercolors*, 469. See also Rewald's comments on *Three Pears* (ibid., 157–58) and *The Green Pot* (ibid., 192).

64 See Richard Kendall, "Degas and Cézanne: Savagery and Refinement," in Ann Dumas et al., *The Private Collection of Edgar Degas* (New York: The Metropolitan Museum of Art, 1997), 197–219.

65 In a review of the 1892 exhibition of the Société des aquarellistes français, Geffroy made clear his attraction to watercolor as a means of rendering fleeting and fragile sensations. His disdain for the thick gouaches and heavily worked watercolors of the majority of the exhibitors accords well with the general consensus of critics, discussed earlier in this chapter. "Watercolor should serve to render certain aspects

that are not within the range of oil painting," explained Geffroy, "such as fugitive effects that vanish as soon as they are born and atmospheric transparency" (Gustave Geffroy, "Peintures et aquarelles," in *La Vie artistique*, vol. 2 [Paris: Dentu, 1893], 361).

66 Gustave Geffroy, "Salon de 1901," in *La Vie artistique*, vol. 8 (Paris: Dentu, 1903), 376; reprinted in Geffroy, *Paul Cézanne et autres textes*, 64.

67 Richard Shiff, "To Move the Eyes: Impressionism, Symbolism, and Well-Being, c. 1891," in *Impressions of French Modernity*, ed. Richard Hobbs (Manchester: Manchester University Press, 1998), 192. On the question of unfinish in Cézanne, see also Shiff, *Cézanne and the End of Impressionism: A Study of the Theory, Technique, and Critical Evaluation of Modern Art* (Chicago: University of Chicago Press, 1984), 189–94.

68 Henri Bergson, *Creative Evolution*, trans. Arthur Mitchell (New York: Dover, 1998), 1–2; quoted in George Heard Hamilton, "Cézanne and the Image of Time," *College Art Journal*, vol. 16, no. 1 (Fall 1956), 11.

69 Hamilton, "Cézanne and the Image of Time," 6.

70 Ibid., 11.

71 Rewald, *Cézanne and America*, 141–51.

72 Edward Steichen, letter to Alfred Stieglitz, early 1911, quoted in Rewald, *Cézanne and America*, 141.

73 Cited in Rewald, *Cézanne and America*, 146.

74 Joseph Edgar Chamberlin, "Cézanne Embyos," *Evening Mail* (March 8, 1911); cited in Rewald, *Cézanne and America*, 146.

75 Anonymous [Arthur Hoeber], "Art and Artists," *New York Globe and Commercial Advertiser* (March 3, 1911); cited in Rewald, *Cézanne and America*, 146.

76 Anonymous, "Water Colors by Cézanne," *New York Times* (March 12, 1911); cited in Rewald, *Cézanne and America*, 148–49.

Four: Sensations of Light and Air

1 Paul Cézanne *fils*, letter to Ambroise Vollard, November 11, 1904, in *Paul Cézanne: Letters*, rev. edn., ed. John Rewald, trans. Seymour Hacker (New York: Hacker, 1984), 303 [this letter is not included in the French edition of Cézanne's letters].

2 Meyer Schapiro, "Cézanne as a Watercolorist," in *Modern Art: 19th and 20th Centuries: Selected Papers* (New York: George Braziller, 1979), 44.

3 See Isabelle Cahn, "Chronology," in Françoise Cachin et al., *Cézanne*, exh. cat., trans. John Goodman (New York: Harry N. Abrams / Philadelphia: Philadelphia Museum of Art, 1996), 556–59.

4 Léo Larguier recalled that the studio on the rue Boulegon was "an attic under the eaves, an immense room with small windows . . . which smelled like those pantries in the countryside where pears and mushrooms are stored in the autumn" (Léo Larguier, *Le Dimanche avec Paul Cézanne: souvenirs* [Paris: L'Edition, 1925], 107).

5 Cézanne, letter to Paule Conil, September 1, 1902, in *Paul Cézanne: correspondance*, rev. edn., ed. John Rewald (Paris: Grasset et Fasquelle, 1978), 290.

6 Cézanne, letter to Ambroise Vollard, January 9, 1903, in *Paul Cézanne: correspondance*, 292.

7 Jules Borély, "Cézanne à Aix," *Vers et prose*, vol. 27 (1911), 109–13; reprinted in *Conversations avec Cézanne*, ed. P.-M. Doran (Paris: Macula, 1978), 19.

8 Karl Ernst Osthaus, "Une visite à Paul Cézanne," *Das Feuer* (1920–21), 81–85; reprinted in *Conversations avec Cézanne*, 99. A recently discovered photograph of Cézanne, taken by Gertrude Osthaus, the collector's wife, at the time of the visit, shows Cézanne carrying a chair out of the studio onto the terrace for one of his guests (see Philip Conisbee and Denis Coutagne, *Cézanne in Provence*, exh. cat. [New Haven and London: Yale University Press, 2006], ii).

9 Emile Bernard, "Souvenirs sur Paul Cézanne," *Mercure de France* (October 1, 1907), 385–404; "Souvenirs sur Paul Cézanne," *Mercure de France* (October 16, 1907), 606–27; reprinted in *Conversations avec Cézanne*, 55.

10 Ibid., 62.

11 Cézanne, letter to Gasquet, July 21, 1896, in *Paul Cézanne: correspondance*, 252.

12 Ibid.

13 Cézanne, letter to Philippe Solari, July 23, 1896, in *Paul Cézanne: correspondance*, 254.

14 Ibid., 253–54.

15 On Mistral and the Félibrige, see Tudor Edwards, *The Lion of Arles: A Portrait of Mistral and his Circle* (New York: Fordham University Press, 1964); and Robert Lafont, *La Revendication occitaine* (Paris: Flammarion, 1974). See also, among other documents, the special issue of *La Plume* (July 1, 1891), devoted to the Félibrige. On the group around Gasquet, see Edmond Jaloux, *Les Saisons littéraires*, 2 vols. (Fribourg: Editions de la librairie de l'université, 1942–50); and Eugène Montfort, "La Mort de Gasquet," *Les Marges*, vol. 21, no. 84 (June 15, 1921), 83–87.

16 Cézanne encouraged Gasquet to send him his publications in his letters from Tailloires. "It will thus be a true act of compassion and a comfort to me if you continue to send me your review, which will remind me both of the distant country and of your benevolent youthfulness I have been allowed to brush elbows with." And, farther along in the same letter: "I cherish the hope of being able to read more from you and your ardent collaborators" (Cézanne, letter to Joachim Gasquet, July 21, 1896, in *Paul Cézanne: correspondance*, 252).

17 Cézanne, letter to Joachim Gasquet, January 30, 1897, in *Paul Cézanne: correspondance*, 259.

18 Cézanne, letter to Gasquet, July 21, 1896, in *Paul Cézanne: correspondance*, 252.

19 Ibid.

20 See, for example, Paul Smith, "Joachim Gasquet, Virgil and Cézanne's Landscape: 'My Beloved Golden Age,'" *Apollo*, vol. CXLVII, no. 439 (October 1998), 11–23; Nina Maria Athanassoglou-Kallmyer, *Cézanne and Provence: The Painter in His Culture* (Chicago: University of Chicago Press, 2003).

21 Cézanne, letter to Emile Bernard, April 15, 1904, in *Paul Cézanne: correspondance*, 300.

22 Cézanne, letter to Emile Bernard, 1905, in *Paul Cézanne: correspondance*, 314.

23 Cézanne quoted in Larguier, *Le Dimanche avec Paul Cézanne*, 136. Larguier reported that this and other comments were recounted to him by

Cézanne's son, who had heard his father make them.

24 R. P. Rivière and J. F. Schnerb, "L'Atelier de Cézanne," in *Conversations avec Cézanne*, 89.

25 Ibid.

26 Carol Armstrong, *Cézanne in the Studio: Still Life in Watercolors* (Los Angeles: Getty, 2004), 9–40.

27 Faith Zieske, "Conservator's Note," in *Cézanne in Focus: Watercolors from the Henry and Rose Pearlman Collection*, ed. Carol Armstrong and Laura Giles (Princeton: Princeton University Press, 2002), 105.

28 Lawrence Gowing thought that these repeated lines represented "the irreducible ambiguity of binocular vision" (Gowing, *Watercolour and Pencil Drawings by Cézanne* [London: Arts Council of Great Britain, 1973], 18–19). In opposition to this perceptualist explanation, Robert Ratcliffe described Cézanne's repeated contours as zones of expansion, "showing the gradual heightening or expanding of the form to fill the design better" (Robert William Ratcliffe, 'Cézanne's Working Methods and Their Theoretical Background,' Ph.D. dissertation, Courtauld Institute of Art, University of London [1961], 209). Neither of these accounts takes note of Cézanne's stated goal of rendering the "envelope."

29 See note 21 above.

30 Rivière and Schnerb, "L'Atelier de Cézanne," in *Conversations avec Cézanne*, 87.

31 Eugène Delacroix, January 25, 1857, in *The Journal of Eugène Delacroix*, trans. Walter Pach (New York: Crown, 1948), 558, translation modified.

32 In a letter dated February 22, 1906, Cézanne wrote: "I just received 'Delacroix's Journal.' I accept it with the greatest pleasure, for reading it, I hope, will reconfirm my sense of the truth of certain of my studies of nature" (John Rewald, *Cézanne and America: Dealers, Collectors, Artists, and Critics, 1891–1921* [Princeton: Princeton University Press, 1979], 108). Curiously, this letter is not included in either the English or French editions of Paul Cézanne's letters.

33 Félix Bracquemond, *Du dessin et de la couleur* (Paris: Charpentier, 1885), 106.

34 Ibid., 98.

35 Ibid., 99.

36 Ibid., 101.

37 Ibid., 101.

38 See note 10 above.

39 Cézanne, letter to Paul Cézanne *fils*, August 3, 1906, in *Paul Cézanne: correspondance*, 318–19.

40 Pissarro informed his son: "Cézanne, whom I met yesterday at Durand's gallery, is very much in agreement with me that this is the work of a careful, reflective man, pursuing the ungraspable nuance of effects, something that I don't see any other artist achieving" (Pissarro, letter to Lucien Pissarro, May 26, 1895, in *Correspondance de Camille Pissarro*, ed. Janine Bailly-Herzberg, 5 vols. [Paris: Presses universitaires de France, 1980–91], vol. 4, 75).

41 Charles Camoin in Charles Morice, "Enquête sur les tendances actuelles des arts plastiques," *Mercure de France* (August 1, 1905), 353.

42 Raymond Bouyer, "Le Procès de l'art moderne au Salon d'Automne," *Revue bleue* (November 5, 1904), 605.

43 Claude Monet, letter to Gustave Geffroy, October 7, 1890; quoted in John House, *Monet: Nature into Art* (New Haven and London: Yale University Press, 1986), 220. House's discussion of the "envelope" on pages 220–21 of his book is the best historical account of the term in the literature on Impressionism.

44 André Michel, *Notes sur l'art moderne* (Paris: Armand Colin, 1896), 290.

45 Robert de la Sizeranne, "Le Bilan de l'impressionnisme," in *Les Questions esthétiques contemporaines* (Paris: Hachette, 1904), 94.

46 Theodore Reff, "Cézanne: The Logical Mystery," *Art News*, vol. 62, no. 2 (April 1963), 30.

47 Borély, "Cézanne à Aix," in *Conversations avec Cézanne*, 20.

48 Ambroise Vollard, *Paul Cézanne: His Life and Art*, trans. Harold L. Van Doren (New York: Dover, 1984), 69.

49 See Chapter One, note 1.

50 Paul Cézanne, letter to his son, October 13, 1906, in *Paul Cézanne: correspondance*, 331.

51 Maurice Denis, *Journal: vol. 1, 1884–1904* (Paris: La Colombe, 1957), 157.

52 Vollard, *Cézanne: His Life and Art*, 76.

53 Ibid., 78.

54 Lawrence Gowing, "The Logic of Organized Sensations," in *Cézanne: The Late Work*, ed. William Rubin (New York: Museum of Modern Art, 1977), 61.

55 Ibid.

56 See the oil and watercolor of *Seated Peasant* (1900–04), reproduced on facing pages in Cachin et al., *Cézanne*, 508–09.

57 Vollard, *Cézanne: His Life and Art*, 79.

58 Joachim Gasquet, *Joachim Gasquet's Cézanne: A Memoir with Conversations*, trans. Christopher Pemberton (London: Thames and Hudson, 1991), 121.

59 Bernard, "Souvenirs sur Paul Cézanne," in *Conversations avec Cézanne*, 57.

60 Cézanne quoted in Emile Bernard, "Paul Cézanne," *L'Occident* (July 1904); reprinted in *Conversations avec Cézanne*, 37.

61 Riviere and Schnerb, "L'Atelier de Cézanne," in *Conversations avec Cézanne*, 91.

62 Paul Cézanne *fils*, letter to Ambroise Vollard, January 20, 1902, in *Paul Cézanne: Letters*, 276 [this letter is not included in the French edition of Cézanne's letters].

63 Cézanne, letter to Charles Camion, February 3, 1902, in *Paul Cézanne: correspondance*, 281. Cézanne became cross with his son when he began to speak with other, rival dealers. In another letter to Camoin, dated March 11, 1902, he wrote: "I believe absolutely in Vollard as an honest man. Since your departure, the Bernheims and another dealer have been to see me. My son had some dealings with them. However, I remain faithful to Vollard, and I deeply regret that because of my son he got the impression that I might take my canvases somewhere else" (Cézanne, letter to Charles Camion, March 11, 1902, in *Paul Cézanne: correspondance*, 284).

64 Cézanne mentioned in a letter to Charles Camoin dated January 28 that Vollard had "passed through Aix two weeks ago." See Cézanne, letter to Charles Camion, January 28, 1902, in *Paul Cézanne: correspondance*, 280.

65 John Rewald, "Chocquet and Cézanne," in *Studies in Impressionism*, ed. Irene Gordon and Frances Weitzenhoffer (New York: Thames and Hudson, 1985), 174.

66 Cézanne thanked Vollard for the "magnificent gift of the great Master's work you have given me" in a letter dated January 23, 1902 (*Paul Cézanne: correspondance*, 278–79). Rewald notes that Vollard informed him in 1935 that he had not given the watercolor as a gift, but rather as an exchange (Rewald, "Chocquet and Cézanne," 187, note 106).

67 Bernard, "Souvenirs sur Paul Cézanne," in *Conversations avec Cézanne*, 67.

68 Cézanne, letter to Ambroise Vollard, January 23, 1902, in *Paul Cézanne: correspondance*, 278.

69 Cézanne, letter to Maurice Denis, March 17, 1902, in *Paul Cézanne: correspondance*, 285.

70 Cézanne, letter to Ambroise Vollard, April 2, 1902, in *Paul Cézanne: correspondance*, 286.

71 Paul Cézanne *fils*, letter to Ambroise Vollard, April 20, 1905, in *Paul Cézanne: Letters*, 310 (this letter is not included in the French edition of Cézanne's letters).

72 Anonymous, "Expositions nouvelles," *Chronique des arts et de la curiosité* (June 17, 1905), 187.

73 R. M., "Petites exhibitions: exposition Paul Cézanne (Galerie Vollard)," *Chronique des arts et de la curiosité* (July 1, 1905), 192.

74 The recent exhibition, *Cézanne to Picasso: Ambroise Vollard, Patron of the Avant-Garde*, made no reference to Vollard's dealings with Cézanne's watercolors. Richard Jensen's otherwise informative catalogue essay on the relationship between Vollard and Cézanne also makes no mention of the watercolor exhibition (Jensen, "Vollard and Cézanne: An Anatomy of a Relationship," in *Cézanne to Picasso: Ambroise Vollard, Patron of the Avant-Garde*, ed. Rebecca A. Rabinow [New York: The Metropolitan Museum of Art, 2006], 29–47). In the catalogue, only Rabinow's thorough chronology acknowledges the existence of the exhibition of 1905 (Rabinow, "Exhibitions *chez* Vollard, 1894–1911," in ibid., 305–22).

75 André Fontainas, "Les Aquarelles de Cézanne," *Mercure de France*, 56, 16e année (July 1, 1905), 133–34; quoted and translated in Cachin et al., *Cézanne*, 41.

76 Maurice Denis, "La Peinture," *L'Ermitage*, vol. 2, no. 11 (November 15, 1905), 314.

77 Bernard, "Souvenirs sur Paul Cézanne," in *Conversations avec Cézanne*, 55.

78 Ibid.

79 Ibid., 59.

80 Ibid., 60.

81 Ibid., 59.

82 A watercolor by Cézanne in the Annenberg Collection, which depicts a view of Montagne Saint-Victoire, and which, according to an inscription on its verso, was given to Bernard by Cézanne in 1904, is clearly not the one that Bernard describes in his "Souvenirs." On the one hand, from a technical standpoint it appears to date from much earlier in Cézanne's career (he might simply have given Bernard an early work), while, on the other, the surface does not display the kind of complicated imbrication of colored laminae that Bernard describes in his eyewitness account. See Colin Bailey et al., *Masterpieces of Impressionism and Post-Impressionism: The Annenberg Collection* (Philadelphia: Philadelphia Museum of Art, 1989), 85.

83 Charles Blanc, *Grammaire des arts du dessin* (Paris: Renouard, 1867), 630.

84 Marie-Elisabeth Cavé, *L'Aquarelle sans maître* (Paris: Napoléon Chaix, 1851), 22.

85 Jules Adeline, *Peinture à l'eau: aquarelle–lavis–gouache–miniature* (Paris: Quantin, 1888), 71; see also Marjorie B. Cohn, *Wash and Gouache: A Study of the Development of the Materials of Watercolor* (Cambridge, MA: Fogg Art Museum, 1977), 44–51.

86 Paul Signac, *Jongkind* (Paris: G. Crès, 1927), 106.

87 Ibid., 106–07. Signac had learned this trick from Ruskin, of whom he was an avid reader: "Yellow or orange will hardly show, if pale, in small spaces; but they show brightly in firm touches, however small, with white beside them" (John Ruskin, *The Elements of Drawing* [1857; New York: Dover, 1971], 152).

88 Paul Signac, *D'Eugène Delacroix au Néo-Impressionnisme* (Paris: Floury, 1921); see also Georges Roque, *Art et science de la couleur: Chevreul et les peintres, de Dealcroix à l'abstraction* (Paris: Jac-queline Chambon, 1997).

89 Roger Fry, *Cézanne: A Study of His Development* (Chicago: University of Chicago Press, 1989), 61.

90 Cézanne comes close to Turner here. Turner also used the white of his watercolor papers to figure the washing out of sensation in the blinding light of the sun. See, for example, Andrew Wilton, *Turner and the Sublime* (London: British Museum, 1980).

91 Rainer Maria Rilke, letter to Paula Modersohn-Becker, June 28, 1907, in *Letters on Cézanne*, ed. Clara Rilke, trans. Joel Agee (New York: Fromm, 1985), 52–53, note 1.

92 Rilke, letter to Clara Westhoff, November 8, 1900, quoted in *Letters on Cézanne*, 43, note 1.

93 Rilke, letter to Clara Westhoff, October 10, 1907, in *Letters on Cézanne*, 43.

94 In his review of the exhibition, one critic noted that the walls had been "religiously" hung with "paintings and watercolors; finished works, and sketches and scrawls" (André Pérate, "Le Salon d'automne," *Gazette des Beaux-Arts*, 3rd ser., 38 [November 1, 1907], 387). See Jayne Warman, "List of Exhibitions," in John Rewald, *Paul Cézanne: The Watercolors* (Boston, MA: Little, Brown, 1983), 469.

95 Rilke, letter to Clara Westhoff, October 13, 1907, in *Letters on Cézanne*, 50.

96 Rilke, letter to Clara Westhoff, October 16, 1907, in *Letters on Cézanne*, 57.

97 Rilke, letter to Clara Westhoff, October 22, 1907, in *Letters on Cézanne*, 79.

98 Rilke, letter to Clara Westhoff, October 23, 1907, in *Letters on Cézanne*, 85.

99 Félix Vallotton, "Au Salon d'automne," *La Grande Revue* (October 25, 1907), 917.

100 Ibid., 918.

Five: Vital Sensations

1 Emile Bernard, "Souvenirs sur Paul Cézanne," *Mercure de France* (October 1 and 16, 1907); reprinted in *Conversations avec Cézanne*, ed. P.-M. Doran (Paris: Macula, 1978), 57, 69.

2 Cézanne, letter to Emile Bernard, September 21, 1906, in *Paul Cézanne: correspondance*, rev. edn., ed. John Rewald (Paris: Grasset et Fasquelle, 1978), 327.

3 See, for instance, Cézanne, letter to Charles Camoin, February 22, 1903, in *Paul Cézanne: correspondance*, 293.

4 Ambroise Vollard, *Cézanne: His Life and Art*, trans. Harold L. Van Doren (New York: Dover, 1984), 79.

5 R. P. Rivère and J. F. Schnerb, "L'Atelier de Cézanne," in *Conversations avec Cézanne*, 91.

6 The most comprehensive account of the sequence of the canvases is Theodore Reff, "Cézanne's Late Bather Paintings," *Arts Magazine*, vol. 52, no. 2 (October 1977), 116–19.

7 Paul Cézanne, "Mes confidences," in *Conversations avec Cézanne*, 102. See also Fabrice Touttavoult [Jean-Claude Lebensztejn], *Confessions: Marx, Engels, Proust, Mallarmé, Cézanne* (Paris: Belin, 1988); Jean-Claude Lebensztejn, "Persistance de la mémoire," *Critique*, vol. 54, nos. 555–56 (August–September 1993), 609–31.

8 Georges Rivière, "L'Exposition des impressionnistes," *L'Impressionniste* (April 14, 1877), 1–4, 6; reprinted in *The New Painting: Impressionism, 1874–1886: Documentation*, ed. Ruth Berson, 2 vols. (San Francisco: The Fine Arts Museums of San Francisco, 1996), vol. 1, 181.

9 On Cézanne's sources for his bathers, see Gertrude Berthold, *Cézanne und die alten Meister: die Bedeutung der Zeichnungen Cézannes nach Werken anderer Künstler* (Stuttgart: W. Kohlhammer, 1958); Mary Louise Krumrine, *Paul Cézanne: The Bathers* (New York: Harry N. Abrams, 1989). For an important critique of Krumrine's strategy of labeling the poses in Cézanne's bather paintings "tempter," "temptress," etc., see Kathleen Adler, "Cézanne's Bodies," *Art in America*, vol. 78, no. 4 (April 1990), 235–77.

10 There are two exceptions, in which men spy on their female counterparts in an erotically suggestive manner (John Rewald, *Paul Cézanne: The Watercolors* [Boston, MA: Little, Brown, 1983], nos. 250 and 251).

11 T. J. Clark, "Freud's Cézanne," in *Farewell to an Idea: Episodes from a History of Modernism* (New Haven and London: Yale University Press, 1999), 139–67. For an earlier instance of psychoanalysis applied to the interpretation of Cézanne's bathers, see Theodore Reff,

"Cézanne's Bather with Outstretched Arms," *Gazette des Beaux-Arts*, 6th ser., 59 (March 1962), 173–90. See also Jean-François Lyotard, "Freud selon Cézanne," in *Des dispositifs pulsionnels* (Paris: Galilée, 1994), 71–89.

12 Joachim Gasquet, *Joachim Gasquet's Cézanne: A Memoir with Conversations*, trans. Christopher Pemberton (London: Thames and Hudson, 1991), 78.

13 Laura Giles makes this connection in an entry in *Cézanne in Focus: Watercolors from the Henry and Rose Pearlman Collection*, ed. Carol Armstrong and Laura Giles (Princeton: Princeton University Press, 2002), 85–91.

14 Melvin Waldfogel has shown that this watercolor relates closely to a decorative panel that Cézanne was commissioned to paint for Chocquet in the late 1880s, albeit with certain significant differences (Waldfogel, "A Problem in Cézanne's *Grandes Baigneuses*," *Burlington Magazine*, vol. 104, no. 710 [May 1962], 203).

15 Both Gustave Geffroy and Joachim Gasquet reported Cézanne's respect for Rodin. Geffroy noted Cézanne's almost obsequious behavior around Rodin during the meeting in 1894 (Geffroy, *Claude Monet: sa vie, son temps, son oeuvre* [Paris: G. Crès, 1922], 196–98). For his part, Gasquet reported that Cézanne had dined with Rodin in Paris (Gasquet, *Joachim Gasquet's Cézanne*, 100).

16 Rodin, quoted in Paul Gsell, "Rodin racontée par lui-même," *La Revue* (May 1, 1906), 99–100.

17 George Bois, "Le Sculpteur Rodin et les danseuses cambodgiennes," *L'Illustration* (July 28, 1906), 64. This page is reproduced in Claudie Jurdin, "Rodin Watercolors," in *Auguste Rodin: Watercolors from the Collection of the Musée Rodin, Paris*, ed. Thomas Knubben and Tilman Osterwald (Ostfildern-Ruit: Hatje Cantz, 2005), 17. See also Christina Buley-Uribe, "The Work in Its Ultimate Form," in *Auguste Rodin: Drawings and Watercolors*, ed. Antoinette Le Normand-Romain and Christina Buley-Uribe (New York and London: Thames and Hudson, 2006), 24–67.

18 Mario Meunier, "Rodin dans son art et dans sa vie," *Le Marges* (April 1914), 250–51.

19 For a discussion of the perception of implied movement in still images, see E. H. Gombrich, "Movement and Moment in Art" and "Standards of Truth: The Arrested Image and the Moving Eye," in *The Image and the Eye* (Ithaca, NY: Cornell University Press, 1982), 40–62 and 244–77.

20 Una E. Johnson, *Ambroise Vollard, Editeur: Prints, Books, Bronzes* (New York: Museum of Modern Art, 1977).

21 Douglas Druick, "Cézanne's Lithographs," in *Cézanne: The Late Work*, ed. William Rubin (New York: Museum of Modern Art, 1977), 119–37. See also Michel Melot, *The Impressionist Print*, trans. Caroline Beamish (New Haven and London: Yale University Press, 1996), 263–66.

22 Bernard, "Souvenirs sur Paul Cézanne," in *Conversations avec Cézanne*, 58–59.

23 Paul Souriau, *The Aesthetics of Movement*, trans. Manon Souriau (Amherst: The University of Massachusetts Press, 1983), 121.

24 Bernard, "Souvenirs sur Paul Cézanne," in *Conversations avec Cézanne*, 58.

25 Maurice Denis, *Journal: vol. II, 1905–1920* (Paris: La Colombe, 1957), 30.

26 Maurice Denis, "Cézanne," in *Theories, 1890–1910: du symbolisme et de Gauguin vers un nouvel ordre classique*, 4th edn. (Paris: Rouart et Watelin, 1920), 174–75.

27 For a discussion of the etymology and nuances of the term *repentirs*, see Françoise Viatte, "Weaving a Rope of Sand," trans. Roland Racevskis, *Yale French Studies*, no. 89 (1996), 85–102.

28 Denis, *Journal: vol. II, 1905–1920*, 30.

29 Jules Borély, "Cézanne à Aix," *Vers et prose*, vol. 27 (1911); reprinted in *Conversations avec Cézanne*, 19.

30 Eugène Véron, *L'Esthetique*, 2nd edn. (Paris: Reinwald, 1883), 302 note 1.

31 Louis Vauxcelles, "Les Dessins et aquarelles du 'Petit Palais,'" *L'Art et les artistes* (October 1906), 437.

32 Ibid., 435.

33 Denis, "Cézanne," in *Theories, 1890–1910*, 250.

34 Bernard, "Souvenirs sur Paul Cézanne," in *Conversations avec Cézanne*, 70.

35 He notes in the same letter that an acquaintance has offered to pose by the river, but that suspicion of ulterior motives led Cézanne to decline the offer: "Two days ago, Sire Rolland came to see

me; he engaged me in conversation about the painting. He offered to pose for me as a bather on the banks of the Arc – that idea rather appealed to me, but I am afraid that the gentleman only wants to get his hands on my study" (Cézanne, letter to his son, August 12, 1906, in *Paul Cézanne: correspondance*, 320).

36 Cézanne, letter to his son, August 14, 1906, in *Paul Cézanne: correspondance*, 321.

37 Cézanne, letter to his son, August 26, 1906, in *Paul Cézanne: correspondance*, 322.

38 Cézanne, letter to his son, September 2, 1906, in *Paul Cézanne: correspondance*, 323.

39 Cézanne, letter to Paule Conil, September 1, 1902, in *Paul Cézanne: correspondance*, 290.

40 Cézanne, letter to Zola, April 9, 1858, in *Paul Cézanne: correspondance*, 17.

41 Ibid., 19.

42 Tamar Garb, "Visuality and Sexuality in Cézanne's Late Bathers," *Oxford Art Journal*, vol. 19, no. 2 (1996), 46–60.

43 Cézanne, letter to Emile Bernard, 1905, in *Paul Cézanne: correspondance*, 313–14.

44 Cézanne, letter to Roger Marx, January 23, 1905, in *Paul Cézanne: correspondance*, 312.

45 André Masson, "Le Scandale de la figuration," in *Entretiens avec Georges Charbonnier* (Paris: Julliard, 1958), 146.

Conclusion

1 Théodore Duret, *Histoire des peintres impressionnistes*, 3rd edn. (Paris: H. Floury, 1922), 148.

2 Marie Cézanne, letter to Paul Cézanne *fils*, October 20, 1906, in *Paul Cézanne: correspondance*, rev. edn., ed. John Rewald (Paris: Grasset et Fasquelle, 1978), 333–34.

3 See John Rewald, with Walter Feilchenfeldt and Jane Warman, *The Paintings of Paul Cézanne*, 2 vols. (New York: Harry N. Abrams, 1996), vol. 2, nos. 950 and 953.

4 Duret, *Histoire des peintres impressionnistes*, 148.

5 Georges Rivière, *Le Maître Paul Cézanne* (Paris: Floury, 1923), 123.

6 Rewald's title for the work is *Bottle of Cognac*. See John Rewald, *Paul Cézanne: The Watercolors* (Boston, MA: Little, Brown, 1983), 258–59.

7 Duret, *Histoire des peintres impressionnistes*, 148.

8 Isabelle Cahn, "Chronology," in Françoise Cachin et al., *Cézanne*, exh. cat., trans. John Goodman (New York: H. N. Abrams / Philadelphia: Philadelphia Museum of Art, 1996), 569.

Bibliography

About, Edmond, *Voyage à travers l'exposition des beaux-arts*, Paris: Hachette, 1855.

Adeline, Jules, *Peinture à l'eau: aquarelle–lavis–gouache–miniature*, Paris: Quantin, 1888.

Adler, Kathleen, "Cézanne's Bodies," *Art in America*, vol. 78, no. 4 (April 1990), 235–77.

Adriani, Götz, *Cézanne Watercolors*, trans. Russell M. Stockman, New York: Harry N. Abrams, 1983.

Andersen, Wayne, "Watercolor in Cézanne's Artistic Process," *Art International*, vol. 5, no. 5 (May 25, 1963), 23–27.

Anonymous, "Expositions nouvelles," *Chronique des arts et de la curiosité* (June 17, 1905), 187.

Anonymous [Arthur Hoeber], "Art and Artists," *New York Globe and Commercial Advertiser* (March 3, 1911).

Anonymous, "Water Colors by Cézanne," *New York Times* (March 12, 1911).

Antoine, Jules, "Galerie Petit: Exposition de la Société des aquarellistes," *La Plume*, no. 45 (March 1, 1891), 98–99.

Armstrong, Carol, *Cézanne in the Studio: Still Life in Watercolors*, Los Angeles: Getty, 2004.

Athanassoglou-Kallmyer, Nina, *Cézanne and Provence: The Painter in His Culture*, Chicago: University of Chicago Press, 2003.

————, "Cézanne and Delacroix's Posthumous Reputation," *Art Bulletin*, vol. 87, no. 1 (March 2005), 111–29.

Aurier, G.-Albert, "Les Aquarellistes," *Revue indépendante*, no. 40 (February 1890), 321–33.

Badt, Kurt, *The Art of Cézanne*, trans. Sheila Ann Ogilvie, New York: Hacker, 1985.

Baignières, Arthur, "Exposition de peinture par un groupe d'artistes, rue Pelietier, 11," *L'Echo universel* (April 13, 1876).

——, "Société d'aquarellistes français," *Gazette des Beaux-Arts*, 2nd ser., 19 (May 1, 1879), 491–501.

Bailey, Colin, et al., *Masterpieces of Impressionism and Post-Impressionism: The Annenberg Collection*, Philadelphia: Philadelphia Museum of Art, 1989.

Barr, Alfred H. Jr., "Cézanne in the Letters of Marion to Morstatt, 1865–1868: Chapter 1," trans. Margaret Scolari, *Magazine of Art*, vol. 31, no. 2 (February 1938), 84–89.

——, "Cézanne in the Letters of Marion to Morstatt, 1865–1868: Chapter 2," trans. Margaret Scolari, *Magazine of Art*, vol. 31, no. 4 (April 1938), 220–91.

——, "Cézanne in the Letters of Marion to Morstatt, 1865–1868: Chapter 3," trans. Margaret Scolari, *Magazine of Art*, vol. 31, no. 5 (May 1938), 288–91.

Baudelaire, Charles, "Salon de 1845," in *Critique d'art*, ed. Claude Pichois, Paris: Gallimard, 1976, 11–67.

——, "Salon de 1846," in *Critique d'art*, 75–156.

——, "Le Peintre de la vie moderne," in *Critique d'art*, 343–84.

——, "L'Oeuvre et la vie d'Eugène Delacroix," in *Critique d'art*, 402–30.

Baumann, Felix, et al., *Cézanne: Finished/Unfinished*, exh. cat., Ostfildern-Ruit: Hatje Cantz, 2000.

Benesch, Evelyn, "From the Incomplete to the Unfinished: Realization in the Work of Paul Cézanne," in Felix Baumann et al., *Cézanne: Finished/Unfinished*, exh. cat., Ostfildern-Ruit: Hatje Cantz, 2000, 41–62.

Bensusan-Butt, John, "Recollections of Lucien Pissarro in His Seventies," in *Lucien Pissarro, 1863–1944*, London: Anthony d'Offay, 1977, 5–27.

Bergol, Ivan, and Arlette Sérullaz, *Eugène Delacroix: aquarelles et lavis au pinceau*, Paris and Martel: Réunion des musées nationaux / Laquet, 1998.

Bergson, Henri, *Creative Evolution*, trans. Arthur Mitchell, New York: Dover, 1998.

Bernard, Emile, letter to his mother, February 5, 1904, in *Conversations avec Cézanne*, ed. P.-M. Doran, Paris: Macula, 1978, 23–25.

——, "Paul Cézanne," *L'Occident* (July 1904), 17–30; reprinted in *Conversations avec Cézanne*, 30–42.

——, "Souvenirs sur Paul Cézanne," *Mercure de France* (October 1, 1907), 385–404; "Souvenirs sur Paul Cézanne," *Mercure de France* (October 16, 1907), 606–27; both reprinted in *Conversations avec Cézanne*, 49–80.

——, "Les Aquarelles de Cézanne," *L'Amour de l'art* (February 1924), 33–36.

Berson, Ruth, ed., *The New Painting: Impressionism, 1874–1886: Documentation*, 2 vols., San Francisco: The Fine Arts Museums of San Francisco, 1996.

Bertall [Charles-Albert d'Arnoux], "Les Impressionnalistes," *Les Beaux-Arts* (1876), 44–45.

Berthold, Gertrude, *Cézanne und die alten Meister: die Bedeutung der Zeichnungen Cézannes nach Werken anderer Künstler*, Stuttgart: W. Kohlhammer, 1958.

Bigot, Charles, "Causerie artistique: l'exposition des 'impressionnistes,'" *La Revue politique et littéraire* (April 28, 1877), 1045–48.

Blanc, Charles, *Grammaire des arts du dessin*, Paris: Renouard, 1867.

Blémont, Emile [Emile Petitdidier], "Les Impressionnistes," *Le Rappel* (April 9, 1876), 2–3.

Boime, Albert, *The Academy and French Painting in the Nineteenth Century*, London: Phaidon, 1971.

——, "The Teaching Reforms of 1863 and the Origins of Modernism in France," *Art Quarterly*, vol. 1, no. 1 (1977).

Bois, Georges, "Le Sculpteur Rodin et les danseuses cambodgiennes," *L'Illustration* (July 28, 1906), 64–65.

Bois, Yve-Alain, "Words and Deeds," trans. Rosalind Krauss, *October*, no. 84 (Spring 1998), 31–43.

Borély, Jules, "Cézanne à Aix," *Vers et prose*, vol. 27 (1911), 109–13; reprinted in *Conversations avec Cézanne*, ed. P.-M. Doran, Paris: Macula, 1978.

Bouyer, Raymond, "Le Procès de l'art moderne au Salon d'Automne," *Revue bleue* (November 5, 1904), 601–605.

Bracquemond, Félix, *Du dessin et de la couleur*, Paris: Charpentier, 1885.

Brettell, Richard, "The 'First' Exhibition of Impressionist Painters," in Charles Moffett et al., *The New Painting: Impressionism, 1874–1886*, exh. cat., San Francisco: The Fine Arts

Museums of San Francisco, and Washington, DC: National Gallery of Art, 1986, 189–202.

——, *Pissarro and Pontoise: The Painter in a Landscape*, New Haven and London: Yale University Press, 1990.

——, "Cézanne/Pissarro: élève/élève," in *Cézanne aujourd'hui*, ed. Françoise Cachin et al., Paris: Réunion des musées nationaux, 1997, 29–37.

——, *Impressionism: Painting Quickly in France, 1860–1890*, New Haven and London: Yale University Press, 2000.

——, and Christopher Lloyd, *Catalogue of Drawings by Camille Pissarro in the Ashmolean Museum, Oxford*, New York and Oxford: Oxford University Press, 1980.

Bürger, W. [Théophile Thoré], ed., *Salons de T. Thoré: 1844, 1845, 1846, 1847, 1848*, Paris: Librairie internationale, 1868.

Burty, Philippe, "Exposition de la société anonyme des artistes," *La Republique française* (April 25, 1874), 2.

——, "The Paris Exhibitions: *Les Impressionnistes*," *The Academy* (May 30, 1874), 616.

Cachin, Françoise, et al., *Cézanne*, exh. cat., trans. John Goodman, New York: Harry N. Abrams / Philadelphia: Philadelphia Museum of Art, 1996.

——, ed., *Cézanne aujourd'hui*, Paris: Réunion des musées nationaux, 1997.

Cahn, Isabelle, "L'Exposition Cézanne chez Vollard en 1895," in *Cézanne aujourd'hui*, ed. Françoise Cachin et al., Paris: Réunion des musées nationaux, 1997, 135–44.

Callen, Anthea *The Art of Impressionism: Painting Technique and the Making of Modernity*, New Haven and London: Yale University Press, 2000.

Camp, Maxime du, *Les Beaux-Arts à l'exposition universelle de 1855*, Paris: Librarie nouvelle, 1855.

Carjat, Etienne, "L'Exposition du boulevard des Capucines," *Le Patriote français* (April 27, 1874), 3.

Cassagne, Armand, *Traité d'aquarelle* [1875], 2nd edn., Paris: Fouraut, 1886.

Castagnary, Jules-Antoine, "Exposition du Boulevard des Capucines: Les Impressionistes," *Le Siècle* (April 29, 1874), 3.

——, *Salons*, vol. 1 [1857–70], Paris: Charpentier, 1892.

Cavé, Marie-Elisabeth, *L'Aquarelle sans maître*, Paris: Napoléon Chaix, 1851.

Cézanne, Paul, "Mes confidences," in *Conversations avec Cézanne*, ed. P.-M. Doran, Paris: Macula, 1978, 101–04.

——, *Paul Cézanne: correspondance*, rev. edn., ed. John Rewald, Paris: Grasset et Fasquelle, 1978.

——, *Paul Cézanne: Letters*, rev. edn., ed. John Rewald, trans. Seymour Hacker, New York: Hacker, 1984.

Chamberlin, Joseph Edgar, "Cézanne Embryos," *Evening Mail* (March 8, 1911).

Chennevières, Henri de, "Maurice Leloir," in *Société des aquarellistes français*, vol. 2, Paris: H. Launette, 1884, 289–304.

Chesneau, Ernest, "A côté du Salon: II. Le Plein Air: exposition du boulevard des Capucines," *Paris-Journal* (May 7, 1874), 2.

Clark, T. J., *The Painting of Modern Life: Paris in the Art of Manet and His Followers*, Princeton: Princeton University Press, 1985.

——, "Freud's Cézanne," in *Farewell to an Idea: Episodes from a History of Modernism*, New Haven and London: Yale University Press, 1999.

——, "Phenomenality and Materiality in Cézanne," in *Material Events: Paul de Man and the Afterlife of Theory*, ed. Barbara Cohen et al., Minneapolis: University of Minnesota Press, 2001.

Cohn, Marjorie B., *Wash and Gouache: A Study of the Development of the Materials of Watercolor*, Cambridge, MA: Fogg Art Museum, 1977.

Conisbee, Philip, and Denis Coutagne, *Cézanne in Provence*, exh. cat., New Haven and London: Yale University Press, 2006.

Coplans, John, *Cézanne Watercolors*, exh. cat., Los Angeles: Pasadena Art Museum / Ward Ritchie Press, 1967.

Coutaigne, Denis, "Les 'Eaux-Légères' de Granet," in *Granet: paysages de l'Isle de France: aquarelles et dessins*, Aix-en-Provence: Musée Granet, 1984.

Crary, Jonathan, "Unbinding Vision," *October*, no. 68 (Spring 1994), 21–44.

——, "Attention and Modernity in the Nineteenth Century," in *Picturing Science, Producing Art*, ed. Caroline A. Jones and Peter Gallison, New York: Routledge, 1998.

——, *Suspensions of Perception*, Cambridge, MA: MIT Press, 1999.

Crouzet, Marcel, *Un méconnu du réalisme: Duranty (1830–1880)*, Paris: Nizet, 1964.

Delacroix, Eugène, *Correspondance générale de Eugène Delacroix*, ed. André Joubin, vol. 2, Paris: Plon, 1936.

——, *The Journal of Eugène Delacroix*, trans. Walter Pach, New York: Crown, 1948.

Denis, Maurice, "La Peinture," *L'Ermitage*, vol. 2, no. 11 (November 15, 1905), 309–19.

——, "Cézanne," in *Theories, 1890–1910: du symbolisme et de Gauguin vers un nouvel ordre classique*, 4th edn., Paris: Rouart et Watelin, 1920, 245–61.

——, *Journal: vol. I, 1884–1904*, Paris: La Colombe, 1957.

——, *Journal: vol. II, 1905–1920*, Paris: La Colombe, 1957.

Doran, P.-M., ed., *Conversations avec Cézanne*, Paris: Macula, 1978.

Druick, Douglas, "Cézanne's Lithographs," in *Cézanne: The Late Work*, ed. William Rubin, New York: Museum of Modern Art, 1977, 119–37.

Drumont, E., "L'Exposition du boulevard des Capucines," *Le Petit Journal* (April 19, 1874), 2.

Duranty, Edmond, "Pour ceux qui ne comprennent jamais," *Le Réalisme*, no. 2 (December 15, 1856), 1–2.

——, "Le Peintre Louis Martin," *Le Pays des arts*, Paris: Charpentier, 1881, 315–50.

Duret, Théodore, *Histoire des peintres impressionnistes*, 3rd edn., Paris: H. Floury, 1922.

F. E., "Le Groupe d'artistes de la rue Le Peletier," *Moniteur des arts* (April 21, 1876), 1–2.

Fielding, Thales H., *On Painting in Oil and Watercolours for Landscape and Portraits*, London: Ackerman, 1839.

Fillonneau, Ernest, "Les Impressionnistes," *Moniteur des arts* (April 20, 1877), 1.

Focillon, Henri, *The Life of Forms in Art*, trans. Charles B. Hogan and George Kubler, New York: Zone Books, 1989.

Fontainas, André, "Les Aquarelles de Cézanne," *Mercure de France*, 56, 16e année (July 1, 1905), 133–34.

Fry, Roger, *Cézanne: A Study of His Development*, Chicago: University of Chicago Press, 1989.

Gachet, Paul, *Lettres impressionnistes et autres*, Paris: Bernard Grasset, 1957.

Gage, John, *Turner and Watercolour: Exhibition of Watercolours from the Turner Bequest*, London: Arts Council of Great Britain, 1974.

——, "Turner: A Watershed of Watercolour," in *Turner*, ed. Michael Lloyd, Canberra: National Gallery of Australia, 1996, 101–27.

Garb, Tamar, "Visuality and Sexuality in Cézanne's Late Bathers," *Oxford Art Journal*, vol. 19, no. 2 (1996), 46–60.

Gasquet, Joachim, *Joachim Gasquet's Cézanne: A Memoir with Conversations*, trans. Christopher Pemberton, London: Thames and Hudson, 1991.

Geffroy, Gustave, "Peintures et aquarelles," in *La vie artistique*, vol. 2, Paris: Dentu, 1893, 361.

——, "Paul Cézanne," in *La vie artistique*, vol. 3, Paris: Dentu, 1894, 249–60.

——, "Paul Cézanne," in *La vie artistique*, vol. 6, Paris: Floury, 1900, 214–20.

——, "Salon de 1901," in *La vie artistique*, vol. 8, Paris: Dentu, 1903, 376.

——, *Claude Monet: sa vie, son temps, son oeuvre*, Paris: G. Crès, 1922.

——, *Paul Cézanne et autres textes*, ed. Christian Limousin, Paris: Séguier, 1995.

Gombrich, E. H., *The Image and the Eye*, Ithaca, NY: Cornell University Press, 1982.

Gonse, Louis, "Aquarelles, dessins, et gravures au Salon de 1875," *Gazette des Beaux-Arts*, 2nd ser., 12 (August 1, 1875), 167–74.

———, "Aquarelles, dessins, et gravures au Salon de 1876," *Gazette des Beaux-Arts*, 2nd ser., 14 (August 1, 1876), 138–45.

———, "Les Aquarelles, dessins, et gravures au Salon de 1875," *Gazette des Beaux-Arts*, 2nd ser., 16 (August 1, 1877), 156–69.

Goupil, Frédéric, *Traité méthodique de dessin de l'aquarelle et du lavis*, Paris: Renouard, 1876.

Gowing, Lawrence, *Watercolour and Pencil Drawings by Cézanne*, London: Arts Council of Great Britain, 1973.

———, "The Logic of Organized Sensations," in *Cézanne: The Late Work*, ed. William Rubin, New York: Museum of Modern Art, 1977, 55–106.

———, et al., *Cézanne: The Early Years, 1859–1872*, exh. cat., New York: Harry N. Abrams, 1988.

Grimm, Thomas, "Les Impressionnistes," *Le Petit Journal* (April 7, 1877), 1.

Gsell, Paul, "Rodin racontée par lui-même," *La Revue* (May 1, 1906), 92–100.

Guerlin, Henri, *Le Dessin*, Paris: Henri Laurens, n. d.

Hamilton, George Heard, "Cézanne and the Image of Time," *College Art Journal*, vol. 16, no. 1 (Fall 1956), 2–12.

Hannoosh, Michelle, "The Poet as Art Critic: Laforgue's Aesthetic Theory," *Modern Language Review*, vol. 79, no. 3 (July 1984), 553–69.

Hildebrand, Adolph von, *The Problem of Form*, trans. Max Meyer and Robert Morris Ogden, New York: G. E. Stechert, 1932.

House, John, *Monet: Nature into Art*, New Haven and London: Yale University Press, 1986.

———, *Impressionism: Paint and Politics*, New Haven and London: Yale University Press, 2004.

Houssaye, Henry, *L'Art français depuis dix ans*, Paris: Didier, 1882.

Imdahl, Max. *Couleur: les écrits des peintres français de Poussin à Delaunay*, trans. Françoise Laroche, Paris: Maison des sciences et de l'homme, 1996.

Isaacson, Joel, "Pissarro's Doubt: *Plein-air* Painting and the Abiding Questions," *Apollo*, vol. 136, no. 369 (November 1992), 320–24.

———, "Constable, Duranty, Mallarmé, Impressionism, *Plein Air*, and Forgetting," *Art Bulletin*, vol. 76, no. 3 (September 1994), 427–50.

Jacques, "Menus propos: exposition impressionniste," *L'Homme libre* (April 12, 1877), 1–2.

Jaloux, Edmond, *Les Saisons litteraires*, 2 vols., Fribourg: Libraire de l'Université, 1942.

Johnson, Una E., *Ambroise Vollard, Editeur: Prints, Books, Bronzes*, New York: Museum of Modern Art, 1977.

Kahn, Gustave, "Art," *Mercure de France* (December 16, 1913), 822.

Kendall, Richard, "Degas and Cézanne: Savagery and Refinement," in Ann Dumas et al., *The Private Collection of Edgar Degas*, New York: The Metropolitan Museum of Art, 1997, 197–219.

Knubben, Thomas, and Tilman Osterwald, eds., *Auguste Rodin: Watercolors from the Collection of the Musée Rodin, Paris*, Ostfildern-Ruit: Hatje Cantz, 2005.

Krumrine, Mary Louise, *Paul Cézanne: The Bathers*, New York: Harry N. Abrams, 1989.

Lafenestre, Georges, *L'Art vivant: la peinture et la sculpture aux Salons de 1868–1877*, vol. 1, Paris: G. Fischbacher, 1881.

Laforgue, Jules, "L'Impressionnisme," in *Jules Laforgue: mélanges posthumes*, Paris: Mercure de France, 1903; reprinted in *Laforgue: textes de critique d'art*, ed. Mireille Dotin, Lille: Presses universitaires de Lille, 1988, 168–75.

Landon, C. P., *Annales du musée et de l'école moderne des beaux-arts: Salon de 1883*, Paris: Pillet Ainé, 1833.

Larguier, Léo, *Le Dimanche avec Paul Cézanne: Souvenirs*, Paris: L'Edition, 1925.

Le Normand-Romain, Antoinette, and Christina Buley-Uribe, eds., *Auguste Rodin: Drawings and Watercolors*, New York and London: Thames and Hudson, 2006.

Lebensztejn, Jean-Claude, "Les Couilles de Cézanne," *Critique*, vol. 44, no. 499 (December 1988), 1031–47.

———, "Persistance de la mémoire," *Critique*, vol. 54, nos. 555–56 (August–September 1993), 609–31.

Leiris, Alain de, *From Delacroix to Cézanne: French Watercolor Landscapes of the Nineteenth Century*, exh. cat., College Park, MD: The University of Maryland, 1977.

Lemaître, Henri, *Le Paysage anglais à l'aquarelle*, Paris: Bordas, 1955.

Leroy, Louis, "L'Exposition des impressionistes," *Le Charivari* (April 25, 1874), 79–80.

Levine, Steven Z., "The 'Instant' of Criticism and Monet's Critical Instant," *Arts Magazine*, vol. 55, no. 7 (March 1981), 114–21.

Leymarie, Jean, *L'Aquarelle*, Geneva: Skira, 1984.

Lichtenstein, Sara, "Cézanne and Delacroix," *Art Bulletin*, vol. 46, no. 1 (March 1964), 55–67.

———, "Cézanne's Copies and Variants after Delacroix," *Apollo*, vol. 101, no. 156 (February 1975), 116–27.

Lloyd, Christopher, *Camille Pissarro*, Geneva: Skira, 1981.

———, and Richard Thompson, *Impressionist Drawings from British Public and Private Collections*, London: Phaidon / Arts Council, 1986.

———, "'Paul Cézanne, Pupil of Pissarro': An Artistic Friendship," *Apollo*, vol. 136, no. 369 (November 1992), 284–90.

Lora, Léon de [Felix Pothey], "Petites nouvelles artistiques: exposition libre des peintres," *Le Gaulois* (April 18, 1874), 3.

———, "L'Exposition des impressionnistes," *Le Gaulois* (April 10, 1877), 1–2.

Lostalot, Alfred de, "Exposition universelle: aquarelles, dessins, gravures," *Gazette des Beaux-Arts*, 2nd ser., 18 (October 1878), 634–56.

Lyotard, Jean-François, "Freud selon Cézanne," in *Des dispositifs pulsionnels*, Paris: Galilée, 1994, 71–89.

Machotka, Pavel, *Cézanne: Landscape into Art*, New Haven and London: Yale University Press, 1996.

Mallarmé, Stéphane, "The Impressionists and Edouard Manet," *Art Monthly Review and Photographic Portfolio*, vol. 1, no. 9 (September 30, 1876), 117–22.

Maloon, Terrence, "Critical Responses to Cézanne's Unfinished Works," in Felix Baumann et al., *Cézanne: Finished/Unfinished*, exh. cat., Ostfildern-Ruit: Hatje Cantz, 2000, 85–97.

Mancino, Léon, "Deuxième exposition de peintures, dessins, gravures faite par un groupe d'artistes," *L'Art*, vol. 5 (1876), 36–37.

Manoeuvre, Laurent, "Boudin's Watercolours of Beaches," in *Boudin at Trouville*, ed. Vivian Hamilton, London: John Murray / Glasgow Museums, 1992, 147–53.

Martelli, Diego, "Les Impressionnistes," in *Les Impressionnistes et l'art moderne*, ed. Francesca Errico, trans. Francis Darbousset, Paris: Vilo, 1979, 15–27.

Marx, Roger, "Petites exhibitions: exposition Paul Cézanne (Galerie Vollard)," *Chronique des arts et de la curiosité* (July 1, 1905), 192.

Masson, André, *Entretiens avec Georges Charbonnier*, Paris: Julliard, 1958.

Maus, Octave, "Exposition des aquarellistes (premier article)," *L'Art moderne*, vol. 1, no. 8 (April 24, 1881), 58–59.

———, "Exposition des aquarellistes (secondième article)," *L'Art moderne*, vol. 1, no. 9 (May 1, 1881), 67–68.

———, "Referendum artistique," *L'Art moderne*, vol. 10, no. 52 (December 28, 1890), 409–12.

———, "Referendum artistique," *L'Art moderne*, vol. 11, no. 2 (January 11, 1891), 11–14.

Melot, Michel, *The Impressionist Print*, trans. Caroline Beamish, New Haven and London: Yale University Press, 1996.

Merleau-Ponty, Maurice, "Cézanne's Doubt," in *Sense and Non-Sense*, trans. Hubert L. Dreyfus and Patricia Allen Dreyfus, Evanston, IL: Northwestern University Press, 1964, 9–25.

Ménard, Réné, "François-Louis Français," *Société des aquarellistes français*, vol. 1, no. 8, Paris: Goupil, 1883, 113–28.

Meunier, Mario, "Rodin dans son art et dans sa vie," *Le Marges* (April 1914), 250–51.

Michel, André, *Notes sur l'art moderne*, Paris: Armand Colin, 1896.

Moffett, Charles, et al., *The New Painting: Impressionism, 1874–1886*, exh. cat., San Francisco: The Fine Arts Museums of San Francisco, and Washington, DC: National Gallery of Art, 1986.

Montfort, Eugène, "La Mort de Gasquet," *Les Manges*, vol. 21, no. 84 (June 15, 1921), 83–87.

Morice, Charles, "Enquête sur les tendances actuelles des arts plastiques," *Mercure de France*, 56 (August 1, 1905), 346–59.

——, "Enquête sur les tendances actuelles des arts plastiques (suite)," *Mercure de France* (August 15, 1905), 538–55.

——, "Enquête sur les tendances actuelles des arts plastiques (suite)," *Mercure de France* (September 1, 1905), 61–85.

Munhall, Edgar, *François-Marius Granet: Watercolors from the Musée Granet in Aix-en-Provence*, New York: The Frick Collection, 1988.

Munro, Jane, *French Impressionists*, Cambridge: Cambridge University Press, 2004.

Natanson, Thadée, "Paul Cézanne," *La Revue blanche* (December 1, 1895), 496–500.

Osthaus, Karl Ernst, "Une visite à Paul Cézanne," *Das Feuer* (1920–21), 81–85.

Paillot de Montabert, J. N., *Traité complet de la peinture*, 8 vols., Paris: J.-F. Delion, 1829–51.

Paradise, JoAnne, *Gustave Geffroy and the Criticism of Painting*, New York and London: Garland, 1985.

Pératé, André, "Le Salon d'automne," *Gazette des Beaux-Arts*, 3rd ser., 38 (November 1, 1907), 385–407.

Piette, Ludovic, *Mon cher Pissarro: lettres de Ludovic Piette à Camille Pissarro*, ed. Janine Bailly-Herzberg, Paris: Valhermeil, 1985.

Pissarro, Camille, *Correspondance de Camille Pissarro*, ed. Janine Bailly-Herzberg, 5 vols., Paris: Presses universitaires de France, 1980–91.

Pissarro, Joachim, *Camille Pissarro*, New York: Harry N. Abrams, 1993.

——, *Pioneering Modern Painting: Cézanne and Pissarro*, New York: Museum of Modern Art, 2005.

Platzman, Steven, *Cézanne: The Self Portraits*, Berkeley and Los Angeles: University of California Press, 2001.

Prouvaire, Jean [Pierre Toloza], "L'Exposition du boulevard des Capicines," *Le Rappel* (April 20, 1874), 3.

Rabinow, Rebecca A., ed., *Cézanne to Picasso: Ambroise Vollard, Patron of the Avant-Garde*, New York: The Metropolitan Museum of Art, 2006.

Ratcliffe, Robert William, "Cézanne's Working Methods and Their Theoretical Background," Ph.D. dissertation, Courtauld Institute of Art, University of London, 1961.

Reff, Theodore, "Cézanne's Drawings, 1875–85," *Burlington Magazine*, vol. 101, no. 674 (May 1959), 171–76.

——, "Cézanne's Bather with Outstretched Arms," *Gazette des Beaux-Arts*, 6th ser., 59 (March 1962), 173–90.

——, "Cézanne's Constructive Stroke," *Art Quarterly*, vol. 25, no. 3 (Autumn 1962), 214–26.

——, "Cézanne: The Logical Mystery," *Art News*, vol. 62, no. 2 (April 1963), 28–31.

——, "Cézanne's Late Bather Paintings," *Arts Magazine*, vol. 52, no. 2 (October 1977), 116–19.

——, "The Pictures within Cézanne's Pictures," *Arts Magazine*, vol. 53, no. 10 (June 1979), 90–104.

——, and Innis Howe Shoemaker, *Paul Cézanne: Two Sketchbooks*, Philadelphia: Philadelphia Museum of Art, 1989.

Rewald, John, *Paul Cézanne: A Biography*, trans. Margaret H. Liebman, New York: Schocken, 1968.

——, *The History of Impressionism*, 4th edn., New York: Museum of Modern Art, 1973.

——, *Cézanne and America: Dealers, Collecters, Artists, and Critics, 1891–1921*, Princeton: Princeton University Press, 1979.

——, *Paul Cézanne: The Watercolors*, Boston, MA: Little, Brown, 1983.

——, "Cézanne and Guillaumin," in *Studies in Impressionism*, New York: Abrams, 1985, 103–19.

——, "Chocquet and Cézanne," in *Studies in Impressionism*, ed. Irene Gordon and Frances Weitzenhoffer, New York: Thames and Hudson, 1985.

——, with Walter Feilchenfeldt and Jane Warman, *The Paintings of Paul Cézanne*, 2 vols., New York: Harry N. Abrams, 1996.

Riegl, Alois, *Late Roman Art Industry*, trans. Rolf Winkes, Rome: Giorgio Bretschneider, 1985.

Rilke, Rainer Maria, *Letters on Cézanne*, ed. Clara Rilke, trans. Joel Agee, New York: Fromm, 1985.

Rivière, Georges, "L'Exposition des impressionnistes," *L'Impressionniste* (April 14, 1877), 1–4, 6.

——, "Les Intransigeants et les impressionnistes: souvenirs du salon libre de 1877," *L'Artiste* (November 1, 1877), 298–302.

——, *Le Maître Paul Cézanne*, Paris: Floury, 1923.

Rivière, R. P., and J. F. Schnerb, "L'Atelier de Cézanne," *La Grande Revue* (December 25, 1907), 811–17.

Roque, Georges, *Art et science de la couleur: Chevreul et les peintres, de Delacroix à l'abstraction*, Paris: Jacqueline Chambon, 1997.

Rubin, William, et al., *Cézanne: The Late Work*, exh. cat., New York: Museum of Modern Art, 1977.

Ruskin, John, *The Elements of Drawing* [1857], New York: Dover, 1971.

Schapiro, Meyer, "Cézanne as a Watercolorist," in *Modern Art: 19th and 20th Centuries. Selected Papers*, New York: George Braziller, 1979, 43–45.

Sérullaz, Arlette, and Régis Michel, *L'Aquarelle en France au XIXe siècle: dessins du musée du Louvre*, Paris: Réunion des musées nationaux, 1983.

Shiff, Richard, *Cézanne and the End of Impressionism: A Study of the Theory, Technique, and Critical Evaluation of Modern Art*, Chicago: University of Chicago Press, 1984.

——, "Cézanne's Physicality: The Politics of Touch," in *The Language of Art History*, ed. Ivan Gaskill and Salim Kemal, Cambridge: Cambridge University Press, 1991, 129–80.

——, "To Move the Eyes: Impressionism, Symbolism, and Well-Being, *c.* 1891," in *Impressions of French Modernity*, ed. Richard Hobbs, Manchester: Manchester University Press, 1998, 190–210.

——, "Mark, Motif, Materiality: The Cézanne Effect in the Twentieth Century," in *Cézanne: Finished/Unfinished*, ed. Felix Baumann et al., Ostfildern-Ruit: Hatje Cantz, 2000, 99–123.

Shikes, Ralph E., and Paula Harper, *Pissarro: His Life and Art*, New York: Horizon, 1980.

Signac, Paul, *D'Eugène Delacroix au Néo-Impressionnisme*, Paris: Floury, 1921.

——, *Jongkind*, Paris: G. Crès, 1927.

Silvestre, Théophile, *Eugène Delacroix: documents nouveaux*, Paris: Michel Lévy, 1864.

Simms, Matthew, "The Impression to Excess: Color and Drawing in Cézanne," Ph.D. dissertation, Harvard University, Cambridge, MA, 1998.

———, "Painting on Drawing," in *Cézanne in Focus: Watercolors from the Henry and Rose Pearlman Collection*, ed. Carol Armstrong and Laura Giles, Princeton: Princeton University Press, 2002, 13–25.

Simon, Robert, "Cézanne and the Subject of Violence," *Art in America*, vol. 79, no. 5 (May 1991), 120–35, 185–86.

Sizeranne, Robert de la, *Les Questions esthétiques contemporaines*, Paris: Hachette, 1904.

Smith, Paul, "Joachim Gasquet, Virgil and Cézanne's Landscape: 'My Beloved Golden Age'," *Apollo*, vol. CXLVII, no. 439 (October 1998), 11–23.

Souriau, Paul, *The Aesthetics of Movement*, trans. Manon Souriau, Amherst: The University of Massachusetts Press, 1983.

Taine, Hyppolite, *Philosophie de l'art*, 2 vols., Paris: Hachette, 1946.

Terrasse, Antoine, *Les Aquarelles de Cézanne*, Paris: Flammarion, 1995.

Touttavoult, Fabrice [Jean-Claude Lebensztejn], *Confessions: Marx, Engels, Proust, Mallarmé, Cézanne*, Paris: Belin, 1988.

Vallotton, Félix, "Au Salon d'automne," *La Grande Revue* (October 25, 1907), 916–924.

Vauxcelles, Louis, "Les Dessins et aquarelles du 'Petit Palais'," *L'Art et les artistes* (October 1906), 435–42.

Venturi, Lionello, *Paul Cézanne: Water Colours*, Oxford: Bruno Cassirer, 1943.

Véron, Eugène, *L'Esthetique*, 2nd edn., Paris: Reinwald, 1883.

Viatte, Françoise, "Weaving a Rope of Sand," trans. Roland Racevskis, *Yale French Studies*, no. 89 (1996), 85–102.

Vollard, Ambroise, *Paul Cézanne: His Life and Art*, trans. Harold L. Van Doren, New York: Dover, 1984.

Wadley, Nicolas, *Impressionist and Post-Impressionist Drawing*, New York: Dutton, 1991.

Waldfogel, Melvin, "A Problem in Cézanne's Grandes Baigneuses," *Burlington Magazine*, vol. 104, no. 710 (May 1962), 200–04.

Ward, Martha, *Pissarro, Neo-Impressionism, and the Spaces of the Avant-Garde*, Chicago: Chicago University Press, 1996.

Werth, Léon, "Dessins aquarellés de Cézanne," *L'Art vivant* (March 1, 1925), 18.

White, Barbara Ehrlich, *Impressionists Side by Side*, New York: Alfred A. Knopf, 1996.

Wildenstein, Daniel, *Claude Monet: biographie et catalogue raisonné, vol. 3: 1887–1898*, Paris: La Bibliothèque des arts, 1979.

Wilton, Andrew, *Turner and the Sublime*, London: British Museum, 1980.

———, and Anne Lyles, *The Great Age of British Watercolours, 1750–1880*, London and Munich: Royal Academy of Art / Prestel, 1993.

Wittkower, Rudolf, "Introduction," in *Masters of the Loaded Brush: Oil Sketches from Rubens to Tiepolo*, New York: Columbia University Press, 1967.

Wyzewa, Theodore de, "Du soleil, de la Provence, et de la mer Mediterranée," *Revue bleue* (January 13, 1894), 59–61.

Zieske, Faith, "Paul Cézanne's Watercolors: His Choice of Pigments and Papers," in *The Broad Spectrum: Studies in the Materials, Techniques, and Conservation of Color on Paper*, ed. Harriet K. Stratis and Britt Salvesen, London: Archetype, 2002, 89–100.

———, "Technical Observations," in *Cézanne in Focus: Watercolors from the Henry and Rose Pearlman Collection*, ed. Carol Armstrong and Laura Giles, Princeton: Princeton University Press, 2002, 27–29.

Zola, Emile, "Mon Salon [1866]," in *Ecrits sur l'art*, ed. Jean-Pierre Leduc-Adine, Paris: Gallimard, 1991, 87–135.

———, "Mon Salon [1868]," in *Ecrits sur l'art*, 191–228.

———, "Le Naturalisme au Salon [1880]," in *Ecrits sur l'art*, 409–38.

———, *L'Oeuvre* [1886], Paris: Hachette, 1968.

———, *Correspondance*, ed. B. H. Bakker et al., 10 vols., Montréal: Presses de l'université de Montréal, 1978–95.

Index